# Masters of American Comics

# Masters
## *of* American Comics

Essay by
John Carlin

With contributions by

Stanley Crouch, Tom De Haven, Dave Eggers,

Jules Feiffer, Jonathan Safran Foer, Glen David Gold,

Matt Groening, Pete Hamill, J. Hoberman,

Karal Ann Marling, Patrick McDonnell, Françoise Mouly,

Raymond Pettibon, Robert Storr, and Brian Walker

Edited by John Carlin, Paul Karasik,
and Brian Walker

Hammer Museum and The Museum of Contemporary Art, Los Angeles,
in association with Yale University Press, New Haven and London

This catalogue was published in conjunction with
*Masters of American Comics,*
an exhibition jointly organized by the Hammer Museum and
The Museum of Contemporary Art, Los Angeles.
This exhibition is made possible, in part, by the
National Endowment for the Arts.

This exhibition was organized by John Carlin and Brian Walker with Cynthia Burlingham and Michael Darling.

*Exhibition Itinerary*

Hammer Museum and
The Museum of Contemporary Art, Los Angeles
November 20, 2005 to March 12, 2006

Milwaukee Art Museum
April 27 to August 20, 2006

The Jewish Museum and The Newark Museum
September 15, 2006 to January 7, 2007

Edited by
Stephanie Emerson

Designed by
Lorraine Wild with Victoria Lam
and Stuart Smith/
Green Dragon Office, Los Angeles

Publication Coordinator
Claudine Dixon

Most photographs are reproduced courtesy of the creators and lenders of the material depicted. We would appreciate notification of additional credits for acknowledgment in future editions.

Typeset in Dom Casual, News Gothic, and Vendetta by Green Dragon Office.

Printed by Dr. Cantz'sche Druckerei Ostfildern, Germany

Published in 2005
by the Hammer Museum
and The Museum of Contemporary Art,
Los Angeles, in association with
Yale University Press, New Haven and London.

Hammer Museum
10899 Wilshire Boulevard
Los Angeles, CA 90024
Phone: 310-443-7000
www.hammer.ucla.edu

The Armand Hammer Museum of Art and Cultural Center is operated by the University of California, Los Angeles. Occidental Petroleum Corporation has partially endowed the Museum and constructed the Occidental Petroleum Cultural Center Building, which houses the Museum.

The Museum of Contemporary Art, Los Angeles
250 South Grand Avenue
Los Angeles, CA 90012
Phone: 213-621-2766
www.moca.org

Yale University Press
302 Temple Street
P.O. Box 209040
New Haven, CT 06520-9040
Phone: 203-432-0960
www.yalebooks.com

Library of Congress Cataloging-in-Publication Data

*Masters of American Comics* / edited by John Carlin, Paul Karasik, and Brian Walker ; essay by John Carlin ; with contributions by Stanley Crouch ... [et al.].
    p. cm.
 "This catalogue was published in conjunction with *Masters of American Comics*, an exhibition organized by the Hammer Museum and The Museum of Contemporary Art, Los Angeles, and on view from November 20, 2005 to March 12, 2006."
 Includes bibliographical references and index.
 ISBN 0-300-11317-X (cloth : alk. paper)
 1. Comic books, strips, etc.—United States—History—20th century—Exhibitions. 2. Cartoonists—United States—Exhibitions.  I. Carlin, John, 1955– II. Karasik, Paul. III. Walker, Brian. IV. Crouch, Stanley. V. UCLA Hammer Museum of Art and Cultural Center. VI. Museum of Contemporary Art (Los Angeles, Calif.)

NC1426.M34 2005
741.5'973'07479494—dc22

2005019449

## Directors' Foreword

It is a privilege for the Hammer Museum and The Museum of Contemporary Art, Los Angeles, to collaborate on this ground-breaking exhibition of American comic art. Presented simultaneously at both institutions, the exhibition includes over 900 drawings, newspaper pages, graphic novels, and comic books by fifteen outstanding twentieth-century American artists. The virtually unprecedented step of two institutions not only co-organizing, but co-presenting an exhibition attests to the importance of this rich and diverse subject. The art of comics is one of the most distinctive and important genres in the history of American art and has had immeasurable impact on other forms of art and culture. At the same time, however, it has remained a subtext in the history of art. Certainly the subject never has been presented on such a scale in any major museum, and the work of each of the featured artists has not been seen in such breadth and depth. We at the Hammer and MOCA believe that the works of these comic artists will be a revelation for audiences here in Los Angeles and across the country.

The idea for this exhibition was proposed by Art Spiegelman to Ann Philbin when she was at the Drawing Center many years ago. Art's enduring commitment to this project in his role as special advisor has been crucial. Over the years, the focus of the exhibition has been continuously discussed, debated, refined, and expanded, resulting in these superb in-depth selections of work by fifteen masters of comic art, ranging from the early twentieth-century Sunday pages of Winsor McCay to the contemporary graphic novels of Chris Ware. Narrowing the selection from the wide range of artists who have produced comics over the last century was a challenging process, and we hope that this exhibition will open the doors for future museum presentations that reflect the diversity of the medium as it further evolves in the twenty-first century.

The efforts of exhibition guest curators John Carlin and Brian Walker have been critical to its success. We thank them for lending their invaluable expertise in historical and contemporary comic art, as well as their continual enthusiasm and dedication to this exhibition. We also thank coordinating curators Cynthia Burlingham, Director of the Grunwald Center at the Hammer Museum, and Michael Darling, Assistant Curator at MOCA, for overseeing all aspects of this complex project and providing a model of professional collaboration.

The development of this exhibition led to partnerships with many individuals and institutions. Principal among these new partners are the artists represented in the exhibition and the collectors who have graciously lent the works from their collections, and we thank them for their generosity and enthusiasm. In addition, we are delighted that this exhibition will be presented at additional venues in Milwaukee, New York, and Newark. We thank our colleagues David Gordon, Director of the Milwaukee Art Museum; Joan Rosenbaum, Director and CEO, and Ruth Beesch, Deputy Director for Program at The Jewish Museum; and Mary Sweeney Price, Director of The Newark Museum, for sharing the exhibition with us.

Finally, we wish to thank the National Endowment for the Arts for providing early and valued support to the exhibition.

**Ann Philbin**
Director, Hammer Museum

**Jeremy Strick**
Director, The Museum of Contemporary Art, Los Angeles

# Acknowledgments

From the start, this exhibition has been defined by collaboration. It began as a partnership between the Hammer Museum and The Museum of Contemporary Art, Los Angeles (MOCA), two institutions deciding to host one exhibition at two venues in Los Angeles. The partnership expanded, gaining collaborators and sharing responsibilities among a large group of people. Credit should go to Hammer Museum Director Ann Philbin and MOCA Director Jeremy Strick for initiating this model of collaboration and also for the example of collegiality and cooperation they set for all of us to follow. The curatorial direction of the project was shaped by months of lively discussion and debate. Art Spiegelman provided the intellectual impetus for the exhibition and has been the indispensable catalyst for all aspects of the project in his role as special advisor. Co-curatorship of the exhibition was graciously shared by John Carlin and Brian Walker, both of whom lent their particular expertise and vision to the shaping of the exhibition and tirelessly saw it through to completion. In particular, John's initial vision and selection of artists and works included in the exhibition established the curatorial focus, and Brian's detailed knowledge of the works of each artist was crucial to its final shape.

The list of lenders to this exhibition is even longer, all of them generously parting with their beloved and often fragile comic art works so that the history of comics can be better understood by a large and eager public. For this we have to thank Araio Gallery, Glenn Bray, Professor Lucy Shelton Caswell at the Ohio State University Cartoon Research Library, Dinaburg Arts, Sara Duke at the Library of Congress, the Will Eisner Estate, Craig Englund, Andrew Farago at the Cartoon Art Museum of San Francisco, Jack Gilbert, Glen David Gold, Dr. Samuel Grubman, Jim Halperin at Heritage Galleries and Auctioneers, Steve Calrow and Helen Hamilton and the Bruce Hamilton Estate, Gallery Hyundai, the International Museum of Cartoon Art, Bill Janocha, Drew Anna King Schutte and the King Family, Denis Kitchen, Adele Kurtzman, Joe Maddalena, Peter Maresca, Matt Masterson, Patrick McDonnell, Ann Moniz and the Moniz Family, Tom Morehouse, Paul Morris at the Paul Morris Gallery, Bob Murphy, The Museum of Modern Art in New York, Gary Panter, Ethan Roberts, Eric F. Sack, Jim Scancarelli, Jean Schulz, Annee Knight, and Gianna Capecci at the Charles M. Schulz Museum, Randall Scott at Michigan State University Libraries, Tod Seisser, Art Spiegelman, Garry Trudeau, Dr. Stephen R. Turner, Mort Walker, Chris Ware, Andy Kraushaar at the Wisconsin Historical Society, Wally Wolodarsky, Craig Yoe, and various private collectors. The lenders also provided us with crucial information about works in their collections, and additional expertise and guidance was offered by Jonathan Fineberg, A. M. Homes, Chip Kidd, Greil Marcus, Achim Moeller, Marc Pascale, Helene Silverman, and Monika Stump. The staff of Funny Garbage, particularly Robert del Principe, Peter Girardi, Kristin Ellington, Ryan Germick, Libby Gery, and Colin Holgate deserve special thanks, as do Natalia Indrimi and Renee Dossick. The Whitney Museum of American Art Independent Study Program supported an earlier exhibition on the history of comic art curated by John Carlin.

This publication has also featured a host of contributors, from its organizational team to its design and editorial content. Paul Karasik, guest co-editor, worked with John Carlin to commission essays by fifteen outstanding authors, whose texts provide magnificent insights into the work of the featured artists. Carlin's own central essay is also a great contribution to the field as well as an illuminating coda to the exhibition. Brian Walker's proofreading and fact checking were indispensable, as was his advice and consultation about images and essayists. Lorraine Wild's graphic design of the book is amongst her finest to date and is proof of her range and flexibility. She was ably assisted by Victoria Lam and Stuart Smith at Green Dragon Office. Copyediting was accomplished with skill and aplomb by Stephanie Emerson, while the mammoth tasks of photo-editing and coordinating countless other aspects of the publication were carried out by Hammer Curatorial Associate Claudine Dixon. Photographer Robert Wedemeyer ably photographed the majority of works for the catalogue. Rights and reproduction assistance was provided by Jack N. Albert, Lishma Anikow, Dorothy Crouch, Erica Gibbs, Harry Guyton, Thomas King, Denis Kitchen, Maria Fernanda Meza, Carol G. Platt, Joel Press, Marcia Terrones,

Michelle Urry, Trisha Van Horsen, and Julia Wynn. We were also aided in various aspects of the catalogue by Jayne Antipow, Kim Goldstein, Mary Gollhofer, Susan A. Grode, Julie Hough, Michelle Meged, Karen O'Connell, Shaun Caley Regen, Michael D. Remer, Jenny Robb, Marilyn Scott, Shannon Supple, Evany Thomas, Kelly Troester, Sara Vanderbeek, and Dianne Woo. We are especially pleased that Yale University Press is co-publisher of the catalogue and thank Patricia Fidler for her enthusiasm and support.

Bringing all the works together safely and soundly was a task taken up with efficiency by MOCA Assistant Registrar Melissa Altman, working in partnership with Hammer Senior Registrar Portland McCormick. Keeping track of these hundreds of objects was MOCA Curatorial Associate Rebecca Morse, whose hard work was aided by Curatorial Secretary Cynthia Pearson. The installation of the exhibition required extra creativity and sensitivity, and for this we turned to Rick Gooding and Annie Chu of Chu+Gooding Architects. Rick and Annie, in collaboration with Michael Matteucci and Katherine Kwan from their office, brought a level of rigor and seriousness to the design of the exhibition that directly contributed to its success. They were aided and assisted at each institution by two teams of experienced installers led by Director of Exhibitions Production Brian Gray at MOCA and Chief Preparator/Exhibition Designer Mitch Browning at the Hammer. The MOCA team responsible for carefully arranging and placing artworks included Jang Park, Sebastian Clough, David Bradshaw, Annabelle Medina, Barry Grady, Shinichi Kitahara, Monica Gonzalez, and Jason Pugh. At the Hammer, these tasks were ably carried out by Steven Putz, Giorgio Carlevaro, Randall Kiefer, Jay Lizo, and Justin Stadel. Extensive behind-the-scenes work by the Hammer's Director of Administration Stacia Payne and MOCA's Manager of Exhibition Programs Susan Jenkins ensured that all aspects of the exhibition planning ran smoothly, fairly, and on budget. The exhibition's engaging programming was organized by James Bewley, Head of Public Programs at the Hammer, and Aandrea Stang, Senior Education Program Coordinator at MOCA, while publicity was coordinated by Hammer Communications Director Steffen Böddeker and MOCA Creative Director Olga Gerrard. Other staff members who have

lent their expertise include Lynne Blaikie, Sean Deyoe, Julie Dickover, John Farmer, Russell Ferguson, Melissa Goldberg, Maria Hummel, Lisa Mark, Grace Murakami, Paulette Parker, Carolyn Peter, Lauren Reilly, Sophia Rochmes, Paul Schimmel, Heidi Simonian, Deborah Snyder, and Karen Weber.

The funding of the exhibition was anchored by an important grant from the National Endowment for the Arts. Again, the development staffs of both museums worked very hard as a single unit, led by the Hammer's Director of Development Jennifer Wells Green and MOCA's Director of Development Thom Rhue and Manager of Institutional Giving Jennifer Arceneaux. We were also very fortunate to find outside partners for the presentation of the exhibition, allowing us to expand the audience for this significant history of an American cultural pursuit. David Gordon, Director of the Milwaukee Art Museum, was quick to recognize the importance of the exhibition and moved rapidly to secure its travel to Wisconsin, a commitment for which we are grateful. Likewise, Joan Rosenbaum, Director, and Ruth Beesch, Deputy Director for Program at The Jewish Museum, have collaborated with Mary Sweeney Price, Director, and Zette Emmons, Manager of Traveling Exhibitions at The Newark Museum, to host the exhibition in New York and Newark for its final stop.

As this large roster of collaborators attests, *Masters of American Comics* has been a complex undertaking involving a great number of people, but we feel we can speak for all involved in saying it was worth the effort to pay tribute to the fifteen talents who are the focus of this exhibition. For it is they who deserve our thanks for the insights their work has offered over more than a century of urgent and creative productivity.

**Cynthia Burlingham**
Hammer Museum

**Michael Darling**
The Museum of Contemporary Art, Los Angeles

## Lenders to the Exhibition

Glenn Bray
Cartoon Art Museum,
    San Francisco, California
Dinaburg Arts,
    New York, New York
Will Eisner Estate
Craig Englund
Jack Gilbert
Glen David Gold
Samuel Grubman, M.D.
Estate of Bruce Hamilton
Heritage Gallery,
    Dallas, Texas
Gallery Hyundai,
    Seoul, Korea
International Museum of
    Cartoon Art,
    Stamford, Connecticut
Bill Janocha

King Family
Denis Kitchen
Adele Kurtzman
Library of Congress,
    Washington, D.C.
Joe Maddalena
Peter Maresca
Matt Masterson
Patrick McDonnell
Michigan State University
    Libraries, Cartoon Art
    Collection,
    East Lansing, Michigan
Moniz Family
Thomas A. Morehouse
Paul Morris Gallery,
    New York, New York
Bob Murphy
Ohio State University
    Cartoon Research Library,
    Columbus, Ohio

Gary Panter
Ethan Roberts
Eric F. Sack
Jim Scancarelli
Charles M. Schulz Museum
    and Research Center,
    Santa Rosa, California
Tod Seisser
Art Spiegelman
Garry Trudeau
Dr. Stephen R. Turner
Mort Walker
Chris Ware
Wisconsin Historical Society
Wally Wolodarsky
Craig Yoe
and Private Collections

TIME FLIES...

# MASTERS of AMERICAN COMICS: An ART HISTORY of TWENTIETH-CENTURY AMERICAN COMIC STRIPS and BOOKS

### by John Carlin

...there are two sorts of...[caricature] which are to be prized and commended for different and almost contrary reasons. One kind have value only by reason of the fact which they represent.... But the others... contain a mysterious, lasting, eternal element, which recommends them to the attention of artists.

—*Charles Baudelaire* (1855)

American comics[1] were born in newspapers more than 100 years ago. Originally printed in Sunday supplements, comics became immensely successful and provided a way for artists to reach a larger audience than any other medium at the time.[2]

Along the way a few artists made comics one of the great forms of personal expression in twentieth-century America. The first of these was Winsor McCay, who developed a creative language that set the foundation for the medium. He did for comics what D. W. Griffith did for movies and Louis Armstrong did for music—he transformed mechanical reproduction into a creative medium for self-expression.

McCay's *Dream of the Rarebit Fiend* (1904) and *Little Nemo in Slumberland* (1905) stretched the boundaries of one-page, illustrated newspaper comics further than seemed possible. His work made comics a magnet for such creative forces as George Herriman, E. C. Segar, Harvey Kurtzman, R. Crumb, Art Spiegelman, and Chris Ware, artists who drew some of the most popular, experimental, and revealing images ever made.

The history of American comics falls into four distinct periods. The first ran from the mid-1900s to the mid-1920s and was in some ways the period of greatest experimentation and achievement. Artists such as McCay and Herriman took a disposable popular medium and raised it to unexpected heights. McCay did so by taking the graphic potential as far as it could go in purely formal terms. He worked out variations on how one could display, distort, and relate visual imagery on a printed color page.[3] And he did so in a way that has defined artistic comics ever since—a graphic medium made of harmonious abstract shapes and forms that also tell amusing stories.

Herriman took those experiments even further, particularly in terms of poetic language and playful design. He also perfected the drawing style upon which the entire history of comics rests—simple, jazzy lines that convey an incredible amount of emotion for whimsical characters and strange backgrounds. Artists and intellectuals at the time knew immediately that the sophisticated and innovative *Krazy Kat* was not throwaway amusement for kids. It was as sophisticated and important as any art being made in America at the time.

In the second period, the comics' success almost became their undoing. The format became standardized, and massive popularity gave rise to middlebrow comics that regressed from the antic fun of *Krazy Kat* and its peers. At the same time, this period brought better storytelling and even more memorable characters into American culture. Popeye joined the cast of Segar's *Thimble Theatre* in 1929, the same year as Buck Rogers and Tarzan brought exotic adventures to the comics. By the mid-1920s, Frank King developed the domestic comic strip into a living work of art. His *Gasoline Alley* told the story of a family that aged in real time. And on some Sundays, the color pages broke loose from drama to portray wild graphic fantasies that displayed McCay's ongoing influence.

By the mid-1930s, Chester Gould developed both a sensational new form of storytelling in which violence was anything but comic, and a visual style that was as brutal as the trouble Dick Tracy got in and out of every week. At the same time, Milton Caniff's *Terry and the Pirates* transformed kids' adventures into gripping adult stories that perfected the balance between realism and graphic design that is the hallmark of all great comics.

In the third period, comic books began to compete with newspaper strips in terms of both popularity and creativity. Fueled by the success of *Superman*, comics started to emphasize superheroes whose stories were sold as books rather than included in daily newspapers.[4] Two very different artists—Jack Kirby and Harvey Kurtzman—dominated this period. Kirby co-created *Captain America* at the height of the *Superman* boom during the 1940s and then made Marvel Comics the most important comic publisher in the 1960s.[5] Kurtzman made EC the most important publisher in the 1950s, first through evocative war and horror comics, then in *MAD*, which brought graphic and verbal wit back into the comics in the guise of grossout parody.[6]

The fourth period began with the publication of independent comics by R. Crumb in the mid-1960s and continues into the present, notably in the work of Art Spiegelman, Gary Panter, and Chris Ware. These four artists brought formal innovation and psychological expression back into the comics in a truly personal way, unencumbered by the censorship and commercial restrictions of mass media. These artists and their peers are still creating comics that reflect the complex reality of America at the turn of the twenty-first century as well as words and pictures can.

# THE GOLDEN AGE OF AMERICAN COMICS

## 1
## The Origin of American Comics

Comics came into being after the invention of the printing press and the rise of mass culture. William Hogarth (1697–1764) was the first important artist to transform the nascent print medium into one that balanced creative and popular expression. His breakthrough work was *A Harlot's Progress* (1732), which embodied the hallmark of what was to become the comics medium—a story told in a series of related pictures with continuing characters.[7] One scholar cited an 1828 copy of *A Harlot's Progress*, simplified and printed in two vertical rows in *Bell's Life in London and Sporting Chronicle* as "arguably the first ever newspaper strip."[8]

Hogarth's work and that of nineteenth-century British caricaturists who followed him, such as Thomas Rowlandson and James Gillray, introduced the individual elements of the comic strip: word balloons, panels, and illustrated stories. However, a Swiss teacher of rhetoric, Rudolph Topffer (1799–1846), is credited with the ultimate consolidation of those elements. Topffer transformed Hogarth's picture-stories into a new form that directly integrated text and image as well as showing continuous action from one panel to the next.[9] By the middle of the nineteenth century, picture-stories had become popular throughout Europe.

The most influential European cartoonist in terms of American comics was Wilhelm Busch (1832–1908). His illustrated antics of *Max und Moritz* were the model for Rudolph Dirks's *The Katzenjammer Kids*, one of the first and most successful early American comic strips.

American cartoonist Thomas Nast (1840–1902) used cross-hatching to create complex compositions in print that impacted the style of comics from George Herriman through R. Crumb. Nast also proved the power of cartoon iconography by creating and popularizing images that remain part of American culture, such as the Republican elephant, the Democratic donkey, Santa Claus, and Uncle Sam, though he rarely told stories in sequential panels.[10] American illustrator A. B. Frost (1851–1928) developed a fluid and natural sense of action in successive drawings that paved the way for McCay's motion drawings in comics and animated cartoons.[11]

These formal and stylistic antecedents do not fully explain how comics grew to be such an important medium for personal expression in twentieth-century America. Other artists such as William Blake and Francisco Goya developed ways to make printed drawings and words capable of representing more than humorous scenes and political satire.[12] The French poet Charles Baudelaire, writing in 1855 about French caricaturists such as Honoré Daumier, Grandville, and Gustave Doré defined this characteristic as "mysterious" rather than "factual" to show how printed drawings could create atmosphere and emotion as much as specific ideas or stories.[13] The blend of the "mysterious" innovative aspect of comics along with mastery of craft is what defines the fifteen artists in this exhibition and makes them exemplary of the lasting quality of American comics.

## 2
## The First American Comic Strips

Comics emerged as a new medium when American newspapers started publishing them in the early 1890s[14] and became an indelible part of popular culture when Richard F. Outcault (1863–1928) created *The Yellow Kid*, a single panel cartoon about a young street urchin who wore a yellow nightshirt and lived in a slum called Hogan's Alley,[15] for Joseph Pulitzer's *New York World* in 1895.[16] *The Yellow Kid* was so successful that William Randolph Hearst hired Outcault away from Pulitzer, giving rise to the term "yellow journalism." Pulitzer then hired a young artist named George Luks to continue another version of the feature for the *World*.

The war over *The Yellow Kid* demonstrated that comics were big business and had a dramatic impact upon circulation and revenues, so much so that Hearst established his own color comics section in 1896.[17] He described *The American Humorist* as "Eight pages of iridescent polychromous effulgence that makes the rainbow look like a lead pipe."[18] Hearst's editor, Rudolph Block, also started another milestone comics feature, *The Katzenjammer Kids*, drawn by Rudolph Dirks (1877–1968), who pioneered many graphic symbols such as speed lines and sweat drops.[19] Frederick Burr Opper (1857–1937) was a first-generation cartoonist who combined world-class drawing skills with innovative depiction of physical action. He was already one of the most respected illustrators and panel cartoonists in America when his most famous character, Happy Hooligan, first appeared in 1900.[20]

It is hard to imagine the initial impact of these first comic strips. In 1900, media was static, text-based, and almost exclusively black and white. Movies did not exist, much less television or the Internet, and newspapers were dominant in a way that no single form of media is today.[21] They were not only the sole source of news but also the place where the lifestyle of modern America was being represented and shared by millions of people. In that context, large, beautifully printed color comics jumped out at newspaper readers in a truly revolutionary fashion.

## 3

## Winsor McCay—The First American Master of Comic Art

One hundred years ago comics also became an artistic medium with the publication of Winsor McCay's *Little Nemo in Slumberland* (1905). McCay (1869–1934) began his career in the Midwest drawing posters for carnivals and illustrations for local newspapers.[22] He moved to New York in 1903 to be part of the most dynamic and lucrative media business in the world. Publisher's Row in Lower Manhattan was a pressure cooker where creative and commercial people did more than represent the news, they made it.

By 1904 McCay was publishing an interesting half-page Sunday feature in the *New York Herald* called *Little Sammy Sneeze*, a beautifully drawn comic strip about a little boy whose weekly sneeze disrupted the world around him. This absurd device allowed McCay to showcase his ability to create explosions and movement in static drawings. In one notable example, Sammy's "KAH CHOW" breaks the frame of his own comic strip (fig. 1).[23]

By the end of the decade *Little Nemo* had taken over the front of the comics supplement, pushing *Buster Brown* to the back. McCay was already one of the most accomplished cartoonists in America. His formal sophistication rivaled the work of artists of the preeminent fine art movement at the time—the Ash Can School. In 1905 artists associated with the Ash Can School graduated from working as illustrators for Philadelphia newspapers, moved to New York, and started painting the new urban environment around them.[24] Unlike other American artists of their time, they strived to paint everyday people and places in a realistic way, including their surrounding poverty. This was the same world depicted in Outcault's *Yellow Kid*—urban slums teeming with poor people. McCay comics also showed urban New York, even shantytowns. But instead of focusing on individuals, McCay drew people in relation to the new urban landscape in a way that expressed a more modern sense of alienation and abstraction than the Ash Can artists.

Though most Americans were not fully aware of modern art until the Armory Show in 1913,[25] they had already seen the essence of modernism in McCay's comics without knowing it. McCay utilized many of the hallmarks of modernism—figures in motion, twentieth-century machines, and modern urban architecture—in much the same way as later Cubist and Futurist painters. The use of paint to convey the immediacy of the human touch was, of course, not possible in comics, nor was the complete abstraction of individual scenes, but McCay compensated for these restrictions by creating complex overall graphic design made up of multiple layers of meaning.[26]

1 Winsor McCay
*Little Sammy Sneeze*
Drawing for newspaper Sunday page
(published September 24, 1905)
Pen and ink, 19 ½ x 15 inches
Collection of the Moniz Family

2 Winsor McCay
*Little Nemo in Slumberland*
Drawing for newspaper Sunday page
(published September 29, 1907)
Pen and ink, 28 ½ x 22 ½ inches
Collection of the Moniz Family

3 Winsor McCay
*Little Nemo in Slumberland*
Drawing for newspaper Sunday page
(published July 26, 1908)
Pen and ink, 28 1/2 x 22 1/2 inches
Collection of Garry Trudeau

4 Winsor McCay
*Little Nemo in Slumberland*
Newspaper Sunday page in bound volume
(published July 26, 1908)
40 x 24 inches
Private Collection

**5** Winsor McCay
*Little Nemo in Slumberland*
Newspaper Sunday page
(published February 23, 1908)
23 x 17 inches
Collection of Peter Maresca

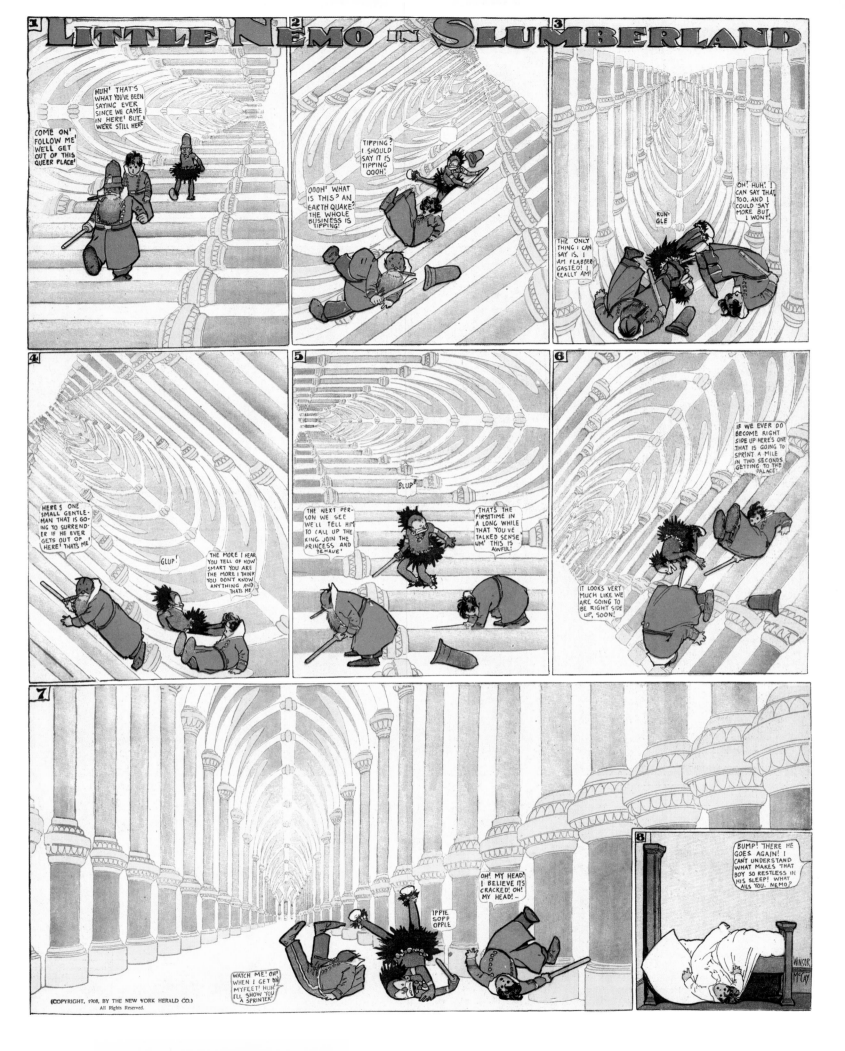

6 Winsor McCay
*Little Nemo in Slumberland*
Newspaper Sunday page
(published March 1, 1908)
23 x 17 inches
Collection of Peter Maresca

7 Winsor McCay
*Little Nemo in Slumberland*
Drawing for newspaper Sunday page
(published February 2, 1908)
Pen and ink, 28 x 22 inches
Ohio State University Cartoon Research Library,
Woody Gelman Collection

8 Winsor McCay
*Dream of the Rarebit Fiend*
Newspaper Sunday page
(published February 9, 1913)
23 x 17 inches
Private Collection

Our Boys and Girls.
PROFUSELY ILLUSTRATED.

Los Angeles Sunday Times

Part VIII—8 Pages
THE HOUSEHOLD—FASHIONS.

XXXIIND YEAR.

SUNDAY MORNING, FEBRUARY 9, 1913.

HUMOR: Fun for the Young, Smiles for Their Elders

# DREAM OF THE RAREBIT FIEND
BY SILAS

He devised a way to create a balance between the flat printed page as an arrangement of abstract forms on one hand, and as recognizable pictures in which characters did things on the other. The realism of McCay's drawings and their shifting perspectives do not just show off the artist's virtuosity, they force the reader to think about visual perceptions. In other words, he brought an abstract formal dimension to comics, which added to the theatrical action that one saw *through* the panels. This technique allowed the page to be read both as a story told over time and as a relation of design elements printed on the page. The combination of temporal and spatial relations helped *Little Nemo* become a significant and innovative form of American art and transcend the disposable nature of the newspapers it was printed in.[27]

McCay's graphic technique can be divided into two major categories. The first is a subtle transformation of forms within the narrative sequence, often establishing an oblique relation between disconnected shapes on the page. In one exceptional example, from April 29, 1906, the round yellow image of the moon in the title panel echoes a circular plaza in the panoramic bottom panel. The formal relation between these two objects establishes a visual dislocation to give the sensation of floating in space as the reader follows Nemo flying a giant bird in his dream. In other words, the dreamlike atmosphere of McCay's drawings isn't merely decorative, but fundamental to the feeling he conveyed to his readers.

The second of McCay's graphic techniques draws the entire page as a single design element in which abstract vertical and horizontal shapes develop relations that are independent of the story. The most famous examples are a series of architectural abstractions in a sequence called "Befuddle Hall," published from January 19 through March 15, 1908. The February 16, 1908, page shows Nemo, Flip, and the Imp climbing through a succession of curving architectural details depicted upside-down in slow motion, from an extreme close-up in the first panel to an identifying long shot in the last (fig. 177). The next week's story is essentially the same, except the architecture is linear rather than curvilinear and everything is shown sideways, not upside-down (fig. 5). The effect of both is visual disorientation, which again replicates the way the characters feel floating in space on the level of design and not just appearance.

Another similar graphic technique plays with the standard grid of panels across the page. In one example, the frames become taller as Nemo's bed grows legs and walks from his suburban home into the city (figs. 3, 4). This remarkable page also uses representational figures, such as the yellow moon in the bottom tier of panels, as abstract formal objects. For example, McCay splits the circle of the moon between the third and fourth bottom panels to further the Art Nouveau motif of the page, while allowing less sophisticated readers simply to read the "moon" as a sign that Nemo's bed is walking the city at night.

McCay was also a master colorist who used shading and tone to strengthen and unify the effect of his lines. In the sequence of architectural fantasies described above, he uses conical forms of very pale red and blue shapes, which force us to see flat, graphic patterns behind his fully inked characters floating in space. Few cartoonists have cared as much (or had as much control) as McCay did about how his black-and-white drawings were printed in color.[28]

A year before McCay began drawing *Little Nemo* he started publishing another feature called *Dream of the Rarebit Fiend* under the pseudonym "Silas." Although *Fiend* does not have the same graphic complexity of *Nemo*, its themes were darker and more adult, much like the same dark absurdist vein of humor that Franz Kafka explored a few years later in stories such as *The Metamorphosis*. Nemo's fantasies allowed McCay to explore a universe of visual representation that was ultimately more wild and engaging than the dreams of its central character. *Fiend* suggested a more overtly Freudian view of dreams by concentrating on the anxieties of modern life more than their visual fantasies. Among the prescient subjects of the strip were early views of telephones (with numbers literally falling out of the machine), movie theaters, and baseball games. Other strips showed a person being buried alive, a man growing antlers, and a character that resembled the artist being covered in ink splats (fig. 175).

One of the greatest *Fiend* pages, from February 9, 1913, perfectly embodied the nightmare quality of dreams in the formal design of the page (fig. 8). A man is shown literally running in circles, faster and faster as the circles grow larger and eventually dwarf his efforts to escape. At the same time, the artist shows his own control of his medium by creating a series of perfect circles that counterpoint the rectangular frames of the comic strip to great effect and whose repetition creates the same sense of futility visually that his character experiences in his fiendish dream.

After McCay joined Hearst in 1911, he began to concentrate more on his animated films. *Gertie the Dinosaur* (1914) is considered by many, including Walt Disney, to be the first important American cartoon. McCay drew every frame by hand, and the finished film shows him making the drawings, photographing them, and finally the dinosaur walking off to the consternation of skeptical fellow cartoonists, including George McManus. McCay went on to create several more moving cartoons of increasing sophistication and developed many of the techniques that form the foundation of American animation to this day.

# 4
# Lyonel Feininger and the Art of Sunday Pages

The other master of visual invention in the early comic strips was Lyonel Feininger (1871–1956). A distinguished American artist living in Berlin and a faculty member at the Bauhaus, Feininger also published fifty-one pages of comic strips in the *Chicago Tribune* in 1906 and 1907.[29] Through two short-lived but remarkable features, *The Kin-der-Kids* and *Wee Willie Winkie's World*, Feininger equaled and often surpassed the work of all other cartoonists in combining fine art and comics.

Feininger linked his Sunday children's stories into a sophisticated overall design much like McCay had done in 1905. One remarkable example shows the Kin-der-Kids caught up in a storm at sea (fig. 11). The title panel shows a tornado-like spout of water from a distance along with a boat carrying the kids and crew in the foreground. The next two panels, on the tier below, illustrate the boat swept up into the water. The bottom tier of panels depicts a mysterious dark figure in a hat and cloak named Pete shooting the spout down to save the lads.

What makes this page stand out is the oblique relation between shapes that are independent of the narrative sequence. Specifically, the water spout on the left half of the page forms a serpentine line stretching from the cloud on the bottom through the water and onto the boat in the title panel. That line ends in the snout of a dog on the ship's prow. What the dog sees, too late, is the coming disaster. This forms, on the right half of the page, a linear funnel, narrow toward the top and wide toward the bottom. The abstract effect, along with the sophisticated, chromatic tones of the waves (perhaps derived from Hokusai's woodblock prints), as

**9** Lyonel Feininger
*The Kin-der-Kids abroad*
Newspaper Sunday page
(published May 6, 1906)
23 1/8 x 17 1/16 inches
Ohio State University Cartoon Research Library,
San Francisco Academy of Comic Art Collection

**10** *left*: Lyonel Feininger
*Wee Willie Winkie's World*
Newspaper Sunday page
(published September 23, 1906)
23 1/8 x 17 1/16 inches
Ohio State University Cartoon Research Library,
San Francisco Academy of Comic Art Collection

*following pages*

**11** *right*: Lyonel Feininger
*The Kin-der-Kids*
Newspaper Sunday page
(published September 16, 1906)
23 1/8 x 17 1/16 inches
Ohio State University Cartoon Research Library,
San Francisco Academy of Comic Art Collection

# The Chicago Sunday Tribune.

SEPTEMBER 23, 1906.

# Wee Willie Winkie's World

Copyright 1906 by Tribune Company, Chicago, Illinois.

This is the way the thunderstorm came the other day: At first a couple of clouds crept up, like scouts, over the hill, back of the little fern-house there, and peered over into the fields below.

They must have decided that there was a good wide space for an invasion, for soon a gigantic trumpeter-cloud mounted the hill-top, leading on a disorderly array of cloud-soldiery, with eager, threatening faces, and a great gray cat-flew sprawling along overhead, so that things took on a very weird and uncomfortable appearance.

Then long lines of fighting troopers crept up, row after row of shouting, angry giants, and the first big drops began to fall. The tall poplars swayed to and fro and struggled with the wind, and the little quince-tree tried ever so hard to run away, and couldn't.

And now the giants swept simultaneously over the hill-top, the *lightning-thrower*, the *thunder-drummer*, and the *rain-carrier*, and oh, my! how they behaved! Lightning-thrower hurled one great bolt of polished zig-zag lightning right across the fields and scared the little farm-house and the two poplars nearly into fits—it was a narrow escape for them.

After all was over Williewinks put on his blue-hooded circular and went out over the wet fields to watch the quaint procession of wind-driven clouds against the evening sky. There was a funny ducklet who marched on ahead; then a fiddler, and then a whole row of old Rococo-Dames, with torn skirts fluttering in the wind, dancing lustily along.

# The Kin-der-Kids
## Bloodcurdling Whirl in a Water-spout
## Mysterious Pete's Timely Interference.

well as the tailored panel frames and borders, gives this page its reputation as one of the finest in comics history.

The action that drives *The Kin-der-Kids* gives way to a kind of visual poetry in *Wee Willie Winkie's World*. Here the borders and design elements virtually take over the page. Willie is a tiny, almost grotesque child with an enormous head. Every object in his world is anthropomorphized; telegraph poles bend over and smile, benches growl when someone tries to sit, and houses stare as trains rush by.

One extraordinary drawing for a Sunday page depicts a menacing thunderstorm with exquisite beauty and rhythmic flow (fig. 12). The panels are arranged on the page in a large "I" shape that has two panels above with a large horizontal panel below and two narrow panels in between. (The printed Sunday page has a slightly different layout. See fig. 10.) The first frame shows a house in a field with two poplar trees nearby. The trees have faces and are anxiously watching three people looming over the horizon. In the next frame the trees become genuinely alarmed as the figures in the sky become more numerous and threatening. The largest figure raises a horn to its lips and carries a lightninglike sword. In the next and most remarkable panel we return to the original farm scene, but now the sky is swarming with angry faces that surround the frightened tree faces and bend them against their will. In the penultimate scene the storm finally arrives in the form of three enormous figures seen from below, from a small child's point of view, stretching into the sky. One figure beats a drum, another pours a bucket of rain, and the third hurls a bolt of lightning, which crosses the tree faces and merges with the decorative forms that border the panels immediately to their right. The final frame shows Willie, for the first time, in the far right corner tentatively looking up at what is now a happy sky and two smiling tree faces.

This symphonic orchestration of forms illustrates the comics' full artistic potential. *Wee Willie Winkie's World* presents dramatic action as a psychological event, depicting dreamlike metamorphoses in a manner that is both naturalistic and obviously abstract. In every detail, from the arrangement of the frames into the first-person pronoun "I" to the anthropomorphic border that links the panels, Feininger created the page as an expressive mark of his artistic vision. In fact, the run of *Willie Winkie* can be read as a prototypical graphic novel. Or perhaps more precisely, a graphic poem in which shapes and colors transform in a way that makes the story about the reader's experience of them rather than the apparent adventures of the strange little boy who is the main character. After all, the title makes it clear that

**12** Lyonel Feininger
*Wee Willie Winkie's World*
Drawing for newspaper Sunday page
(published September 23, 1906)
Pen and ink, 30 x 22 inches
Collection of Jack Gilbert

**13** TAD, Untitled, c. 1910
Inscribed with a dedication to George Herriman
Pen and ink, 23 ¹⁵/₁₆ x 14 ¹⁵/₁₆ inches
Private Collection

the strip is about Willie's *world* and not about him. And Feininger's art makes it clear that Willie's world is the place where imagination and experience come together rather than how the world appears in the news part of the paper.

# 5
# The Rise of Daily Comics

The fantastic visual and slapstick antics that characterize the comics' formative years were often aimed at young children who identified with the small boys who were some of the early comics' most popular characters. But cartoons did appear in other sections of the newspaper beginning in the 1890s, primarily in the sports and editorial pages.[30] Political cartoons did not develop directly into the comic strip form, although there are significant parallels and examples of artists working in both mediums. For example, Opper's magazine illustrations for *Puck* and his newspaper editorial cartoons were often as interesting as his comics and used more inventive layouts and designs. And McCay spent the final decades of his career doing single-panel political illustrations that were visually impressive but limited in content by the editorial viewpoints of the newspaper and in design by the single-panel, black and white format.[31]

On the other hand, sports cartoons stimulated the adult orientation of post-1910 comics and pioneered the daily format. (The daily comic strip format, as opposed to the Sunday strip page, is typically black and white and limited in size to a single tier of panels rather than multiple tiers of color panels.) The inherent limitations of the daily strip gave rise to a new generation of cartoonists more attuned to character and sustained narrative than the fantastic visual designs encouraged by the wide open spaces in the Sunday supplements.

The most influential of the early sports cartoonists was Thomas Aloysius "TAD" Dorgan (1877–1929). He came into his own in 1904 when Hearst hired him to draw the sports world for the *New York Journal*, making him famous along with the phrases he popularized such as "23-skiddoo" "hot dog," "the cat's pajamas," "ball and chain," and "yes, we have no bananas."

TAD's drawing style refined the doodles that characterized Opper's work and abandoned McCay's ornate design altogether to create a distinctive, adult-oriented style that influenced the look of the comics for decades to come. TAD had a particularly important influence on the early career of George Herriman. The two became close friends when they worked together at the *New York Journal* beginning in 1910.[32] Herriman had several TAD drawings in his personal collection, including one dedicated "to Herriman, the worries" from the elder cartoonist (fig. 13). In that particular drawing, one can see how TAD's cross-hatched drawing style,

excellent ear for contemporary slang, and jazzy layouts created the foundation from which Herriman was able to go further than any other cartoonist of the next generation.[33]

Another popular sports cartoonist at the time was Bud Fisher, whose *Mutt and Jeff* helped make the daily comics an American institution in the 1910s.[34] The idea of a daily comics page in addition to the Sunday supplement met resistance at first, but Hearst recognized its commercial potential, and by 1912 dailies such as *Krazy Kat* and George McManus's *Bringing Up Father* (started in 1913) began to run in the *Journal*. By 1914 Hearst's corporation expanded the business of syndicating comics through King Features, which disseminated the same comics in different newspapers throughout the United States.[35] This created the mass distribution system that made comics a cornerstone of American popular culture for the next 100 years.

Hearst's success was matched by another publisher and syndicate, Captain Joseph Patterson of the *Chicago Tribune* and *New York Daily News*. Patterson was instrumental in bringing comics into the mainstream from the late 1910s through the 1930s. He also developed the final chapter in the formal development of the newspaper comic strip and integrated daily/Sunday continuity, which resulted in a cheaper means of production and more crammed space.

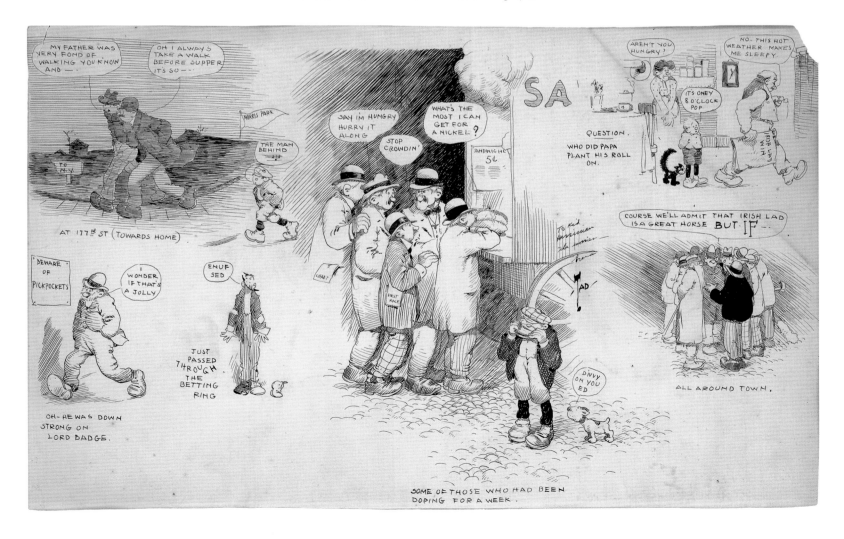

# 6
# George Herriman, Comic Genius

In a recent interview in *The New York Times*, R. Crumb called George Herriman (1880–1944) "the Leonardo da Vinci" of the comics. The more one looks at *Krazy Kat*, the more one realizes that Herriman's work is too complex to get its full meaning at first glance. Herriman took McCay's use of multiple layers of graphic information and expanded it into layers of ideas through a unique blend of language, design, ideas, and drawing. This gave *Krazy Kat* a profound quality that is difficult to find in the best art or literature, much less in comics.

Herriman began his career in 1900, when newspaper comics began to become massively popular and syndicated throughout the country. Within a few years he started publishing in Hearst's newspapers and joined the company of some of the great early cartoonists such as Swinnerton, TAD, and Bud Fisher. Those artists set the bar in terms of how to capture an audience with funny drawings and phrases. By the early 1900s, Herriman was able to mimic their approach and then take it to another level. Features such as *Baron Mooch* (1909) and *Two Jolly Jackies* (1903) copied, respectively, *Mutt and Jeff* and *The Katzenjammer Kids*. Herriman's *Gooseberry Sprig* (1909) was an early comic strip with funny animal characters that elaborated on Swinnerton's work in a way that also worked out how Feininger brought visual poetry to comics through graphic design.

But Herriman's reputation started to develop with an early strip called *The Family Upstairs*. The upstairs family, who never appeared, wreaked invisible havoc on the family who lived below. In 1910 Herriman began to layer another tier of panels beween the two families, featuring a cat and mouse. Their antics soon began to steal the show, and in 1913 they got their own comic strip, *Krazy Kat*. The daily strip started out as a clever, inverted fable about a mouse that tormented a cat by hurling a brick at its head. Each episode wove a variation on this simple routine that became funnier as time went on. By 1916 Herriman began to draw larger Sunday pages that took the funny gags to the highest level comics have ever achieved. *Krazy Kat* was printed in black and white (except for a ten-week color sequence in 1922), in the weekend City Life section of the Hearst papers from 1916 to 1935. The comic ultimately spawned merchandising and a series of mediocre cartoons that never captured the elegant design and poetry of the comic strip.

Within the first few months of drawing black-and-white Sunday pages, Herriman began to redefine the format in terms of design, language, and theme. He invented his own world and the rules that guided characters and props within that world. Herriman's surreal ballet between cat, mouse, and dog occurred in the most beautiful, yet strange locale in comic strip history.[36] The backgrounds are desert scenes of the American Southwest that shift from panel to panel without apparent continuity in a way that makes them more surreal than representational (fig. 20).[37] Yet somehow Herriman's mastery over every aspect of comic strip art gives *Krazy* coherence while abandoning expected continuities of time, place, and causality.

Herriman's inventive use of panels and page layouts is the gold standard for artistic expression in the comics to this day. Throughout their first century of existence, comics used a formal device that has become so commonplace it is invisible—a series of panel illustrations arranged next to each other across a page. They are read left to right, column after column, just like written language. But comics and text use different types of language. Panels are absorbed as one after another as well as one next to another. This is the great conceit of comic illustration—viewing events that are static on the page as if they transpire over time. In this sense, comics, which developed as a medium at exactly the same time as film and recorded music, are founded upon a growing fascination with time-based art in twentieth-century America.

The best slapstick artists are masters at seamlessly showing action and then creating suspense around its anticipation.[38] Think of Krazy Kat's brick. The strip is more about waiting for the inevitable event rather than the brick actually being thrown. Herriman spun a lifetime of variations upon this theme and raised it into a kind of visual poetry. But as much as his illustrations draw us in through lovable characters and jazzy idiosyncratic dialogue, Herriman's true virtuosity was in creating formal patterns on the page independent of the action and dialogue.

Herriman routinely avoided panels altogether or arranged them at will to add another deliberate level of meaning to his polyvalent universe. A famous example from 1918, when the Sunday pages were still printed in black and white, shows Krazy rolling a boulder downward through various trees, hills, and a house (fig. 14). The joke is Ignatz explaining to the Kat that it "didn't gather

any moss." But the real gag is how the page is laid out. Instead of the expected grid of panels, or even a horizontal left to right arrangement of progressive imagery, the page is laid out on a forty-five-degree angle—successfully conveying the sense of something rolling downhill.

One typically brilliant Sunday page not only toys with the panel structure but also meditates on the nature of representation (fig. 19). Ignatz, like many artists, sublimates what society represses (his endless need to bean Kat with a brick) by representing it in art. He inks a frame and fills it with a picture of himself doing what Herriman always draws him doing. Offissa Pupp sees his art, tries to outdo it, and writes his own end to the story by drawing Ignatz into jail. Meanwhile Ignatz, having successfully laid this artistic dog-trap, is free to throw a "real" brick at Krazy and complete his side of the eternal triangle. After acting out their daily ritual the three principals join together in a long narrow panel at the bottom of the page to ponder an isolated incident. A woodpecker with a small tear escaping from his beak stares at a painting of a tree. The main characters comment on the ambiguous significance of this tear. Is it born of instinct or emotion? Krazy answers, "But he's a 'ott krittik' ain't he?" To which Pupp replies, "Yes, but he's also a 'woodpecker.'" Ignatz simply utters a noncommittal "Ah – h."

**14** George Herriman
*Krazy Kat* ➤
Newspaper Sunday page
(published November 3, 1918)
23 x 17 inches
Private Collection

This bottom panel is not a direct part of the action but a marginal gloss on its meaning. Of course this meaning is neither revealed nor resolved, only made more "mysterious" as Baudelaire asserted all artistic illustrations should be. Ignatz and Pupp's artwork in the main body of the page and the woodpecker staring at a painted tree are two sides of the same story. Ignatz frames Pupp while Pupp thinks he is framing Ignatz into "jail."

At the same time the panels' "real" frames play off of standard expectations of panel structure and the frames within the frames drawn by Ignatz and Pupp by setting off a jaunty rhythm that adds another dimension to the strip. The first two frames on the top tier sandwich a characteristically playful *Krazy Kat* logo (which, unlike most other strips,

NEW YORK AMERICAN—*A Paper for People Who Think*—SUNDAY, NOVEMBER 3, 1918

# Krazy Kat   By Herriman

**15** George Herriman
*Krazy Kat*
Drawing for newspaper Sunday page
(published December 9, 1917)
Pen and ink, 22 x 19 inches
Collection of Garry Trudeau

**16** George Herriman
*Krazy Kat*
Drawing for newspaper Sunday page
(published November 11, 1917)
Pen and ink with watercolor, 22 x 19 inches
Collection of Patrick McDonnell

changed each week) and an odd Navajo-like form that Herriman often used to "ground" his titles. After Ignatz draws his own frame, in the second panel, the strip's frames begin to vary. In the second tier the end panels lean toward the square middle panel. In the third tier the end panels lose their frames altogether, but the interior frames are tipped, in the first panel along with the frame above, and in the third against the above frame. The middle frame remains square but its backdrop has turned from day to night. The penultimate frame is an enormous rectangle anchored pictorially by a red road stretching into the distance. In the foreground of the road Pupp is on a ladder inking Ignatz behind bars. In the background Ignatz "zips" a brick at Krazy's head while s/he stares at Pupp's painting.

In terms of framing alone, this page demonstrates Herriman's ability to incorporate complex ideas into a disarmingly simple and appealing visual style. Not only are there frames within frames, but these frames set up relations between each other that create visual tension and a kind of pictorial rhythm as they develop sequentially. The interior frames resemble a simple animated cartoon like those the Hearst studio made of *Krazy Kat*, while the exterior action takes liberties with expected continuity. As with most *Krazy Kat* comics, the backgrounds in each individual panel shift even if the scene itself does not. Together these abstracted desert forms illustrate Herriman's ability to suggest surreal landscapes that are neither grotesque nor sentimental.

Herriman challenged the conventions of each aspect of the comic strip form without undermining their basic appeal. In doing so he was able to make his cute and charming characters enact complex parables about the nature of art and representa-tion that are as rewarding as those found in any visual medium. Even in our admiration for Herriman's artwork he remains one step ahead of us. After re-examining the beauty of this page's first nine panels and thinking that the day's action is over, we come again to the final panel where the woodpecker is admiring one of Herriman's typical landscapes just as we have admired them ourselves. The only difference is that instead of crying, we laugh. And what does our emotive response signify? I can imagine Krazy saying, "They're ott luffers," meaning we respond to Herriman's ironic wit and recognize his complex visual games; and Pupp replying, "Yes, but they also...like a good laugh."

The appeal of this page is almost entirely visual, yet Herriman's verbal wit was equally remarkable. He was one of the only comic strip artists to simultaneously excel at both. A daily from 1938 is a good example of his clever interplay between words and images. It also carries on the visual punning of the Sunday page. In the first of five panels, Offissa Pupp, finding no "semblance of sin, shame or satanity," cries out "ALL-L-S W...." He is interrupted, not surprisingly, by a vision of cat, brick, and mouse shown successively over the next three panels, each of increasing width. The fifth and longest panel reveals the object of Pupp's surveillance to have been a painted sign and not the real thing. From out of the frame we hear "HA HA HA," undoubtedly coming from culprit-artist Ignatz. That much is a simple, clever variation on Herriman's ritual theme. But something else is going on. If we go back to the first panel we see that Pupp's interrupted "all's well" is a simple anagram for "walls." Thus Herriman

**17** George Herriman
*Krazy Kat*
Drawing for daily strip
(published November 18, 1935)
5 x 20 inches
Private Collection

gives the sophisticated reader a verbal clue to the coming visual trick.

The use of layered meanings is a characteristic of Herriman's work throughout his career. Often Herriman uses puns to anchor, and echo, the sheer beauty and pleasure of his pictures. A good example of this is the extraordinary Sunday page comprised of a single, page-sized panel showing Ignatz dropping a brick from a cactus skyscraper onto Krazy's head (fig. 22). Inside the large panel, at each of the upper corners, are two small panels that develop the central scene. In the first Ignatz is scurrying into the cactus while boasting, "He'll not foil me that kop!" In the second Pupp runs by the cactus as Ignatz hides inside. Pupp's line is, "He'll not fool me that mouse." In the grand central panel Krazy finally speaks, "He'll not fail me—that dollin'." The simple pun on foil/fool/fail complements the stunning central scene, making it both ridiculous and sublime. The composition itself is breathtaking. It is primarily a deep, rich black, unusual for the comics, crossed by the bright green, absurdly elongated cactus and an oddly geometric, red, rock-like formation shown in dramatic perspective. At the bottom of the frame that surrounds the entire page a decorative border, interrupted in the middle by a flower and vase, suggests a theatrical proscenium. The play taking place is both a replay of Herriman's characters' triangular interplay of desire, deceit, and eternal vigilance and his own display of artistic virtuosity.

By the end of his career, in the late 1930s and early 1940s, Herriman was routinely using color in the same inventive way. A page from 1941 shifts the color of the sky from orange to tan, blue, black, and finally red (fig. 20). In the spectacular circular image that ends the strip, the original orange color of the sky is repeated on the ground. More than just a bold formal gesture, that circular shape echoes the shell of the turtle that is the subject of Krazy's curiosity in the narrative. Time after time, Herriman tests the boundaries of how nature and art combine to create a sense that we are not just reading Krazy and Ignatz's antics, but watching the brilliant mind of their creator at play.

In other Sunday pages Herriman's visual and verbal harmonies take a back seat to a more developed, often poetic, use of language. In one lovely example the large penultimate panel shows Krazy, Pupp, and Kolin Kelly snoozing on a log as Mock Duck walks by uttering "The night it teems with moon and promise." Above their heads is an oddly shaped moon that resembles a pancake being flipped and a comet streaming across the sky. From his jail cell, in the bottom marginal panel, Ignatz has the last word: "What does one give and keep?"

Another page about the moon from February 1938 combines visual splendor and verbal poetry. Krazy and Pupp are arguing whether the moon is figuratively or literally blue. The background is another of Herriman's stunning geologic fantasies—a huge inverted arch. In the large central panel a silver moon is nestled in the arch, leaving Pupp to rest his case and walk away. In the final panel, behind the inverted arch, Ignatz is preparing to launch a blue balloon-moon into the night sky.

Almost from the start, *Krazy Kat* was the darling of American intellectuals. Gilbert Seldes, one of the first critics to approach popular culture from a positive point of view, wrote glowingly about the strip in his book *The Seven Lively Arts* (1924).[39] He was followed by the poet e. e. cummings, who wrote an introduction to a reprint of *Krazy Kat* in book form (1946). Both writers interpreted the strip as a deceptively complex allegory of social interaction displaced onto funny animal characters. From their perspective *Krazy Kat* was an absurdist morality play. Cummings went so far as to state that Krazy represented the id, Ignatz the ego, and Pupp the superego.

**18** George Herriman
*Krazy Kat*
Drawing for newspaper Sunday page
(published November 22, 1942)
Pen and ink, 22 x 15 inches
Collection of Jack Gilbert

*following pages*

**19** *left*: George Herriman
*Krazy Kat*
Newspaper Sunday page
(published June 11, 1939)
15 x 10 inches
Collection of Patrick McDonnell

**20** *right*: George Herriman
*Krazy Kat*
Newspaper Sunday page
(published December 21, 1941)
15 x 10 inches
Collection of Patrick McDonnell

From a contemporary perspective *Krazy Kat* is celebrated more for its multilayered allegories about representation and reality than for its psychoanalytic symbolism. Instead of presenting meaning (and the world) as a stable, fixed reality, Herriman's work constantly calls reality into question and presents meaning in process. In that context, Herriman's pervasive use of discontinuity can be seen not only as more than surreal whimsy but as a profound statement about the nature of representation. His art is not anchored on the level of realism or fantasy. Nor is it locked into expected causality or standard frames of reference. Instead it is based on a principle of permanent flux that resists any particular interpretation or meaning. In other words, Herriman deconstructed comics at the same time as he invented the highest level of creative expression that the medium has achieved.

In that regard, Herriman's goal is similar to Ignatz's (who is often depicted as the artist within the strip). Both the real and fictitious artist strive to disorient the law, whether it be Offissa Pupp or the law of language and representation. In this respect Herriman hits us, his readers, on the head with a figurative brick each time we read his work. What is particularly intriguing is that, like Krazy, we like it and keep coming back for more.

21 George Herriman
*Krazy Kat*
Newspaper Sunday page
(published November 28, 1937)
15 x 10 inches
Collection of Patrick McDonnell

22 George Herriman
*Krazy Kat*
Reproduction of newspaper Sunday page
(published September 12, 1937)

## Thimble Theatre

# 7
## E. C. Segar and Other Comedy Comics Classics

Herriman wasn't the only spectacularly inventive artist working in the comics after World War I. Other talented cartoonists such as Rube Goldberg, Milt Gross, Billy DeBeck, and Cliff Sterrett show how Herriman both was part of his time and transcended it. But much like Charlie Chaplin, D. W. Griffith, and Louis Armstrong, Herriman invented new forms of expression rather than merely using those forms to create skillful works of popular amusement.

However, there was one other cartoonist who came close to matching Herriman's genius for creating profound, funny characters and complex

situations that grew out of the seemingly simple-minded comics. E. C. (Elzie Crisler) Segar (1894–1938) did not match Herriman's sophisticated lyrical allegories, but he told better stories and ultimately became the most popular cartoonist of his day.

Segar's first job was as a projectionist in his hometown movie theater in Chester, Illinois. Inspired by the films of Charlie Chaplin, Segar enrolled in a cartoon correspondence course, taught himself to draw, and went to Chicago, where he got a lowly job on a second-rate newspaper and continued a comic strip based on Chaplin's Little Tramp character. Chaplin disliked the strip so much that he made the paper stop publishing it. Then the paper was sold to the Hearst syndicate at the same time as another cartoonist, Ed Wheelen, got into a fight with the company and took his popular *Minute Movies* (titled *Midget Movies* from 1918 to 1921) feature to a rival company. Hearst hired Segar to come to New York and create an imitation called *Thimble Theatre* in 1919.

Within a few years *Thimble Theatre* was a favorite among sophisticated urban readers. By the mid-1920s Segar developed a unique form of humor

in *Thimble Theatre* (and his companion strip *Sappo*) based on eccentric speech, random violence, mindless optimism, endless conniving, and a stubborn attention to craft. Segar's early drawing style owed a great deal to Herriman, particularly his short-lived features such as *Baron Bean* (1916) and *Stumble Inn* (1922), which had human characters drawn in the

**23** E. C. Segar
*Thimble Theatre Starring Popeye*
Newspaper Sunday page
(published October 11, 1936)
23 x 17 inches
Private Collection

**24** E. C. Segar
*Thimble Theatre Starring Popeye*
Newspaper Sunday page (detail)
(published December 3, 1933)
23 x 17 inches
Collection of Peter Maresca

same confident funny lines that Segar brought to perfection. But Segar's humor came straight out of Mark Twain, who also balanced exaggerated tall tales and a perfect ear for everyday speech with dark themes that undercut his laugh-out-loud stories.

Segar also shared Twain's ability to string together comic scenes into spellbinding narratives. And in 1929 the eccentric and marginal *Thimble Theatre* transformed into one of the most popular works of art in American history with the

introduction of the character Popeye, who came to dominate *Thimble Theatre* (whose title changed to *Thimble Theatre Starring Popeye* in 1931) and the whole country's imagination. Before Segar died in 1938, Popeye's battles with the forces of evil through his spinach-inspired superhuman strength were among the best-drawn, funniest, and most intelligent comics, and Segar's characters such as Olive Oyl, Wimpy, Eugene the Jeep, Sea Hag, and Alice the Goon became a part of American culture.[40]

Segar did not invent graphic comic strip conventions or experiment with them in the way that Herriman and McCay did. Segar simply showed how rich and supple those conventions could be in terms of creating believable characters and stories that could be enjoyed as daily gags as well as long-running complex stories. In fact, the only Sunday page where Segar played with the formal layout was on August 9, 1936, in which the Jeep looms over

the standard grid of panels almost as large as the entire page (fig. 198). Segar also developed a drawing style unlike anyone else. His characters were the boiled-down essence of something based purely on cartoonlike doodles rather than reality as they were in *Mutt and Jeff* or *Stumble Inn*. In that sense, there is a real purpose to the seemingly casual topper strips that taught readers about how to create different figures with words and lines. They also show how Segar's crazy inventions differed from the brilliant animated cartoons that the Fleischer brothers based on Segar's characters in the 1930s and 1940s.

Segar's work was at its peak from December of 1933 through July of 1934, when he drew one of the longest, most suspenseful (and funniest) stories in the history of comics (figs. 24–28). It began with Popeye knocking heads with a stranger in what was already his characteristic "smack" "bonk" "ump" style (fig. 24). Fists fly, heads butt, and force lines jut across the empty space around the characters. The stranger turns out to be an old acquaintance and the fighting was just a friendly greeting. But "Salty" Bill Barnacle and Popeye's violent get-together lands them in jail.

There they find a scared old man, Professor Cringly, who tells them of a place called Plunder Island, where pirates store their ill-gotten gold (fig. 25). Meanwhile, Wimpy provides comic relief through his long-running gags trying to mooch food off of anyone who comes by.

25 E. C. Segar
*Thimble Theatre Starring Popeye*
Newspaper Sunday page (detail)
(published December 10, 1933)
23 x 17 inches
Collection of Peter Maresca

26 E. C. Segar
*Thimble Theatre Starring Popeye*
Newspaper Sunday page
(published May 20, 1934)
23 x 17 inches
Collection of Peter Maresca

In the same Sunday page, Segar introduced his most wicked villain, the Sea Hag, and her sidekick, the terrifying Goon. This kicks the adventure into high gear, which Segar intensifies by crosscutting between Popeye's not-so-innocent journey and the Sea Hag's fiendish plans. Meanwhile Wimpy turns out to be loyal only to his stomach, not his *Thimble Theatre* crew. He sweet-talks the Hag and ends up having the Goon go sweet on him (fig. 26).

In one great sight gag within the adventure, Popeye hides in a wooden barrel with his iconic

## Thimble Theatre

head sticking out because the Hag says she will kill Wimpy unless he decapitates the sailor. Eventually, Popeye can't stand Wimpy's behavior so he speaks up and spoils the disguise. The Hag and her cronies chase Popeye, but the Hag's real anger is for Wimpy whom she loves and who has betrayed her.

**27** E. C. Segar
*Thimble Theatre Starring Popeye*
Newspaper Sunday page (detail)
(published July 1, 1934)
23 x 17 inches
Collection of Peter Maresca

The Hag chases Wimpy around her ship. He runs like the coward he is, but somehow she becomes tangled in rope and tied up. Wimpy jumps overboard when the Goon comes to the Hag's rescue. He swims to safety only to land on the island of cannibals, where the Chief invites Wimpy to a duck dinner, which is the long-running gag in the strip. Only this time the joke is on Wimpy when the Chief tells him, "You'll be the duck" as he points toward a boiling cauldron of water.

Several weeks later, Popeye finds the treasure on Plunder Island. When he tries to take it, the Hag challenges him and claims it to be her own (fig. 27). Popeye offers only to take what is fair and owed to him, but the Hag wants it all. Popeye disagrees and he tells the Hag he will wager over the fortune. They play a hysterical game of dice, which the Hag loses in spectacular fashion. In the end she has lost everything and has to wager her own clothing for one last throw of the dice. In a brilliant moment, Segar draws the Hag covering her grotesque naked body in the same-style wooden barrel that Popeye hid in weeks earlier. Popeye wins again and the sequence ends with him taking the fortune to give away to the less fortunate, like a comic Robin Hood.

Segar's gift was both for extended narrative and for the high degree of self-contained wit and energy in each individual page. He did this not by making each page a single compositional element or by experimenting with shading or eccentric points of view, but by creating a strong sense of identity through the masterful repetition of characters, comic violence, and running gags. The Sea Hag's final costume is a perfect example. The connection

between her barrel and the one Popeye hid in earlier is not just a brilliant sight gag. It is also fundamental to how the plot is structured and indicates the reversal between the seemingly omnipotent Hag and the hapless one-eyed sailor.

The breakthrough aspect of Segar's work is not that Popeye participates in so many fights and scraps, but that he emerges victorious. The early comic characters were fall guys, invariably the butt of someone else's joke, and the subject of much sadomasochistic energy. Popeye on the other hand is omnipotent and, as Bill Blackbeard points out, pre-figures the rise of superheroes in the 1930s and 1940s.[41] At the same time Popeye is a much more complex and sympathetic character than the later superheroes, who tend to be somewhat stiff and colorless.

Popeye is exactly the opposite. His name itself proclaims his bold, eye-catching personality. He smacks, socks, and bonks everyone who gets in the way of good (and gets a few splats and bops himself), but his fights are rarely an end in and of themselves. In the early comics the anarchic and apocalyptic violence that defined *Happy Hooligan* and *The Katzenjammer Kids* punctuated each strip

and was their entire raison d'être. Segar exploits the slapstick tradition, but only to contextualize concern for his characters and the trouble they get themselves in.

The Plunder Island sequence illustrates the variety of masterful attributes that distinguishes Segar's work. First and foremost is his gift for complex narrative over a period of time that blends suspense, violence, sympathetic characters, and humor. Segar was able to do so on a level of mass popularity after 1929 because the character of Popeye brought a leading man to the cast. More than just a graphic invention of a talented cartoonist within a great format, Popeye allowed Segar to display one of the rarest and most precious gifts a cartoonist can achieve—acting.

Though he does the most ridiculous things, Popeye is a believable character because Segar drew his movements and wrote his dialogue as if he were performing in the Chaplin films Segar admired in his youth. It took him almost a decade to be able to create a comic strip that was more than a superficial imitation of how Chaplin appeared. With Popeye starring in *Thimble Theatre* Segar added his own narrative and dramatic genius to the graphic and conceptual complexity that McCay and

Herriman had developed a few years earlier. As Art Spiegelman put it, "I think of *Thimble Theatre* as blue collar Beckett."

In the 1920s, Herriman and Segar's greatest peer in eccentric vision and absurd humor was Rube Goldberg (1883–1970), whose name is now synonymous with the elaborate yet useless machines he drew under the title *Foolish Inventions*. Goldberg began his career as a sports cartoonist at the same time as Bud Fisher. Billy DeBeck (1880–1942) was another masterful cartoonist who began his work in the sports pages in the 1910s. His signature feature became *Barney Google*, which debuted in 1919. The strip took off as a popular phenomenon in 1922 when Barney came upon a racehorse named Spark Plug.[42]

The other great comic nut of equal skill and verve was Milt Gross (1895–1953), who also started as a sports cartoonist, working for TAD. Gross's *Count Screwloose* and *Dave's Delicatessen* remain two of the wackiest strips of all time. Like Goldberg, Gross made his name with a miscellaneous feature called *Gross Exaggerations*. It contained two extremely popular items, *Banana Oil* and *Nize Baby*. The latter was reprinted in book form and became a hit in the mid-

1920s, leading to other illustrated books, including his masterpiece *He Done Her Wrong*. But Gross's contemporary reputation rests on *Count Screwloose* and his simplified anything-for-a-gag style, which influenced the look Harvey Kurtzman developed in *Silver Linings*, brought to *MAD*, and later passed on to underground comics.

Goldberg, Gross, and DeBeck elaborated on Herriman's use of visual and verbal puns and combined it with the absurdist-vaudeville tradition that stretched back to *Happy Hooligan*, *The Katzenjammer Kids*, and *Mutt and Jeff*. At the same

**28** E. C. Segar
*Thimble Theatre Starring Popeye*
Newspaper Sunday page (detail)
(published July 8, 1934)
23 x 17 inches
Collection of Peter Maresca

time, another artist, Cliff Sterrett (1883–1964), developed Krazy's graphic innovations into a unique and masterful feature, *Polly and Her Pals*, that began in 1912 and reached artistic maturity in the 1920s and early 1930s.

**29** Frank King
*Gasoline Alley*
Newspaper Sunday page (detail)
(published May 10, 1931)
23 x 17 inches
Private Collection

**30** Frank King
*Gasoline Alley*
Drawing for newspaper Sunday page panel, c. 1930s
Pen and ink with watercolor, 5 x 5 inches
Private Collection

**31** Frank King
*Gasoline Alley*
Drawing for daily strip, c. 1921
Pen and ink, 6 x 20 inches
Collection of Jim Scancarelli

*Polly and Her Pals* also marked the rising popularity of comics set in domestic situations with female characters rather than fantasies with small children or sports settings filled with men. The domestic genre began with George McManus's (1884–1954) *Bringing Up Father* in 1913[43] and was popularized by *The Gumps* and *Gasoline Alley* along with *Polly and Her Pals*.

*The Gumps* began at the instigation of Captain Patterson.[44] It was the first of what became a stable of extraordinary comics features, including *Gasoline Alley*, *Dick Tracy*, *Little Orphan Annie*, and *Terry and the Pirates*. Patterson sensed that the comics could appeal to the entire family and created a comics section with different features targeted at every member. At the center were the family strips that appealed directly to the adults who bought the majority of papers. The influence of this genre continued outside of the comics in radio and television, where it developed into two staples of that medium, situation comedies and soap operas.

## 8
## Frank King and the Art of Everyday Life

*Gasoline Alley* began as part of *The Rectangle* in 1918 and became a daily feature in the *Chicago Tribune* in 1919. It took off in 1921 when the central character, Walt Wallet, a bachelor, found a baby on his doorstep. The baby's name was Skeezix and, as they say, the rest is history. What had begun as a marginal story about car culture (a novelty at the time) became an engrossing ritual in which half a nation watched Skeezix and his siblings, Corky and Judy, grow up in real time. Frank King's (1883–1969) slow, deliberate pace gave the feature its character and made it an invaluable document of everyday life in Midwestern America in the 1920s and 1930s. At the same time King blended images from nature and art history to lend a wistful, poetic quality that made the story more profound and soulful than the simple depiction of family life it appeared to be on the surface.

Compared to the slapstick antics of most comics, *Gasoline Alley* is relatively unexciting. Virtually nothing dramatic ever happens beyond the cycle of

everyday activities, births, deaths, marriages, and other neighborhood events. Almost all comics are fantasies of one sort or another, and *Gasoline Alley* holds the honor of being the best fantasy of normalcy. As such it is drawn with simple nobility and a sincere sense of wonder. It is a mistake to judge this as naïve or innocent. The illusion of ease and simplicity is a difficult one to master, and King was its king. He continued a long tradition of American artists making work with double layers of meaning. Typically the first layer is simple and amusing and borrows from popular culture. The second layer is more personal and often hidden for other artists and readers to uncover.

King's Sunday pages, filled with unexpected fantasy and visual inventiveness, complemented the quiet poetry of his daily strips. (A well-known single-panel daily from 1921 shows how King incorporated innovative visual perspective while depicting the characters as a complex community of individuals [fig. 31].) In terms of the color Sunday pages, King was often the equal of McCay and was one of the last newspaper artists to follow his lead. In fact, one of King's pre-*Gasoline Alley* Sunday strips, *Bobby Make-Believe* (fig. 199), was a direct variation on *Little Nemo*.

TRY TO FLOAT LIKE THIS, SKEEZIX. IT'S EASY.

I'D SINK. I PUT ALL THE WIND I HAD INTO THESE WATER WINGS.

 **32** Frank King
*Gasoline Alley*
Drawing for newspaper Sunday page
(published August 19, 1934)
Pen and ink with watercolor, 26 x 20 inches
Collection of Art Spiegelman

**33** Frank King
*Gasoline Alley*
Newspaper Sunday page (detail)
(published August 24, 1930)
23 x 17 inches
Private Collection

One of King's most original devices was to treat the entire Sunday page as a single scene, although still divided into the traditional 3 x 4-inch panel structure. These pages are shown from an aerial perspective, similar to that found in many Japanese paintings and prints. They sometimes have a single character moving from frame to frame in what is otherwise a static tableau.

One remarkable example from August 24, 1930, shows a summer beach scene from above (fig. 33). It begins with Walt and Skeezix walking across a crowded sandy beach. The difficulty of doing so is punctuated with physical humor as Walt trips over a man's legs, gets hit by a beach ball, walks into a female bather, and is finally pushed into the water by his son. The final verbal gag shows Walt floating in the water with his belly sticking out like a beach ball while Skeezix explains that he can't float because he has used up all his air filling a water wing.

> ◢ **34** Frank King
> *Gasoline Alley*
> Drawing for daily strip
> (published March 23, 1939)
> Pen and ink, 6 x 20 inches
> Private Collection

This in itself is unremarkable, and like most of *Gasoline Alley*, more anecdotal than funny or eventful. Yet at the same time, the picture has an extraordinary visual appeal created by the single beach scene spread out over the entire page. The breakdown into panels heightens the effect, particularly when figures are cut in half by the intervening borders. King also uses color to create a pleasing pattern on the page. The flat yellow color of the beach covers most of the page, with a jolt of the bright blue ocean in the lower right balanced by the colorful bathing suits and skin of the beachgoers. Walt's red bathing suit—the same color as the title letters—helps us follow him as he moves through the scene. King used the same device four years later with Skeezix's

younger brother, Corky, joining them. In this version, Walt asks his older son to look after Corky, but the younger boy gets lost, and the wandering figure across the aerial perspective is Skeezix, not Walt.

Another bold Sunday page from 1931 uses its rectangular panel structure as a foil for interior circular patterns as McCay did almost twenty years earlier in *Dream of the Rarebit Fiend* (fig. 29). This page begins with Skeezix trying out a new compass and develops into a literal play of geometric versus natural circles that resembles modern art abstractions, particularly those of Robert Delaunay and Stanton McDonald-Wright. The page ends with Skeezix, boasting like any good modern artist, "I draw better circles than nature does." The result of this artistic play is one of the most purely abstract Sunday pages in the comics' history. King was one of the best artists at combining the graphic experiments of early comics with storytelling and everyday realism. This charming Sunday page shows King's balancing act at its best. On one hand, it could be read as a typical response to a child asking questions about nature. On the other hand, it is a sophisticated use of abstraction by a talented artist in the guise of family oriented storytelling.

King's Sunday pages from this era (roughly 1926–1934) often use nature themes to show off the graphic quality of printed comic strip color pages. One example is the use of deep black lines to mimic woodcuts (fig. 35). Another is to use color to mimic the hues of leaves changing on trees in autumn. One such page from 1928 also uses a circle in its title panel, this time as an abstract color wheel that sets the tone for the natural colors in the body of the story (fig. 203). In this sense King is following McCay not just in terms of how to draw and lay out the page but also in that a cartoonist must construct a sense of reality in his design and not just copy from nature.

Another remarkable *Gasoline Alley* Sunday page clearly shows that King was deeply aware of modern art and that the quotidian character of his work was an attempt to find an indigenous American balance between art and life. In the page, Skeezix and Uncle Walt visit an art gallery and walk into an abstract painting filled with effects culled from Picasso, Kandinsky, and Kirchner (fig. 36).

The title panel begins with Walt and his son talking about a painting during a museum visit. Walt says, "Modernism is a bit beyond me. I'd hate to live in the place that picture was painted." Skeezix differs, "I'd like to go there Uncle Walt." In the nine square panels on the main body of the page they are shown inside the painting. At first their visit is like a walk into a slightly skewed fairy tale. By the second tier things start to go awry. Walt comments, "Nature was wonderful but how she has changed." By the time they reach the bottom tier they are completely disoriented. They approach a misshapen stranger who looks a lot like Picasso's self-portrait of 1907 and ask, "Can you tell us the way out of all this?" He replies, "There is no way out!" The remarkable final panel complicates the already complex depiction of pictures within pictures by having Walt and Skeezix blur into trails of paint. Skeezix's final comment is reminiscent of Edgar Allan Poe's poem "A Dream Within a Dream:" "That was an awful dream Uncle Walt, or was it a dream?"

In the first few decades of the twentieth century, comics were still the newspaper equivalent of Coney Island—a structured form of release for lower- and middle-class readers more comfortable with pictures than printed words. Nonetheless, McCay, Feininger, Herriman, Segar, and King were able to create innovative and expressive art that related directly to drawing and graphic design. As a result, a significant number of very different artists over the next half-century, such as Chester Gould, Harvey Kurtzman, R. Crumb, and Art Spiegelman, have been able to create comics that express their idiosyncratic and personal thoughts in a way that continues to contribute to the history of American art and the visionary spirit of American popular culture.

Chicago Sunday Tribune.
THE WORLD'S GREATEST NEWSPAPER

NOVEMBER 30, 1930

Gasoline Alley

8 PAGES OF COMICS

Chicago Sunday Tribune.
THE WORLD'S GREATEST NEWSPAPER
NOVEMBER 2, 1930

8 PAGES OF COMICS

GASOLINE ALLEY

# NEWSPAPER COMICS IN MID-TWENTIETH-CENTURY AMERICA

## 1
## The Comics Grow Up

In the first decade of the twentieth century, comics and movies simultaneously developed a visual language to generate the illusion of reality through a succession of individual shots or frames. At first this was done with a methodical variation of mid-range and long shots. While this minimized a certain staginess, it still left the impression of a limited field of vision.[45] Early comic artists such as McCay and Feininger made the most of this limitation by playing off the flatness of the page and creating specific formal patterns or effects. In one episode of *Dream of the Rarebit Fiend*, for example, McCay shows an artist drawing the landscape in front of him while it transforms from a realistic space into a series of inkblots that take over the page like a bad dream or a truthful representation of the image as print on paper, depending on one's point of view.

Comic artists in the 1920s such as Frank King used realistic imagery to enhance the illusion of their stories and adventures rather than to show fantasy within the context of a dream or ironic joke. Instead of what amounted to two planes of images—characters and scenery—they created receding perspectives and chiaroscuro, moving the point of view around the characters to bring out their sense of physical mass rather than flat caricature. A beautiful, hand-colored Sunday page of *Gasoline Alley* from 1923 (fig. 202) purports to be an April Fool's gag about explosions that Uncle Walt thinks are a flat in his car tire. But the page is really a loving depiction of a Midwestern small town and its colorful inhabitants on an early spring day. Compare that approach to one that King created about a decade earlier, called *Early Spring Pome*, a delightful and beautifully drawn amalgam of different pictures and anecdotes about the season that ultimately lacks the full sense of reality that King created in *Gasoline Alley* by integrating his drawing skill and imagination with familiar pictures, people, and places.

After more than three decades of popular, creative, and commercial success, the mature form of the comics became episodic storytelling that combined pictures and words with iconic characters and accurate backgrounds. They were meant to be "read" like the text in newspapers (left to right, top to bottom), but they also built upon a new type of "reading" that McCay and Herriman had developed in their work, which involved layered visual and verbal information. In that sense, comics are not just *read* as a sequence of images like words in a sentence or phrases in a paragraph. They are also *seen* as one integrated image. As a result, the comics developed a "language" appropriate to the visual culture of the time.

*Gasoline Alley*, for instance, is about not just car culture, but how the people and environment of America were transformed by innovations like the automobile. To create a visceral sense of that change, King created a variety of perspectives and angles of vision within the expected grid of panels with a type of virtuosity so natural that it never called attention to itself. A hand-colored page from 1934 is a visual tour de force in the guise of a small-town anecdote (fig. 32). Skeezix sees his town reflected in his swimming hole and each frame is a mirror-play as sophisticated as McCay's Befuddle Hall, but grounded in the reality of everyday life rather than fantasy. In that regard, King's use of standard frames signifies the ordinary foundations of his imagination, while McCay's ever-changing use of panels signals how his imagination tried to be out of this world.

Framing helps to establish comics as a visual art form to be read, because panel size and placement sets the rhythm and pace of a story or gag.[46] In framing, as in so many aspects of the comics, Winsor McCay established both the norm and its exceptions. McCay (like D. W. Griffith in film) explored every permutation he could imagine in terms of the overall design of the page, while at the same time developing a basic vocabulary still in general use.[47] Herriman's use of framing is the best example of the rhythmic quality its variety and careful juxtaposition can produce. He used frames within frames, dispensed with them altogether, and in one remarkable page followed a flow of ink from the top of the page, along the borders, across the frames, and down to the bottom. We become aware of the literal flow of ink that is usually disguised in figures and forms.

Between Herriman's playful use of comic strip conventions and King's straightforward use of calculated visual effects, the majority of cartoonists stuck to the norm and concentrated on characters and plot. They merely used a variety of panel shapes to keep their strips lively and to allow them to stand out among the competition. A big close-up followed by some quick action was as sure to draw the reader's eye as good draftsmanship and recognizable characters. But by and large what happened within the panels was more important than the graphic arrangement of panels across the page.

By the late 1920s comics were a popular institution. And most of the conventions of its language were established—the use of sequential panels to indicate time, the use of page design and interior panel design to indicate different types of spatial relationships, the use of word balloons and typography to indicate dialogue and sound, and the relationship of individual strips over days and sometimes months to indicate narrative continuity.[48]

## 2
## The Black-and-White World of Chester Gould

The mass popularity of comics was secured in January 1929 when Popeye joined the cast of *Thimble Theatre*, Buck Rogers blasted into space, and Tarzan swung through the jungle. By the end of the year, they were helping Americans escape from the stock market crash and the onset of the Great Depression. Adventure and suspense helped keep people's attention and sell newspapers more than pratfalls and slapstick.

Although *Thimble Theatre* is the transitional comic strip between the comedic characters of the 1920s and the heroic ones of the 1930s, Roy Crane (1901–1977) was the first artist to incorporate all the elements of what became the adventure strip. His feature *Wash Tubbs* debuted in 1924[49] and displayed the narrative and graphic style that came to dominate the comics after 1929. Crane brought authentic realism to comics and developed new graphic devices such as duotone paper and pebble board to create dramatic background effects, which heightened the atmospheric potential of comics by incorporating intermediate gray tones that indicated shading better than cross-hatching.

*previous pages*

**35** *left:* Frank King
*Gasoline Alley*
Newspaper Sunday page
(published November 30, 1930)
23 x 17 inches
Private Collection

**36** *right:* Frank King
*Gasoline Alley*
Newspaper Sunday page
(published November 2, 1930)
23 x 17 inches
Private Collection

**37** Chester Gould
*Dick Tracy*
Newspaper Sunday page
(published July 18, 1943)
23 x 17 inches
Collection of Matt Masterson

**5¢**   **SUNDAY**  **NEWS**   **5¢**

Copyright 1943 by News Syndicate Co. Inc. Reg. U.S. Pat. Off.

NEW YORK'S   PICTURE NEWSPAPER

Comic Section     NEW YORK, SUNDAY, JULY 18, 1943★     Published Each Sunday.

LEAVING HEADQUARTERS AT A LATE HOUR, DICK TRACY STARTS FOR HIS HOME ONLY TO BE CONFRONTED BY A BLINDING RAIN-STORM. NO CABS ARE AVAILABLE. HIS NEAREST TRANSPORTATION IS A STREETCAR LINE FIVE BLOCKS AWAY. HE SETS OUT AFOOT.

SUDDENLY, HE IS AWARE HE IS BEING FOLLOWED—BY A **BUXOM WOMAN!** OR **IS** SHE FOLLOWING HIM???

THE RAIN POURS DOWN. OVER HIS SHOULDER, TRACY SEES THE BIG FEMALE FIGURE GRADUALLY DRAW CLOSER

SOMETHING SWISHES PAST HIS HEAD. HE **TURNS**—

I'D SWEAR SHE THREW SOMETHING

IN THE RAIN, HE SEES NOTHING. CHUCKLING AT HIS CONCERN OVER THIS FEMALE SHADOW, HE HASTENS ON—

NOW!

A BRAWNY ARM IS HURLED FORWARD! WITH THE SPEED OF LIGHTNING, A LEATHER THONG WRAPS ITSELF AROUND THE DETECTIVE'S NECK—HE CHOKES.

HIS HANDS STRUGGLE TOWARD HIS THROAT. HIS BODY IS YANKED BACKWARD.

THE PAIN IS EXCRUCIATING! THE WHIP BUTT RISES AND DESCENDS AS ALL SENSES LEAVE THE BRAIN OF DETECTIVE DICK TRACY—

HE MUST NOT CHOKE TO DEATH. — NOT NOW.

DOWN ALLEYS, BEHIND FENCES, ACROSS YARDS, THE AMAZON FIGURE TRUDGES THE RAIN BEATS DOWN HARDER. BLACK, COLD RAIN!

HERE.

EMIL!

Reg. U.S. Pat. Off. Copyright, 1943, by The Chicago Tribune.

**APR. 17 -50**

A BLAST! FLAMES! TOPPLING WALLS! SUDDEN! OVERWHELMING! DICK TRACY'S HOME BURNS!

IS THERE **NO WAY OUT**?

JUNIOR— JUNIOR!

DICK! DON'T GO BACK THERE.

**APR. 20 -50**

SCENE: BLOWTOP'S GARAGE. WE HAD TO DO IT, BLOWTOP. COULDN'T HELP OURSELVES.

YOU DOPES!

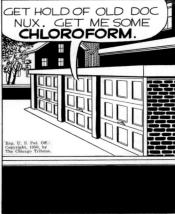

GET HOLD OF OLD DOC NUX. GET ME SOME **CHLOROFORM**.

JUNIOR, JUNIOR! WHERE ARE YOU?

GET HIM OUT OF THERE BEFORE WE LOSE BOTH OF THEM.

**APR. 21 -50**

THROWING A WATER-SOAKED BLANKET AROUND HIMSELF, DICK TRACY CONTINUES TO SEARCH FOR JUNIOR.

CAN'T YOU HEAR ME, KID? WHERE ARE YOU?

A FIREMAN RISKS DEATH TO TAKE TRACY BY FORCE.

YOUR **HAIR'S AFIRE**! THIS WALL'S GOING!

**APR. 22 -50**

THAT'S THE END OF OUR NEW HOME—AND—

CRASH

JUNIOR! THAT POOR KID!

OH, DICK—

HERE COMES JOE WITH THE CHLOROFORM.

LET HIM IN—QUICK.

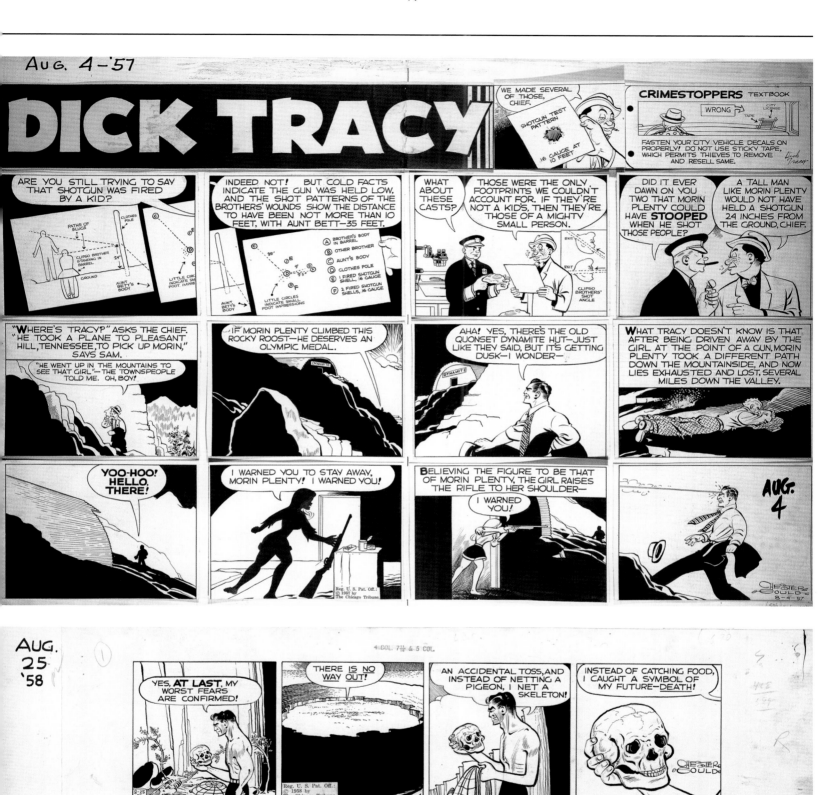

38–41 Chester Gould
*Dick Tracy*
Four drawings for daily strips
(published April 17, 20, 21, and 22, 1950)
Pen and ink, each 6 x 20 inches
Collection of Matt Masterson

42 *top*: Chester Gould
*Dick Tracy*
Drawing for newspaper Sunday page
(published August 4, 1957)
Pen and ink, 18 x 27 inches
International Museum of Cartoon Art

43 *bottom*: Chester Gould
*Dick Tracy*
Drawing for daily strip
(published August 25, 1958)
Pen and ink, 5 x 17 inches
Collection of Art Spiegelman

*Little Orphan Annie* also debuted in 1924 and brought extended dramatic continuity to comics. Harold Gray (1894–1968) started as an assistant on *The Gumps* and his strip, *Annie*, began as an imitation of *The Gumps*, with short anecdotal situations of a sentimental or flatly humorous nature. By the early 1930s, *Annie* took on a distinctly different tone. Gray explained: "She was not a 'comic.' She didn't attempt to panic the public every day or send millions into hysterics with her wit. Life to her was deadly serious. She had to be hard to survive, and she meant to survive."[50]

44  Chester Gould
*Dick Tracy*
Drawing for newspaper Sunday page
(published August 11, 1957)
Pen and ink, 18 x 27 inches
Private Collection

At the same time, comics continued to take their readers into fantastic worlds, but now they began to do so in a straightforward and realistic fashion. From the start *Tarzan* and *Buck Rogers* looked and behaved differently.[51] First, they made absolutely no attempts at humor. Even *Annie* and *Wash Tubbs* used humor to contextualize the grim world they represented. Second, these new adventure strips took place in other worlds. Tarzan's jungle and Buck's future world were neverlands of a concrete and definable nature, equally distant from the experience of ordinary Americans.

Soon after Tarzan and Buck Rogers took their readers to far-off adventures, another famous feature was born that brought a sense of dramatic realism close to home and helped create another new comic genre, the detective strip. Chester Gould's (1900–1985) *Dick Tracy* is perhaps the best known and most iconographically potent comic character aside from Mickey Mouse. *Tracy* began in 1931 in what later became a conventional form of motivation for the entire genre. He witnesses a crime in which his girlfriend is kidnapped and her father killed. Tracy joins the force and sets out for revenge.

*Tracy* is perhaps the best example of a feature that turned the constraints of the medium into its strength. It is drawn in an unconventional way, with attention to detail or accurate proportions viewed in terms of their graphic impact on the printed page rather than how they resemble things in real life. Gould used contrast, surface patterns, and unexpected juxtapositions to create a powerful sense of atmosphere that gave his stories emotional impact. As Art Spiegelman put it, "Gould understood better than anyone that comic strip drawing isn't really drawing at all, but rather a kind of diagramming."[52]

The strip's overall success can be attributed to several things. The subject was a perfect reflection of the 1930s, a period when gangsters such as Machine Gun Kelly, Baby Face Nelson, and John Dillinger were celebrities. In addition to a recognizable and iconic title character it housed the best collection of grotesque villains ever assembled. And Gould had a way with the contrast between black and white that closely paralleled film noir and gave his strip an aesthetic impact perfectly suited to the print medium in which it appeared.

The strip also had a seemingly inexhaustible formula. Tracy would routinely get into a fix that seemed to signal his inevitable demise, only to emerge a day later with barely a scrape on his chiseled chin. Yet Tracy was no superman. He had no extraordinary powers other than the force of his will, a keen Sherlock Holmes-like mind, and Good on his side. In that sense, Tracy had it both ways. He was both of and out of this world, and Gould played the thin line between character and symbol for all it was worth.

AUG. 14-'66

AUG. 14-'66

Tracy's most endearing characteristic is his cool. All preceding comic heroes were emotional and frenetic. Even if they were adults like Popeye, they acted impulsively like children. Tracy's cool was of a different order. Gould's sense of design and draftsmanship did not convey realism in a conventional way, but it made readers feel as if what was happening was real. *Tracy* also broke new ground, in Gould's own words, by showing "a detective character fighting it out face to face with crooks via the hot lead route."[53] *Dick Tracy* was the first comic strip to graphically illustrate murder, gunfights, bloody fistfights, kidnappings, and other explicitly violent crimes. Tracy himself endured all kinds of physical pain and abuse over the years. As Ellery Queen relates in his introduction to a reprint of Tracy's celebrated cases, he was "slugged, pistol whipped, tortured, burned, beaten, pressurized, dynamited,

dragged by a car at sixty miles an hour, stabbed, crushed…" and who knows what else.[54]

Comics had always been violent, but in a very cartoony way; readers knew that Ignatz's brick wouldn't really knock Krazy's head off and that Popeye wouldn't show a bruise. Tracy always emerged from his violent battles intact, but the implicit reality of death was never in doubt. Along with the novels of Dashiell Hammett and Raymond Chandler (as well as the movies made from them) *Tracy* created a new form, a popular genre in which violence was a real and omnipresent aspect of everyday life.[55]

Gould's primary graphic device to convey a sense of brutal violence was the contrast between massive black forms and the white spaces in-between. For example, Gould used images of fire over and over to convey danger, but also to create interesting graphic patterns on the page. A daily

strip from April 21, 1950, makes this clear, as the flames cover the panels and transform them into something abstract that is attractive, but not pretty in the way we typically think of decorative patterns (fig. 40). The irregularity of the fire imagery contrasts with Gould's black inking.[56] This literalized the good-versus-evil moral tone, but unlike the overt message, black and not white defined the medium. This contributes to the feature's success and may suggest why this stone-faced cop has become such an important American icon in a society not overly enamored with heroic policemen. His purity and strength are mythic, not simply by design, but in contrast to the environment he exists in. Tracy's cool transcends death through violence, just as Flash Gordon's cool transcended death through sexuality.

**45** Chester Gould
*Dick Tracy*
Drawing for newspaper Sunday page
(published August 14, 1966)
Pen and ink, 23 x 17 inches
Collection of Matt Masterson

**46** *top:* Chester Gould
*Dick Tracy*
Drawing for daily strip
(published March 7, 1962)
Pen and ink, 5 x 17 inches
Private Collection

**47** *bottom:* Chester Gould
*Dick Tracy*
Drawing for daily strip
(published July 18, 1964)
Pen and ink, 5 x 17 inches
Private Collection

## 3
## Milton Caniff—Master of Suspense

*Terry and the Pirates* was the most visually exciting and compositionally complex comic strip of the late 1930s and 1940s. It began in 1934, the same year as *Flash Gordon*, *Secret Agent X-9*, *The Little King*, *Mandrake the Magician*, and *Li'l Abner*. A month earlier, in December 1933, Noel Sickles took over *Scorchy Smith*. He and Caniff followed Roy Crane to perfect most of the conventions of realistic illustration still used in comics. Foremost among these innovations was using a brush in addition to a pen to indicate chiaroscuro and developing a sense of uncluttered visual accuracy by detailing an important foreground object to indicate the mood of the entire panel. But it was Caniff alone who developed the vocabulary of realistic suspense to its classic form.

The height of Caniff's artistry and suspense took place in the 1940s, before and during World War II, after Terry had grown from a small boy over the strip's development and enlisted in the U.S. Army Air Force. One remarkable sequence from November 1940 (perhaps deliberately over the Thanksgiving holiday) shows Hu Shee saving Terry in a gripping car chase and taking him to a local doctor to have a bullet removed from his side (figs. 50, 51). The next frame shows Terry waking from unconsciousness, wondering, "Wh-what's going on?" Hu Shee explains that he was shot and that invaders are chasing them. A graphic sense of action is communicated by the angle of vision. The characters are shown from above. The top of the car's front seat forms a strong diagonal line that cuts across the lower left of the panel. Both

figures are falling toward the bottom right, giving the impression that they have just hit a sharp curve. The next shot is a close-up of the car's right rear tire, slightly off the road, with another vehicle in hot pursuit. The third panel reverses the angle of the first. It shows the two characters from the front left. We see them through the car's front windshield. The car's black hood forms a triangle on the lower right, echoing the black triangle formed by the car seat in the first panel. We see the protagonists from the front because they are now being attacked from both sides. The final panel of the day's action is a long shot, revealing an "invader tank" heading toward them.

The next day's first panel repeats the same shot from the opposite point of view, with our heroes still sandwiched between the invader's car and tank. The second panel is a classic identifying shot, midrange, showing Terry and Hu from the side as she reveals her past experience as a stunt driver. That fortuitous revelation is spread out over the final three panels as she demonstrates her skill. The third panel narrows to indicate the rapidity of the unfolding action. The car and the tank are about to collide. The final panel shows the car swerving onto the bank of a

ravine and away from its first danger. The next day reminds us that the original car is still hot on their tail. The first panel repeats the third of two days before, with Terry looking anxiously behind his back at the encroaching invaders. The next shot again reverses the angle and shows the two from behind as the next cliffhanger unfolds. The third panel shows a river ahead, and the fourth, a drawbridge rising over it. This sequence contains a remarkable abstract design element that connects the bottom of all four panels. A white stripe begins in the lower left of the first frame and runs across to the second. The line continues toward the lower right of that panel and crosses onto a stream of water in a ditch, which runs under the artist's signature, and onto the road, the raising bridge, and the two cars streaming toward it.

The next day's strip begins with our first glimpse of the Asian invaders. The middle shot of the strip's

three panels shows Terry and Hu from behind, anxiously watching the rising drawbridge. The long final panel shows our heroes jumping across the open bridge in their car and to safety on the other side of the river. This is shown from a standard, middle-distance perspective that dramatically depicts the small car leaping toward us. Our eye is led into the scene by the strong black mass formed by the river and stopped by the arrangement of boat, bridge, and car in the middle of the picture. The resolution comes the next day, Saturday, in an unusual shot. The car is shown from a bird's-eye view as it lands safely on the road, separated from the invaders by the now completely open drawbridge. This panel is the only one in the entire sequence organized vertically rather than horizontally. The aerial perspective and change in the axis of composition indicates in a purely pictorial way that Terry and Hu are, for the moment, out of harm's way. In the final two panels Hu drags Terry from the car in search of a doctor, whom she finds in the next day's Sunday feature.

In addition to the suspenseful plot, artful juxtaposition of shots, and dynamic composition, this sequence is distinguished by another, less obvious characteristic. The entire sequence is held together obliquely by a thread that runs through it in the form of the serpentine line that passed through Caniff's signature in Thursday's strip. It first appears in the second frame of the first day's action, again in day three, and finally twice in the final strip of the sequence, vertically in the first panel and horizontally in the last. The abstract diagonals of car forms, roads, rivers, and streams give the strip a strong sense of design that created the suspenseful impact of the story.

Caniff's most famous sequence depicts the death of Raven Sherman from October 13 to 19, 1941. The two strips from October 16 and 17, without any text or dialogue, are among the most poignant in comics history. Raven's main squeeze, Dude, does a dance of death with his dying beloved in the first three panels. The perspective shifts around the couple in each successive frame, one of Caniff's favorite techniques, to suggest that they are real figures existing in three-dimensional space. The three panels decrease slightly in width as Raven expires. The final, wide-angle panel shows Terry's profile in close-up with Dude pulling a blanket over Raven in the middle ground. Behind them is a cluster of rocks that prefigure the dramatic single panoramic panel in the next day's conclusion (figs. 52, 53).

It shows a grief-stricken Dude and Terry to the left and right of a makeshift grave and tombstone—a pile of rocks, under which Raven lies.

These two sequences are among the best *Terry* had to offer, but Caniff maintained a remarkably high caliber of art throughout the strip's life. He reached an average of thirty million readers every day during World War II. Caniff left the feature at the end of 1946 to create *Steve Canyon*, whose copyright he controlled. But before he left, Caniff produced a tour-de-force final sequence of Sunday pages (fig. 55).

*Terry* brought together all the nascent elements of the adventure comics and gave them their classic form. Caniff's use of framing, blocking, and juxtaposed angles of vision to create montagelike effects was unmatched. He was the first comic artist to completely control his reader's point of view and did so to convey a sense of realism and urgency that was tremendously influential on artists in the comic book era.

In comparison to the early masters of visual composition such as McCay and Herriman, Caniff's work is more functional and less fantastic. His purpose was to enmesh readers in epic narratives over extended periods of time. The early cartoonists,

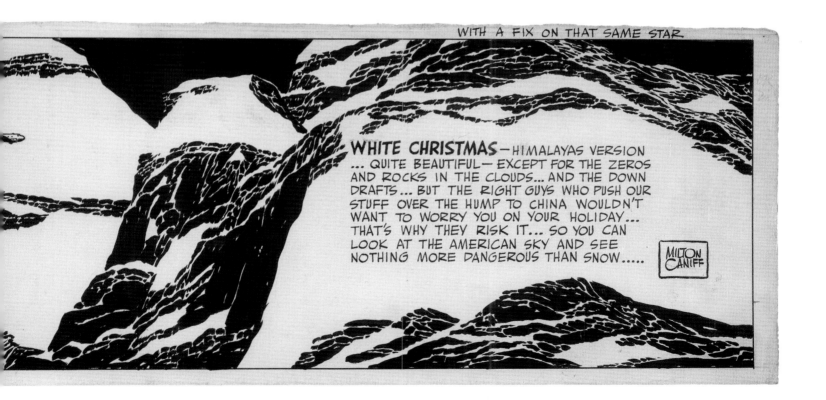

## MONDAY, NOVEMBER 25, 1940
### TERRY AND THE PIRATES—TAP THE SURPLUS

## TUESDAY, NOVEMBER 26, 1940
### TERRY AND THE PIRATES—YOU TAKE THE HIGH ROAD—AND ME TOO

## WEDNESDAY, NOVEMBER 27, 1940
### TERRY AND THE PIRATES—BANK BALANCE

## THURSDAY, NOVEMBER 28, 1940
### TERRY AND THE PIRATES—BRINK OF THE DRINK

## FRIDAY, NOVEMBER 29, 1940
### TERRY AND THE PIRATES—PLAYING BRIDGE FOR HIGH STAKES

## SATURDAY, NOVEMBER 30, 1940
### TERRY AND THE PIRATES—ROLL OUT THE BARROW

50  Milton Caniff
*Terry and the Pirates*
Proof sheet for weekly daily strips
(published November 25 to 30, 1940)
24 x 12 5/8 inches
Ohio State University Cartoon Research Library,
Milton Caniff Collection

51  Milton Caniff
*Terry and the Pirates*
Drawing for daily strip (detail)
(published November 27, 1940)
Pen and ink, 7 x 23 inches
Collection of Bob Murphy

# TERRY
## AND THE PIRATES
by MILTON CANIFF

TERRY, WOULD YOU MIND IF I... SORTA STAYED HERE ALONE WITH RAVEN FOR A LITTLE WHILE? I'LL CATCH UP...

SURE, GO AHEAD, DUDE! I'LL JUST MOVE ALONG DOWN THE ROAD!

....GUESS THE FOOTBALL SEASON'S GOING FULL SWING BACK HOME ABOUT NOW....

YEAH... GUESS SO!

...WON'T BE ABLE TO SEE THE HILL WHERE WE LEFT HER... AFTER WE ROUND THIS BEND...

...THAT'S RIGHT...

GETTING DARK... BETTER TRY TO SLEEP... PLENTY HOT WALK TOMORROW...

AND THE NEXT DAY ...AND THE NEXT...

FOR A LONG TIME TERRY LIES AWAKE... AND DUDE HENNICK STARES INTO THE NIGHT.... FINALLY, THEY SLEEP...

...THEN, THE NEXT MORNING...

10-19

84

*previous pages*

**52** *left:* Milton Caniff
*Terry and the Pirates*
Drawing for newspaper Sunday page
(published October 19, 1941)
Pen and ink, 28 3/8 x 21 13/16 inches
Ohio State University Cartoon Research Library,
Milton Caniff Collection

---

**53** *right:* Milton Caniff
*Terry and the Pirates*
Color proof for newspaper Sunday page
(published October 19, 1941)
14 1/16 x 10 3/4 inches
Ohio State University Cartoon Research Library,
Milton Caniff Collection

by nature, were less concerned with time and concentrated on spatial relations. Their work existed entirely within the frame created by a single newspaper page. Of course the panels were read sequentially, and there was novelty in the development of unfolding pictures within a prescribed story or theme. This lent itself to autonomous visual designs that built a continuing audience because of a satisfying sense of closure and repetition more than narrative.[57] Caniff's art, typical of the later period, was based on storytelling and hooked its audience through cliffhangers and suspense.

Joseph Patterson, Caniff's publisher, deserves much of the credit for this new trend. Patterson not only had a strong hand in the development of features, naming them and suggesting characters, but

he also inaugurated synchronized, seven-days-a-week continuity, beginning in the 1920s with *The Gumps*, *Little Orphan Annie*, and *Gasoline Alley*, and reaching its peak with *Dick Tracy* and *Terry and the Pirates* in the 1930s.[58]

Of all Patterson's features, *Terry* was the most visually complex and influential. It did not have the iconographic power of *Tracy* or *Annie*, or the low-key poetic charm of *Gasoline Alley*, but it completely changed the way adventure comics looked, and set the tone the comics, particularly comic books, followed after the mid-1940s. Unlike McCay and Herriman, who created idiosyncratic masterpieces that were the envy of all cartoonists but did not lend themselves to imitation, Caniff created a style both masterful and eminently imitable. Caniff, like filmmaker Alfred Hitchcock, took an already established medium and broadened its palette in

a manner that significantly changed the way subsequent artists have worked. They both introduced depth of field, atmospheric lighting, and novel perspectives or camera angles to suggest dramatic points of view. Another interesting parallel between Hitchcock and Caniff is the delayed impact their work had on "new wave" artists of the early 1960s. As Hitchcock became the darling of the *Cahiers du Cinema* group in Paris, Caniff inspired Harvey Kurtzman and Jack Kirby to create the comic books produced by EC and Marvel, which highlighted the next wave of comics art.

Another notable feature to appear in the mid-1930s was *Li'l Abner*, one of the last great features of the comics' golden years. If *Terry and the Pirates* represents the height of graphic suspense in the medium, *Abner* is the apex of satire and inspired fable.

Al Capp (1909–1979) began his career ghosting the popular feature *Joe Palooka*, signed by Ham Fisher. While working on *Palooka*, Capp introduced a number of humorous characters, notably the hillbilly Big Leviticus and his mammy and pappy. They became so popular that less than a year later, on August 13, 1934, Capp struck out on his own with *Li'l Abner*, focused entirely on the strange goings-on in Dogpatch, U.S.A.

Capp was a Jewish boy from New Haven, Connecticut, whose knowledge of the American South was based on fantasy and a brief trip to the South when he was a teenager. These hillbilly stereotypes seemed to literally come to life in the mid-1950s when Elvis Presley burst on the scene looking and acting suspiciously like Li'l Abner. Elvis made the connection himself: "When I was a boy I was the hero in comic books and movies. I grew up believing in a dream. Now I've lived it out. That's all a man can ask for."[59]

*Li'l Abner* was one of the wittiest and most visually inventive features of its time. It was also a corrosive property that ate away at the illusions depended on by features, like *Dick Tracy* and *Annie*. Capp seemed on a mission to educate comic strip readers into not accepting their simplistic entertainment and soporific suspension of disbelief at face value, much as Harvey Kurtzman did in *MAD* during the mid-1950s. Though neither man tried to destroy the simpleminded comics (which would have been impossible), each made his pretensions so obvious that they eventually destroyed themselves simply by never violating their own ludicrous conventions.

**54** Milton Caniff
*Terry and the Pirates*
Newspaper Sunday page
(published July 7, 1946)
11 x 15 inches
Private Collection

**55** Milton Caniff
*Terry and the Pirates*
Color proof for newspaper Sunday page
(published December 29, 1946)
7 3/4 x 10 11/16 inches
Ohio State University Cartoon Research Library,
Milton Caniff Collection

# 4
## Comics Go Small and *Peanuts* Takes Over

Newspaper comics reached their maturity in the 1930s and 1940s and in many respects the work in that era defined the shape of the comics from that time to the present. Although there are contemporary cartoonists such as Patrick McDonnell who equal the early masters, few combined the artistry and mass appeal that peaked from Herriman and Segar through Caniff and Gould. The law of diminishing returns in comic strip history is not solely the result of lesser talent or shifting demographics, but a function of changes in the form itself.

By the late 1940s the size and printing quality of newspaper comics diminished dramatically. It was no longer possible for the comics to experiment boldly with form or use dramatic visual effects like Alex Raymond's feathering in *Flash Gordon* or Caniff's stark chiaroscuro. The editors and publishers closed the book on visual complexity and encouraged the growth of simpler features whose minimal graphics lent themselves to the compressed space resulting from the introduction of advertising in the Sunday papers in the 1930s. The size of the comics was further reduced to save paper during World War II.[60]

At the same time, the comic strip faced stiff competition from two other media whose growth stole most of its audience. The comic book, under the aegis of *Superman*, took most of the juvenile market and many of the young, up-and-coming artists as a result. This assault did more harm than Mickey Mouse and the rise of animated cartoons a decade earlier. And, unlike film, which on the whole had a complementary rather than competitive relationship with comics, commercial television dramatically appropriated most of the comics' themes and delivered them "free" into an increasing number of homes.[61]

In spite of these constraints, some great cartoonists, notably Chester Gould, adapted to the new format and created work in each successive era that became increasingly bizarre, well designed, and artistic. In the 1950s, when other comics were waning and Al Capp was lampooning his stiff style, Gould produced some of his best work. He began to simplify his pictures to adapt to the cheap printing processes that became standard after World War II. This made *Dick Tracy* appear more dramatic and iconic. In some ways the repetition of his image and story line made it more compelling.

In this era Gould also continued to create great villains and impossible situations for his hero to get in and out of. One great sequence from 1956 shows Tracy being shot in the forehead in the final scene of the first Sunday page (fig. 42). The panel looks great in the color newspaper page. It looks even better in the black-and-white original where the stark color contrast suits the violent action of a bullet suspended in midair inches away from Tracy's skull. The next Sunday page shows, to no surprise, that the bullet only grazed his skin (fig. 44). Dick lies unconscious, while a mysterious woman tends to him and the evil forces that attacked him continue their nefarious schemes. The page shows Gould's ability to resolve and renew suspense as well as the hidden artistry of his sense of design. The flat black areas of the original form a subtle pattern independent of the story that gives it emotional depth

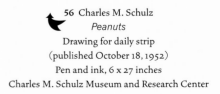
**56** Charles M. Schulz
*Peanuts*
Drawing for daily strip
(published October 18, 1952)
Pen and ink, 6 x 27 inches
Charles M. Schulz Museum and Research Center

**57** Alex Raymond
*Flash Gordon*
Newspaper Sunday page (detail)
(published August 25, 1940)
21½ x 15 9/16 inches
Private Collection

**58** Charles M. Schulz
*Peanuts*
Drawing for newspaper Sunday page
(published October 26, 1952)
Pen and ink, 15 x 23 inches
Charles M. Schulz Museum and Research Center

and weight. More than just a well-plotted violent story, Gould's art also displays a mastery of graphic design obscured for many years by the popularity of his stories. In case anyone missed Gould's artistic subtext, Tracy moved into a Frank Lloyd Wright house after he married Tess Trueheart and settled down.

As Gould's work progressed from the 1950s until 1977, when he stopped drawing the strip, he started to take more liberties with his work. His plots became even more bizarre and the repetitive, flat black patterns in his work became pronounced almost to the point of abstraction. In a daily strip from March 7, 1962, Gould reduces one of his villains, called The Brush, to a face with ink scribbles covering it (fig. 46). The proceeding panel showed him and his sidekick standing over a man who "for all practical purposes...is dead" while an atomic bomb explodes in the background.

Gould also started to parody his own medium by drawing strips within the strip supposedly created by fictional idiots whose lack of talent or ideas is celebrated by the public, who continued to read the comics in the 1960s and 1970s. A daily from July 18, 1964, shows a pair of hands holding a comic strip drawing in the first panel. Called *Sawdust*, it consists of four panels of a pile of sawdust talking. The next panel shows Tracy holding the drawing while the man facing him explains, "I always wanted to be a cartoonist—but I couldn't draw." The next image shows an old-style house sitting alone in a field of tree stumps with big-city skyscrapers in the background. Gould signed this panel and the picture shows off his ability to use blocks of black to create a believable world that is the exact opposite of the minimalist cartoons he is making fun of. In the last panel the man continues to explain, "I assembled...the finest group of artists in the world." The image shows four idiots humming to themselves as they ink the nondescript dots that make up the sawdust in the strip.

Gould was still at it nine years later. A daily from June 9, 1973, shows an aspiring cartoonist (working as a janitor) asking Tracy if he could join the force. To display his talent the boy shows Dick his artwork. It's a comic strip called *Buggs and Worms*. The boy's signature is a "pea" and a "nut" combined with the word "butter." Gould was clearly not a fan of popular mimimalist comics such as *Peanuts*.

In spite of Gould's withering perspective on comics where less is supposedly more, contemporary comics have forged their own identity, and in some respects raised their inherent limitations to unexpected heights. From the start, Charles Schulz's (1922–2000) drawings were pure and simple, and his gags psychologically complex. The combination clicked and the interrelation of Charlie Brown, Lucy, Schroeder, Pigpen, Peppermint Patty, Woodstock, and Snoopy took its place in American culture.

By drastically reducing the comic palette, Schulz was able to do several remarkable things. First, he controlled all aspects of the strip, including lettering, without hiring ghosts or assistants. This gave his work a unified psychological tone and a consistent visual style. Second, his visual minimalism was perfectly in keeping with the style of its times—shoebox skyscrapers, color-field painting, black-and-white TV, early rock'n'roll, and frozen dinners. The minimalism that defines *Peanuts* forces its readers to focus on subtle nuances rather than broad actions or sharp transitions. Everything is kept in the same minor key so that the simplest turn of a line can transform a character's expression or indicate the entire background in which the action is taking place. Often Schulz left out the backgrounds altogether to center the strip on the world of little kids he created. When he used backdrops or props, like the pathetic, scrawny Christmas tree Charlie Brown adopts, they are fraught with meaning because of their isolation.

A daily strip that was published three days after Christmas 1958 shows Charlie Brown throwing a snowball to Snoopy in the first panel. In the second, Snoopy chases after the snowball, which has landed on the side of a hill. Schulz is able to give a sense of what is happening through a bare minimum of lines—the puppy running, the snowball falling, and a tiny plant sticking out of the snow in the foreground. In the third panel, the snowball begins to roll back down the hill at Snoopy, who responds with a big "?" in a word balloon. In the final panel the snowball has become larger than the dog and chases him down the hill. Forty years earlier, Herriman drew a Sunday page based on a ball growing larger as it rolls down a hill. But he did so with a complicated shift of the page layout to skewed lines in place of the expected grid of panels with a masterful drawing of the rock blasting through a house. Schulz's genius is that he worked within his contemporary constraints by inventing a new style to create a similar effect.

By 1960, Schulz went even further by routinely drawing strips that repeated the same image in every panel, with subtle variations. A famous example from August 14, 1960, shows Charlie Brown lying on a hill with Lucy and Linus staring up at the clouds (fig. 59). The title panel shows the three kids on the hill from the side with an ordinary formation of clouds to their right. Lucy exclaims: "Aren't the clouds beautiful? They look like big balls of cotton..." In the first of six panels below, she continues "I could just lie here all day, and watch them drift by..." In the next three panels, Linus finds three esoteric images in the same group of clouds. He sees a map of the Caribbean, the profile of Thomas Eakins, and an image from the New Testament. When he finishes Lucy asks Charlie Brown what he sees. In the final panel Charlie replies, "Well, I was going to say I saw a ducky and a horsie, but I changed my mind!" By maintaining the image from frame to frame, Schulz shifts our focus from action to the subtle inner psychology of his characters.

At the same time, Schulz helped to shift the overall focus of comics from heroes to underdogs. He titled the strip *Li'l Folks*; his publisher replaced it with *Peanuts*. As an artist, Schulz was interested in atypical comic characters as well as most of art, literature, and popular culture. In that sense, the formal limitations of comics after World War II became part of the intrinsic character of *Peanuts*. It was all about coping with a world of limits, accepting who you are, and making the best of it, rather than taking us to another world like adventure or fantasy comics.

59 Charles M. Schulz
*Peanuts*
Color proof for newspaper Sunday page
(published August 14, 1960)
11 x 15 inches
Private Collection

In a sequence of daily strips from one week in 1958, Schulz grounds the life of his kid characters in the classic American game of baseball (figs. 60–63). Over the years, Charlie Brown's lack of athletic prowess and the slights and humiliation he suffers as a result were among the strip's constant settings. The first strip shows Charlie pitching for the championship. His friends create anxiety by letting him know how important the moment is for all of them. In the final panel, Lucy gives her version of encouragement by her familiar taunt: "You blockhead!" He pitches and in the second and third daily sequence the ball flies into the air and Charlie Brown's task is to catch it before it falls. He ruminates that if he catches it, he will be the hero and if he drops it, he will be the goat. In the final panel he thinks to himself, "Good grief! How did I ever get into this?" Of course, he drops the ball in the next daily strip in the sequence. His team wails, "Now we're nothing!" Charlie Brown looks to "camera" in the final panel with his mouth turned down and his baseball cap looking two sizes too big. The ball sits on the ground beside his feet, the only prop needed to complete the sad tale.

*Peanuts* was one of the first strips to acknowledge the power and autonomy that suburban children have in our society, and all their attendant problems. From the adventures of Tom Sawyer and Huck Finn to those of the Katzenjammer Kids and the Yellow Kid, children have been a staple of comic representation. Until *Peanuts* most characteriza-

tions of kids have been realistic, at least in terms of their physical context. Schulz's little folks, however, don't wreak havoc on authority figures; they can't because there aren't any in their world. Instead, the *Peanuts* characters wreak havoc on each other emotionally. *Peanuts*'s realism is an abstract, psychosocial one rather than a depiction of a physically violent world of action.

Charlie Brown's unflappable optimism makes him the perfect fall guy for Lucy van Pelt's cynicism. The other side of their complex triangle is Charlie's perennial puppy, Snoopy, perhaps the greatest comic creation this side of *Krazy Kat*, a comic strip that influenced Schulz more than most people realize. Part of that legacy is how Schulz is able to evoke the complex interaction of his cast of characters with a few simple lines.

Another early strip to concentrate on children in a simple, direct fashion was Ernie Bushmiller's *Nancy*. Bushmiller was a pioneer of the "gag" format and a master minimalist though he was looked down on for a long time. Art Spiegelman notes that "cartoonist Wally Wood once said that it takes more effort to not read *Nancy* than it does to read it. Now that's instant communication."[62]

Nancy began as a sidekick to the title character in another strip, *Fritzi Ritzi*, which was created by Larry Whittington in 1922 and taken over by Bushmiller in 1925. Nancy's popularity grew, and by 1938 she got a feature all her own. *Nancy* was *so* bad that it became good, so much so that the banal adventures of this young girl and her sidekick, Sluggo, became the unofficial mascot of many young artists in the 1960s and 1970s.[63] In

fact, Bushmiller seemed quite aware of what he was doing and drew as many strips about art and the nature of representation as any other newspaper cartoonist.

Aside from *Peanuts*, the other great comic strip that emerged in the 1950s was Walt Kelly's (1913–1973) *Pogo*. Over several decades, it grew from a funny animal kid's comic to a complex and often politically potent adult feature. *Pogo* began as a comic book around 1942 after Kelly stopped working as an animator at the Walt Disney studios. It moved into the newspapers in 1948, full-born, with a memorable sequence—Pogo and Albert's search for the Fountain of Youth.[64]

With *Pogo* and *Peanuts* the comics both reached the end of its greatest period and set the groundwork for its continued commercial survival through less fertile times. In the second half of the twentieth century, Schulz, Kelly, and Mort Walker dominated the comics and provided the best jolts of wit, humor, and visual spunk. The most significant newcomer to challenge their hegemony and inject a sense of post-1960s reality has been Garry Trudeau, whose *Doonesbury* left the *Yale Daily News* for national syndication in 1970 and brought Kelly's political wit out of allegory and into direct engagement.

In the decades after *Peanuts* several cartoons have continued the artistic tradition in the pages of American newspapers. Among the most interesting is Patrick McDonnell's *Mutts*, a seemingly simple strip about a dog and a cat. McDonnell is

60–63 Charles M. Schulz
*Peanuts*
Four drawings for daily strips
(published June 9, 10, 12, and 15, 1958)
Pen and ink, each 6 x 27 inches
Collection of Craig Englund

64 Patrick McDonnell
*Mutts* Sunday page,
after Lyonel Feininger's *Kin-der-Kids* comic strip
Newspaper Sunday page (detail)
(published April 1, 2001)
4 x 11 ½ inches
Collection of Patrick McDonnell

65  *top:* Charles M. Schulz
*Peanuts*
Drawing for daily strip
(published July 24, 1969)
Pen and ink, 6 x 27 inches
Collection of Craig Englund

66  *bottom:* Charles M. Schulz
*Peanuts*
Drawing for newspaper Sunday page
(published October 13, 1974)
Pen and ink, 15 x 23 inches
Charles M. Schulz Museum and Research Center

**67** *top*: Charles M. Schulz
*Peanuts*
Drawing for daily strip
(published March 11, 1980)
Pen and ink, 6 x 27 inches
Charles M. Schulz Museum and Research Center

**68** *bottom*: Charles M. Schulz
*Peanuts*
Drawing for newspaper Sunday page
(published September 14, 1986)
Pen and ink, 15 x 23 inches
Charles M. Schulz Museum and Research Center

also one of the authors of the definitive book about *Krazy Kat*. On April 1, 2001, McDonnell published a loving tribute to Lyonel Feininger in a *Mutts* Sunday page (fig. 64). The title panel appropriates the first printed page of *The Kin-der-Kids*, with McDonnell in place of "Uncle Feininger." In both versions the artist depicts himself as a disheveled puppeteer with his principal characters dangling from his fingers. The main body of the *Mutts* strip borrows from Wee Willie's remarkable use of modernistic design to show the relation of nature to the imagination. The first panel shows Mooch and Earl sitting under a tree watching a cloud roll in. Earl exclaims "April!" Four circular shapes in the foreground indicate crocuses, the first flowers of spring. In panel two Mooch worries that the growing clouds will bring showers. In panel three the showers arrive. The transformation of the cloud over the first three panels is another homage to Feininger, who created this sort of time-lapse effect years before it became a standard way of showing the passage of time in film. In the final panel, the showers have passed, and the squirrel peeps out of the hollow in the tree, looks down at the dripping-wet duo, and declares them "Fools."

But on closer inspection, the squirrel is not looking at Mooch and Earl, but at us. The whole strip is an April fool's joke with the spirit of Feininger taking the place of his young disciple, McDonnell. In between the four panels is a series of abstract natural forms typical of early modernism in general and Feininger's work in particular. The tree branches become Art Nouveau lines and the flowers become abstract organic patterns. In the center a fool's head beams out, reassuring us that all is well.

The limited space and mediocre printing of contemporary comics typically precludes the type of experimental and expressive qualities that made the comics so entertaining and artful in the first half of the century. Newspaper comics are no longer the primary source of popular culture, even though many features remain extremely popular. By the end of the twentieth century, the best graphic work was being distributed outside newspapers in comic books and anthologies such as *Zap* and *RAW*. In many respects, comics are flourishing outside of the mass distribution, and work of the highest artistic quality, perceptively reflecting contemporary social values, is stronger than ever.

# COMIC BOOKS

## 1
## America at Midcentury

In 1900, when American comics began to be distributed on a mass scale, Europe was still the center of international commerce and culture. After World War II, however, American media and mass production took on an omnipresent role in modern life. Some of this had a positive effect in terms of technological advances and social equality. But it also led to a general sense of anxiety about the potential threat of nuclear war and a disparity between what people saw represented in the media and what they felt in their everyday lives.

The painter Jackson Pollock said in 1950 that the "modern painter cannot express his age, the airplane, the atom bomb, the radio in the old forms of the Renaissance.... The modern artist is living in a mechanical age...working and expressing an inner world—in other words—expressing the energy, the motion, and other inner forces."[65] At the same time, writers such as Jack Kerouac, Allen Ginsberg, and William Burroughs helped make the counterculture part of American life. They were inspired, in turn, by bebop musicians such as Charlie Parker, whose balance of wild improvisation with sophisticated harmonic and melodic structure changed the nature of personal expression in American culture.

Newspaper comics could not keep up with these changes, even in sophisticated features like *Peanuts*. Television became the main source of information, which helped inaugurate a more overtly visual culture, one anticipated in comics, but one that text-heavy newspapers could not capitalize upon. Thus some of the most influential and innovative creative work found its way into comic books rather than newspaper comic strips. These ranged from massively popular mainstream titles such as *Superman*, *MAD*, *Spider-Man*, and *Fantastic Four* to idiosyncratic independent work such as R. Crumb's *Zap* and Art Spiegelman's *RAW*.

## 2
## The Spirit of the Comic Book

Will Eisner's (1917–2005) *The Spirit* was the most important bridge between newspaper comics and comic books. Eisner ran a studio with Jerry Iger in the 1930s that produced material for some of the earliest comic books, which were largely for kids and either reprinted or copied popular newspaper features.[66] By 1940, Eisner had terminated his partnership with Iger and began producing an adult newspaper feature called *The Spirit*, which was printed in comic book form, inserted into newspapers, and distributed free with the comics section on Sundays.[67]

Eisner used newspaper distribution to create comics for "an audience dominated by adults, rather than children." He explained that he "suddenly found an opportunity to do what I had really always wanted to do, which was to write 'seriously' or write good material, and at the same time stay within the medium I knew and had developed skills for."[68] Eisner took full advantage of the multipage format of comic books to tell complicated stories that balanced suspense, humor, and violence in a way that represented the 1940s as much as Segar's *Thimble Theatre* represented the 1930s.

Eisner used atmospheric backgrounds to reflect the complex psychological state of his characters. His hero was clearly grown-up in a way that few comic characters had been up to that time. Eisner also used extremely complicated panel layouts and visual cues. And he did so deliberately to convey mood and content through the form of his work and not just the stories or situations themselves.

In doing so, Eisner developed the language of comic books in much the same way that McCay perfected the formal language of comic strips almost a half century earlier. Whereas McCay established a visual vocabulary based on the integration of a single page, Eisner showed how telling stories over successive pages could be equally creative. In place of McCay's formal design of graphic elements, Eisner created a "harmony" of visual elements over seven-page stories to convey suspense and mood in ways not possible within the limits of newspaper comics. Eisner also created an inventive and

69  Will Eisner
*The Spirit* ("Croaky Andrews' Perfect Crime")
Newspaper splash page
(published April 13, 1941)
11 x 9 inches
Collection of Denis Kitchen

COMIC BOOK SECTION

RECORD
PHILADELPHIA

ACTION
Mystery
ADVENTURE

Copyright, 1941, by Everett M. Arnold

SUNDAY, APRIL 13, 1941

The SPIRIT BY Will Eisner

dynamic sense of what a comic book cover or lead page could be. Each *Spirit* comic book began with new cover art, typography, and exciting imagery that advertised the story inside with playful parodies of graphic forms including other comics, eye charts, wanted posters, and IRS forms.

But Eisner's innovations would not have been so influential without the breakthrough popular success of another comic book creation—Jerry Siegel (1914–1996) and Joe Shuster's (1914–1992) *Superman*. Siegel and Shuster created the feature around 1933 when both were nineteen. They submitted the idea of a superhuman character who comes to Earth to every major newspaper syndicate and studio (including Eisner's) without luck for five years until an influential comic book editor, M. C. Gaines, suggested that his publisher, Harry Donnenfield, give it a try. Superman first appeared in *Action Comics* #1 in June 1938. By the next year it was an unqualified smash, with its own quarterly book and, soon after, serial films, animated cartoons, radio and TV programs, and a newspaper strip.[69]

When Eisner returned from World War II, he was only twenty-eight years old and ready to reinvent himself and his most famous creation. At that point, the Spirit character appeared less and less frequently and the feature developed an anthology format that gave free rein to Eisner's creativity. The new spirit of *The Spirit* was in keeping with that of the film noir being produced in Hollywood at the same time, which reflected darker and more morally ambiguous themes.

A good example of Eisner's new direction is the story of Gerhard Shnobble (figs. 71–77). First published in 1948, it begins with an introduction from the author explaining, "This is not a funny story!!" Underneath the text is a cartoon of a silly-looking man in a bowler hat and yellow tie floating in the air. Underneath the image is another line of text asking, "Please....no laughter...." The next page shows a cartoon panel floating on a grainy photo of New York City skyscrapers in the top panel and then a younger image of the main character flying above the cityscape in the same pose as on the title page. The juxtaposition of the two images sets up the story about a man who learned he could fly as a young boy, but whose talent is suppressed by his parents and the society in which he lives.

The relation of these two images also shows how Eisner used formal relationships to tell more complicated stories in terms of plot and theme than one could in newspaper comics. The next two pages show Gerhard's sad life as an adult. On page four, he crosses paths with the Spirit, who is in the middle of a manhunt for a group of bank robbers. Eisner crosscuts between the Spirit's crime fighting and Gerhard's inner thoughts about being a nobody and how he could change all that if he showed the world that he could fly. He ends up in an elevator with the Spirit going to the roof.

The next two pages present one of the most dynamic layouts in the early history of comic books. Eisner divides page five into five panels. Unlike most comics, Eisner's arrangement conveys the sense of drama and movement on the rooftop the same way editing would in a well-crafted film. The cluster of four panels on the top of the page sets up the psychological feeling of the final horizontal panel, which shows Gerhard falling in free space among the rectangular forms of the city skyscrapers that surround him. He is no longer seen floating from the side as he was in the first two pages, but from above, as if we were on the roof watching him fall.

The sixth and seventh pages show Gerhard from various angles falling through space while behind him the Spirit battles bad guys. The first panel of the final page shows one of the bad guys shooting and killing Gerhard as he flies by, then the Spirit capturing the criminal without seeing what had happened to the "hero" of this story. The large final panel returns to the graphic treatment of the first splash page. But now Gerhard is floating in space, deceased, with a halo above his head. The author implores us not to "weep" for Shnobble as he told us not to "laugh" six pages earlier. In both instances, dramatically linked and separated by the span of the main character's life, the author twists a story in front of us and dangles it like an object floating in space.

Like Shnobble's flight, Eisner's innovations remained largely unheralded during his lifetime. But years later, most comic book artists, if not their audiences, realized that Will Eisner had created a new and complex comic language.[70]

**70** Will Eisner
*The Spirit* ("Fox at Bay")
Drawing for newspaper splash page
(published October 23, 1949)
Pen and ink, 20 x 14 inches
Collection of the Will Eisner Estate

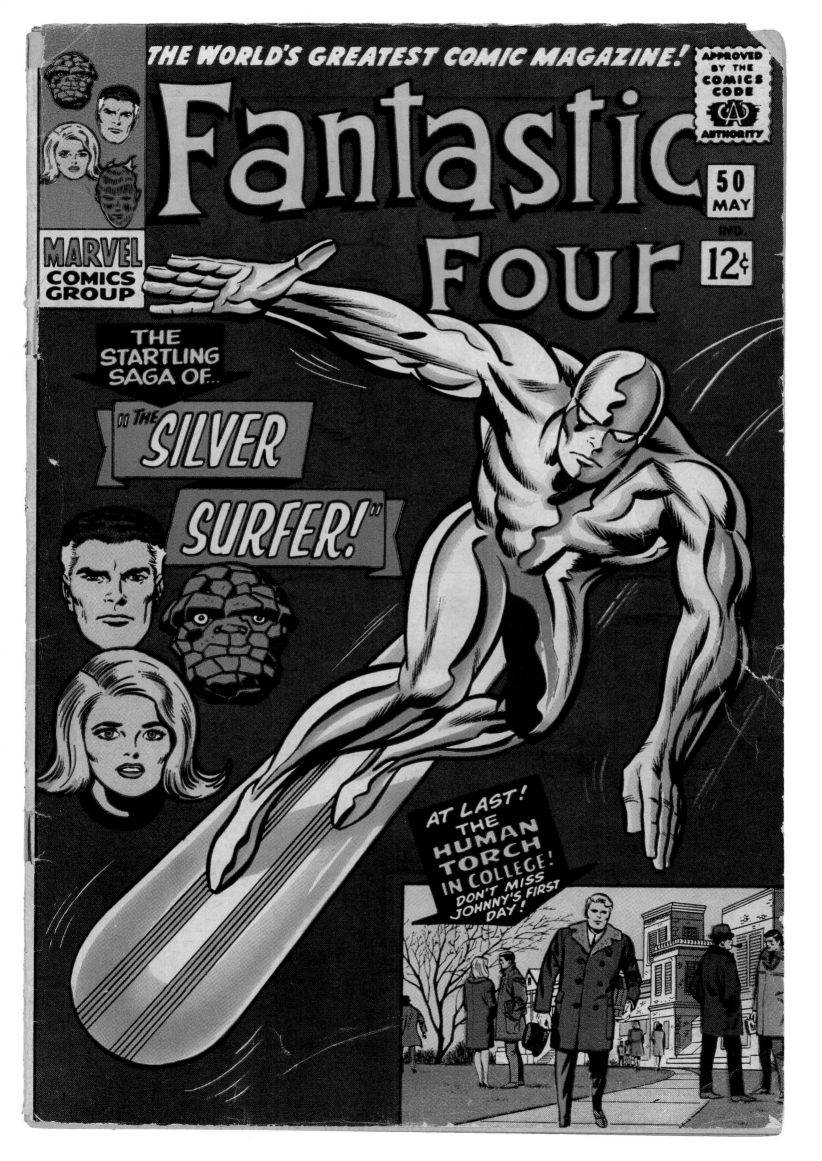

### 3
### Jack Kirby—Superhero of Style

Around the time of Gerhard Shnobble's boyhood flight through the canyons of Manhattan, Jack Kirby (1917–1994) began his career in a midtown office building where the Fleischer brothers produced madcap cartoon versions of Popeye, Betty Boop, and Koko the Clown. Kirby moved on to comic book factories and worked briefly for Eisner and Iger. He rose quickly in the competitive world of New York cartoonists, creating heroes and myths that were the cornerstone of American pop culture from the 1940s through the 1970s.

By 1940, Superman and Batman had torn the roof off pop culture. They made kids feel free to fantasize about power and glory at the same time as youth culture began to dominate American society. Kirby was the perfect cartoonist for the early rock'n'roll era, much as Herriman was for the Jazz Age.[71] Where Herriman was stylish and sophisticated, Kirby was deliberately primitive and bombastic, but in a way that perfectly embodied the fantasy life of young American boys in the middle of the twentieth century.

Kirby's first success was *Captain America*, which he created with his first partner, Joe Simon, in 1941 to take advantage of the superhero boom and tie it into the war that was looming. The cover of the first issue shows the Captain hitting Hitler in the jaw in a room where the Nazis are planning to sabotage U.S. war efforts (fig. 79). The first two pages of the story illustrate Kirby's innovative style in expressing violence and fantasy in comic books, and in particular his ability to link individual panels into a unified effect, unfolding like an action sequence in a well-made movie. For instance, the large top panel on page two displays Kirby's raw talent for indicating realistic violence without copying earlier cartoon conventions. To the left a Nazi spy pushes a plunger to trigger the explosion shown on the right. The Nazi's hand is shown from two angles simultaneously while a U.S. munitions factory is being blasted to bits. The sense of mass destruction is conveyed graphically through the unusual form and impact of the drawing style as much as through what it depicts.[72]

On the same page, the lower panels reveal a secret plan to transform an ordinary American into a superhero to fight the Nazi menace. A doctor injects a "strange seething liquid" into the ordinary man's arm and his muscles grow gigantic. But just as the experiment is about to finish, another Nazi spy enters. The newly muscled man defeats him in a dramatic four-panel sequence at the bottom of page six that illustrates the integrated action sequences that became the hallmark of Kirby's style. After that, the Captain puts on his trademark red, white, and blue costume and leaps into action.[73]

Kirby and Simon left *Captain America* after thirty-five issues and moved to National (later DC), where they created *Sandman, Newsboy Legion, Manhunter, Boy Commandos,* and *Challengers of the Unknown.* They also created *Boy's Ranch* and *Boy Explorers* for Harvey Comics and helped invent the romance genre with

*My Date.* Kirby and Simon drew stories in every conceivable genre during the late forties and fifties: war, western, romance, superhero, monster, mystery, and crime.

Yet Kirby's period of greatest fame and artistic accomplishment came in the early sixties when he joined forces with Stan Lee (b. 1922) to create many of the most famous Marvel features such as *The Incredible Hulk, The Avengers, The X-Men, Fantastic*

**79** Jack Kirby and Joe Simon
Reproduction of cover of *Captain America* #1
(published March 1941)

*Four, Silver Surfer, Thor,* and *Sgt. Fury.* Stan Lee wrote the story outlines and some of the dialogue, but Kirby created the casts and the conceptual layout

**78** Jack Kirby and Joe Sinnott
Cover of *Fantastic Four* #50
(published May 1966)
10 ¼ x 6 ⅞ inches
Michigan State University Libraries,
Comic Art Collection

for each title. In Lee's autobiography he explained that Kirby

> was not only a great artist, he was also a great visual storyteller. I only had to say, "Look, Jack, here's the story I want to tell," and he'd bring back the concept I had given him, but with the addition of countless imaginative elements of his own.... He knew just when to present a long shot or a close-up. He never drew a character that didn't look interesting or pose that wasn't dramatic. In virtually every one of his panels there was something to marvel at. There have always been artists who concentrate more on producing impressive illustrations than on visually telling a story in a clear, compelling way. Jack wasn't one of them. As amazing as his artwork was, he also depicted a story that you could almost follow without reading the words.[74]

Kirby and Lee's work peaked in 1966 with the Galactus Trilogy featuring the Fantastic Four.[75] The story revolved around the Silver Surfer turning from Galactus's servant to his adversary. The Surfer, one of the great iconic figures of the mid-1960s, succumbs to the pull of humanity and turns against his evil master, who was the Fantastic Four's greatest adversary. Together with Mr. Fantastic, the Invisible Girl, the Human Torch, and the Thing,[76] the Silver Surfer defeats Galactus and saves Earth from "total destruction!"

Kirby and Lee raised this simple story into a great contemporary myth by doing two things that greatly influenced later comic book adventures. First, they grounded their characters in a world that was tangibly real and morally complex. Second, they experimented with a number of new visual devices, including a higher degree of intentional patterning elements than previously found in comic books. These elements built upon the overall page designs pioneered by McCay in newspaper comics and added the use of layout to convey pacing and psychology over successive pages as in Eisner's work.

A sequence from Part II of the Galactus Trilogy in which the Human Torch travels by "time space distortion" to retrieve a machine that will neutralize Galactus's power is a good example of how Kirby used graphic design to make the reader feel the story he was telling (figs. 89–91). It begins by exploding the Torch into space. This is shown in a highly abstract and decorative manner, including the radiating effect of feathered lines and brilliant colors that was one of the hallmarks of Kirby's style. The Torch's passage takes him through a series of space forms, which take on a decorative character that resembles the amoebic forms favored by psychedelic artists a few years later. Finally, in the large splashy panel that concludes the sequence, the Torch reaches his destination—a huge space station whose shape and composition are the most unusual and interesting aspect of Kirby's style. This twisting mechanical form takes on a purely abstract character with a blend of nonfigurative surface pat-

80–85 Jack Kirby and Joe Sinnott
Six pages from *Fantastic Four* #50
(published May 1966)
Each 10 ¼ x 6 ⅞ inches
Michigan State University Libraries,
Comic Art Collection

CONTINUED AFTER NEXT PAGE

terns and recognizable objects. The combination of Lee's metaphysical plotting, Kirby's forceful stylization and their combined love of unlikely heroes made their work the best the medium had to offer. It influenced not only other comic book artists but sixties culture as a whole.

Kirby left Marvel in the late 1960s and rejoined National, where he produced what many considered another masterpiece, *New Gods*. Here, Kirby's obsession with abstract mechanistic forms and hyperbolic anatomy was given free rein to develop into a distinct personal style. The *New Gods* plot also had a tangible effect on contemporary speculative fiction and fantasy art, notably George Lucas's *Star Wars* series, which combined Kirby's cosmic space opera with complex westerns, notably John Ford's *The Searchers*.

Although Kirby invented Marvel's overall look and feel in the 1960s, he did not create its most famous and lucrative property. That honor goes to

**86–88** Jack Kirby and Joe Sinnott
Page and details from *Fantastic Four #48*
(published March 1966)
10 1/4 x 6 7/8 inches
Michigan State University Libraries,
Comic Art Collection

Steve Ditko (b. 1927), who created *Spider-Man* with Stan Lee in 1962 (fig. 94). Spider-Man became the archetypal Marvel hero. He had superpowers, but was compromised by personal problems and adolescent anxieties. Spider-Man perfectly captured the climate of the sixties as Superman did the forties, and remains one of the most commercially successful comic book characters.

Ditko went on to create *Doctor Strange*, one of Marvel's most bizarre and visually exciting features. *Doctor Strange* was a particular favorite of hippies before underground comix became available. It dealt directly with drugs, and some people recognized that Ditko took the baroque elements of Spider-Man's distinctive red-and-blue costume and webbing and developed them into free-floating, psychedelic designs.[77]

Though commercial comic books remained a force in American pop culture through successful movie versions of Superman, Batman, Spider-Man, the X-Men, and various other characters, much of the pulp, pop, and artistry of mainstream comics evolved into filmmaking and video games. At the same time, some of the most innovative aspects of comics were being developed in the work of Harvey Kurtzman (1924–1993).

89–91 Jack Kirby and Joe Sinnott
Two pages and detail from *Fantastic Four #49*
(published April 1966)
Each 10 1/4 x 6 7/8 inches
Michigan State University Libraries,
Comic Art Collection

92 *left:* Jack Kirby and Joe Sinnott
Drawing for *Silver Surfer*
1978
Pen and ink with graphite
16 x 10 inches
Collection of Tod Seisser

**93** Jack Kirby and Joe Sinnott
Page from *Fantastic Four* #51 (detail)
(published June 1966)
10 ¼ x 6 ⅞ inches
Michigan State University Libraries,
Comic Art Collection

**94** Steve Ditko
Cover of *Spider-Man* #33
(published February 1966)
10 ¾ x 6 ⅞ inches
Private Collection

## 4
## Kurtzman Goes *MAD*

During the 1950s the American comic book lost any serious claim to art, high or low. The medium's initial, crude energy had given way to a range of genre comics and funny animal cartoons for kids that lacked much innovation or skill. There were individual exceptions such as Carl Barks's Uncle Scrooge, but it took EC to create an entire trend of significant comic book art.[78]

The force behind EC was William Gaines, the son of M. C. Gaines, who had played a pivotal role in the early development of the comic books' Golden Era. The elder Gaines sold his interest in National Comics in the early forties and began publishing a series of Educational Comics notably illustrating stories from the Bible. When William Gaines inherited the company in 1947, its fortunes and that of the industry as a whole were at an all-time low. He tried his hand at most of the marginal comic book genres—romance, western, and funny animal books—with little or no success. In the early 1950s, along with editor Al Feldstein, Gaines launched EC's so-called New Trend comics. They included science fiction, war, crime, and horror features and revived the comics' commercial and creative potential.

Gaines's company became one of the most fertile and unexpected vehicles for comic book art once writer/artist/editor Harvey Kurtzman came aboard. At that point, many of the finest comic book artists began working at EC, including Will Elder, Jack Davis, Graham Ingels, Bernie Krigstein, John Severin, Al Williamson, Basil Wolverton, and Wally Wood. By 1952 Gaines was publishing eleven very successful titles: *Haunt of Fear*, *Crypt of Terror*, *Vault of Horror*, *Crime SuspenStories*, *Shock SuspenStories*, *Weird Science*, *Weird Fantasy*, *Two-Fisted Tales*, *Frontline Combat*, *MAD*, and *Panic*.

Although the artistry of these early EC titles is now commonly acknowledged, at the time they were considered deplorable and took the rap for the moral degradation of American youth, most spectacularly in Frederic Wertham's 1953 *Seduction of the Innocent*. Wertham was one of the first to advocate that excessive crime in modern America was stimulated by violence in popular media. The attacks hurt Gaines deeply and forced him to cut back his crime and horror features at the peak of their popularity

and to concentrate his energies on *MAD*. It made him a fortune and remains a cultural icon, even if it lost its cutting edge forty years ago.

Kurtzman played the most important role in taking EC beyond its pulp origins. While there he wrote, edited, and often drew three influential comic books that redefined the comedic and dramatic potential of the medium. In the war titles, *Two-Fisted Tales* and *Frontline Combat*, Kurtzman brought realism and a human perspective to what had previously been a vehicle for heroism and fervent patriotism. Adventure comics like *Terry and the Pirates*, *Steve Canyon*, and *Buz Sawyer* were visually stunning and complex, but their views of human nature and the agonies of war were often one-dimensional and jingoistic. Kurtzman projected a dark, fatalistic vision of men in combat that was more in tune with the complexity of late-twentieth-century American culture than the optimistic patriotism and heroism of the World War II era.

Although many of the artists who worked with Kurtzman were technically better draftsmen and added detail to his pencil sketches, Kurtzman drew his own best work.[79] "Corpse on the Imjin" (figs. 95–100) is an excellent example of how Kurtzman

95–100  Harvey Kurtzman
Six drawings for
"Corpse on the Imjin" from *Two-Fisted Tales* #25
(published February 1952)
Pen and ink with colored pencil and opaque white
Each 20 x 14 inches
Collection of Glenn Bray

could turn a series of simple drawings, revolving around a single situation, into a masterful expression of moral philosophy and artistic control.

The first and final panels of this six-page story are essentially the same—a corpse floats down a river along with other debris of war—but their meaning changes dramatically as the story unfolds. By the second page, we are introduced to the "hero" of the story, a lone American soldier meditating on the corpse floating by. He imagines the horrible ways the corpse could have died. The page's final frame reveals an enemy soldier peering through a bush.

On the third page the soldier becomes engaged in hand-to-hand combat with the enemy—the same horrible fate he had imagined for the floating corpse. Their fight continues over the next three pages, until the soldier finally drowns his assailant. The final page shows a new corpse floating slowly out onto the river and then along its course. In six pages the scene is transformed from an abstraction to an uncomfortably real event.

Kurtzman creates the emotional impact of his theme through subtle graphic design to make us feel his story as more than just documentary. The first page is organized on a horizontal axis, like the earth itself. The second page is vertical in its axis, representing the individuality of the lone protagonist. The juxtaposition of the horizontal earth and the solitary vertical figure is disrupted by the intrusion of a second figure. Their battle transforms the simple design pattern into one of agonized circularity. The extended give-and-take remains balanced in this messy show of violent force over two pages, until the dominance of the American soldier is shown graphically by returning to a vertical. At this point he forcefully pushes his enemy below the water. The first four panels show the end of their struggle from midrange. The images depict the enemy's desperate struggle for survival in a simplified, expressionistic style that looks like a woodblock print.

The final picture of the two interlocked bodies depicts the back of the soldier's elongated neck extending down as the enemy's hands stretch out one last time for life. The second tier of panels on this page shows the soldier's victory in literally dark terms. There is no cathartic heroism here. The three shots unfold as our point of view moves closer and closer to the killing. The final panel in this sequence is so close to the soldier that his image becomes all arms and trunk, reducing him to pure muscle and might. The bottom row of panels begins with a grim midrange shot of the soldier, head bowed, with his image reflected in the now empty water. He climbs,

shaking, from the river and runs away from his ugly act of self-preservation. The soldier's survival is expressed graphically by returning him to a vertical orientation. The enemy, on the other hand, is shown drifting in a circular movement from an initial close-up to a long shot six frames later. In the final frame his lifeless corpse floats down the river, returned to the earth's horizontal axis.

Compared to Caniff's "Death of Raven," "Corpse on the Imjin" is drawn simply, without a great deal of attention to lighting and authentic detail, but its emotional impact and moral complexity is far greater. Caniff's art is compromised by his sentimental themes. Kurtzman's work is elevated by his utter rejection of sentiment and an idealized vision of combat heroism. By making death and the agony of war graphically real, Kurtzman helped inspire the questioning of war and jingoism that some of his adolescent readers carried out as college students in the sixties.

Kurtzman both anticipated and helped inspire the social upheavals of the 1960s to an even greater extent in MAD. He started out by parodying pop culture in general, but by the fifth issue MAD began to concentrate on parodies of very specific topics, in particular other popular comics such as Superman, Archie, Gasoline Alley, and Bringing Up Father (fig. 246). In these parodies, Kurtzman layered the same dark humanistic themes he brought to his war comics, though this was difficult to see at the time since the parodies were so funny, innovative, and crammed with grotesque detail. But stories such as "Gasoline Valley" not only poke fun at Frank King's characters aging in real time but also show the real tragedies of death and human frailty in much the same way as "Corpse on the Imjin." In "Bringing Back Father!" Kurtzman alternated pages of Elder's mimicry of George McManus's cartoons with Krigstein's more expressive style. The contrast brought the formal dimension of comics to the fore in a way that also heightened his ironic critique of violence in comics and American society as a whole.[80]

Kurtzman wrote all twenty-three issues of MAD and edited the first five magazine issues from 1954 to 1956. He collaborated with several talented artists working at EC, but his most consistent and outrageous partner-in-crime was Will Elder, whose perfect, uncanny imitations of Kurtzman's targets added more acid to what were already caustic satires of upstanding comics citizens like Archie Andrews, Jiggs, and Uncle Walt.

One of Kurtzman's most enduring attributes was his development of the self-reflexive, ironic aspect of modern comics begun with Nibsy the Newsboy in the early comics and with Al Capp's par-

ody of Dick Tracy, Fearless Fosdick. Kurtzman's satiric work actually began in the late forties, with a one-page gag strip called Hey Look!. One remarkable example depicts a chef boasting to a little boy that he can "flip an egg ANY way!" His flipping grows increasingly baroque until the last frame, where he literally flips the panel over. Kurtzman continued this trend in his short-lived newspaper strip Silver Linings. In one page, a figure bounces into the first frame asking for a cup of coffee. A group of grotesque cooks and waiters, of decreasing height, yell to each other "Draw one!" The customer in the next panel complains, "Uk! This isn't Coffee!! It's black ink!" In the final unframed panel the customer turns the cup over, leaving an ink smudge at his feet. He asks rhetorically, "Hey Reader!! Look! Izzat Coffee or Black Ink—Hah?" This lacked the whimsy of Ignatz and Krazy Kat pondering the nature of art, but Kurtzman set the stage for irony and introspective satire in late twentieth-century comic books, much as Herriman did in early twentieth-century comic strips.

One brilliant story from MAD #12, "3-Dimensions," took the flipped-panel gag to its nonsensical limit, while lampooning the fad for 3-D films in the fifties (fig. 101). It ends with the writer and artist lunging after a pin-up girl and pulling everything off the page in the process. The artist says to the writer, "You're knocking everything off of the page! This is a six-page story!...We still have one more page to go..." The final page, as printed, is literally blank. This type of sophisticated humor in a debased medium that called itself "miserable junk" caused J. Hoberman to label the trend "vulgar modernism" in an Artforum article, which linked Kurtzman's work with that of Tex Avery, Ernie Kovacs, and Jerry Lewis. Hoberman found that the four shared a healthy disrespect for everything, including the tastefulness of their own work, while at the same time remaining "reflexively concerned with the specific properties of its medium or the conditions of its making."[81]

Hoberman goes on to make two important distinctions between MAD's parodies and those of collegiate humor magazines or the pornographic "eight-pagers" (often called "Tijuana Bibles") of the thirties and forties that put famous comic characters in compromising positions (and were technically the first independent or underground comic books). First, MAD characters like Mickey Rodent, Starchie, or Little Orphan Melvin have highly developed self-consciousness that fundamentally disrupts the continuity of the comics' suspension of disbelief. For example, Starchie is shown with stubble on his face and ends up in jail for juvenile delinquency.

**101** Harvey Kurtzman and Wally Wood
Drawing for "3-Dimensions!" from MAD #12
(published June 1954)
Pen and ink with colored pencil and opaque white
20 x 14 inches
Collection of Glenn Bray

**102–109** Harvey Kurtzman
Drawings and layouts for
"Little Annie Fanny in Greenwich Village"
(published in *Playboy* magazine, September 1963)
Pen and ink, colored pencil, watercolor, and opaque white
Each approx. 16 x 12 inches
Private Collection

Second, and most importantly, as Hoberman writes, "for early *MAD*...the media constituted a single system." After undermining the continuity of individual comic strips, *MAD* reintegrated them on the larger general level of cultural spectacle. Kurtzman's understanding of how mass media was coming to dominate postwar American reality made his parodies more profound and disturbing than even their harshest critics claimed them to be. In that sense, Kurtzman anticipated what critics such as Marshall McLuhan described as the impact of media on people's perception of existence within everyday life.[82]

After leaving EC, Kurtzman created several more satiric magazines, including *Trump* (funded by Hugh Hefner) and *Help!*. He also developed an influential comic strip called *Goodman Beaver* with Will Elder, about an innocent character in an experienced world based loosely on Voltaire's *Candide*. Then he and Elder joined *Playboy* magazine, whose founder, Hugh Hefner, started his career as a cartoonist and offered them a steady job for many years.

Right before joining *Playboy*, Kurtzman created one of the finest *Goodman Beaver* stories appropriately called "Goodman Goes Playboy." The title character returns to Riverdale, "scene of his youth," which just happens to be the fictitious town where Archie and his friends lived. In fact, the first panel shows Goodman walking up to a *Playboy* version of Archie and his pals. Though the strip cannot be reprinted for legal reasons,[83] the story is worth retelling.

It begins with Goodman (and the reader) jolted into the "swinging" sixties by comparing the innocence of the youthful *Archie* comics with the hedonistic debauchery that Hugh Hefner brought into pop culture. In the final panel on the first page Goodman bemoans, "I get the feeling things are not really the same," while the *Archie* characters utter ridiculous sophisticated phrases straight out of the men's magazines and movies that were popular at the time. In fact, the Jughead and Reginald characters are "reading" the magazine's centerfold on page two while the Archie character locks lips with Veronica. On the fourth page Goodman enters a Roman-style toga party in Archie's pad. Archie guides Goodman through the party, which is as full of sight gags as it is half-clothed bodies. Archie explains, "I've got an unlimited supply of everything..." as he walks through a detailed catalogue of conspicuous consumption. In the midst of this decadence Goodman wonders how his childhood

buddy could afford such luxury. Then suddenly in the middle of the second-to-last page, Archie reveals how he really got everything a red-blooded American misogynist ever wanted: "I've signed a pact with the devil...that's where it comes from!... In exchange for my soul!"

Goodman goes screaming from the burning orgy. But the next day when he finds the rest of the old gang at the local soda fountain, Goodman is in for an even bigger surprise. There is a suave older man sitting there who looks suspiciously like Hugh Hefner. He holds a glass jar in which Archie's soul is trapped. The gang realizes that Archie did sell his soul for libidinous pleasure. But rather than seeing the error of his ways, they want some of the action.

The final panel shows the Archie gang, along with a lineup of other famous cartoon characters—including Andy Gump, Superman, Jiggs, and the Katzenjammer Kids—signing on with the debonair demon. In the end, Goodman turns to the reader and ponders whether he should leave "to find a place where the dark forces aren't closing in...where honor is still sacred and where virtue triumphs." But then he pauses and leaves us wondering with his final words: "Maybe I should sign up."

Which is, of course, exactly what Kurtzman and Elder did, though *Playboy* was not as bad as the *Goodman Beaver* story feared. In fact, the two artists turned Goodman into a busty female named Annie Fanny and put her in a sumptuous color comic that anchored the back of *Playboy* for the rest of Kurtzman's career. *Little Annie Fanny* was a postmodern version of the Hogarth sequence, *A Harlot's Progress*, which kicked off comic storytelling in the eighteenth century.

In the September 1963 issue of *Playboy* Kurtzman wrote a remarkable episode that was a sophisticated play on art and representation (figs. 110, 111). The original sketches show Kurtzman's working process—how he scripted, drew, and colored the stories and then gave them to Will Elder and Russ Heath to complete the finished paintings, which were then reproduced in the magazine (figs. 102–109). The first panel shows Annie as an artist's model exposing herself to him (and us) surrounded by his paintings, which are cheap imitations of famous works like Manet's *Déjeuner sur l'Herbe*. The artist is painting Annie from the rooftop of his studio through an open window. This upsets Annie, who doesn't mind being nude, but dislikes being peeped. In the first picture, Kurtzman knowingly titillates us with his voluptuous cartoon character, but also gives voice and identity to a *Playboy* model in a way that did not exist elsewhere in the magazine.

In the next four panels, Annie gets dressed and tries to get the artist to pay her. He is a bit slippery and she follows him to his big opening to make sure she gets what she is owed. The next panel cuts to the opening, where a crowd is staring at an empty frame in a room otherwise filled with painted parodies of famous art like the ones in the artist's studio (and similar to the work Kurtzman did at *MAD*). The artist enters and tries to put the painting he has just finished in place, which is a parody of Manet's *Olympia* with Annie as courtesan. Just to make sure we get what's going on, Kurtzman and Elder swap the dog in Manet's painting for a parrot. (Get it? Parrot...parody.) To further exaggerate the irony, the next panel shows the artist pouring Annie a glass of champagne with another Manet behind them, showing a barmaid in a Parisian bistro. The panel after that shows the artist and Annie in the empty gallery after the crowd leaves. The Manet painting in the background is suddenly empty as well.

The story jumps forward several months in the next panel. The artist has become famous for his empty frames. The art crowd has "discovered" him as a conceptual genius. Annie observes, "I see you still have this empty frame that they thought held a modern painting, but was actually the wall behind." The artist replies, "This time what you think is the wall behind an empty frame is actually a painting!" His new parodies of the postmodern style have made him rich and famous, but he is about to take a fall. In the large last panel, filled with parodies of Pop art and Picassos, he is hauled off to jail for his work, much like Kurtzman ran afoul of the law in *MAD* and his parody of Archie selling his soul to the devil in "Goodman Goes Playboy."[84] The moral of the story seems to be that there is a thin line between appropriation and plagiarism, just as there is between "high" and "low" art.

Within a few years, some of the artists whom Kurtzman first published in *Help!* started a new underground movement that would make his own comics seem tame in comparison. R. Crumb, in particular, pushed the boundaries of what could be shown and expressed in comics further than anyone had done before. If Kurtzman was a modern-day Hogarth, telling sophisticated stories about vulgar subjects, Crumb was our Daumier. He showed every nuance of the world around us (and the world in his head) with such brutal detail that it often seemed more painfully accurate than any other form of art in America at the time.

**110–111** Harvey Kurtzman, Will Elder, and Russ Heath
Printed pages for
"Little Annie Fanny in Greenwich Village"
(published in *Playboy* magazine, September 1963)
Each 11 x 8 ½ inches
Private Collection

# TRADITIONAL COMICS AND RADICAL PERSONAL EXPRESSION

## 1

## MAD about America

In the mid-1950s, Harvey Kurtzman had begun poking fun at the seemingly benign surface of American society. One *MAD* cover (fig. 112) shows him selling comics to kids on a street corner under the headline: "Comics Go Underground."[85] After Kurtzman left *MAD* in 1956, he started a series of new humor books that continued his barbed approach to the one-dimensional society that the majority of Americans seemed to prefer at the time.[86] Kurtzman took many of his best collaborators with him, notably Will Elder, but he also began to publish the work of younger "amateur" artists who would become the foundation of a new wave of independent comics.[87]

## 2

## Twisted Folk: R. Crumb and First-Person Comics

R. Crumb (b. 1943) was the most important of these young artists. He began drawing homemade comic books as a kid in Philadelphia with his older brother Charles. From the start, he had a gift for drawing the world around him in a variety of styles that ranged from old-fashioned funny animal comics to Old Master realism. Kurtzman was the first to recognize Crumb's talent and published an early version of *Fritz the Cat* in *Help!* in 1964.

Flush with modest recognition from one of his heroes, Crumb came to New York in 1964 hoping to work with Kurtzman and arrived at just the right time to become part of the burgeoning underground scene.[88] Kurtzman's own career was floundering, but after he escaped to the relatively safe haven of *Playboy* he helped Crumb get work as a commercial illustrator. Eventually Crumb settled in Cleveland, working for American Greetings, where he met Harvey Pekar, a file clerk with a similar passion for old 78 vinyl records.[89]

In 1967, Crumb moved to San Francisco, where the counterculture was blossoming into a new form of mass youth culture. Within a year, Crumb began publishing *Zap*, the groundbreaking underground comix (fig. 113). He sold copies of the first issue to hippies from a baby buggy on Haight-Ashbury. *Zap* quickly became a huge success across the country, launching popular characters like Fritz the Cat and Mr. Natural and proving that there was an underground of disenfranchised young people waiting for something new.

The art Crumb created for *Zap* and the other self-published comic books that quickly followed was radically new in terms of content.[90] He adapted the naked self-expression of the Beat generation to comics by dealing directly with sex, drugs, and neurotic self-expression. The fact that he actually showed pictures of forbidden subjects made Crumb's comics as scandalous to the old as they were seductive to the young. But because of changes in censorship law and cultural standards, Crumb was able to create, publish, and openly sell explicit material. As he explained, "We didn't have anyone standing over us saying, 'No, you can't draw this' or 'You can't show that.' We could do whatever we wanted."[91] By publishing his own comics, Crumb didn't so much go underground as become independent.

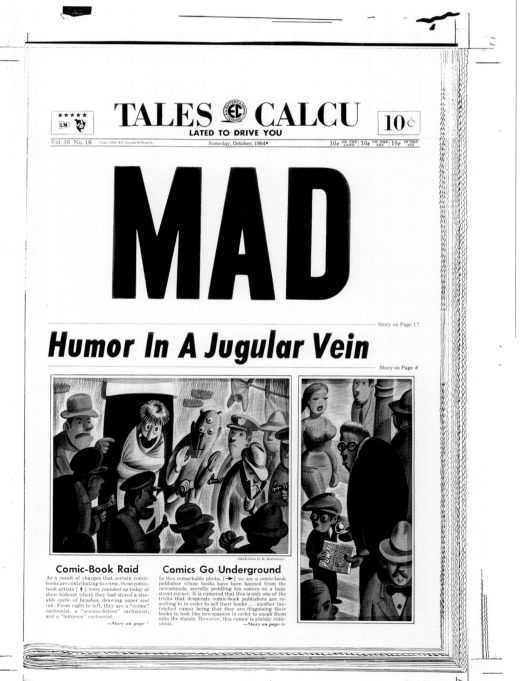

**112** Harvey Kurtzman
Drawing for cover of *MAD* #16
(published October 1954)
Pen and ink with colored pencil and opaque white, with typeset
20 x 14 inches
Collection of Glenn Bray

**113** R. Crumb
Cover of *Zap* #1
(published 1967)
9 7/8 x 7 inches
Private Collection

**114–117**  R. Crumb
Four drawings for "Meatball" from *Zap #0*
(published 1967)
Pen and ink, each 14 x 10 inches
Collection of Eric F. Sack

Although Crumb's content seemed radically new, his drawings and sense of humor were based on older forms of comics that had gone out of style by 1960. This was true of music and fashion as well as comics. Around the same time Crumb was publishing underground comix, Bob Dylan invented a new poetic form of rock'n'roll out of the folk music of Woody Guthrie and obscure blues songs.[92] In fact, one of the most interesting aspects of sixties culture was the use of old styles to express new content. The Grateful Dead, who were among the best of the rock groups to emerge in San Francisco while Crumb was publishing *Zap*, melded traditional bluegrass and blues with electric guitars and free-form jams. One of the Dead's most popular songs came from Crumb's famous 1960s image, "Keep on Truckin'," which shows a happy person strutting down the street with his big right foot forward.[93] Crumb's work first became known to a wide audience through the album cover he drew for another psychedelic San Francisco blues band, Big Brother and the Holding Company, led by Janis Joplin. The cover is laid out like a comic strip, illustrating each song on the album in a style that mixed old and new, much like the music inside.[94]

Crumb did the same thing in his comics. He avidly collected old blues and jazz records, and some of his best work illustrates and revives the reputation of great American musicians such as Charlie Patton.[95] One of Crumb's finest stories, "That's Life," depicts both country blues musicians and Crumb's own obsessive collecting of the obscure vinyl records that preserved their music. At the same time, Crumb's drawing style reflected traditional American cartooning from Thomas Nast through E. C. Segar more than it did that of artists like Jack Kirby and Charles Schulz, who were making comics during the 1960s. (It is almost hard to believe that Crumb and Kirby were doing their best work at the same time.) In the same way that Dylan made folk music electric in the mid-1960s, Crumb went back to the roots of American culture and twisted them to represent what he felt inside. As he put it, "Comics are an American folk art form. The way to turn people's head is to take a medium they're familiar with and then do something new..."[96] The design historian Steven Heller described *Zap* in a similar way: "They looked like comics, and they read like comics—but they were 'comix,' combining the genre's conventional visual language of panels and balloons with scabrous story- and gag-lines, heretofore banned from mainstream comic books."[97]

For example, the story "Meatball," which appeared in *Zap* #0 in 1967, is a funny parable about a variety of Americans being transformed when they are hit in the head by a lump of chopped meat falling from the sky (figs. 114–117).[98] The title alludes to a popular folk song by Josh White, "One Meat Ball," which was part of the traditional music revival in the early 1960s. On one level, "Meatball" is a parody of enlightenment in which angry housewives, beatniks, businessmen, and a famous philosopher (Bertrand Russell) are transformed by a hunk of meat, as opposed to, say, a bolt of lightning. On another level, the story subtly transforms the cartoon style that Herriman took from TAD and passed on to Segar to express a new type of content. Crumb makes this clear in the first panel by drawing two housewives in ugly print dresses fighting over underwear on sale in a department store. The lady on the right says "shit," which may seem innocuous now, but would have been quite shocking to see a cartoon character utter in 1968. (The real shock of the word is that it clues the reader in to the physical resemblance of the meatball to a turd.) The story then shows a variety of before-and-after vignettes that transform the style and typical gag structure of traditional comics. But as the

Crumb's use of independent distribution allowed him to express himself with utter candor in a way that most popular musicians and filmmakers of the day could not. In that sense, Crumb's first-person comics were not just directly autobiographical, but psychologically (and literally) naked. One gets a sense of Herriman's soul from reading *Krazy Kat* or the psychology of growing up in midcentury America from *Peanuts*, but no one before Crumb made comics that were so directly about themselves and their own mental state.

One can see this in Crumb's line work as well as in what his lines depict. He deliberately draws lines that seem out of place and about to drift across the page to convey a sense of the emotional impact of what he is looking at and drawing.[99] Herriman's line work also defied convention, but Crumb took the approach further, giving future cartoonists not just the freedom to express themselves but also the tools with which to do so.[100] At a time when abstract and conceptual art dominated American culture, Crumb's comics stubbornly remained based on skillful realistic drawing. At first this made his work seem old-fashioned and out of touch. But Crumb's work was able to represent significant aspects of modern life that were almost completely missing in mass media.[101] He showed how it felt to be alive in the middle of the twentieth century as well as how it really looked.

"The Adventures of R. Crumb Himself," for example, begins with a full-page illustration of the artist sitting in an armchair staring out his window and thinking to himself, "I think I'll go for a walk.... "His clothes are disheveled, the knees of his pants are torn, there is stubble on his chin, and papers are strewn about the floor under his feet; the ink lines are as dense and expressive to suggest his empty and boring life.

On the next page he walks outside humming a gospel tune, and runs into a "school of hard knocks," where a nun wearing funky high-heeled boots kicks him in the ass with the help of a cop, soldier, and teacher. They strip him naked and bring him to the nun, who puts his penis on a chopping block and is about to hack it off with a butcher's knife. Crumb grabs the blade just in the nick of time and cuts off the nun's head instead. He runs outside and into an old man in a trench coat, who sells him a bomb. Crumb chants some sixties-style revolutionary slogans, throws the bomb at the school, and blows it up. He runs from the explosion and into a sign that advertises "school of hard knockers" which causes his still-naked penis to swell. In the last panel he grabs two busty girls, asks "Where do I enroll?" while drooling, and then partially apologizes to

story evolves it becomes clear that the gag is mental rather than physical.

In fact, one could say that Crumb transformed the physical humor of old-time comics into a kind of psychological slapstick. Instead of characters fighting, falling, or being beaned with a brick, Crumb shows people falling down the rabbit hole of their own psyches. And much of the suspense in Crumb's following comics is anticipating just how far he will fall in following his primal instincts.

By using older, popular styles to express himself, Crumb brought a self-conscious sense of history to comics that built on the parodies Kurtzman created in *MAD* and the way in which earlier artists such as Herriman had fun with the form. Overall, the counterculture that blossomed in the mid-1960s was the first mass American movement with a fundamental sense of its own history. American artists at the time, from Crumb to Brian Wilson, Bob Dylan, or Andy Warhol, all began to look at the history of American culture and appropriate elements they found interesting into a new form of personal expression.

118  R. Crumb
Two pages from "The Many Faces of R. Crumb" from *XYZ Comics*
(published 1972)
Each 9 7/8 x 7 inches
Private Collection

his readers in a square of text right below his penis that states he is "a male chauvinist pig." The text ends the story with the line: "Nobody's perfect...- R. Crumb".

In "The Many Faces of R. Crumb" (fig. 118) the artist gives us "an inside look at the complex personality of the great me!!!" He first shows us the artist "hard at work," masturbating out the window to one of his comics. In the next panel he explains, "I get what I want by drawing a picture of the desired object" while showing us a picture of Crumb drawing a girl named Kathy Tuffbuns. The next seventeen panels show the different sides of Crumb from existential artist to calculating businessman to sentimental slob to wasted degenerate. The last panel shows Crumb again in the familiar style of the first two panels (and other autobiographical stories) looking at the reader, explaining that "it all depends on the mood I'm in!!" while he waves and says goodbye.

This fractured sense of self, depicted in a range of recognizable pictures, is an uncomfortable portrait of the artist in contemporary life. He is no longer an elegant figure advertising his talent like Dürer or a tortured being baring his soul like van Gogh, but some weird creature in between. Crumb twists the tradition of comics by making the fantasy something inside his head rather than in the reader's. Comics from McCay through Kirby created a fantastic world of escape for their readers. Crumb's fantasy is too crude, too personal, and too eccentric to invite the reader in that way, but it is perfectly suited to the complex world of the late twentieth century.

In that sense, Crumb's work is not as crude and self-deprecating as it seems. He actually seems to be holding out hope for individual expression in a world that is increasingly plastic and homogenized. Stories such as "The Many Faces of R. Crumb" represent a unique vision of contemporary America where craziness has come to the surface and individuality, however hysterical or grotesque, thrives. This view inspired the next generation of cartoonists, who built on Crumb's first-person comics and expressive drawing style, demonstrating Crumb's long-lasting influence on American art.

119  R. Crumb
Page from *The Snoid Goes Bohemian*
(published 1980)
11 x 9 inches
Private Collection

120  R. Crumb
Cover of *American Splendor* #4
12 x 10 inches
Private Collection

## 3
## Of *Maus* and Men:
## Art Spiegelman and Comics of Crisis

Independent comics suffered several major setbacks by the mid-1970s because of the commercialization and dilution of underground culture and tightening obscenity laws. At the same time, some artists reversed track and began exploring the potential of comics as art rather than pop culture. The central figures in this regard were two cartoonists on the fringe of the underground movement who suddenly came into their own, Bill Griffith (b. 1944) and Art Spiegelman (b. 1948).

They edited a comic book magazine, *Arcade*, which carried the work of earlier artists like Crumb and Gilbert Shelton, but focused on the new sense of formal sophistication the editors developed in their own work (see fig. 121). Griffith describes the change as follows: "*Arcade* was...a conscious effort to move away from the stifling and limiting themes of the early underground—sex, dope, violence, etc. The need for that sort of catharsis had passed...we wanted to get on with the business of being artists. Nothing's wrong with a belly laugh—we just wanted to tickle the cerebellum [sic] as well as the funny bone."[102]

*Arcade*'s co-editor, Art Spiegelman, went even further and pioneered the development of the postmodern comic strip, characterized by elaborate layers of meaning that demand to be read over and over again rather than as a serial story. Spiegelman's strips were so densely impacted in terms of narrative and graphic design that they became more about themselves and their medium than the individual characters or situations they represented. The difference between Crumb's strips and Spiegelman's is emblematic of the overall shift in underground cartooning that occurred in the mid-seventies. This can be seen in the contrast between the abstract quality of Crumb's "Cubist Be-Bop Comics" (fig. 253) and Spiegelman's early masterpiece *Ace Hole, Midget Detective* (fig. 122). The former is a wonderfully kinetic, crazy-quilt comic that includes examples of every conceivable visual style from big-foot to Picasso to purely abstract. It features characters like Bradford Bush-Stroke and specific references to modernism along with as many visual gags as Crumb can cram into eight pages. Spiegelman also makes reference to modernism (Picasso is a character) and earlier cartoon styles, but in a fundamental rather than superficial manner. Crumb strings his comic collage together in a loose, jazzy fashion while Spiegelman orchestrates his structurally in a way that is obviously more concerned with thematic and formal relation than the originality of individual images.

After *Arcade* folded, Spiegelman launched another anthology series, *RAW*, with Françoise Mouly. *RAW* clearly set out to challenge the traditional hierarchy between fine art comics and graphic illustration. Mouly made this clear in an interview from the early 1980s:

> There's something about the comics being a printed medium which is really fascinating. We're in touch with a certain number of artists...who are trying to work the "gallery circuit" and are stuck in that. For us that seems almost a certain dead-end. In working for galleries, in being elitists, in doing an original work of art which can't be accurately reproduced. And that group of well-meaning doctors and lawyers on Fifty-seventh Street going to see it in a gallery. Somehow it is so perverted. Artists have tried everything for the past fifty years or more to come out of that ghetto. They have not succeeded.[103]

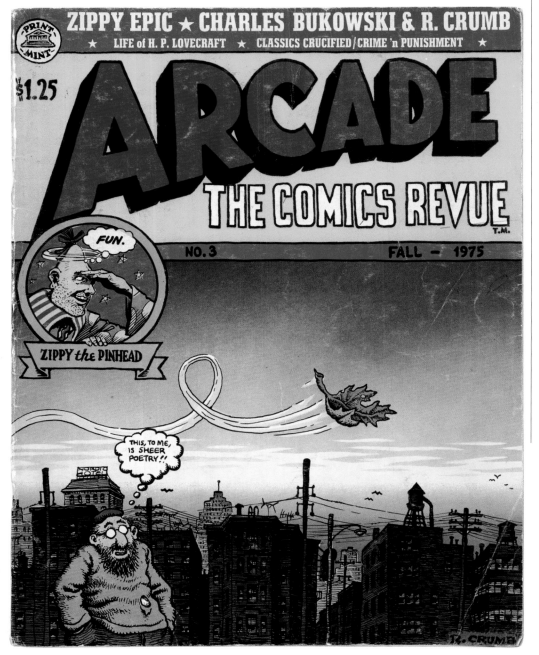

121 R. Crumb
Cover of *Arcade* #3
(published 1975)
12 x 10 inches
Private Collection

122 Art Spiegelman
Drawing for cover of *Ace Hole, Midget Detective*
(published 1974)
Pen and ink, brush, and crayon
20 1/2 x 14 1/2 inches
Collection of the artist

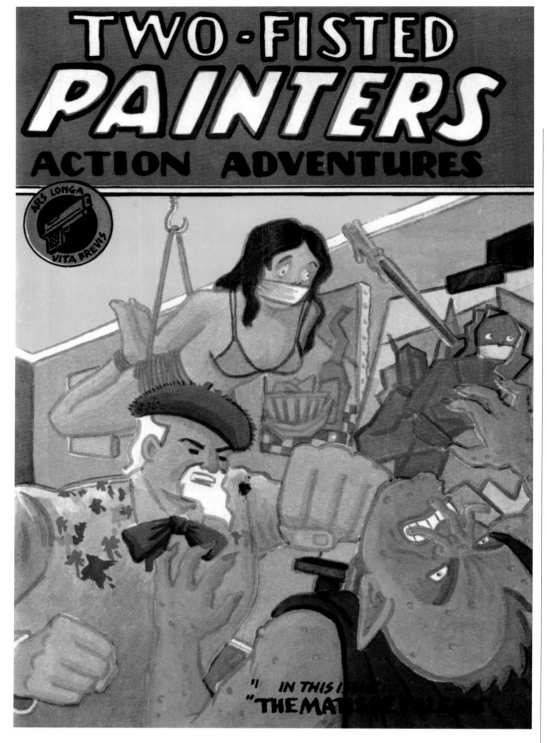

August Dabbler, is painting an abstract still life with a nude model standing before him (she is not in the picture). On the next page a long shot reveals a series of the same still life registered in different colors in the manner of Andy Warhol. At this point the writer's text reaches the same dead end as Dabbler's art. So he crosses out the preceding lines and adds some pulp violence to the scene. The resulting image grafts Dabbler's head onto a panel conspicuously labeled "swiped from: *Detective Comics* #395." In the picture August slugs an intruder whom he later recognizes as a performance artist whose work consists of murdering painters. Just as Dabbler is about to write his own ending to the performance, a seven-foot alien creature enters the scene with a "color siphon." Dabbler's nude model Suzette tries to escape by descending a staircase but to no avail. All the color is siphoned from her. Dabbler tries to shoot the alien but he too has all the color drained from him. Just as the artist is drained, so is the writer typing the story. He runs out of wine and inspiration.

Fortunately the narrative continues without him. The alien reveals that he is from a planet without color. His theft will make him the greatest artist his world has ever known. Upon hearing the alien is an artist, the performance artist stabs him in the back. He comments, "Killing a painter from outer space—that oughta get me a Guggenheim." Together Dabbler, Suzette, and the performance artist smash the color siphon bottles and return themselves to color. Meanwhile the author complains that this is all escapist tripe and passes out. In the final page the typewriter continues without him and writes itself into the ending. The alien revives, embraces the typewriter, and together they float off beyond the stars.

**123** Art Spiegelman
Cover of *Two-Fisted Painters*, *RAW 1*, Issue 1
(published 1980)
6 x 4 inches
Collection of the artist

In this tiny twelve-page story Spiegelman comes as close as possible to making the comic medium an expression of avant-garde tendencies without undermining its basic integrity and fundamental parodistic character. It is a color comic about color, including so many issues of self-reference and intellectual versions of Kurtzman

Mouly's comments come as close as any to advocating the equality, if not superiority, of contemporary comic art in relation to fine art.[104] She and Art Spiegelman made *RAW* a meticulously designed and printed oversize magazine of graphic art, one of the finest anthologies of comic art ever published. It was distinguished by its witty, self-aware explorations of the comics format, both in its reprints of European and Japanese comics and in its publication of eccentric and visionary American comics by Gary Panter, Charles Burns, Sue Coe, Kaz, Mark Beyer, and many others.

Spiegelman's contribution to the first issue of *RAW* was a small comic book insert called *Two-Fisted Painters: The Matisse Falcon* (fig. 123). It made clear from the start his aggressive conflation of American popular culture, modernist practices, and the print technology of the comics medium. It begins with a quote from Robert Rauschenberg and a progression of four horizontal patterns that become increasingly abstract, like Matisse's famous series *The Back* (1930). The story itself begins with a writer hard-pressed to meet a deadline. He takes a slug of *vin ordinaire* and begins to type. First we see the typed page, then the unfolding of the plot in comic book pictures. A Matisse look-alike,

and Elder's famous visual gags (the title itself is a reference to Kurtzman's *Two-Fisted Tales*, but the story is closer in theme to "3-Dimensions" from *MAD*) that it demands and satisfies multiple readings. Spiegelman said of his own taste in comics: "Good comix are nourishing comix—unlike the Hostess Twinkies to be found in most children's comic books. The comix I like can be read slowly and often. Hopefully each reading serves up something new."[105]

Spiegelman's comics and editorial choices helped establish a history of the medium and a sense of how to read comics in a serious way. He made it clear that Nemo's dreams and Krazy Kat's funny animal fantasies were really about their authors' grown-up ideas and execution, and helped us to see the hidden pathos in McCay's work and the way his characters float through a cold and uncaring world without being able to express themselves.

Spiegelman's early work was the most controlled and self-limiting of any cartoonist. He was one of the few cartoonists to eschew continuing characters and extended variations on the same themes until telling the story of his father's survival of the Holocaust in *Maus*, which he began publishing in the second issue of *RAW* (figs. 124–140).

Spiegelman learned from Crumb (and other underground cartoonists, notably Justin Green) that comics could work in the first person and that they had matured to the point where a certain kind of psychological realism could be achieved. But in *Maus* Spiegelman went further and began to develop a new form of self-expression in comics. Crumb perfected a way to make his drawings expressive by creating a density of lines that filled the image rather than outlining figures and backgrounds to indicate their shape and form. But Crumb took a more natural approach to page layout and design and used that aspect of comics mainly to convey his expression. For example, in *The Many Faces of R. Crumb* the multiple versions of his personality are displayed in a traditional grid of panels, which are laid out in a conventional way rather than designed to further our experience of the personalities as we read the story. Consequently, the panels and layout in his work serve the characters and stories and do not become independent layers of information.

Spiegelman, however, typically uses line drawings to serve the information he conveys in layout and design and not as spontaneous emotional gestures. This allows him to present multiple layers of information that make his work more conceptual than expressive. Where Crumb presents eighteen versions of himself as individual characters, which are aspects of his moods, Spiegelman integrates those layers into the form of his work rather than into the split personality of himself and his characters. For example, in *Ace Hole, Midget Detective*, the story itself fractures into multiple styles of expression rather than the main character expressing multiple personalities. It is a detective story that transforms, through its self-conscious use of form, into a *defective* story in which our attempts to follow the clues are thwarted at every turn until we realize that they are not actually within the story, but in the form through which the story is presented. In other words, Spiegelman developed the multiplicity of being that Crumb expresses on the level of character and drawing as an aspect of form and design.

In *Maus*, Spiegelman learned how to do both things at once. His first-person story works as a script in which he acts out in drawings the way Crumb or Segar would do. But he varies the style of his line work and the layout of the pages to create additional layers of expression that change the mood of the story as we read it. This makes his work conceptual as well as emotional. He is able to have it both ways because the tension between these layers mirrors the tension between Spiegelman's feelings toward his father and how their personal history relates to the history of the Holocaust and the assimilation of Jews into late twentieth-century America.

Of course those feelings themselves are expressed on multiple layers. An obvious sign of this mix of psychology and artistic craft is the title Spiegelman chose for the compilation of his pre-*Maus* strips—*Breakdowns*. It refers, on one level, to the style that Spiegelman developed in that era, which focused on how a comic book page can break down into formal components to express personal themes in a more complicated way than pictures or dialogue alone. But the title also refers to breakdowns on a deeply personal level—the mental struggles that Spiegelman suffered, as well as the fact that his parents were Holocaust survivors; one of his early comic strips, *Prisoner from Hell Planet*, was about his mother's suicide.

*Maus* began as a three-page strip in 1972, which Spiegelman drew for an underground comix called *Funny Animals* #1, edited by Justin Green who pioneered first-person confessional comics along with R. Crumb in the 1960s. The strip looks like an old-fashioned woodcut in which the sense of a gouged surface covered with ink evokes Spiegelman's Eastern European background and also the anguish he feels about his mother's death, his father's reaction to it, and how it has made him who he is. But even here, Spiegelman's emotional expressions are more in the overall style of the story rather than in the character of the line work.

*Prisoner from Hell Planet* was reprinted in chapter five of the first volume of *Maus* in the context of the artist finding out that his father had read the strip in spite of its being printed in an obscure place. *Prisoner of Hell Planet* heightens the sense that *Maus* is not just a biography of Spiegelman's father and his survival against the odds, but also an autobiography of the author. The balance between Vladek's harrowing tale and his son's story of trying to deal with it makes the Holocaust feel like something immediate and present tense. And the way Spiegelman is able to do this in a comic book shows how he progressed from acting out his angst in *Hell Planet* to drawing multiple layers of meaning into his story.

*Maus* begins with a two-page flashback of the author as a boy roller-skating. We see how he draws himself as a mouse in the style of old funny animal comics. But we get the sense that something more serious is about to happen. This prologue is laid out like a conventional comic book, with a long horizontal panel on the top and a square of four panels below. They show Art falling off his skates, being left behind by his friends, and going to his father looking for comfort. He doesn't get it.

The next page has a square of four panels on the top and a long horizontal panel on the bottom, subtly setting up the formal design that underlies the construction of the whole book. On this page we get a foreshadowing of Vladek's character and the contrast between his son's childhood in the Bronx and his own life in Poland during the Holocaust. Vladek admonishes his son about his friends: "...lock them together in a room with no food for a week...then you could see what it is, friends!"

The first page of the first chapter is a conventional layout of six panels that sets up the difficult relation between Spiegelman as an adult and his father as a dying old man. Before turning the page we get a sense of the two main characters and the complicated relationship between them and the other people in their lives. The first full two-page spread, the second and third pages of the book, establishes how the formal layout is as important as what the characters do and say.

On the left page, Vladek gets on a stationary bicycle while he talks with his son. Immediately we get the sense that this man of action who survived

relitter
Czestochowa

**124–131** Art Spiegelman
Eight drawings for
*Maus: A Survivor's Tale, I. My Father Bleeds History*
(first published in *RAW* magazine, 1980–85)
Pen and ink, each approx. 11 x 8 ½ inches
Collection of the artist

Auschwitz is infirm, but still struggling to stay alive. The middle of the page is made up of a long horizontal panel that shows the number tattooed on Vladek's arm for the first time. There is also a circular insert that echoes the bicycle wheel as he spins his story: "It would take many books, my life, and no one wants to hear anyway such stories." But of course we do.

Spiegelman crosscuts between Vladek's story in the past and his life in the present tense of the book. The two strands come together pictorially at the bottom of the third page. He continues to cycle his feet (and his life) while a poster of Rudolph Valentino in *The Sheik* floats behind him in another circular form as a symbol of the good life he led before the war. That all ends when Vladek and his wife, Anja, first see a swastika on a train traveling to a spa in Czechoslovakia to help Anja calm her nerves. Their train moves across a trestle bridge drawn across the top of page thirty-two while the couple look out and see a Nazi flag for the first time. The facing page then floats the swastika like an angry moon behind a series of events described by their fellow travelers, which foreshadows the terrible cruelty to come.

The image of the train reappears almost fifty pages later as a toy that Vladek's son, Richieu, who died in the war, plays with on the floor. The toy train echoes the first train, which foreshadows the trains that later carry Jews to the death camps. On page eighty-one Vladek finally stops pedaling his exercycle for a moment to pause and remember that his first son did not survive.

A similarly harrowing echo appears on page 125, where Vladek and Anja wander out of the ghetto looking for shelter. The road they travel on takes the form of a swastika, showing that the dark shadow of the Nazis has gone from a flag flying out a train window to an inescapable part of the ground they walk on. Forty years earlier, Milton Caniff used a similar device to underscore the menace that his characters faced on the other side of the world during the same war. Caniff perfected a way to create mood through the language of comics. But, in the end, his work seemed too fantastic and remote from the subjects he depicted. Spiegelman, on the other hand, uses the language of comics to help us feel what cannot be said or seen about the real horrors of genocide.

The end of the book makes this clear. Chapter two of *Maus* Part II is called "Time Flies." It begins with the artist sitting at his drawing table wearing a mouse mask (figs. 132, 136, 137). Flies buzz around his head. He turns to the reader and tells us how his life has changed after the publication of *Maus*. A TV crew is standing by to "shoot" him. Below his table, in place of the expected pile of crumpled paper, is a pile of mouse bodies looking like the dead buried in mass graves at Auschwitz. Flies buzz around them, while the white shape in the background suggests a broken swastika and the way in which the Nazi horror has become embedded in the world the artist lives in and not just the memories of his father.

The story at this point goes deep into the experience of the death camps. Vladek worked near the gas chamber and discusses it in detail. On page sixty-nine, he is shown talking to his son, who is smoking a cigarette. The smoke from it rises above a drawing of the smokestack from Auschwitz while Vladek explains, "For this I was an eyewitness." On page seventy-two the smoke rises from the faces of burning bodies who twist and scream in a way that the victims piled up under Spiegelman's drawing table did not (figs. 135, 138). The chapter ends with Art and his wife, Françoise, sitting outside Vladek's cabin in the Catskills while Art sprays repellent and complains, "These damn bugs are eating me alive."

The image of the pile of bodies reappears on page 115 near the climax of the story. Here they are shown as photographs falling at Vladek's feet. On the next page we see him holding a picture, which is all that remains from his past life (figs. 139, 140). At this point he has grown from a small mouse character within single panels to a huge figure that needs four panels to show his whole body bent over the photograph with the weight of what it symbolizes. Then, we realize that the pictures he has conjured for his son will survive longer than his family and he can—the tragic catharsis of the book. In spite of Spiegelman's painful relationship with his parents and their tragic past, he was able to make something of it. He transformed their lost lives into the present tense of a masterful book that will continue in our minds as we piece together the layers and find ourselves reflected in truths that pictures or words alone cannot tell.

132 Art Spiegelman
Drawing for *Maus: A Survivor's Tale, II. And Here My Troubles Began*
(originally published in *RAW* magazine, 1986–91)
Felt-tip pen, 2 1/2 x 5 7/8 inches
Collection of the artist

133 Art Spiegelman
Drawing for *Maus: A Survivor's Tale, I. My Father Bleeds History*
(originally published in *RAW* magazine, 1980–85)
Pen and ink, 11 x 8 1/2 inches
Collection of the artist

**134–138** Art Spiegelman
Five drawings for
*Maus: A Survivor's Tale, II. And Here My Troubles Began*
(originally published in *RAW* magazine, 1986–91)
Pen and ink, each approx. 11 x 8 ½ inches
Collection of the artist

**139–140** Art Spiegelman
Two drawings for
*Maus: A Survivor's Tale, II. And Here My Troubles Began*
(originally published in *RAW* magazine, 1986–91)
Pen and ink, each approx. 11 x 8 ½ inches
Collection of the artist

# 4
## Gary Panter:
## The *RAW* and the Cooked

The history of comics is about many things—stories, gags, characters, and layouts. But in the end it all boils down to inventive ways to design pictures and words to engage readers and make them pay attention amid the cluttered landscape of disposable pop culture. E. C. Segar got it right when he titled his comic strip *Thimble Theatre*—a little box in which his characters got in and out of trouble.

In the 1920s and 1930s most comics were a little window you looked through to see the theatrics of the main characters. The graphic innovation was in what happened within that frame more than the formal quality of the work itself. There were famous exceptions such as *Krazy Kat*, which had gags that delighted intellectuals by referring to representation and the printing process. However, it was not until the contemporary era, notably in *RAW* magazine and the artists it helped to promote and nurture, that the graphic character of the comics overtly became as important as story and character. Comics became "art" in a deliberate manner rather than sneaking in through the backdoor of popular culture.

Gary Panter (b. 1950), along with Spiegelman, did the most to expand the range of expression in comic books and create something new and influential. Panter began publishing comics in the mid-1970s in an L.A. punk rock magazine called *Slash*. From the start his work looked different. Panter's drawings didn't refer back to older forms of cartooning in the same way that Crumb and Spiegelman did. His scratchy line work and seemingly dumb characters were as radical a break from underground comix as punk music was from the hippie bands of the 1960s.

*Jimbo Meets Rat Boy* from 1978 begins with a character named Smoggo walking a giant lizard (fig. 141). They are about to run into Jimbo, Panter's everyman main character, who is sitting on the ground trying to remember how to tie the shoelaces on his sneakers. The lettering and line work are deliberately crude and filled with scribbles and seeming mistakes that take on an artful pattern in spite of themselves. On the next page, the style becomes even more jumbled. The layout throws ten panels across the page in a haphazard way that indicates the trouble that Jimbo gets into by tying his shoelaces together, falling over, and having his legs ripped off by the giant lizard named Devil Dog. We learn in the next episodes that only

Jimbo's pant legs, not his actual legs, were ripped off. That page is only two panels. Each has a large cross-hatched face, one on top of the other in a way that suggests a weird mix of tribal and modern art. The lettering in the lower panel reads: "If you can't stand a little emotion go read *Nancy!*" (fig. 142) Ernie Bushmiller's character shows up in the next episode transformed into a punkish death face. Nancy chastises Jimbo for not understanding the absurdist quality of her comic strip. Then she asks Jimbo what he is doing walking around a punk magazine without a guitar. She gives him one that has a Mickey Mouse-like body while her sidekick Sluggo (looking a bit like Smoggo), ends the story by shouting "Hey pal! You startin' a band? Lemme join it or I'll kill ya!" (fig. 143).

In this early story Panter shows how much his style was part of another continuity of comics—not the refined world of Herriman, Kurtzman, or Spiegelman perhaps, but the utilitarian style of throwaway pop culture like *Nancy*. At the same time Panter blasts apart comic strip style in terms of how he draws and designs his comics. The new jagged approach he pioneered created a sense of psychological expression in comics just at the time when Americans were sensing that things had changed all around them.

By the late 1970s it became clear that America was entering a postindustrial era where exchanging information was taking precedence over making things. In that sense Panter and Spiegelman's mix of styles was the perfect counterpoint to what was happening in the culture at large. Jimbo's conversation with Nancy about humor and emotion in comics is more than a throwaway gag. It was emblematic of how Americans were trying to come to grips with the vulgar vernacular culture that surrounded them at a time when technological advances and material comfort were at an all time high. Synthesizing the high and low was no longer an academic concern, but a way of life.

Panter wrote a manifesto in 1980 called *Rozz-Tox*, a term that had already appeared cryptically in the Jimbo comics that he published in *Slash*. He wrote in the style of early avant-garde manifestos: "Capitalism good or bad is the river in which we sink or swim. Inspiration has always been born of recombination."[106] By that time, Panter's own recombinations had grown increasingly complex and masterful. The early Jimbo comics like *Rat Boy* were as confrontational and shocking in terms of their crude style and subject matter in the 1970s as Crumb's work had been in the 1960s. And just

as Crumb's work matured from funny scatological humor into intense introspection, Panter began to develop a range of visual effects that make his work more than just a period style.

By 1981, when Panter drew the cover of *RAW* #3, what appeared as crude in the context of the L.A. punk scene grew into a new kind of elegance.[107] The first page of the story shows Jimbo trying to disarm a thermonuclear device (fig. 146). The title and bottom panels are drawn in a thick cross-hatching style that owed as much to Jasper Johns's paintings of the late 1950s as it did to Thomas Nast or R. Crumb. The style is used not only to combine art and comics, but also to indicate Jimbo's jitters as he toys with the bomb. The middle panel, which takes up almost half the page, is drawn in an elegant gray wash that sets the cross-hatching above and below into relief. The mix of styles continues on the double-page spread that follows, which shows a parade of "followers of Vex Prohias," who looks like a futuristic, masked Mexican wrestler. By this time, Panter's recombinations were thematic as well as stylistic. His comics were set in an undefined future city called Dal Tokyo, which prefigured the cyber-punk style of writing that grew out of the work of Philip K. Dick, whose pulp novels helped to develop psychological, as opposed to technological, science fiction in the early 1960s (figs. 264–268 and 272–275).[108]

The next page is also a double spread that combines a Cubist version of the smog monster, Smoggo, who appeared on the first page, with a futuristic version of Jimbo, who admits that he cannot prevent the bomb from going off. The next

141 Gary Panter
Page from *Jimbo Meets Rat Boy*
(originally published in *Slash*, 1979)
12 x 9 inches

double-page spread is an enormous image of a living human skull whose face was burned off in the explosion. The final two pages mysteriously depict Smoggo and Jimbo standing in the flaming ruins of their postapocalyptic world. They face each other, but have nothing to say.

The story continues in 1983 with Jimbo and Smoggo moving through the same burning world. Successive pages show them moving through a similar mix of avant-garde and cartoon styles, but here, technique becomes a clear expression of the psychological mood of the characters. We see how they feel in the form of the drawing more than in the dialogue or story, which are meager in comparison. Panter displaced the meaning of comics from the level of action onto the level of visual

**142**  Gary Panter
Page from *Jimbo Meets Rat Boy*
(originally published in *Slash*, 1979)
12 x 9 inches

**143** Gary Panter
Page from *Jimbo Meets Rat Boy*
(originally published in *Slash*, 1979)
12 x 9 inches

144 Gary Panter
Drawing for
*Jimbo (Jimbo's house is gigantic, but condemned)*, 1987
Pen and ink, 29 x 23 inches
Collection of the artist

**145** Gary Panter
Drawing for
*Jimbo (Jimbo's house is gigantic, but condemned),* 1987
Pen and ink, 29 x 23 inches
Collection of the artist

style, much as Spiegelman had done in terms of formal composition.

For example, in *Don't Get Around Much Anymore*, Spiegelman created a comic strip about nothing (fig. 158). He transformed Crumb's approach to representing the bald facts of his actual existence into something that dares to be even more blank and boring. A man sits in a room, puts a record on (seemingly the Duke Ellington song of the title), stares at the silent TV, looks out the window at a boy bouncing a ball, reflects on the empty refrigerator, and peruses banal articles in magazines the prior tenant has left behind. In the final panel, the record skips and pushes us back to the top panel to ponder how there could be a comic strip where nothing happens. And then nothing happens again and again, until we realize that Spiegelman was in the process of creating a new form of expression in comics that was similar to what artists in experimental film, modern classical music, and conceptual art were doing at the same time.[109] Less became more, and our focus shifts to details that were on

the margin of the page rather than just following characters acting out stories.[110]

This became a significant way to make art in the 1970s. Lacking a vocabulary, visual or verbal, to represent the complex times, cartoonists like Spiegelman and Panter had to invent a new one. Spiegelman built on this formal breakthrough to tell seemingly simple (though actually quite complex) biographical and autobiographical stories. Panter took his stories out of this world into a future that is actually closer to the way we live now than we are willing to express.

Jimbo wanders a wrecked zone where nuclear explosion is a metaphor for modern America. But almost as little happens in Jimbo's world as in Spiegelman's banal urban apartment life. And Jimbo's blankness is also a device to force us to pay attention to details that otherwise might slip by. In the process we begin to feel what Jimbo experiences rather than merely looking at it. The story's range of visual styles gives us a sense of the chaotic environment Jimbo moves through as well as the confusion

within his own mind. He is not a hero in the sense of a classic adventure comic, or even an antihero in the mold of Marvel comics. He is not even an ironic comic book character like Crumb's Mr. Natural or Fritz the Cat. Instead, Jimbo is a cipher, a blank canvas on which Panter can reflect the sense of living in the contemporary world that many people felt in the 1980s. Or, as Panter put it at the end of a 1983 story (spoken by a six-eyed monster squatting over Jimbo's naked body), "You don't have it ½ bad. You're literature, buddy."

Three years later Panter continued to explore his new style of expression in the Jimbo saga (figs. 148–156). This time it begins with a more primitive looking Jimbo about to step "off the edge of a cliff... running barefoot on fire with his clothes melted off." The next double-page spread is one of the most impressive and disturbing in the history of comics. A horse is shown running through a blasted landscape with its flesh burning off its bones. The image looks more like Picasso's *Guernica* than Jack Kirby's epic battles. The horse's mad dash continues on the next two pages, where the animal crashes through a building onto a cliff similar to the first page. The image is doubly ironic because the flaming horse is seen next to a giant Shell Oil sign (Shell's logo at the time was Pegasus, a flying horse of epic and heroic proportions).

Jimbo follows the horse down a twisting trail along the cliff. Then, on the next two pages, the battered horse falls painfully through the air as we watch along with Jimbo. After climbing to the bottom of the cliff, he takes a shard from the ground and tries to put the animal out of its misery. He sticks the metal into the horse's neck, which spews blood all around while ashes keep raining from the sky. The final double-page spread is even more disturbing and evocative. Now the horse is dead, killed by Jimbo, with its entrails spilling onto the ground. Twisted tree trunks and electrical towers stand in the distance while the foreground is filled with

146 Gary Panter
Drawing for splash page from *Jimbo*
(published March 31, 1981)
Pen and ink with acrylic, 14 x 11 inches
Collection of Art Spiegelman

147 Gary Panter
Drawing for *Jimbo*, 1987
Pen and ink, 29 x 23 inches
Collection of the artist

organic and man-made debris. Here the agitated surface pattern of things is not so much a design for us to admire and enjoy as a sign of what Jimbo feels like at the end of his adventure. We see him standing like the battered hero of some adventure movie, half man and half monster, with his head turned back and his hands stretching outward toward something he cannot grasp.

Over the next two decades, Jimbo's adventures turned less existential and more formally complex. Panter began to show the full dimension of Dal Tokyo, both in artfully designed four-panel newspaper strips and in a series of new comic book stories (figs. 264–268, 272–275). The next two, from 1987, go back to what seems like a more conventional comic book narrative style. Jimbo appears to have adjusted to the postapocalyptic world in which he lives. His daily life is as banal as his world is fantastic.

In one story Jimbo follows some low-level robots through a series of architectural forms that rival the skyscrapers Little Nemo wandered through at the beginning of the century (figs. 147, 269). In fact, the story begins with Jimbo musing on dreams within dreams. But whereas McCay's fantasies were drawn in a consistent, accurate style, Panter's styles slip from frame to frame without breaking the spell or the continuity of his story. In fact, the mix of styles, much like Herriman's discontinuous backgrounds, highlights the idea that comics are ultimately a form of reading that involves pictures, rather than a series of pictures meant to create the illusion of reality. In Panter's words, "A whole different component of my work is having it be off, the happy accidents that Stravinsky talked about, having the viewer...complete it."[111]

The mastery of Panter's stories from the late 1980s is in his ability to combine so many different styles—from Chester Gould's stark, black-and-white designs to Thomas Nast's cross-hatching to Jack Kirby's foreshortened perspective drawing of figures moving through space—without resolving them into one continuous whole. In fact, his intent was to create something entirely new out of the recombination, to show us that originality at the end of the twentieth century was more about sampling and combining existing information rather than trying to express something new. This represented not only a new style of visual culture but also a new sense of psychology. Panter moved beyond

the existential, first-person expression of cartoonists like Crumb and Spiegelman to create a sense of what it was like to live a culture full of amusing signs that make less and less sense the more you stare at them.

The same can be said for Charles Burns's twisted version of fantastic comic book tales where the benign surface of American pop culture is shown to be teeming and infested with wayward thoughts and feelings. In the mid-1990s Burns collaborated with Panter and writer Tom De Haven to create a tour de force of comic book drawing, design, and twisted themes called *Pixie Meat*. It is literally like a comic book on acid—a fractured take off of conventions that grows increasingly weird and disturbing.

The front page is somewhat conventional in form, if not style. It looks like the title page of a typical comic book, with the authors' names and circular inserts with what seem to be the main characters. A sad-looking woman dressed like a dominatrix holds a wormlike creature in front of a giant eyeball. Behind her a planet is exploding. The next two pages almost appear like a twisted story about some drifter moving through a world of strange humans and alien creatures. By the fifth page it becomes clear that the "story" is not linear and that the comic is drifting as much as its characters. The story is about a collage of symbols designed into interesting pictures that force the reader to either ignore them or deal with them in a new way. The fifth page is a masterpiece of this new style of comics, which combines a series of references to pop culture into a crammed landscape of violence and suburban surrealism. A naked dad cooks hot dogs on the grill while a Japanese anime girl fondles the scars over a harsh woman's breasts. By the last page, things have progressed so far that the last page cannot contain them in the same size format. The page folds out to reveal a swirling pattern packed with pop culture detritus exploding over a landscape that suggests the layers beneath the earth's crust.

The relation between what goes on within the panels and how the panels are designed into an overall image on the page has been a hallmark of artistic comics from McCay through Spiegelman. Panter's *Jimbo in Purgatory* (1997–2000) updates that tradition and makes it the centerpiece. The thirty-two-page story is based loosely on Dante's

*Inferno* with the Jimbo character taking the role of the Renaissance poet. Each page is filled with a grid of 3 x 3-inch, rectangular panels with a designed abstract border surrounding them (fig. 270).

The "story" begins with Jimbo meeting a character out of a kung fu movie who is based on the Kato character that Bruce Lee played on the *Green Hornet* TV show (whose name also refers to the Roman statesman, Cato). A box-robot begins to guide Jimbo through the wonderland of Western culture as Virgil did to Dante five hundred years ago. On the second page, the novelty singer Tiny Tim makes an appearance outside of a cone-shaped building that appears to be the Tower of Babel. On page three, the rock'n'roll imagery coalesces into the figure of an Elvis Zombie, which was the subject of an earlier book by Panter in the 1980s. He transforms into Boy George, then Alice Cooper, John and Yoko, Frank Zappa, Kurt Cobain, and a number of other icons of contemporary culture. By page eight, these figures subside and the background imagery start to overwhelm the foreground and transform the page into a series of psychedelic patterns that become the real story of this twenty-first-century comic book.

At first the pattern is a snake that squirms across the page; the snake's skin then becomes an abstract form on page nine, while the border imagery starts to mesh with the pattern behind the grid of panels. These patterning elements become more and more complex until they completely overwhelm the story. On page ten, Jimbo wanders through a corridor that seems part shopping mall and part Mayan temple. The walls are filled with panel drawings that resemble the previous pages in the comic book. On page twelve, those pages flatten and become a mosaic floor where Jimbo is guided by the female robot from the German expressionist film *Metropolis*. By page seventeen the swirling patterns overwhelm everything and become a focused central image that dominates Jimbo walking up Mount Purgatory, which resembles the Tower of Babel in the panel drawings. Over the next five pages things begin to simplify and form more basic patterns that resolve into a ribbonlike road on page twenty-five and a circular mandala shape on page twenty-seven. At that point Jimbo is no longer bound by the images within the panels and floats through the pattern at various angles, while a Native American princess rides a canoe into the whirlpool.

148–156 *Right and following pages:*
Gary Panter
Nine drawings for *Jimbo: Jimbo is Stepping Off the Edge of a Cliff!*, 1986
Pen and ink
Seven drawings: each 20 x 15 inches;
one drawing 20 7/16 x 29 inches;
one drawing 20 1/4 x 28 3/4 inches
Collection of the artist

# JIMBO

NOV 21 1985

## JIMBO IS STEPPING OFF THE EDGE OF A CLIFF!

What does it matter? He already is Bar-B-Qued and in the middle of a section of Dal-Tokyo destroyed by a small homemade terrorist A-bomb. All is ashes and carnage. The best aspect of the situation for Jimbo is that he doesn't feel guilty. Well, maybe a little. He didn't stop the bomb from going off, but he tried. He didn't make a career out of it or anything, but he was guileless. He didn't not let it go off on purpose. Sort of a blameless feeling anyway. Well, pay- ing it off in the currency of the gods.

He feels at least that nothing could be worse, that this is the bottom.

Running barefoot on fire with his clothes melted off. Pulverised. Pure.

Perhaps there is no...                    ...experiential Bottom.
JimBo, as projectile, smashed into a pile of blazing Jackstraws, unfettering another

unfortunate: a horse.

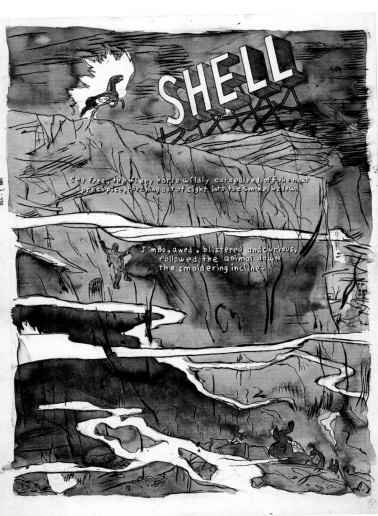

SHELL

Set free, the fiery horse wildly catapulted off the next precipice, torching out of sight into the smoke below.

JimBo, awed, blistered and curious, followed the animal down the smoldering incline.

When he got his first B-B gun, Jimbo was advised that sport is not really sporting, that killing to eat is with... out referendum, that when the time comes to kill, it should be done quickly, and that something in agony beyond hope or help should be destroyed as the nearest act to kindness possible.

To his un-clouded mind this advice made sense, represented the best course of action under duress. Pain, killing, and death were perhaps the clouds rolling in, but cultivating rational, empathetic, behavior seemed a weapon or refuge against the extremes thrust upon the living, wounded or dead. Agreeing in principle was easy enough, but putting the miserable bird he wounded out of its pain—even finding it after it flopped off into the scrub—proved impossible. So, even though the advice became his opinion, he had failed his first test as a child and never really been tested as an adult. Now, before him, the horse rocked up and down in a slough of pain. Black ash still rained down from the red sky. Jimbo began desperately looking for something kindly.

JIMBO SEARCHED AROUND IN THE RUBBLE UNTIL HE FOUND A PIECE OF METAL SHARP ENOUGH TO DO THE JOB. HE DIDN'T KNOW HOW A HORSE WAS BUILT, BUT HE KNEW PEOPLE HAVE BIG BLOOD VESSELS IN THE NECK THAT KILL YOU IF YOU CUT THEM. HE THOUGHT HORSES MIGHT HAVE SOMETHING LIKE THAT. THE HORSE MIGHT'VE BEEN DEAD WHEN HE GOT OVER TO IT (IT WASN'T MOVING OR BREATHING), BUT HE DIDN'T THINK IT WAS COMPLETELY GONE.

FINALLY, HE JAMMED THE KNIFE INTO THE HORSE'S NECK AND CUT AS DEEP AND FAR AS HE COULD, AS IF HE WAS TRYING TO CUT ITS HEAD OFF; THAT'S WHAT HE WAS TRYING TO DO—HE DIDN'T HAVE NERVES TO KEEP CUTTING FOR LONG. WHEN AIR AND WATER SPEWED OUT OF THE HORSE'S NECK, THE HORSE WRENCHED AGAIN INTO MOTION, KICKING OFF ITS BACK, PUMPING ITS LEGS AND JUMPING OFF ITS OWN HEAD.

AFTER THAT, THE HORSE ONLY SHIVERED AND BREATHED FOR A WHILE  THEN STOPPED. THE HORSE WAS DEAD. DID JIMBO HELP, HE WONDERED? HE LOOKED AT THE OPEN WIND-PIPE, AT THE OPEN ESOPHAGUS, AT THE CUT BLOOD-VESSELS WITH BLACK BLOOD DRIPPING OUT, HE'D CUT THE VEIN, SO OXYGEN, MAYBE, WAS CUT OFF SOONER FROM THE BRAIN, BUT HE'D ALSO OPENED THE WIND-PIPE, MAYBE PROLONGED THE SUFFERING.

HE SAT DOWN THEN... HE DECIDED HE'D HELPED ENOUGH FOR ONCE. IT KEPT ON RAINING ASHES AND THE SUN WENT,

The succession of images comes to a climax on page thirty-one, which shows a single image of a young woman's face staring at us through the grid of nine panels wearing a crown of thorns.

This dense series of pages filled with obscure imagery demonstrates the progression of comics beyond character creation and storytelling. The form now can accommodate complex, historical narratives in graphic novels like *Maus* and epic poetry in oversize art books such as *Jimbo in Purgatory*. This leap in potential has led to an explosion of creativity, one that, in some ways, is as high as when McCay and Herriman were inventing the form. Though comics are no longer mass media on the same scale as movies, music, or video games, they remain a way for individuals to publish and distribute their work without the expensive and compromised process of the American entertainment industry or the high barrier of entry and limited audience of the fine art gallery system.

## 5
## Be Ware!—The New Comic Language of the Twenty-First Century

Over the past half century, American culture has been shaped more by visual information than by a direct experience of reality. In theory, media and modern technology were designed to make our lives easier and more efficient. But the result has been more unexpected and destructive, particularly in terms of personal and societal alienation.

This is partly why the comics made by Chris Ware (b. 1967) and Dan Clowes (b. 1961) have become so important over the past ten years. As Gary Panter put it in a recent interview, Ware has become "a one-man *RAW*," drawing, designing, and publishing his own comics as *The Acme Novelty Library*. The two most substantial bodies of work within that series so far—*Jimmy Corrigan, The Smartest Kid on Earth* and *Quimby the Mouse*—have been reprinted to great acclaim as standalone volumes.

Clowes's comic books are called *Eightball* (fig. 157). His most celebrated series within those books to date is *Ghost World*, a low-key humorous account of two teen girls (made into a movie by Terry Zwigoff). Clowes's work builds on Crumb's detailed representation of the world around him into canny slice-of-life anecdotes that sum up not only how people look and move but also how they feel in a way that is almost entirely hidden in mass culture. His work is perfectly suited for filmmaking because it is already like a storyboard in which characters act out and speak dialogue in a comparatively linear fashion. Recent versions of *Eightball* have transformed that approach to a narrative version of Cubism in which a variety of styles and authorial points of view combine to tell a story in many dimensions.

Ware's work goes the furthest among the new generation of cartoonists in creating a new language of expression altogether, one that combines different points of view and then brings them

**157** Dan Clowes
Cover of *Eightball* #23
(published 2004)
12 x 9 inches
Private Collection

together through the overall design and publication of his work. Ware's comics express emotional content through form and design more than just story or dialogue. His work builds on Spiegelman's development of the formal language of comics as much as Clowes's work builds on Crumb's psychosocial storytelling.

Ware uses his obsessive control over every aspect of the printed page to expand on Spiegelman's early insight that comics about "nothing" can be as interesting as traditional comics built upon action or underground comix with explicit depictions of sex and drugs. Spiegelman's *Don't Get Around Much Anymore* was a relatively obscure one-page comic in 1973, but it prefigured what was to come in a dramatic way. By drawing a comic in which nothing happens, Spiegelman echoes the tactics of nineteenth-century French novelist Gustave Flaubert, who described his novel *Madame Bovary* as a book about nothing.[112] In both instances the artists wanted to call attention to form and away from the story. They also wanted to show how form is a creative tool to express ideas and emotions as much as story or character.

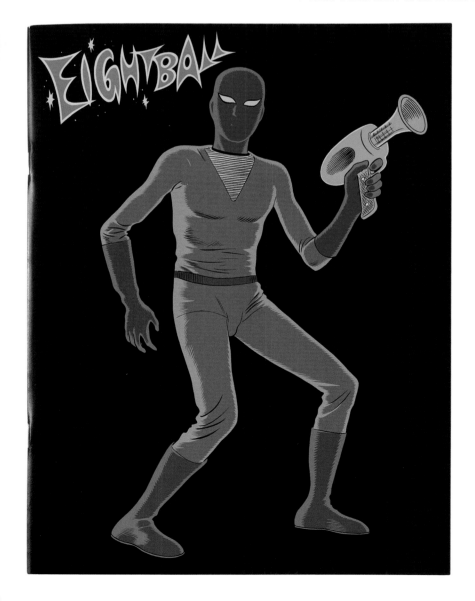

**158** Art Spiegelman
Drawing for *Don't Get Around Much Anymore*
(published 1973)
Pen and ink, brush, zipatone, and collage, 20 ½ x 16 ¼ inches
Collection of the artist

---

**159** Chris Ware
Drawing for paperback edition of
*Jimmy Corrigan, The Smartest Kid on Earth*, 2002
Pen and ink with brush, colored pencil, and opaque white
14 x 32 inches
Collection of the artist

Chris Ware's work falls squarely within the same tradition. He explains: "*Gasoline Alley* changed a lot of my thinking about comics. It made me realize that the mood of a comic strip did not need to come from the drawing or the words. You got the mood not from looking at the strip, or by reading the words, but from the act of reading it. The emotion came from the way the story itself was structured."[113] Ware highlights how the formal language of comics can create a sophisticated way for readers to experience difficult ideas and emotions by reading a formal arrangement of pictures.

Flaubert did more than call attention to the form of the novel in *Madame Bovary*; he also wrote a book in which the main character's life was altered by reading. She starts to believe the romantic clichés of pulp fiction more than the reality of the life around her and, as a result, makes decisions that alter the course of her life in a tragic way. In much the same way, the main character of *Jimmy Corrigan*

160 Chris Ware
Cover of *The Acme Novelty Library* #8
(published 1996)

is informed and misinformed by comic books in a modern update of Flaubert's approach to fiction.

Ware uses form and design to build on comics tradition and to find new ways to tell stories and reveal human emotions that are appropriate to his generation. In other words, Ware's abstractions, combinations of apparently ephemeral elements, and leaps of logical continuity are all part of how people now experience the world around them. Ware uses the history of comics as a kind of thumbnail lesson about how our experience of the world is determined by preexisting images as much as what we see through our eyes.

The story of Jimmy Corrigan is Ware's own story, but mediated and processed through imagery much like all of us sift through memories and images from pop culture to explore and define our own identity. Ware and Jimmy were both abandoned by their fathers when they were very young and then met them briefly in later life without resolving anything before their fathers died. The sadness behind this disconnect is played out as much in the way the form of the story breaks down time into discrete elements as in the psychology of

the characters. In the same way, that psychology itself is conditioned and mutated by the character's experience of reading comic books as well as the author's experience of making them.

Ware's work blends the kind of naturalism he experienced as a boy through Frank King's work and the abstract use of the intrinsic elements of printed comics he saw in Spiegelman's work. A simple example of this is how Ware uses narrative conventions of comics storytelling such as "later," "much later," and "but," as well as marginal detail

161 Chris Ware
Drawing for *Jimmy Corrigan, The Smartest Kid on Earth*
1994–99
Pen and ink with brush, colored pencil, and opaque white
23 3/4 x 15 inches
Collection of the artist

directly addressing the reader in an ironic way that never lets us forget we are reading comics. We don't get lost in the story the way we do in Spiegelman's *Maus* or Crumb's comics. In that sense Ware is closer to Panter, who expresses himself through

AND SO.

OUR VACATION...

TWO YEARS AGO.

And so, on the first warm day of our New Year...

THUS.

**162** Chris Ware
Drawing for cover of
*The Acme Novelty Library* #15, 2001
Pen and ink with brush, colored pencil, and opaque white
30 x 36 inches
Collection of the artist

**163** *top:* Chris Ware
Drawing for cover of
*The Acme Novelty Library* #10, 1998
Pen and ink with brush, colored pencil, and opaque white
18 x 30 inches
Collection of the artist

**164** *bottom:* Chris Ware
Drawing for hardcover edition jacket of
*Jimmy Corrigan, The Smartest Kid on Earth*, 2000
Pen and ink with brush, colored pencil, and opaque white
24 x 36 inches
Collection of the artist

the character of his line and the way in which his pictures almost fight with each other rather than resolve into a pleasing pattern. But Ware does so in a much quieter and reflective way, one that is about his own experience of the world rather than a projection into a fantastic futuristic environment.

The January 24, 2003, page from *Rusty Brown* illustrates how Ware takes the form of old comics and transforms them into something new. The page is laid out like *Little Nemo*, except instead of waking up from a fantastic dream, the main character is shown in the last panel crying in bed wearing superhero pajamas. The preceding scenes are shown from above in a style Frank King used from time to time. Ware also uses the shape of tree branches and giant snowflakes in the same way that King combined natural forms with printed patterns on the page. But Ware brings out the sadness and emptiness of contemporary experience in a way that never came to the surface in King's work. The conventions of the comics have become ironic symbols of the artist's mature ability to create a beautiful page, but remains crippled by the experiences of childhood. In place of nostalgia, Ware represents painful mem-

ories of youth with the same psychological overtones as *Peanuts* but without the saving grace of humor. In fact, the design of Jimmy Corrigan's face can be seen as an ironic play on Charlie Brown. They are both defined by almost perfect, circular outlines with a minimum of pen lines, indicating a broad range of emotions. But whereas Schulz's character is a child caught between wonder and worry, Ware's character is an adult caught in a child's body whose illusions have lost their charm.

The superhero costume as signifier of lost illusions is a major component of the more complicated storytelling in *Jimmy Corrigan* (see figs. 167–170). The image first appears on the third page. Jimmy puts on a red eye band as he gets ready to go to an automobile show with his mother. The final panel on the page shows the same eye band on a poster advertising "Meet the Super-man!" On the fourth page we see the man is not really super at all. In fact he hits on Jimmy's mom and comes home with them. The page ends with Jimmy in bed like Little Nemo, though one did not imagine that Little Nemo had a single mother, much less that the strange men she brought home would interrupt his dreams. This first sequence in the *Jimmy Corrigan*

book ends with the man sneaking out of the house the next morning, running into the boy eating breakfast cereal. Before the man leaves, he gives the boy his superhero mask. The last panel shows Jimmy wearing the mask, telling his mom that the man "said to tell you he had a good time!"

Although the form of Ware's comics recalls the lost elegance of Herriman and King, his content is distinctly contemporary. Jimmy's experience could never have happened in newspaper comics. And the exquisite way they are designed and published differs from other comic books. Ware has found a way to balance the unrequited longing of his main character for both his father and the lost innocence of youth by using the form of comics as a vehicle for his own artistic expression. This is not ironic, but truly tragic.

A few pages later the superman image reappears as a tiny figure on top of an office building much like the ones McCay loved to draw. In the second panel he is shown splat on the ground. Another less-than-super man. The same buildings reappear in the two pages of the book just before the final

epilogue. Jimmy is on the sidewalk beneath them in the snow. The facing page shows the buildings from Jimmy's point of view and repeats the same image twice. This is a device Ware uses throughout the book to punctuate and control the sense of time as a conscious manipulation of the act of reading. Jimmy sees within the book as we the reader see the book. We are both processing difficult information unresolved in ways we have been led to believe fiction (and comic books) should behave.

Jimmy's search for his lost father is deliberately confused with his comic book fantasies. And the fact that the character is so clearly an avatar of the author, who has grown up to create some of the most celebrated contemporary comics, makes the book's formal layers work on an emotional level

**165–166** Chris Ware
Two pages from
*Jimmy Corrigan, The Smartest Kid on Earth*
(published 2000)
Each 6 ½ x 7 ¾ inches

as well. But this is not cathartic, like typical comic books. Ware does not let us get lost in his fiction or even dream along with his characters. He always makes us conscious that we are reading and processing information, making us collaborators in the fiction, rather than passive consumers of it.

When Panter spoke about keeping the mistakes in his work, he meant that he wanted to make his work as discontinuous as the world he lives in. He needed to create a new form of realism, one that did not create the false sense of control that the comic books that Jimmy Corrigan read did. The world we live in is a collage of different types of information—a mix of optical perceptions from everyday reality mixed with iconography on screens and in print that is often far more seductive and easy to remember. Ware's work is about the disjunction between those layers. In fact, he re-creates that experience in the design and layout of his comics, which is part of what makes them such an important expression of what it is like to be alive in the early twenty-first century.

In 2004 Ware edited and designed a special issue of *McSweeney's Quarterly* devoted to the best of contemporary comics. It was a loving tribute to the genre and the best compilation since the heyday of *RAW* in the 1980s. A decade and a half later comics are thriving. Cartoonists such as Crumb, Spiegelman, Panter, and Burns are still producing great innovative work, while younger artists such as Chester Brown, Lynda Barry, Dan Clowes, Julie Doucet, Debbie Drechsler, Gilbert Hernandez, Jamie Hernandez, Ben Katchor, Kaz, Richard McGuire, Mark Newgarden, Joe Sacco, Richard Sala, Seth, Adrian Tomine, Jim Woodring, and Ware continue to make work that proves comics are among the best genres for self-expression in America.[114] It no longer matters who you are, but only how good your work and vision are to be published, read, and inspiring to the next generation of comics creators and readers lurking out there in basements and bedrooms across America.

*******

167 Chris Ware
Page from *Jimmy Corrigan, The Smartest Kid on Earth*
(published 2000)
7 3/4 x 6 1/2 inches

168–169 Chris Ware
Two pages from *Jimmy Corrigan, The Smartest Kid on Earth*
(published 2000)
Each 7 3/4 x 6 1/2 inches

170 Chris Ware
Page from *Jimmy Corrigan, The Smartest Kid on Earth*
(published 2000)
7 3/4 x 6 1/2 inches

171 Chris Ware
Sketchbook page, 1995
Pen and ink, watercolor and colored pencil
12 x 9 inches
Collection of the artist

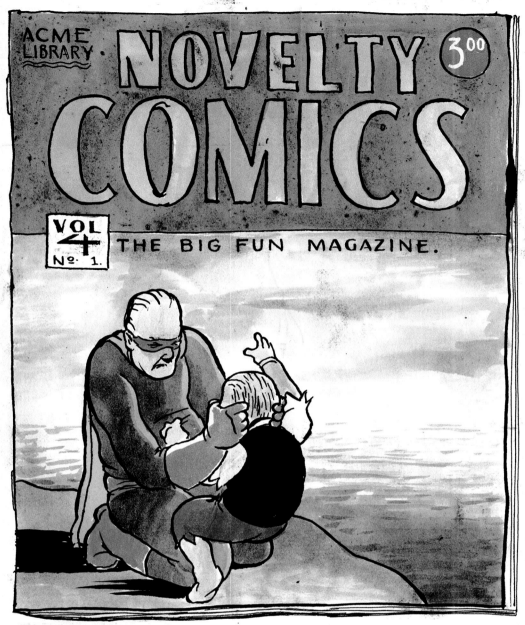

**ACME LIBRARY**

# NOVELTY COMICS

**3.00**

**VOL 4 No. 1** — THE BIG FUN MAGAZINE.

← 24 pages 'ACME NOVELTY LIBRARY' "#4"—
ALL "BLAB" stuff in full color
— published by Kitchen Sink?

— IS ACME #1 ever reprinted,
redo the cover in one color—?

WARMTH IN 1988 comics
STILL MISSING—
how to get it back?

10/30 — spent entire day trying to work on
strip — going to do one on just trees, birds,
with assemblage of old Jimmy logos at the
bottom — intended to utilize top half preceding
the civil war episode — but once finished, it all
looked so bad I trashed it all and set up to
rerun 'C. Burns'-looking Quimby from 1991 I
can't believe I wasted the whole day— tense,
gross feelings amplified by my hangover...
too much to do before I go to phoenix. Will use
'bird' strip as first page in 4th issue — doesn't
seem as rythmically necessary before p. 90,91
now as it did, though it might later—.

glass globe.

knob same as noses.

QUIMBY THE MOUSE

SPARKY THE CAT

ROCKETS

ROCKET SAM

JIMMY CORRIGAN,
THE SMARTEST KID ON EARTH

glass lens.

no eyes-
frown

Squatter

GOD

## ACME WOODEN FIGURINES

TISSUE PAPER

QUIMBY the MOUSE

CHEAP SHIT PACKAGING

ACME

ALL HAVE SOME
LABEL ON THEM — on feet?
SOME W/ NAMES
PAINTED ON THEM, TOO—

**WE ARE SORRY,**
BUT 'SPARKY THE CAT'
IS NOT SOLD SEPARATELY.

After a century of creativity and popular acceptance comics have become a central part of American culture and a significant form of American art. In the early days the art was hidden in the guise of popular amusement. Nonetheless, cartoonists such as McCay, Herriman, Segar, King, and Gould found ways to develop the form of their art and express themselves in the pages of daily newspapers, even if their work was disposed of almost as quickly as it was read. In the comic book era, comics became collectible and were saved and eventually cherished for their original drawings. But censorship and mass appeal often compromised personal expression.

By the 1960s cartoonists such as R. Crumb were able to take advantage of a growing youth culture market and liberal censorship laws to produce comic books that showed and said exactly what they wanted. Underground cartoonists also began to create a sense of history by re-creating older styles of cartooning in their drawings and by reprinting original comics by Herriman and McCay for the first time. Over the past quarter century, comics have grown into an important genre for creative expression, with artists in America and around the world working at a level of personal accomplishment and public acceptance equal to any other form of art or popular culture.

Art Spiegelman's most recent book, *In the Shadow of No Towers*, is a perfect summation of the art history of comics and what it is capable of expressing about contemporary American culture. The first half of the book consists of ten large-format color pages in the style of old-fashioned newspaper comics. But the story is about the author's experience in and reaction to the terrorist attack on New York City on September 11, 2001, a few blocks from where he lives and works.

Almost two decades after *Maus*, Spiegelman was confronted with another subject that seemed too complex and painful for his art, a subject that was about him and his family in the present, rather than recovering something lost in the past. Comics have changed in part because of the success and influence of *Maus*, but also because changes in technology, particularly digital image processing through computers and applications like PhotoShop, made the multilayered collages that Spiegelman pioneered a ubiquitous part of contemporary American culture.

Spiegelman himself now assembles and creates the final version of his work on a computer. There are no "originals" other than the final printed page. And the ability to manipulate his drawings and arrange them digitally has expanded what he is able to do. As a result, each page in *No Towers* is so dense with information and allusions that it is a self-conscious antidote to the escapist entertainment that newspaper comics (and most pop culture in America) have become.

The first page shows the attack. The series of images makes it clear that Spiegelman saw the planes hit the tallest buildings in Manhattan with his own eyes and not on television or the Internet. At the same time, the page is filled with traditional eyeball kicks (visual explosions, as it were) that link the tradition Kurtzman perfected in the 1950s to how Spiegelman is able to process and deal with the realities of his own time.

By page three Spiegelman is back in his mouse persona directly referring to his father's experience, tying Vladek's attempt to describe the smoke in Auschwitz to the smoke in lower Manhattan sixty years later. Page four begins to weave older comic strip characters into the mix as well as a variety of visual styles to try and capture how the moment felt to the artist rather than merely how it appeared in other forms of media. The pastiche of styles reaches beyond cartooning and illustration on page four to show a loosely drawn version of the famous image of *The Gleaners* by the nineteenth-century French painter Millet. Here, instead of working peasants, Spiegelman shows us Americans hiding their heads in the sand with targets on their behinds. The allusions and meditation on how to represent reality grow in density and difficulty as the series progresses. On page eight, Art and Françoise morph into Maggie and Jiggs from *Bringing Up Father*. The page ends with an image of the artist as Ignatz (another mouse) holding a World Trade Tower-shaped brick while a New York City cop version of Pupp looks on and Krazy Kat sings a line from Kris Kristofferson's "Me and Bobbie McGee:" "Freedom's just another word for nothin' left to lose...."

The final page shows two towers of comic book panels. On the left Art morphs into a very un-Happy Hooligan and shows how the seemingly benign comic violence has become all too real. The tower of panels on the right explodes into a large middle panel, with cowboy boots falling from the sky as a symbol of how the Republican Party, led by a faux Texan, George W. Bush, has co-opted the tragedy as a way to maintain its political power. Spiegelman illustrates that American politics is as much in the business of symbolism and media as art or comics.

The panel shows Art and his family running in terror, with his daughter Nadja (who was at school near the towers when they were hit) wearing an R. Crumb T-shirt that she had on that day. On the front, Crumb's character Mr. Natural explains: "The whole universe is completely insane!" Behind Spiegelman's family is a crowd of cartoon characters rushing along with them—including Uncle Walt, Little Annie, Wimpy, Charlie Brown, and a terrified Hooligan. Small print to the side reveals that some of the panel was drawn by Crumb while Spiegelman's family was staying at his house in the south of France. The final three panels show the tower in the digitally processed style of the first page, fading to black. The text explains that they now both loom larger than life and "seem to get smaller every day."

After this ten-page tour de force of personal expression and comics language exploding in on itself, Spiegelman reprinted seven original comic strip pages as close to their original size and color as anyone has ever done.[115] The first is a page from Feininger's *The Kin-der-Kids*, showing the Kids sailing on a tugboat into New York harbor with the Statue of Liberty waving a white flag behind them. The second-to-last reprint is a page from *Little Nemo* showing Nemo as an enormous figure wandering through the lower Manhattan towers where McCay worked and New York newspapers were published, a few blocks from where the World Trade Towers once stood. By combining the past and present, Spiegelman demonstrates how comics have survived and grown to become one of the preeminent ways to express what it was like to live in America over the past 100 years.

**172** Art Spiegelman
Page from *In the Shadow of No Towers*
(published 2004)
19 7/8 x 14 3/8 x inches

## Notes

**1** The standard definition of comics is a narrative sequence of printed drawings featuring a continuing cast of characters that tell an incident, situation, or story in pictures (and usually words) over a short but noticeable span of time. The term "comics" is used here to indicate both newspaper comic strips (typically printed daily in black and white with a larger, color Sunday page) and comic books (typically printed, distributed, and sold separately or republished in book form rather than distributed as part of a larger newspaper or magazine). In that sense, the term "comics" has become like the term "jazz," which connotes a broad-based genre of creative and popular expression.

**2** It is also important to remember that the men who drew comics were among the highest-paid artists and entertainers in America. Cartoonists were routinely drawing salaries in excess of $100,000 a year in the 1920s. Only major movie stars, professional athletes, and industrialists were making more money at the time.

**3** Lyonel Feininger was the only other artist of this era to approach McCay's formal genius, but Feininger only drew his two comic strips for less than a year, April 29, 1906– January 20, 1907, and did not have the same impact on comics and American culture.

**4** The transitional figure in this regard was Will Eisner, whose comic supplement *The Spirit* was distributed in newspapers. *The Spirit* also set the stage for the comic book era in terms of its complex layouts, expressive backgrounds, and adult themes.

**5** Kirby co-created most of his work at Marvel with the editor and writer Stan Lee. In the mainstream comic book era, the finished work was often the product of a team of creative people. Kirby was clearly the lead, but Lee helped create situations and characters and several talented artists inked and colored Kirby's pencil layouts.

**6** Kurtzman did write and draw some of his work, but typically he created scripts and pencil layouts that were embellished by a talented crew of graphic artists, notably Will Elder, Wally Wood, and Jack Davis.

**7** Hogarth's sequential narratives and later studies such as *The Analysis of Beauty* consolidated the graphic experiments of earlier prints and established a complex language of graphic devices that artists have borrowed from ever since.

**8** Charles Dierick and Pascal Lefevre, eds., *Forging a New Medium* (Brussels: VUP University Press, 1998), 90.

**9** Thierry Groensteen has been the most convincing advocate of Topffer's pivotal role. See e.g., "Topffer, the Originator of the Modern Comic Strip" in *Forging a New Medium*, 107–8. He writes, "In the search for a hypothetical inventor [of the comic strip], I believe…that one can find a degree of consensus on Rodolphe Topffer…. Topffer's work represents a decisive break with older formats and…he initiated a new form of expression which has continued until the present which we now call the comic strip." Groensteen also notes that Topffer's only references to antecedents were "to the engraving of William Hogarth and the broadsheets." Ibid., 109.

**10** He did occasionally lay out stories in sequential panels on the page, such as an illustration from November 11, 1871, that depicts the "political suicide" of an unlucky politician.

**11** Frost began publishing in *Harper's*, *Punch*, *New York Graphic*, *Puck*, and *Life* beginning in the 1870s. His use of motion effects was directly influenced by Eadweard Muybridge's scientific experiments with time-lapse photography.

**12** Blake was one of the first modern artists to integrate images and texts in a truly synchronized fashion. He states the case in an advertisement describing his self-printed books as: "… a method of Printing which combines the Painter & the Poet … a phenomenon worthy of public attention, provided it exceeds in elegance all former methods…." Goya's work is pertinent to the art history of comics because he devised new graphical means to express social and psychological themes that elevated caricature into a truly expressive medium.

**13** Charles Baudelaire, "On the essence of laughter, and, in general, on the comic in the plastic arts," first published July 1855. In, *The Mirror of Art: Critical Studies by Baudelaire*, Jonathan Mayne, trans. (New York: Doubleday, 1956), 131–53. Grandville's use of jarring juxtapositions became a staple of early filmmakers such as Georges Méliès as well as cartoonists throughout the twentieth century from Herriman's *Krazy Kat* through Art Spiegelman's *Maus*. A series of Doré's illustrations, *London: A Pilgrimage*, were serialized in *Harper's Weekly* in 1872, which made them directly available to Thomas Nast and other influential American illustrators whose work paved the way for twentieth-century American comics. Before he became a famous illustrator, Doré made some interesting sequential works such as *Histoire de la Sainte Russie*. The book is crammed with inventive graphic gags such as a page filled only with a blot of red ink purporting to tell the story of Ivan the Terrible as well as sequential drawings as action-packed and witty as anything produced in the twentieth century.

**14** By the end of the nineteenth century a number of American humor magazines, notably *Puck*, *Judge*, and *Life*, developed the panel cartoon and encouraged the talents of many pioneer comic strip artists. These magazines also began printing sequential drawings in pantomime, or with captions, to convey simple, discrete actions. One of the earliest American artists to use sequential drawings was Frank Bellew, around 1880, in *Judge*. In the 1890s this aspect of cartooning became somewhat commonplace in the hands of F. M. Howarth, for *Puck*, and E. W. Kemble for *Life*. *Wild Oats*, as early as 1872, featured sequential comics by Bellew, Opper, Palmer Cox, and many other leading artists of that time.

**15** Outcault did use sequential panels and word balloons from time to time, but *The Yellow Kid* was typically a large crowded single tableau with text interpolated onto the Kid's yellow shirt. In the first color episode on May 5, 1895, the Kid's nightshirt is blue.

**16** Outcault's first drawing of the character who was to become the Yellow Kid appeared in *Truth* magazine on June 2, 1894. The first appearance of this character in Pulitzer's *World*, on February 17, 1895, was a reprint of a cartoon from eight days earlier in *Truth*. In 1893 the World first printed a four-page weekly supplement called the "Youth's Department." However, the first continuing newspaper comic strip is typically considered James Swinnerton's California Bears, which started in William Randolph Hearst's San Francisco Examiner in 1892, although it was not technically a comic strip. The first regular newspaper comic strip series printed in color in America is typically considered *The Ting Ling Kids* by Charles Saalburg in the *Chicago Inter-Ocean* in 1894. See Brian Walker, *The Comics Before 1945* (New York: Harry N. Abrams, 2004), 7–8.

**17** The Chicago Inter-Ocean published a comic supplement in 1892. Hearst's *American Humorist* debuted on October 18, 1896.

**18** Cited in Bill Blackbeard, *R. F. Outcault's The Yellow Kid* (Northampton, Mass: Kitchen Sink Press, 1995), 63.

**19** In 1912 Dirks left the *New York Journal* for Pulitzer's *World*, reversing Outcault's move over a decade earlier. Court battles ensued between the two giants of yellow journalism and the feature eventually split into two versions that ran concurrently for decades. Hearst retained the title and enlisted Harold Knerr to draw it in 1914. Dirks continued his characters Hans and Fritz under the title *Captain and the Kids* for Pulitzer. Whatever the title or the artist, *The Katzenjammer Kids* was the longest running and best remembered of the early comics features.

**20** *Happy Hooligan* first appeared on March 11, 1900, and the comic strip ran until August 14, 1932.

**21** The modern tabloid newspaper was introduced in America in 1919, Joseph Patterson's *Illustrated Daily News*.

**22** The definitive study of McCay's life and work is John Canemaker's *Winsor McCay: His Life and Art* (New York: Abbeville Press, 1987).

**23** Donald Crafton in *Before Mickey* links Sammy's sneeze with Fred Ott's, the famous and humble activity Edison chose to record in one of the first American moving pictures.

**24** The Ash Can was the first major twentieth-century art movement in America. Its leader was Robert Henri, and the group included John Sloan, George Bellows, and George Luks. See, Rebecca Zurier, Robert W. Snyder, and Virginia M. Mecklenburg, *Metropolitan Lives: The Ash Can Artists and their New York* (New York: National Museum of American Art, 1995). Ms. Zurier's contribution, "The Making of Six New York Artists," shows how the Ash Can painters began their careers as illustrators for various Philadelphia newspapers between 1890 and 1905. She also shows how the focus of their work was "sketch-reporting," which led to the immediacy of their realistic paintings made in New York shortly thereafter.

**25** Prior to the Armory Show, Alfred Stieglitz exhibited work by European modernists such as Picasso in his gallery 291. However, the influx of European art and artists did not hit full swing until after World War I, when many significant artists, notably Marcel Duchamp, began living and working in New York.

**26** The only time that McCay actually wrote about art was in a book by fellow cartoonist Clare Briggs called *How to Draw Cartoons*. McCay declares: "A man might go out and paint a beautiful landscape or a beautiful picture of the human figure, but he is copying nature. Men who paint or draw from life…are merely copying what they see. They are called artists. The cartoonist must create, he must see in his mind a situation…. He must draw it with all the feeling in him—without modes or other aids that artists call to hand."

**27** This is the point that Art Spiegelman makes by reprinting early Sunday comic strips in his book *In the Shadow of No Towers* (New York: Pantheon, 2004). In a world fraught with terror, Spiegelman found comfort and inspiration in the seemingly ephemeral printed paper upon which his medium was born and which had survived longer than the lifespan of a human being.

**28** During the time McCay drew *Little Nemo* and *Dream of the Rarebit Fiend*, he worked in the same office building in which newspapers were typeset and printed. It is clear from looking at the original newspaper pages that McCay must have collaborated directly with the printers who created the color separations from which his comics were printed because there is so much shading and nuance within the colored areas as opposed to just the line art. Comics are typically printed from black-and-white line art drawn by the artist and submitted to the newspaper (or syndicate) that makes the plates from which the printed pages are made. Color is typically added at that stage and is indicated only by words, but not drawn, on the cartoonist's original drawings. Very few artists in the history of newspaper comics had direct control over the color of their pages other than to indicate what color should be printed and where in relation to the black outlines. Most cartoonists do detailed color guides, often on tissue overlays, to instruct the printers (or color prep people) how they want their comics colored.

**29** *The Kin-der-Kids* is perhaps an intentional version of the popular *The Katzenjammer Kids*. Whereas Dirks's characters wreaked havoc on whatever institutional authority came their way, Feininger's characters were victims, chased around the world in a series of suspenseful madcap excuses for his play of colors and forms.

**30** The *New York Evening Telegram* began printing regular political cartoons in 1867.

**31** Editorial cartoons for the most part remained panel illustrations until midcentury when Jules Feiffer began to use sequential drawings in a political context, although many early twentieth-century political cartoonists experimented with multipanel, "comic strip style" layouts. Garry Trudeau has followed him most spectacularly, but this is a late development in the overall history of the comics.

**32** Herriman probably first met TAD while working together on Hearst's *New York American* in 1904.

**33** There is an original drawing for a sports cartoon that Herriman did around 1908 (reprinted in Patrick McDonnell, *Krazy Kat: The Comic Art of George Herriman* [New York: Harry N. Abrams, 1986], 48) that shows the direct influence of this image by TAD, but also how Herriman needed a few more years for his original style to fully mature.

**34** Clare Briggs's *A. Piker Clerk* is considered one of the first daily sports comic strips, although it ran intermittently and only for a short period of time in 1903. Another feature about racing, *A. Mutt,* drawn by Bud Fisher beginning in 1907, became fabulously successful after Mutt picked up Jeff in a madhouse in 1908.

**35** Ansel Kellogg pioneered newspaper syndication in America in the 1860s. Comics were distributed by newspapers and syndicates almost from the beginning, in 1895.

**36** *Krazy Kat* was actually the subject of a well-received ballet first performed in 1922 with music composed by John Carpenter.

**37** Images of New Mexico and the American Southwest around the tribal culture of the Hopi and Navajo tribes became part of the American avant-garde and popular iconography beginning in the 1920s largely through the influence of Mabel Dodge. She was a wealthy arts patron and newspaper columnist who moved to Taos, married a Native American, and invited a number of artists and intellectuals to join her, notably Georgia O'Keeffe, who stayed with Dodge in 1929 and eventually came to live full time in the area. James Swinnerton was the artist who most likely influenced Herriman to use Native American patterns and Southwest landscape imagery in his work. Swinnerton was one of the most important of the first generation of comics artists who created a memorable feature for Hearst called *Mt. Ararat* (1899), whose animal creatures are halfway between Grandville and *Krazy Kat*. Swinnerton was diagnosed with a lung condition and moved to California for his health and visited the desert often. He created a magazine comic feature called *The Canyon Kiddies* that had lovely, but more literal, depictions of the Southwest desert than *Krazy Kat*.

**38** The same can be said for how Charlie Chaplin structured his gags. See *Unknown Chaplin*, a BBC documentary film from 1983, directed by Kevin Brownlow and David Gill.

**39** "*Krazy Kat*, the daily comic strip of George Herriman is, to me, the most amusing and fantastic and satisfactory work of art produced in America to-day…. Mr. Herriman, working in a despised medium, without an atom of pretentiousness, is day after day producing something essentially fine." Gilbert Seldes, *The Seven Lively Arts* (New York: Sagamore Press, 1924), 207.

**40** Segar invented the words Jeep and Goon.

**41** Bill Blackbeard, "Popeye Noir: How E. C. Segar Brought Black Comedy to the Comic Strip and Created a Mythic Hero," in Mike Higgs, ed., *Popeye* (Edison, N.J.: Chartwell Books, 1995).

**42** The horse was nicknamed "Sparky" which inspired a young reader named Charles Schulz, who was called Sparky by his family and friends throughout his life.

**43** George McManus was another of the great artists who began their careers in the first decade of the twentieth century. His first important feature was *The Newlyweds* (in 1904 for Pulitzer), also known by the titles *Their Only Child* (in the 1912 Hearst version) and *Baby Snookums*. Some of McManus's early creations such as *Nibsy the Newsboy in Funny Fairyland*, 1906, and *Spare Ribs and Gravy*, 1912, were extremely well drawn strips that showed that he was the only early cartoonist whose drawing skill came close to Winsor McCay's.

**44** In 1922, Smith signed a million-dollar contract guaranteeing him $100,000 a year for ten years. This salary put him on par with the most highly paid men in America at a time when there was no income tax. In 1935 he got a raise to $150,000 per year. Unfortunately he died in a car accident shortly after signing the new contract. See Walker, *The Comics Before 1945*, 188.

**45** In 1903, Edwin Porter, working at the Edison Studio in northern New Jersey, developed the first effective use of crosscutting and close-ups to create a sense of excitement from the intrinsic language of film and not just the pictures it recorded. At the same time, across the Hudson River in the Vitagraph Studio near Sheepshead Bay, New York, Winsor McCay established a way for comics to create a similar sense of mood through formal composition. In fact, McCay went much further than Porter in developing a full language of formal expression and it would take more than a decade for D. W. Griffith to do the same for film.

**46** In a daily strip there are anywhere from one to six panels, with four being the norm. The classic framing technique begins with a large picture to establish the scene, then follows with two narrow pictures (the height rarely changes because of industry standards), which intensifies the action or suspense like a rapid cut in film editing. Another large picture then concludes the day's action and gives it a sense of closure. The combination of multiple images in sequence produces an emotional impact that is greater than an individual image in isolation. This is how filmmakers and cartoonists draw their audience into feeling the inner life of their characters rather than just looking at how they appear. The basic Sunday format in the early days of comics was 3 x 4-inch rectangular panels covering the entire page. In addition there is often a narrow title panel that runs across the top of the feature to advertise its content, and sometimes a secondary "topper" strip by the same artist, such as the cartoon lessons or *Sappo*, which Segar drew in addition to *Thimble Theatre*. This reduced the main feature to 3 x 3 panels.

**47** Most filmmakers and cartoonists use a seamless form of editing that does not call attention to itself. D. W. Griffith (and his primary film editor, Jimmy Edward Smith) are typically given credit for developing this approach. In Europe a number of filmmakers, notably Dziga Vertov and Sergei Eisenstein in Russia and Abel Gance in France, developed a different approach to editing that is more obvious and calls the viewer's attention to the construction of the medium they are watching. This style of editing is typically referred to as "montage." In comics, one can make a similar distinction between most cartoonists such as Frank King and Milton Caniff, who "cut" between pictures to provide logical continuity and others such as George Herriman, Art Spiegelman, and Chris Ware, who use form to layer additional meaning into the experience of reading their work.

**48** A more methodical semiotics of comics would break the elements of cartooning down into pictures, designs, and text. Within pictures one would analyze characters, props, and backgrounds. Within design one would analyze the type of line work, use of color, and how objects are arranged within panels and across the page or pages. Within text one would analyze the type of prose used in dialogue, the type of sound effects indicated, and the style of lettering used by the artist and how that helps to indicate sonic characteristics such as mood and volume. Then, within each of those categories, one would add the rhetorical devices that each individual artist adds to the basic grammar of comics discourse.

**49** The strip was renamed *Captain Easy* after its most famous character, who joined the cast in 1929. The *Captain Easy* Sunday page debuted as an independent feature in 1933.

**50** In Herb Galewitz, ed., *Great Comics* (New York: Crown Publishers, 1972), xii.

**51** Tarzan did not begin as a comic feature, but as a fictional character created by Edgar Rice Burroughs. In 1928 (ten years after the first Tarzan movie had been made) the comic strip rights were bought and placed in the hands of an illustrator named Harold Foster. He drew sixty daily strips to test the feature's popularity. It was a commercial success and continued with Rex Maxon replacing Foster. In 1931 Foster was called back to do the new Sunday pages. Working in color in the large Sunday format, he developed the qualities that have made Tarzan a memorable part of comic strip history. By drawing Tarzan in what was at the time the most accurate figural rendering in the comics, Harold Foster gave his jungle king palpable reality. The combination of realism and fantasy, like Segar's earlier fusion of humor and adventure, worked amazingly well and set the tone of the comics for years to come. *Buck Rogers* was the creation of Dick Calkins, who drew it, Philip Nowlan, whose story "Armageddon 2419 A.D." inspired it, and John F. Dille, the publisher who put the team together.

**52** Art Spiegelman, "Comix: An Idiosyncratic Historical and Aesthetic Overview," in *Comix, Essay, Graphics and Scraps* (Rio de Janeiro: RAW Book, 1998), 77.

**53** Cited in, Ellery Queen, "Introduction," *The Celebrated Cases of Dick Tracy* (New York: Chelsea House, 1970), xvii.

**54** Ibid, p. xxvi

**55** Interestingly, after Tracy's success, an imitation strip, *Secret Agent X-9* drawn by Alex Raymond, was scripted by Hammett himself. Although it was never as popular as *Tracy* was it did bring more of the blackness associated with Hammett's fiction to the comics.

**56** Gould used so much black ink that he burned candles under the bristol board to help it dry. His originals often still have the smoky residue of the flames on the back.

**57** There were continuity narratives in comics such as *Krazy Kat*, which featured a long-running (and bizarre) sequence around the quest for "tiger tea" in the 1920s (often interpreted as a metaphor for marijuana). However, narrative continuity did not become the centerpiece of comics content until Segar and adventure strips such as *Terry and the Pirates* in the 1930s and 1940s. However, most humor strips of the 1920s featured a different kind of continuity. See *The Comics Before 1945*, page 121, for overview of continuity going back to *The Yellow Kid* in 1897.

**58** Sundays could still be read independently however, and anything that happened on Sunday was recapped on Mondays, for clients that didn't carry the Sundays.

**59** The rockabilly connection became literal when Jerry Lee Lewis made a big hit out of Snuffy Smith's famous expression "Great Balls of Fire." Thirty years earlier, Barney Google had been the subject of Billy Rose's hit "Barney Google with the Goo-Goo-Googley Eyes."

**60** See Walker, *The Comics Before 1945*, 186–87, and 291–92.

**61** Brian Walker, *The Comics Since 1945*, 72–74.

**62** Spiegelman, "Comix: An Idiosyncratic Historical and Aesthetic Overview," 72.

**63** This was particularly true of the New York poets through the work of Joe Brainard. Nancy remains a remarkably prevalent image in contemporary art, from Roger Brown's use of Nancy's Afro-like hair as bushes in many of his paintings to Vernon Fisher, Alexis Smith, and Karl Wirsum's post-Pop appropriations of this strange, out-of-touch, figure. See, John Carlin, "Nancy's Art Attack" in Brian Walker, *The Best of Ernie Bushmiller's Nancy* (New York: Henry Holt and Company, 1988).

**64** *Pogo* was full of self-aware gags that immediately let its readers know that these Disney-like kiddy creatures were involved in something strange, and not quite so straightforward. In one Sunday page from the fountain of youth sequence, Albert exclaims to Pogo, "If you ask me, this is a sloppy comic strip … imagine leaving out the mandolin!" Later in the same page, Albert inadvertently kicks Pogo into an empty treasure chest and then goes off to find the fountain alone. The next Sunday, Albert's nephew, who has been stowing away with his uncle and Pogo, pops out of the formerly missing mandolin. When he realizes he is alone, the nephew tries Albert's cigar and passes out from the smoke. Two other characters come by and mistake little Albert and Pogo's empty hat for a sign that they have undergone the overly powerful effects of the fountain and reverted back to an earlier state of existence. They sit down to mourn, and eat the sandwich they find in the crowded mandolin. The final panel reads, "Not the End." *Pogo* parodied every comic convention, while at the same time giving it new life.

**65** Jackson Pollock, taped interview with William Wright in the artist's studio in East Hampton, N.Y., 1950 and later broadcast on WERI radio, Westerly, Rhode Island, in 1951. Cited in Francis Valentine O'Connor and Eugene Victor Thaw, eds., *Jackson Pollock: A Catalogue Raisonné of Paintings, Drawings, and Other Works*, volume 4 (New Haven, Conn.: Yale University Press, 1978), 248.

**66** Technically the first comics books as opposed to strips were large bound reprints of features such as *Mutt and Jeff*, *Foxy Grandpa*, and *Bringing Up Father*. They never caught on nor found a standardized form. Reprint books of newspaper comics were very popular from the turn of the century on. It was not until the mid-thirties that the American comic book as we now know it came into being. *Funnies on Parade*, a promotional giveaway printed by Procter & Gamble in 1933, is considered the first. It consisted entirely of reprinted comic strip features, as did the first commercial comic book, *Famous Funnies*, sold by Eastern Color Printing Co. in 1934. In the next year Malcolm W. Nicholson began the first comic book that carried all original material, *New Fun*. The significance of these early comic books is not so much their contents as their form. Someone at Eastern Color had the bright idea of folding the Sunday-size color pages into four so that they were of a pamphlet size. This bit of economy meant that the comic books could be given a distinctive look without a basic change in the printing process. See, Ron Goulart, *Comic Book Culture* (Portland, Ore.: Collectors Press, 2000).

**67** Eisner explained how his background helped launch *The Spirit*: "I was running a show in which we made comic-book features pretty much the way Ford turned out cars. So perhaps the reason the *Register* and *Tribune* consented to distribute *The Spirit* in the first place was because I had demonstrated my ability as a producer…" Cited in Michael Barrier and Martin Williams, eds., *A Smithsonian Book of Comic Book Comics* (Washington, D.C.: Smithsonian Institute Press, and New York: Harry N. Abrams, 1981), 269.

**68** Ibid., 270.

**69** Superman was a unique manifestation of adolescent male fantasies in mid-twentieth-century America. Siegel and Shuster combined a love of pulp science fiction, comic strips, and their own sense of social alienation into a feature that every kid in the country could fantasize along with. Siegel explained it in exactly that way: "Clark Kent grew not only out of my private life, but also out of Joe's. As a high school student I thought that some day I might become a reporter, and I had crushes on several attractive girls who either didn't know I existed or didn't care I existed…It occurred to me: what if I were real terrific? What if I had something special going for me, like jumping over buildings or throwing cars around…? Then maybe they would notice me. That night…the concept came to me that Superman could have a dual identity, and that in one of his identities he could be meek and mild as I was, and wear glasses, the way I do. The heroine…would think he was some sort of worm; yet she would be crazy about this Superman character…In fact…the fellow she was crazy about was also the fellow whom she loathed." In, "Of Supermen and Kids with Dreams: A Rare Interview with the Creators of Superman," *NEMO* #2 (August 1983), 11. *Superman*'s popular success helped spawn a whole industry of imitators. Foremost among them was National Comics' own follow-up, *Batman*, created by Bob Kane and Bill Finger and which first appeared in *Detective Comics* #27 in 1939.

**70** Other than *The Spirit*, few early comic book artists experimented with the unique possibilities of the new format. The only variation from a 2 or 3 x 4 layout of panels on a page was to cut corners to meet the low budget and high demands of the early comic book industry. Large dramatic panels reduced the number that had to be drawn, and were prohibited by most publishers. Yet even under these strained circumstances, early comic book artists such as Jack Cole, C. C. Beck, Bill Everett, and Jack Kirby developed many of the effects that later grew to distinguish the genre. These included: varying frame width to give a sense of each "shot's" duration, enlarging panels to give dramatic emphasis, and giving the page or entire story a sense of closure by unifying its overall pictorial form. One of the favorite visual devices of the early comic books was using bold circular forms that played off the rectangular frame of the panel and page. Superman's first costumed appearance uses the sun like a halo around his head. Bill Kane used the same technique in the story of Batman's origins except he is framed by the moon, and not by the sun. Jack Cole was another important early comic book artist, among the first to make fun of its own conventions in a way that brought an ironic tone to comics before Harvey Kurtzman's *MAD*. Art Spiegelman's recent book about Plastic Man shows how virtually anonymous cartoonists like Cole created important bodies of work, much as film critics have revived the reputation of forgotten directors such as Samuel Fuller and Vincente Minnelli. Art Spiegelman and Chip Kidd, *Jack Cole and Plastic Man* (San Francisco: Chronicle Books, 2001).

**71** Jonathan Letham's *Fortress of Solitude* links Kirby's work with the birth of hip-hop in Brooklyn during the mid-1970s.

**72** Kirby described how he arrived at his characteristic style in a more pedestrian way: "Production pressure was overwhelming. I had to draw faster and faster, and the figures began to show it. Arms got longer, legs bent to the action, torsos twisted with exaggerated speed. My pace created distortions. I discovered the figures had to be extreme to have impact…" Cited in, James Steranko, *History of Comics*, vol. 1 (Reading, Penn.: Supergraphics, 1970), 53.

**73** The costume and name were so iconic that Peter Fonda and Dennis Hopper used it ironically for the character Fonda played in their quintessential hippie biker film *Easy Rider* in 1969.

**74** Cited in, Bob Callahan, ed., *The New Smithsonian Book of Comic Book Stories* (Washington, D.C.: Smithsonian Press, 2004), 9–10.

**75** Kirby and Lee had revitalized Marvel's fortunes in 1961 with the launch of *Fantastic Four*, which was a deliberate spin on the popular *Justice League* title at rival DC (home of *Superman* and *Batman*). DC was considered moribund at the time, but still sold well. In retrospect, some of the artists working there, notably Carmine Infantino, did some of the best comic book art of all time. Arlen Schumer's *The Silver Age of Comic Book Art* (Portland, Ore.: Collector's Press, 2003) devotes a chapter to Infantino that highlights his innovative work.

**76** The Thing was one of the most evocative of Kirby's characters. He was a literal version of the Jewish myth of the Golem, a creature made of mud who helps humanity in a complex and troubled manner. Kirby's talent as an artist and storyteller transformed this hulking creature made of earth into a surprisingly sympathetic and compelling character. The most evocative single expression of this was a story called "This Man, This Monster" from 1966. The comic book cover and title page show the Thing as a huge beast filling the entire frame. But his expression and the graphic treatment of the rainy downpour he endures give the character a sense of humanity and vulnerability that most superhero characters lack.

**77** In the late 1960s and 1970s Marvel remained the most innovative and interesting mainstream comic book publisher. Jim Steranko's work, in particular, took aspects of Kirby's style and pushed it to the limit. In *Nick Fury*, Steranko explored the postmodern potential of comics in a way that was ignored to a large degree in the mainstream comic book industry except in the work of Neal Adams, and until Frank Miller and Los Bros Hernandez began experimenting with the formal structure of comics again in the 1980s and 1990s. By the end of the twentieth century it was difficult to maintain the boundaries between American and international comics. The two most creative mainstream comic book creators were Alan Moore and Neil Gaiman, both of whom were British, but created work such as *The Watchmen* and *Sandman*, respectively, that was influential and popular throughout the world.

78 The comic book industry is not exclusively devoted to adolescent fantasies acted out by over-muscled super-heroes. Throughout its history it has also catered to a younger audience through funny books like *Uncle Scrooge*, *Little Lulu*, and *Archie and Jughead*. These juvenile titles have provided some of the finest art, in the least likely of places. The Disney book in particular was raised to unmatched heights through the work of Carl Barks. His work is now considered, along with that of Kirby and Eisner, the pinnacle of creativity in the early days of commercial comic book art.

79 It is important to note that in mainstream comic book, most of the work was done by teams in a studio rather than by individual creators who totally controlled the writing and drawing, as was the case with artists such as Herriman or Segar in the newspaper comics era or Spiegelman or Ware in the independent comic book era. Both Kirby and Kurtzman typically drew pencil versions of their stories, which were inked, lettered, and sometimes embellished by collaborators. In Kurtzman's case, he had a team of artists who were great cartoonists in their own right such as Will Elder and Wally Wood. They often took his work to a more polished and professional level. However, Kurtzman's own line work often did not make it into the published stories although it was among the most expressive and evocative styles any cartoonist has ever created.

80 Krigstein wrote and drew a landmark strip of his own, *Master Race* in 1955, which was an important precursor to Spiegelman's *Maus*. Spiegelman wrote a paper "Master Race: the Graphic Story as an Art Form" as a college student in 1968. It was expanded and revised with John Benson and David Kasakove and published in the EC fanzine *Squa Tront* #6 in 1975.

81 J. Hoberman, "Vulgar Modernism," *Artforum* 20, no. 6 (February 1982): 71–76.

82 See, e.g., Marshall McLuhan, *Understanding Media: The Extensions of Man* (New York: McGraw Hill, 1964).

83 Apparently the owners of Archie did not take lightly to Kurtzman depicting their character at an orgy. They sued, and the settlement has prohibited reproduction of the story to this day.

84 *MAD* was not only groundbreaking in bringing irony to comics; it also established landmark legal precedents that allowed artists to parody pop culture for the first time. See, *Berlin v. E.C. Publications*, 329 F.2d 541 (2nd Cir.) cert. Denied, 379 U.S. 822 (1964). In this case, the Second Circuit court adopted what is known as the "conjure up" test (no more could be taken from the original work than necessary to conjure up the reference to make the parody work) and limited it to a fair use context. The court held that *MAD*'s parodies of Irving Berlin's songs did not intend or serve to compete with the originals in a commercial context. These guidelines for parody were codified several years later in section 107 of the 1976 Copyright Act.

85 The anarchic seeds that Kurtzman sowed in *MAD* and *Help!* blossomed in the mid-sixties in the work of the underground comix. Most of the underground artists began their careers in their early adolescence, drawing fanzines connected to EC during the fifties and early sixties. Robert Crumb and his brother Charles published *Foo!*, Art Spiegelman *Blasé*, Skip Williamson *Squire*, and Donald Dohler *Wild*, which featured the work of Jay Lynch and developed the character Pro-Junior. Another important early underground character, Gilbert Shelton's *Wonder Warthog*, began in a collegiate humor magazine, the *Texas Ranger*, in the late fifties.

Other than fanzines and college humor magazines, an important breeding ground for the underground cartoonists were commercial graphics companies like Topps, Bazooka, and American Greetings, which gave artists such as Crumb, Spiegelman, and Lynch the economic support to develop their independent work. (Spiegelman was responsible for creating products such as *Wacky Packs* and *The Garbage Pail Kids* while working at Topps.) The countercultural design shops that produced posters and cards for Rock music concerts were another important early medium for underground cartooning. The distinctive psychedelic patterning of the Filmore and Family Dog posters sprung from the hot rod, surf, and biker scene in Southern California. Big Daddy Roth was a central figure in this respect. His customized cars and T-shirts greatly influenced the look of psychedelic art, particularly the work of Mouse, Rick Griffin, and Victor Moscosco. The latter two also incorporated these loose metamorphic abstractions into early underground comix like *Zap*.

86 Kurtzman left due to a business dispute with his publisher Gaines. Al Feldstein took over as editor until 1984. See, Herbert Marcuse, *One Dimension Man*, for an influential theory of American society in the 1950s that developed an economic analysis to explain the fact that abundance led to such a paucity of social and emotional benefits for most citizens. Marcuse's work provided much of the intellectual foundation for student rebellion on U.S. college campuses in the 1960s.

87 *Help!* featured illustrations by many artists who later went on to become significant underground cartoonists, including Crumb, Jay Lynch, and Gilbert Shelton. If the magazine had lasted one more issue, it would have also published Art Spiegelman.

88 This nascent underground comix movement came together between 1966 and 1967 with the development of two important alternative publishing outlets. The first was the *East Village Other* whose early strips like *Captain High* by Bill Beckman were not worthy of mention other than that they caught the eye of many young artists who saw the *Other* as a place to publish their own decidedly noncommercial and countercultural work. One of the first to do so was Kim Deitch who contributed *Sunshine Girl*, a freaked-out version of *Little Nemo* in 1967. Another early *Other* artist was Spain Rodriquez, who developed the name "comix" for the new form. He also began the use of overt eroticism in the undergrounds with his *Trashman* feature, which was censored by the New York City police, but eventually found First Amendment protection in the courts. This was a landmark decision for the underground cartoonists, who interpreted it as license to produce and openly sell pornographic comics. Crumb published in the *East Village Other* (1967) and *Gothic Blimp Works* (1969) on the East Coast while publishing his own comic books in San Francisco.

89 In the mid-1970s, after Crumb became one of the most famous cartoonists in America, he visited Cleveland and collaborated on *American Splendor* beginning in 1976, Pekar's deadpan account of his ordinary existence in comic book stories.

90 In addition to *Zap*, Crumb published (and was published in) a large number of underground comix between the mid-1960s and mid-1970s. Among the best known are: *XYZ Comix*, *Mr. Natural*, *Snoid*, *Despair*, *Motor City*, *Big Ass Comics*, *Home Grown Funnies*, *The People's Comics*, *Your Hytone Comics*, *Head Comix*, and *Fritz the Cat*.

91 From, *Comic Book Confidential* (film and DVD, directed by Ron Mann, Home Vision Entertainment, 1989).

92 In the spoken introduction of an early recording by Dylan of "Baby, Let Me Follow You Down" he iconically gives credit to Eric Von Schmidt for teaching him the song "in the green pastures of Harvard University." Dylan later electrified the song and it became one of the signature tunes of the style he developed with the musicians who later became The Band a few years later.

93 The Grateful Dead song was called "Truckin'." Crumb's image was commercially successful and iconic in the era, both for the phrase and the "big foot" style of cartooning that it exemplified. Unfortunately Crumb lost his legal claim to the image because of an obscure requirement in U.S. copyright law prior to 1976 that required the first publication of an image to carry a copyright line. Consequently, Crumb never received royalties or other revenue from one of the most commercially exploited images in 1960s America. In the late 1920s, Bud Fisher did a sequence in *Mutt and Jeff* showing the characters "trucking," which presumably was a popular dance step of the era.

**94** The most popular youth culture film of the era, *Easy Rider*, took its title from a classic blues song from the 1920s and recast its meaning into a meandering trip across America at a time when the old and new worlds were about to collide. The main character in the film, played by Peter Fonda, was called Captain America, ironically reversing the meaning of Jack Kirby's World War II-era superhero. The combination of these two references showed how sixties youth culture borrowed early twentieth-century folk music at the same time as they rejected the mainstream pop culture they were brought up on.

**95** One of Crumb's great early stories, "That's Life," was about record collecting and the disparity between old black artists and the young white men who revered and revived them. Crumb also has painstakingly painted a series of trading cards dedicated to old blues and country musicians.

**96** Robert Crumb, *Yeah, But Is It Art?* (Cologne: Museum Ludwig, 2004), 39. Originally printed in, Thomas Albright, "Zap, Snatch & Crumb," *Rolling Stone*, no. 28 (March 1, 1969), 24.

**97** Steven Heller, "Here at *Zap* Comix," *PRINT Magazine* (May/June 2000): 101. According to Heller, *Zap* comix were selling in excess of 100,000 copies per issue by the end of the sixties.

**98** This issue was listed as #0 because it came out after #1, but was compiled from copies of earlier artwork with a new cover.

**99** The basic instrument of all cartoonists is the pen. In the pre-industrial era, artists, illustrators, and calligraphers used a quill pen, which was made from bird feathers and had to be continually sharpened. It was replaced in the modern era by the steel-nibbed pen which was much stronger and let artists create a broader range of expressive flourishes that could then be reproduced in print. The basic features of the split-nib pen became mass produced in America during the 1950s and 1960s as the fountain pen, which was then replaced by the ubiquitous ball point pen. Most contemporary cartoonists use specialty pens available from art supply stores that give them more control over their line than the ball-point pen. Of course, more and more cartoonists now draw directly on computers and use applications such as Illustrator, Flash, and PhotoShop, which have tools that replicate the line weight, control, and quality of traditional ink drawing on paper. See Walker, *The Comics Since 1945*, pages 11–13 for a detailed description of how syndicated cartoonists produce their work.

**100** In the next generation, Art Spiegelman consciously deployed various styles of line work (and layouts) to convey specific psychological states as well as expanding first-person narrative in comics to create the graphic novel *Maus*. Gary Panter went even further in terms of using line weight, style, and deployment to convey the state of mind of his characters and to expand the overall emotional range of comics.

**101** Perhaps this is the reason that Philip Guston used aspects of Crumb's drawing style to transform his work in the 1960s from abstract gestural paintings to seemingly clumsy cartoon canvases. The so-called "big foot" style that can be traced back from Crumb to Herriman and TAD blossomed in a radically different way in Guston's work. His paintings from that era demonstrated how close action painting was to the way cartoonists expressed action in their work through the placement of lines to combine representational and abstract elements in a very sophisticated way. Whereas Pop artists such as Warhol and Lichtenstein appropriated the form of comics iconography, Guston and Peter Saul appropriated the energy of comics that manifested itself in the character of the drawing more than what the drawing represented. Saul developed his own form of Pop art in Paris in the late 1950s by combining de Kooning with *MAD* magazine. In a recent interview Saul explained how he came across the *MAD* cover with Basil Wolverton's image on the front and immediately returned to his studio and began working on new types of painting that included grotesque comic book imagery such as Superman on the toilet. Interview for the PBS television program, "Imagining America," by John Carlin and Jonathan Fineberg, 2005.

**102** In Susan Goodrick, ed., *The Apex Treasury of Underground Comics* (New York: Link Books, Inc., 1973), 62.

**103** From an interview with Art Spiegelman and Françoise Mouly, *The Comics Journal*, no. 65 (August 1981).

**104** The relation of postmodern comics to recent American art has become increasingly close. In the 1960s there was a certain degree of similarity between the work of Crumb and other *Zap* artists such as S. Clay Wilson and that of H. C. Westerman, Peter Saul, and their offspring The Hairy Who. By the 1980s that resemblance became more like an uneasy equality. Artists like Keith Haring borrow heavily from Crumb while cartoonists like Spiegelman and Griffith borrow freely from fine art. The two media remain distinct, but no longer in a clearly hierarchical sense. In an interview with the author from 1982, Haring stated that he became an artist by copying Crumb's comics in the mid-1970s.

**105** In Susan Goodrick, ed., *The Apex Treasury of Underground Comics*, 62.

**106** Gary Panter, *The Rozz-Tox Manifesto* (1980), reprinted in *The Comics Journal* #250 (February 2003), 228.

**107** The character on the cover is Okupant X, although it is often confused with Jimbo.

**108** Notable examples of writers who followed Dick's example include William Gibson, whose breakthrough novel was *Neuromancer*, and Neil Stephenson, author of *Snowcrash*, which anticipated the virtual reality of computers and helped popularize the term "avatar." Dick is perhaps best know for the film *Bladerunner* which was based upon his story *Do Androids Dream of Electric Sheep?*

**109** The practice of slowing things down, using repetition, and/or emptying pictures from traditional forms of content was the hallmark of vanguard art in the 1970s. The same was true for theory and philosophy, particularly the deconstruction movement led by Jacques Derrida and Paul de Man. They created a vocabulary to describe what Spiegelman was doing pictorially—basically, that form was a more interesting vehicle for content than character or story; and that seemingly marginal information and apparent mistakes were actually where the most interesting and revealing form of content could be found.

**110** Spiegelman did this in several strips that followed *Don't Get Around Much Anymore*, notably *Malpractice Suite*, where the "story" is deliberately pushed into the margin of the frame rather than the center, as in traditional comics.

**111** Interview with John Kelly in *The Comics Journal*, No. 250 (February 2003): 210.

**112** A decade after Spiegelman's strip, Larry David and Jerry Seinfeld made a famous TV sitcom, *Seinfeld*, which they pitched and presented as a program about nothing. John Cage did something similar in a famous composition that consisted of roughly four minutes of silence. He explained that the purpose was to make people notice the sounds that existed around them.

**113** Daniel Raeburn, *Chris Ware* (New Haven, Conn.: Yale University Press, 2004), 13.

**114** The inclusion of so many female cartoonists also shows that comics are no longer a boy's club. And that the pioneering work of Trina Robbins and Aline Kominsky-Crumb in the 1970s has paved the way for a significant new generation of female cartoonists.

**115** Richard Marschall reprinted classic comics pages close to full size in a boxed set, *The Sunday Funnies*, in 1978.

**[Winsor McCay]** But for the occasional *Little Nemo in Slumberland* panel—decontextualized, reduced, always in black and white—that I came across in the few histories of the American comic strip I kept borrowing from my public library as a kid, the first real sampling of Winsor McCay's work that I ever saw was published in, of all places, a sleazy back-of-the-rack girlie magazine. (It must have toppled into my hands as I was reaching for a *National Geographic*.) This was sometime in the late 1960s, and McCay's by-then fifty-plus-year-old newspaper strips were trotted out to illustrate an article about "dope in the comics." The article itself, as I recall, stubbornly implied that this bourgeois family man and loyal Hearst chain employee had been— must have been!—a subversive seminal Head slipping drug imagery into his once-celebrated funny sheets like the Beatles and Bob Dylan presumably sneaked them into songs. How else to explain all of those giant mushrooms (ha!) growing wildly in the spongy forests of Slumberland, those sleigh beds sprouting legs to walk, or French horns raveling out like taffy, all of that endless shape-shifting, resizing, free-falling—all of those good and bad psychedelic trips?

# The Master's Hand

Tom De Haven

Winsor McCay was many things during his lifetime—poster painter, artist-reporter, editorial cartoonist, pioneer animator, and creator of the first incontestable comic strip masterpiece—but a Progressive Era Timothy Leary he most definitely was not. And as for his personal addictions, there were cheroots and there was drawing, there was drawing, there was drawing. Which he usually did with his hat on.

# DREAM OF THE RAREBIT FIEND

BY SILAS

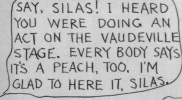 SAY, SILAS! I HEARD YOU WERE DOING AN ACT ON THE VAUDEVILLE STAGE. EVERY BODY SAYS IT'S A PEACH, TOO, I'M GLAD TO HERE IT, SILAS.

YES, IT'S A BEAUT!

 ALLOW ME, SILAS, TO CONGRATULATE YOU. I SAW YOUR PERFORMANCE ON THE STAGE AND I ENJOYED IT VERY MUCH. IT WAS THE BEST ACT IN THE SHOW

YES. THANKS

 SAY, THAT LITTLE STUNT YOU ARE DOING ON THE STAGE IS A PIPPIN! EVERYBODY IS TALKING ABOUT IT. I DIDN'T THINK IT WAS IN YOU, SILAS.

IT WAS A BIG HIT

 IS THIS SILAS? WELL I WANT TO TELL YOU THAT YOUR ACT IS JUST SIMPLY, OH! GRAND! YOU ARE SO CLEVER!

EH, YEH!

 HERE'S ANOTHER BIG BUNCH OF LETTERS FROM MANAGERS, OFFERING YOU ENGAGEMENTS, SILAS.

THEY WANT ME, YOU BET

 THERE'S SOME LADIES OUT SIDE WHO SAID YOU WUZ DE HANDSOMEST MAN DAT DEY EVER SAW COME ON A STAGE. DERE A SWELL BUNCH, TOO, I WUS A LISTENIN' TO 'EM.

UM. HUH!

 MR. SILAS, COULD YOU DO YOUR ACT BEFORE THE ACADEMY OF SCIENCES, NEXT WEEK? I WISH YOU COULD!

SURE! I CAN, SIR!

 SAY, SILAS! COULD YOU HOP OVER TO LONDON AND PARIS, NEXT WEEK? THEY'VE CABLED OVER FOR YOU. YES?

IN A MINUTE! YES!

 CAN YOU DO YOUR ACT AT MRS. VANDERFELLERS, TONIGHT? —

YES MAM

 THE ART STUNDENTS LEAGUE HAVE A BRASS BAND OUT SIDE. CAN YOU COME AND MAKE A SPEECH?

 OH! WAS YOU ASLEEP? SAY I DIDN'T KNOW YOU PLAYED AT K. & P.'S THEATRE LAST WEEK AND I LIVE NEXT DOOR, TOO. HUH, YES.

I ATE A CHEESE PIE FOR LUNCH TODAY AND WHAT A HEAD I HAVE!

SILAS

**174** Winsor McCay
*Dream of the Rarebit Fiend*
Drawing for newspaper Sunday page
1906
Pen and ink, 19 x 14 inches
Collection of Craig Yoe

**175** Winsor McCay
*Dream of the Rarebit Fiend*
Drawing for newspaper Sunday page
(published April 7, 1907)
Pen and ink, 17 x 25 ¾ inches
Collection of the Moniz Family

He was a slight, small, moon-faced fellow of immense self-discipline and enormous vitality, always serious about his career, always striving, yet almost always the goat in his business dealings, unlike far less talented contemporaries like Richard Outcault and Bud Fisher, who got wealthy capitalizing on their celebrity and merchandising their characters. If you saw him on the street in New York City circa 1905 (and he didn't happen to be carrying a portfolio), you might have thought "senior clerk" or "glove salesman at Macy's" and then glanced quickly past him. He was quiet, given to worry, inclined to melancholy, slightly corny whenever he'd crack a joke, and more than a tad bit "henpecked" (as they called it Back Then) by a zaftig, pretty wife who towered over him and likely weighed half again as much as he did.

Don't get me wrong, though. McCay wasn't a milquetoast and he certainly wasn't boring. Except for one crash course in perspective, he had no formal art training; whatever he learned, he taught himself. (The only craft elements that he never mastered were lettering—it was legible but stiff—and executing talk balloons with a sensuous scallop. Well, nobody's perfect.) As a young man, he was quite the footloose bohemian, quitting business school (and thereby crossing his father) to travel to Chicago and Cincinnati, where he hung around the dime museums selling instant portraits at two-bits apiece and soaking up all of that freaky P. T. Barnum stuff, which served him so well later on. And long before Jerry Lee Lewis did it, he ran off and eloped with a fourteen-year-old girl. (When he was twenty-four.)

But all of that scarcely matters. It *doesn't* matter. What matters is this: Winsor McCay was the finest draftsman the comic strip medium has ever produced, and its single greatest fantasist, and the man who synthesized the chaotic vocabulary of the early funny papers, devising and developing a sustaining, flexible grammar and creating the fluent common language of the comics. Since McCay, the basic unit has been the page, the *page,*

and not the panel. He was essential. And he was a genius. And who needs hallucinogens, who needs hookahs, when you're one of those?

While he usually gave his date of birth as 1871, and his gravestone in Evergreens Cemetery in Brooklyn gives it as 1869, Zenas Winsor McCay (he dropped the Zenas during his boyhood) most likely was born in 1867, and probably in Ontario, Canada, while his mother was there on a visit to her parents. He grew up in the north Michigan timbering region, where his father made a modest fortune in real estate. And from early on he was a drawing fool; those who knew him as a boy usually called his attraction to pencil and paper, to the act of *putting* pencil to paper, as a "compulsion." In a story that seems (but who can say for sure) as apocryphal as the one that has young George Gershwin sitting down and playing the first piano he ever laid eyes upon, McCay family lore has it that Winsor the whippersnapper picked up a nail one winter's night and drew a dazzling picture of a house on fire in the frost lacing a windowpane. "I drew on fences, blackboards in school, old scraps of paper, slates, sides of barns," he once wrote about himself in a how-to book for cartoonists. "I just couldn't stop."

And he didn't, drawing virtually every single day up to and including the day that he died, of a cerebral hemorrhage, on July 26, 1934. (According to John Canemaker in his superb biography, McCay's poignant last words, uttered to his wife, Maude, as he collapsed, were, "It's gone, Mother. Gone! Gone!" And he didn't mean his mortal life, he meant his drawing life.)

McCay's graphic virtuosity is always, always a joy and a feast to behold (and it's best beheld, if you can find copies, in the multivolume *The Complete "Little Nemo in Slumberland,"* published by Fantagraphics Books). But his prolificacy, the sheer output of work, is not only staggering to consider, it is almost impossible to believe. One man did all *that?* So *well?* Besides producing *Little Nemo,* which ran weekly in the *New York*

**176** Winsor McCay
*Little Nemo in Slumberland*
Color proof for newspaper Sunday page
(published January 26, 1908)
20 x 15 7/8 inches
Ohio State University Cartoon Research Library,
Woody Gelman Collection

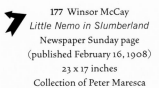

**177** Winsor McCay
*Little Nemo in Slumberland*
Newspaper Sunday page
(published February 16, 1908)
23 x 17 inches
Collection of Peter Maresca

**178** Winsor McCay
*Little Nemo in Slumberland*
Drawing for newspaper Sunday page
(published June 19, 1910)
Pen and ink, 28 ¾ x 22 ½ inches
Collection of the Moniz Family

*Herald* between 1905 and 1911 and then (under the title *In the Land of Wonderful Dreams*) in the *New York Journal* until 1915, McCay also produced, in many cases simultaneously, any number of other Sunday pages, including the remarkable, unsettling, and very adult *Dream of the Rarebit Fiend*. But still the man did more, much more—drawing editorial and political cartoons, newspaper and spot illustrations, advertising art, theatrical posters, and of course rendering, coloring, photographing, and editing together tens of thousands of individual images on rice paper for his groundbreaking series of animated cartoons, which culminated in the phenomenally popular *Gertie the Dinosaur* and the spectacular *The Sinking of the Lusitania*...then promoting them on the vaudeville circuit up and down the eastern seaboard. By all accounts he was a real charmer on stage. A natural. A showman.

How did he *do* it all? *How* for God's sake? Was time somehow—*different* in those days? It almost seems that it must have been: every hour longer by a day, every day by a week, every week by a month. Or maybe there were just fewer distractions. Or maybe...

I have often heard contemporary cartoonists marvel at the productivity of the first and second generation of comic strip artists, who could turn out daily and Sunday strips and often separate Sunday topper strips as well, but still manage to make it to the racetrack, dance the rumba, carouse with movie stars, chase showgirls, even trek off to Monhegan Island in the summer and paint seascapes. (Art Spiegelman once remarked to me that how those guys managed their time was, along with the formula for Greek Fire and the construction of the pyramids, one of the World's Great Mysteries.) While it's true that a lot of them had studio assistants or used underpaid ghost artists, a surprising number, Winsor McCay included, did not. And while neither a rumba man nor a skirt chaser (he was faithfully wed, so far as we know,

for more than forty-three years), he did, incredibly, have a personal life, a life away from the drawing board. He dined out frequently with friends, most of whom were fellow cartoonists and illustrators, was a doting father and a splendid parent to his son, Robert (the model for Little Nemo), and his daughter, Marion—and he kept track, in code, of the times and circumstances of his conjugal lovemaking.

One of McCay's favorite activities, not surprisingly, was to visit the Coney Island amusement parks not far from his big awninged house in Sheepshead Bay. He was especially fond of Luna Park and Dreamland, whose baroque architecture he often appropriated and magically transformed—using only the most basic of tools: a bottle of Higgins black ink, a Gillot #290 pen, an art gum eraser, and a T-square—into the opulent Art Nouveau palaces, courtyards, balconies, boulevards, and loggias of Little Nemo's patron, King Morpheus.

But Winsor McCay mostly lived in his studio—or more precisely, his own head, where his visions of motion, change, and escape (from the mundane to the miraculous) never stopped till they stopped for good.

**179** Winsor McCay
*Little Nemo in Slumberland*
Newspaper Sunday page
(published February 2, 1908)
23 x 17 inches
Ohio State University Cartoon Research Library,
Woody Gelman Collection

# THE NEW YORK HERALD.

NEW YORK, SUNDAY, FEBRUARY 2, 1908.— BY THE NEW YORK HERALD COMPANY.] [COPYRIGHT, 1908. PRICE FIVE CENTS.

[Lyonel Feininger] On April 29, 1906, newspaper readers turned to the comic supplement of the Sunday *Chicago Tribune* and discovered a self-portrait of a tall, lanky man, labeled "your Uncle Feininger," manipulating his characters like marionettes on strings. This distinctive page introduced one of the shortest but most remarkable careers in the history of American comics.

Over the next nine months, fifty-one episodes of Lyonel Feininger's two creations, *The Kin-der-Kids* and *Wee Willie Winkie's World*, appeared in the *Chicago Tribune*. It took almost seventy-five years for the first reprint collection of these comic strips to be published in America. And yet, Feininger is regarded today as one of the great masters of the art form by contemporary scholars and cartoonists.

In his introduction to *The Comic Art of Lyonel Feininger* (1994), Bill Blackbeard wrote: "*The Kin-der-Kids* has achieved an epic status in comic strip history; no other comic strip ever published accomplished more classically memorable art and narrative in so short a time-span or developed and maintained such an in-destructible mystique among aficionados of the comic strip form over the decades, many of whom had never seen the work itself."

Feininger's unique place in the history of American comics is due, in part, to the period in which he worked. When the *Chicago Tribune* hired him in 1906, newspaper comics were in their infancy. It had only been twelve years since the Yellow Kid made his debut in the pages of the *New York World*, and artists and syndicates had yet to establish formal standards of layout, content, and distribution. In this era of freewheeling experimentation it was inevitable that many of these unfettered creations would offend upper-class readers.

# Lightning at the Crossroads

Brian Walker

180 Lyonel Feininger
*The Kin-der-Kids*
Newspaper Sunday page
(published April 29, 1906)
23 1/8 x 17 1/16 inches
Ohio State University Cartoon Research Library,
San Francisco Academy of Comic Art Collection

In June 1906, M. J. Darby gave an address to a group of newspaper executives entitled, "Is the Comic Supplement a Desirable Feature?" In his speech, Darby lamented, "The crude coloring, slapdash drawing, and very cheap and obvious funniness of the comic supplement cannot fail to debase the taste of readers and render them to a certain extent incapable of appreciating the finer forms of art."

Religious leaders, social reformers, and educators also complained about the comics' detrimental effects on children. Newspaper cartoonists adapted the slapstick comedy and ethnic stereotypes of the vaudeville stage, and the funny pages were filled with pratfalls, pranks, and repetitive punch lines. Children loved the comics for the same reasons that sophisticated adults abhorred them—they celebrated anarchy, rebellion, and the triumph of the underdog.

The *Chicago Tribune*, the preeminent newspaper of the American heartland, seized on the potential for publishing comics designed to appeal to a more discriminating audience. In an article accompanying Feininger's debut, editor James Keeley announced that "the *Tribune* will inaugurate a revolution in the comic supplements of Sunday newspapers." To achieve this goal Keeley had traveled to Europe, enlisting the services of the top German humor artists, including Hans Horina, Karl Pommerhanz, Lothar Meggendorfer, and Lyonel Feininger. Since approximately one-quarter of the city's population was of German descent, many Chicagoans were already familiar with these artists. Feininger was introduced as "the most popular artist in the German capital, and his drawings have a worldwide circulation."

Lyonel Feininger was born in New York City on July 17, 1871. His grandparents had emigrated to the U.S. from Germany after the failure of the democratic revolution of 1848. Both of his parents were professional musicians, and the boy was often left alone for long periods of time while they were on tour. He developed an active imagination to fill the void and became entranced with the ships he saw in New York harbor and the trains that thundered by on the elevated railroad tracks of Second Avenue. He stayed with friends on a farm in Sharon, Connecticut, and observed the rolling hills, tall trees, and changing weather patterns of the New England countryside. These experiences had a profound impact on the young Feininger, inspiring recurrent motifs in his work for the remainder of his life.

At the age of sixteen, Lyonel was sent to study at the Leipzig Music Conservatory. He didn't return to America until 1936. More interested in drawing than playing the violin, he soon enrolled in the Hamburg School of Arts. In 1888, he moved to Berlin, attended the art academy there, and sold his first cartoon to a local newspaper a year later. Among his early influences were Wilhelm Busch, the creator of the picture stories starring Max and Moritz, and American cartoonists Eugene Zimmerman, Arthur Burdett Frost, and Frederick Burr Opper. After attending a Catholic school in Belgium, he moved back to Berlin in 1891 and began submitting drawings regularly to the *Humoristischen Blaettern*, a popular periodical.

Lyonel longed to return home to pursue his dreams. On April 2, 1894, he wrote to his childhood friend, H. Francis Kortheuer, "I am daily impressed with the fact that I can do more in America than here and that my country has the first right to my services. I am just thinking now of one thing: how to better the class of juvenile illustrated works and periodicals in America."[1]

By this time, Lyonel was a regular contributor to *Ulk*, the Sunday supplement of the *Berliner Tageblatt*, as well as many of the leading German

181 Lyonel Feininger
*The Kin-der-Kids*
Color proof for newspaper Sunday page
(published September 9, 1906)
23 x 17 inches
Prints and Photographs Division, Library of Congress

**183**  Lyonel Feininger
*Wee Willie Winkie's World*
Color proof for newspaper Sunday page
(published November 25, 1906)
23 x 17 inches
Prints and Photographs Division, Library of Congress

humor magazines. He was also sending illustrations overseas, where they were published in *Harper's Young People* and *St. Nicholas* magazines.

During the next decade, Feininger drew hundreds of cartoons that featured political comment, social satire, and whimsical humor. He was also becoming increasingly frustrated with his editors, who dictated the design and content of his work down to the smallest details.

In February 1906, Feininger met James Keeley in Berlin and agreed to produce two comic strips for the *Chicago Tribune* at a salary of 24,000 marks (US $6,000). This arrangement gave him the financial independence to relocate to Paris in July 1906 and begin painting.

Feininger later described this turning point in his life. "Then suddenly came the liberation!" he recalled. "A contract with Chicago made it possible to move to Paris and at long last get to know the world of art! I could think, feel, and work *for myself...*"[2]

*The Kin-der-Kids* was designed to compete with Rudolph Dirks's popular strip, *The Katzenjammer Kids*, which ran in William Randolph Hearst's *Chicago American*. Feininger's first feature was a week-to-week, whirlwind chase sequence in which the sinister-looking Auntie Jim-Jams and Cousin Gussie pursued the kids—bookish Daniel Webster and his dachshund Sherlock Bones, gluttonous Piemouth, and hyperactive Strenuous Teddy (a caricature of Teddy Roosevelt)—across the globe from New York harbor to the Russian wilderness.

*The Kin-der-Kids* ended abruptly, in midsequence; the last episode appeared on November 18, 1906. Some historians have cited a contract dispute between the artist and his publisher, but there is no evidence to support this theory. In the meantime, *Wee Willie Winkie's World*, which debuted on August 19, 1906, was over halfway through its brief run.

Feininger's second strip, named after an English nursery rhyme, was similar in concept and design to Winsor McCay's *Little Nemo in Slumberland*. Wee Willie was a solitary boy who wandered through a fantastic world brought to life by his fertile imagination, in which buildings, ships, trains, trees, animals, and the forces of nature had remarkable powers of expression and transformation.

With these two creations, Feininger finally had the opportunity to realize his youthful ambitions. Freed from the constraints of the magazine editors, he experimented with composition, storytelling, and visualization. His fascination with Japanese prints inspired flat color schemes and open spaces, and he also incorporated decorative elements borrowed from Art Nouveau. His innovative page layouts anticipated the genius of George Herriman's *Krazy Kat*, which debuted seven years later. Unlike the other German artists whose work was published in the *Tribune*, Feininger used all of the tools of the comic strip form, including speech balloons and continuity (in *The Kin-der-Kids*) and progressive framing techniques to enhance the impact of his narratives.

Feininger's last page of *Wee Willie Winkie's World* ran on January 20, 1907. The experiment had failed; the *Tribune* was unable to sign up subscribers for its new comic supplement. Editors remained unswayed by European artistic refinement, and readers preferred the rough and tumble humor of *The Katzenjammer Kids*, *Happy Hooligan*, and *Buster Brown*.

After his relationship with the *Chicago Tribune* ended, Feininger began to seriously pursue other artistic interests. He experimented with etching, lithography, woodcuts, and sculpture before eventually establishing an international reputation as a watercolorist and painter. One of the founders of the Bauhaus, he taught at the prestigious school for seven years. Although influ-

**184** Lyonel Feininger
Studies for *The Kin-der-Kids*
1906
Pen and ink with chalk, watercolor, and pencil
12 1/4 x 9 1/2 inches
The Museum of Modern Art, Gift of Julia Feininger

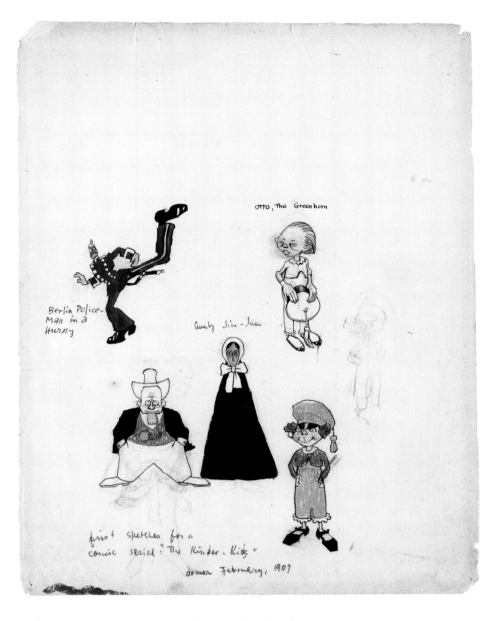

enced by Expressionism and Cubism, he perfected a highly individualized style. While Feininger's fine art accomplishments certainly shed an aura of respectability on his brief career as a newspaper cartoonist, the comic strips he drew for the *Chicago Tribune* also represented an important transition in his artistic development.

In 1964, Ernst Scheyer, author of *Lyonel Feininger: Caricature and Fantasy*, described Feininger's achievement as "an erratic rock on the plains of the American comic strip." Thirty years later, Art Spiegelman wrote in *The New York Times Book Review* that Feininger's "small body of strip work achieved a breathtaking formal grace unsurpassed in the history of the medium."

Lyonel Feininger left behind only a few masterpieces of comic art. These pages represent an unprecedented event in the history of comics and fine art—a flash of brilliance at the intersection of high and low.

**Notes**

**1** Feininger, in *Lyonel Feininger: Caricature and Fantasy*, by Ernst Scheyer (Detroit: Wayne State University Press, 1964).
**2** Feininger, in *Lyonel Feininger*, by Hans Hess (New York: Harry N. Abrams, 1961).

**[George Herriman]** Many of us were introduced to George Herriman's ethnicity when Ishmael Reed dedicated his 1972 novel, *Mumbo Jumbo*, to him. Herriman's *Krazy Kat* had long held its position as one of the few American cartoons appreciated by intellectuals, beginning with Gilbert Seldes in 1924. Some time after Reed had dedicated his novel to Herriman, I had a conversation with Ralph Ellison in which he expressed amazement at the fact that Herriman was, as he said, "a Negro." Since Ellison was a first-class cultural detective and possessed of the most penetrating mind of any American intellectual, we can assume that this was not general knowledge and had not even appeared in the mumbled underground of claims and half truths that all ethnic minorities seem to have in common; "proof" of someone hiding out among the majority, or "proof" that the identity of a member of the group has been "suppressed" in order to maintain the majority's false image of superiority.

## Blues for Krazy Kat

Stanley Crouch

This does not seem to have been the case of George Herriman. He was born in New Orleans in 1880 and was almost assuredly a product of the Creole culture that also produced Jelly Roll Morton, who once admonished a fellow light-skinned musician not to call himself a Negro because "a Negro is dumber than two dead police dogs buried in somebody's backyard." Herriman might not have had sentiments as strong as Morton's, but we do know that he did not parade his ethnic roots and was what James Weldon Johnson would have called an "ex-colored man." In other words, he did not advertise his African blood, even taking the precaution of never removing his hat, in or out of doors, because he had telltale black kinks of the sort that would have raised more than a few questions. Or answered them all.

**185** George Herriman
*Krazy Kat*
Drawing for newspaper Sunday page
(published February 11, 1917)
Pen and ink with watercolor, 22 x 19 inches
Collection of Patrick McDonnell

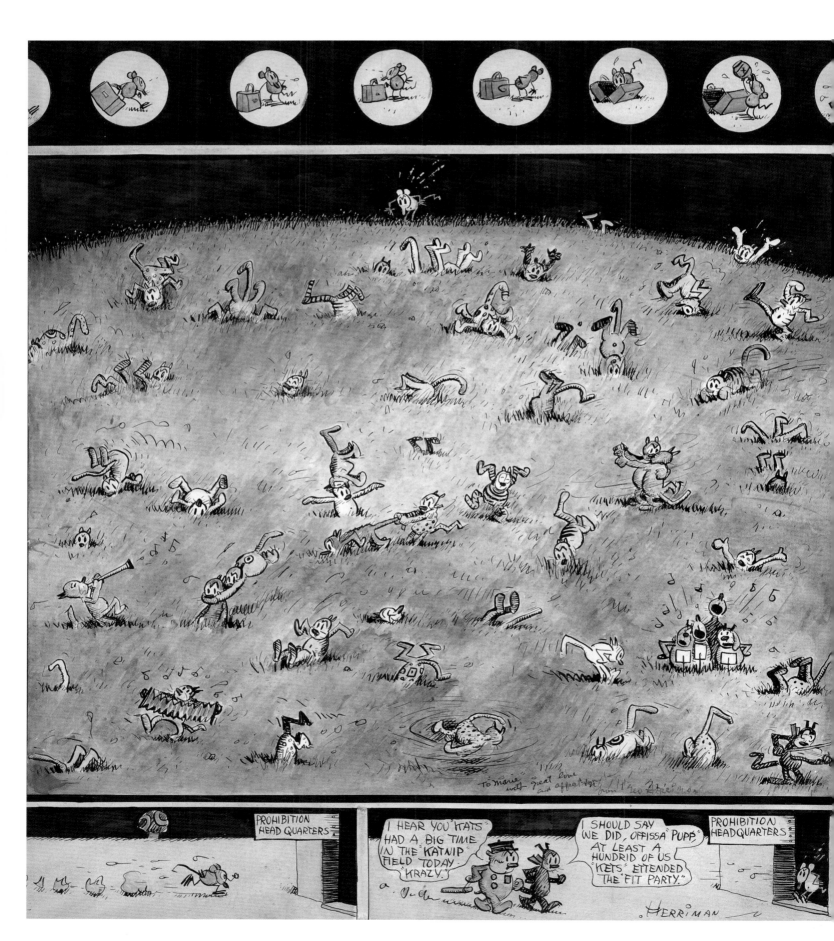

What is most interesting about Herriman, however, is that he had been bitten by the mysterious bug of innovation and created a comic strip that broke all of the rules in order to make a world both unsteady and surreal. In *Still I Rise: A Cartoon History of African Americans*, Charles Johnson wrote of this place of action, "Located in the dreamlike world of Coconino County, which recalls the artist's fondness for Monument Valley in the desert of southeastern Utah, Herriman's characters performed against a constantly transmogrifying background—in the space of two panels, their external world fluidly changed from surrealistic mesas and cactuses to forest scenery and seascapes, ever blurring the border between appearance and reality." In terms of its overall position in American art, this world is interesting beyond the realm of the cartoon because John Ford, perhaps our nation's greatest filmmaker, found the landscape of Monument Valley magnetic and a perfect backdrop for his tragic tales of the winning of the West. That the Creole whom many consider the greatest of all domestic cartoonists and the Irish-American maestro of our cinema would be inspired by the same actual place is far beyond minor. Perhaps both men realized that the desert is especially American because it is in the far end of the West, which is the United States, and has none of the associations that bring North Africa to mind, the territory once called "the Orient" and that we now know as the Middle East. The desert in America is the harsh landscape that always reminds us of some of the most brutal conflicts fought in this country.

Because *Krazy Kat* was born in 1913 and published until Herriman's death in 1944, we can say that it is a product of the same age in which Mack Sennett emerged and made slapstick a fundamental part of American comedy. The crash, the collision, the pratfall, the explosion are all essential elements of a comic sense in which tension is released by violence that is anarchic and dismantling but harmless. The democratic tool of the slapstick comedy is the pie. When thrown in the face it becomes an equalizing force that crosses classes and makes the upper-class person look as ridiculous as the lower-class person or the cop or the bureaucrat or the manual laborer. Its violent use is in the interest of the absurd, not the cruel or harmful. No one is ever wounded, crippled, or killed by a pie in the face. But one's pride can take a beating or one's pretension can be deflated, if not one's belief that he or she is above the travails of those with less money. The pie is an airborne antidote to all of that illusion. In a sense, it is as democratic as death, which plays by no rules other than its own. You can hide in the closet or under the bed or down in the basement, but when you emerge, that pie, flying on the "wings of scorn," as Wallace Shawn has written, will be on its way. You will not escape.

Krazy Kat is in love with a mouse; the mouse, Ignatz, always expresses its contempt for the feline with a brick to the cat's head; Offissa Pupp, both a dog and a cop, loves the cat and is happy to put the violent rodent in jail. Of course, everything "natural" is messed up: the cat loves the mouse and the dog loves the cat; only the rodent is free of unexpected feeling. Once Herriman establishes the surprising as the normal, the reader experiences his dreamworld anticipation of the surreal, which, as some have pointed out, precedes the French movement by at least a decade. In reality, cats love to torture mice in a process that includes battering them about until they cannot move, then toying with them a bit more before biting off their heads. Savage confrontations between cats and dogs can conclude with the eyes of the dogs being scratched out or the cats coming out on the short end, torn apart and dead. Reality is discarded in the interest of comedy, and the violent wound is replaced by the humiliating act that is misinterpreted and, therefore, deprived of its power.

following pages ▶

**186** George Herriman
*Krazy Kat*
Drawing for newspaper Sunday page
(published May 18, 1919)
Pen and ink with watercolor, 22 x 19 inches
Collection of Craig Englund

**187** *left:* George Herriman
*Krazy Kat*
Newspaper Sunday page
(published May 24, 1936)
15 x 10 inches
Collection of Patrick McDonnell

**188** *right:* George Herriman
*Krazy Kat*
Newspaper Sunday page
(published July 24, 1938)
15 x 10 inches
Private Collection

The American quality of Herriman's comedy is always on top because it is the result of a world consistently built on contradictions and counterpoint, the very old and the newly industrial, the stationary and the innovative, the totally planned out and the improvised. The United States was a land where a man born in 1880 knew of the aboriginal languages and customs of those who fell before a civilization that was making itself in motion. In Herriman's hometown, his parents must have become accustomed to the Old World of Europe meeting the timeless ways of Louisiana—the tuneful parades and festivals, the Catholic symbols and saints absorbed by voodoo, the oral history of what had been left of Africa—and of slavery!—in the Negro community, the gloom of a funeral ending with the arrogant affirmation of "Didn't He Ramble?" But since his father hightailed it out of the Crescent City as the laws of segregation began to increase with a fury that limited the lives of even those who could claim a good portion of white blood, Herriman probably heard all he needed to hear about the culture of New Orleans from his parents. This cannot be discounted. As we all know, nothing is more important than the memories of tales told until the child begins to remember them as though he or she was there, felt the weather, ate the food, did the dances, played the games, inhaled the smells, and heard clearly the distinctions of the sounds that attended events either human or those rising from the world of nature.

From all that surrounded him and all that he had heard and everything that he could imagine and realize on the flat pages that held his cartoon inventions, George Herriman grew into his own and took his idiom with him (*Krazy Kat*'s influential progeny includes variously important talents such as Walt Disney, Charles Schulz, and Saul Steinberg). A few years before he was twenty years old the comic strip was born in America. It had become a stable expectation when *Krazy Kat* appeared in 1913 and was immediately a favorite

of newspaper publisher William Randolph Hearst. Hearst's fictional cinematic model, Charles Foster Kane, was not given the good taste to back such a work of popular art, even against the sage decisions of his editors. There again the Herriman story and the story of his amazing cartoon break with convention. Instead of the ruthless magnate submitting to the popular taste for the common and the easily understood, Hearst chose to underwrite what was surely the most far out and imaginative art to appear in that form of popular expression. This is an example of a powerful man becoming a patron of the arts that has little if any parallel in America.

But it is improbable that Hearst thought of *Krazy Kat* as art in the way that its intellectual fans did. He probably had that feeling for American life that made obvious to him something that might not have been obvious to many: this was something new and funny, something that expressed angular thoughts and sentiments that had no precedent. But those ideas and feelings were as purely American as the elements that were creating a new urban civilization from the ground up, or, with the subway, from the underground up. In that sense, George Herriman not only arrived at the right time, but was met by a discerning force that would guarantee his having a place to work until his death. Such sympathetic treatment in the world of commerce now seems even more of a miracle than it must have appeared then.

So, when we move our eyes into the small, mutating universe of George Herriman, we benefit from an imagination that brought together the results of this nation's broad diversity, its many contradictions, and its determination to make fun of pain, disrespect, and humiliation. In private, the clown might weep "the buckets," as the Irish say. But when he comes before the public, his job is to make the audience laugh, not by forgetting but by remembering just how frail and absurd are the tunings of existence. That is his brave job, and George Herriman never failed to report for duty.

**189** George Herriman
Untitled *(Krazy Kat)*
1939
Watercolor
Inscribed with a dedication to Boyden Sparkes
22 x 24 inches
International Museum of Cartoon Art

**[E. C. Segar]** To stir up confusion, there is more than one Popeye. All Popeyes look more or less alike: a runty, squint-eyed sailor with bulbous forearms who smokes a corncob pipe. All Popeyes have one notable physical attribute: they can beat up anybody and mostly do. However, while the animated Max Fleischer Popeye needed a can of spinach to lick Bluto, the daily and Sunday newspaper strip Popeye was perfectly capable of winning fights without strength-enhancing, vegi-based steroids. In fact, the daily and Sunday Popeye didn't bother with spinach (or Bluto) until years after he had secured his name in print.

Popeye's main gift in his early years was endurance. Huge brutes pounded him as mercilessly as Bluto on his best day, but Popeye kept coming back for more. He would not be defeated. He outlasted all villains, outlasted *Thimble Theatre* (the strip he got his start in as a supporting player), and even outlasted his brilliant creator. E. C. (Elzie Crisler) Segar died in 1938, a mere ten years after he introduced Popeye to the world on January 17, 1929—nine days before my own birth. My earliest attempt at drawing centered on Popeye more than on any other hero. And why not? By 1933 he was a national treasure.

## Segar's Popeye

Jules Feiffer

Popeye captured the sensibility of a nation mired in the Great Depression. Suffering a shortage of jobs, little food on the table, and no serious signs of recovery, we remained, somehow, a nation undaunted. It was a time of expansive energy, unreasonable optimism, silliness, and laughs: Rodgers and Hart, the Gershwins, Dorothy Parker, the Marx Brothers, *Gold Diggers of 1933*. Popeye was at one with his time, crossing over from the Jazz Age "boop boop a doop" to the down-and-out age. "Remember My Forgotten Man."

**190** E. C. Segar
*Thimble Theatre Starring Popeye*
Drawing for newspaper Sunday page, with extra replacement panel
(published July 3, 1932)
Pen and ink, 21 x 16 inches
Cartoon Art Museum, San Francisco

## Thimble Theatre

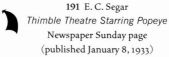

**191** E. C. Segar
*Thimble Theatre Starring Popeye*
Newspaper Sunday page
(published January 8, 1933)
23 x 17 inches
Private Collection

**192** E. C. Segar
*Thimble Theatre Starring Popeye*
Drawing for newspaper Sunday page
(published August 25, 1935)
Pen and ink, 16 x 21 inches
Collection of Patrick McDonnell

**195–197** E. C. Segar
*Thimble Theatre Starring Popeye*
Three drawings for daily strips
(published February 17, 21, and 24, 1936)
Pen and ink, each 5 x 21 inches
Collection of Craig Englund

Popeye was *the* forgotten man: uneducated, unsophisticated, untamable. His mangled English pulsated with the vital spirit of immigrant America: "I yam what I yam and tha's all I yam."

Patient and long suffering in regard to his sweetie-pie Olive Oyl, maternal and fiercely protective of his ward Swee'pea, unassuming and proud of Eugene the Jeep, his magical, gift-giving pet, Segar's Popeye had all sorts of sides to him. In the hands of this genius-cartoonist, a character could be as lovable as Charlie Brown while at the same time explosively violent. On the wrong side of an argument he was perfectly capable of misusing his powerful muscles (muskels, on radio) and readers would love him nonetheless. Popeye, in Segar's vision, was the flawed common man as Walt Whitman might have imagined him. Frank Capra directed him, and Samuel Beckett mixed with Eugene Ionesco were hired to write his dialogue.

In Popeye's world everyone (but our hero) was cheerfully corrupt, giddily greedy, amoral, immoral, without a sign of compassion or conscience—in other words, a farcical cartoon version of Depression-age America. The difference, however, was that beneath it all lay an extraordinary civility. Characters in *Popeye* always displayed good manners as they went about lying, cheating, and stealing. No one was more engagingly polite than the four-flusher Wimpy, Popeye's best friend. Wimpy made few distinctions between good guys and bad guys—all were his marks. He lived to con our hero and everyone else within his proximity. Given an opening, he slyly played his pal for a sucker, but his manners were perfect.

Olive Oyl, the love of Popeye's life, was vain, intemperate, jealous, and felt no qualms about using physical violence. Yet Popeye loved her, and so did the readers—as we enjoyed every variety of swine, scoundrel, brute, and villain, who in real life would have sent us fleeing.

It didn't take long to realize that the rules of Popeye's world were, simply, that there were no rules. So the only corrective was Popeye's fists. His violence restored balance, brought justice, and made everyone feel better, often including the bad guys he beat up. And the graphic cartoon beauty of his fistfights was gorgeously rendered. Segar was a master at whirlwind, over-the-top cartoon violence, as pain-free as Wile E. Coyote's falling off a cliff hundreds of feet down into a gorge below.

In this mad and corrupt universe, Popeye stood out as the one moral force, the single representative of thoughtfulness, goodness, and compassion. He wasn't mawkish about it. It was as innate to his character as his squint and forearms.

The animated Popeye didn't bother with character, wit, or nuance. There was but one story, repeated thousands of times in endless versions: Popeye fighting Bluto over Olive Oyl and able to win in the end only because he was lucky enough to find a can of spinach. Jeez!

It was a wildly successful animated series, moving from Paramount to Famous Studios to TV, and most of it, sixty years' worth, dates badly. Its one lasting charm remains the voices of the actors who played Popeye and Olive Oyl, Jack Mercer and Mae Questel.

But more than sixty-five years after Segar's death, the Popeye that was his creation lives on, still fresh with wit, style, whimsy, and surprise. This Popeye stands with the best of his thirties competitors, who happened not to be comic strip characters but movie clowns: W. C. Fields and the Marx Brothers.

**198** E. C. Segar
*Thimble Theatre Starring Popeye*
Newspaper Sunday page
(published August 9, 1936)
23 x 17 inches
Collection of Patrick McDonnell

SUNDAY, AUGUST 9, 1936

## Thimble Theatre

[Frank King] Back in the early 1980s, I was doing fieldwork for a book on the roadside sculpture of (mainly) Minnesota. In truth, fieldwork meant pleasant weekends on blue highways where the majority of the state's giant Paul Bunyans, voyageurs, Jolly Green Giants, and other mythic figures were to be found. The statues were not museum masterpieces, but they were—and are—excellent vernacular art: huge, arresting, and dependably functional, coaxing the tourist to stop, take a picture, buy a souvenir, and eat a home-made pork-shoulder sandwich.

# Walt Wallet Lives!
Karal Ann Marling

One lovely fall day found me in western Wisconsin on a similar errand. Savvy town fathers, it seemed, no longer toiled at building thirty-foot Vikings in the mayor's garage, with instructions borrowed from a guy who once made a fiberglass canoe. Now they could hold a quick fundraiser and *buy* their Viking, ready-made, from a goofy sculpture factory. So there I was, on a blue highway parallel to the interstate, looking for pork-shoulder sandwiches and a town called Sparta, where America's largest commercial sculpture factory was supposed to be located. Vikings. Big Boys. Ears of corn as tall as trees. All, or so my informants swore, lined up in serried rows in a parking lot awaiting shipment, newly minted and, well, spectacular. A sight that needed seeing.

That parking lot was just as glorious as promised. But where, oh where, was the requisite sandwich? Sorely disappointed, I pressed on eastward, toward Tomah, and found myself inching down Superior Avenue, eyes peeled for a diner, a promising cafe, a neon sign. Instead, what I saw were big, colorful cutouts of vaguely familiar characters, lining the main drag of "the original Gasoline Alley." In other words, I found myself in the middle of a comic strip, scrolled out along the side of the road in the

**199** Frank King
*Bobby Make-Believe*
Drawing for newspaper Sunday page
c. 1918
Pen and ink with wash and watercolor, 27 x 20 inches
Collection of the King Family

town where Frank King had found the story line for his famous cartoon serial in 1918. The street decorations were statues of a sort: Walt, Phyllis, Skeezix, Corky. The Wallet family. The Blossoms. Kitties, babies, jalopies, local color and local characters. The strip itself ran in the newspaper I read at breakfast every morning when I was growing up. In fact, it grew up with me, as yesterday's babies became today's parents; as Walt, the patriarch of the clan, lost hair but acquired new chins; as the novice reader, intrigued by the small human drama unfolding in three or four panels a day, came to wonder why on earth the strip was called *Gasoline Alley*.

By the time I got to the real Gasoline Alley, King and his wife were slumbering in Tomah's Grove Cemetery. In the years since his retirement in the late 1950s, three other artists in succession had continued the strip. At least in Tomah, however, the connection to the place where King was born and grew up (and won a prize in an art contest organized by the local furniture store) never waned, even when the native son moved on to Chicago, made a killing with his syndicated cartoon, and acquired estates in Florida and Illinois. He made good through his own hard work, and Tomah was proud of that.

In the beginning, *Gasoline Alley* had been a little, one-shot, black-and-white panel in the corner of a page of similar bits in the *Chicago Tribune*. The episodes had a recurring cast of characters—the gang of four who hung around the alley behind Walt's house and messed with cars at the height of the postwar auto craze. Given the popularity of the subject, Frank King's single box soon became a daily and then a Sunday strip. But the story goes that the *Tribune's* circulation-conscious publisher wanted something that would appeal to the ladies, too. Thus the carefree, bow-tied Walt Wallet (wearing a giant, flower-strewn bathrobe over striped pajamas), the only bachelor of the bunch, found a baby boy in a basket on his doorstep—on the wintry Valentine's Day morning of 1921.

The saga of Walt and his little Skeezix (a nickname; in a readers' contest, the little fellow was christened "Allison," for "Alley Son") turned the strip in a new direction. Eventually, as Skeezix grew up, he took to fooling around with cars like his "uncle" before him. *Gasoline Alley* soon became what some have called the first soap opera in any medium, a major factor in my own childhood devotion to the ever-growing cast of Frank King's morning saga. The 1940s were the heyday of the thrilling radio serial, and I soon learned the symptoms of every juvenile ailment ranging from earache to incipient appendicitis in order to languish in bed and follow the adventures and miseries of *Young Widow Brown*, *Our Gal Sunday*, and my favorite, *Stella Dallas*. Once, when the explosion of Stella's bakery seemed imminent, I contrived to stay home from school for two full weeks.

Part of the enormous appeal of *Gasoline Alley* was surely the long, slow unfolding of the lives of characters not terribly different from ourselves, whether we were kids, teenagers in love, or senior citizens. Unlike other comics, the people in *Gasoline Alley* grew up, changed, grew old. Walt himself is now on the shady side of 100! Comics buffs amuse themselves on the Internet by arguing about just how old each of the principals must be. And in the spring of 2004, Jim Scancarelli, the most recent author of the comic, made headlines by announcing his intention to kill off one of the aged "stars" of the eighty-five-year-old strip.

Narrative provides one key to the success of *Gasoline Alley*, but so does topicality. Just as the car theme was terribly modern in the 1920s, so too was King's artistic approach to the strip. The colored Sunday versions in particular showed a canny awareness of modern art, its flatness, its use of two-dimensional areas of color, and its propensity for the transformation of pictorial

**200** *top*: Frank King
*Gasoline Alley*
Drawing for daily strip
(published December 26, 1921)
Pen and ink, 6 x 20 inches
Collection of Craig Englund

**201** *bottom*: Frank King
*Gasoline Alley*
Drawing for daily strip
c. 1924
Pen and ink, 6 x 20 inches
Collection of Mort Walker

SUNDAY - APRIL ① - 1923 -

imagery by a process of metamorphosis. One of the justly famous *Gasoline Alley* color pages of 1930 finds Walt and Skeezix in the galleries of The Art Institute of Chicago, inspecting a particularly tipsy Expressionist landscape. "Modernism," says Walt, "is a bit beyond me. I'd hate to live in the place that picture was painted." But Skeezix wants to go there—and so they do, strolling through a Vlaminck, a Kandinsky, and a version of Picasso's *Les Demoiselles d'Avignon* in which one of the young ladies has morphed into a monkey and the sky is filled with Daliesque visions of floating fishes and violins. "Was it a dream?" asks Skeezix, as the two wander deeper into Artland, trailing swaths of pigment behind them.

The strip is a reminder that the infamous 1913 Armory Show, which introduced an American audience to the European avant-garde, had traveled to King's chosen home in Chicago, where, if anything, it caused a worse scandal than it had in New York City. But it also shows that Frank King understood the affinities between what amounted to his ongoing graphic novel and the stylistic experiments of High Modernism. Among art historians, it is commonplace to observe an interplay between art and vernacular art of this era, usually with the latter as a passive source for the sophisticated motifs of the former. But some major comic artists, including Winsor McCay, saw things the other way around. McCay, for example, thought that if Michelangelo had been working in 1914 (when *Gertie the Dinosaur* was being animated), he would have made moving pictures. And King recognized the affinities between his medium and the modern dilemma of how to deal with reality in the context of a two-dimensional surface. One suspects that he might have taught the art world a thing or two about doing so.

In other Sunday offerings of the period, King delved into the journalistic past for patterns and devices useful in exploiting the flatness of the newsprint sheet. From "old woodcut pictures" he borrowed cross-hatching, stippling, and the practice of highlighting areas of dense, black ink with bites of white line. *Gasoline Alley*, in some of its most daring moments, used the full size of the page, divided into a gridwork of comic frames, to present a vast single scene—a house being built, or the whole neighborhood as seen from a backyard perspective. In such works, the divisions between the blocks function both as panes in a window's-eye view of a panorama beyond the pictorial surface and as parts of an intricate, flat mosaic which also contrives to tell a story. The probing inventiveness of King's work ultimately places him in the front ranks of the modernists whose aesthetic he explored within the humble, everyday confines of *Gasoline Alley*.

The comics are a particularly American art form, bred of the cutthroat circulation wars of the early twentieth century. In the early twenty-first century, they face stiff competition from *The Simpsons* and from Japanese anime. Yet *Gasoline Alley* offers the unique charm of being there every day, just like the reader herself: slurping coffee, losing the car keys, watching the life of the Wallet clan with one eye while living out that life simultaneously. Cartoonists come and go. But Frank King's *Gasoline Alley* rolls on, past Sparta, past Tomah, into the history of American art. It is part of the great national saga of our families and neighborhoods, our fads, our little victories, our terrible sorrows. We all live on *Gasoline Alley*, or wish we did.

*following pages*

**203** *left:* Frank King
*Gasoline Alley*
Color proof for newspaper Sunday page
(published November 4, 1928)
22 x 16 inches
Collection of the King Family

**202** Frank King
*Gasoline Alley*
Drawing for newspaper Sunday page
(published April 1, 1923)
Pen and ink with watercolor and gouache, 26 x 20 inches
Private Collection

**204** *right:* Frank King
*Gasoline Alley*
Color proof for newspaper Sunday page
(published October 20, 1929)
22 x 16 inches
Collection of the King Family

GASOLINE ALLEY —King

# Chicago Sunday Tribune.

THE WORLD'S GREATEST NEWSPAPER
OCTOBER 20, 1929

# GASOLINE ALLEY

SKEEZIX, THE WING-SLIPPING AND TAILSPINNING LEAVES REMIND ME IT IS TIME FOR OUR ANNUAL JAUNT INTO THE COUNTRY.

I'M READY, UNCLE WALT.

OH, THAT I WERE A POET AND COULD PUT INTO WORDS THE THRILL OF THESE TOASTED AVENUES!

I WISH I WAS AN ARTIST SO I COULD FIX THIS FLEETING SPLENDOR ON A CANVAS.

IF I COULD PAINT IT PEOPLE WOULD NEVER BELIEVE IT!

THEY'D SAY I WAS EXAGGERATING— THAT SUCH COLORS NEVER HAPPEN.

LOOK THERE FOR EXAMPLE! WHERE ELSE WOULD YOU SEE SUCH A RIOT OF GLORY AS ON THIS VERY SPOT?

NATURE KNOWS WHERE TO THROW HER VIVID CONTRASTS— HER ABYSMAL PURPLES, HER PIERCING YELLOWS.

HER PALETTE VIBRATES WITH A MYRIAD HUES— THE JOY OF THE WANDERER AND THE DESPAIR OF THE PAINTER.

WHY, IT MAKES A MAIL ORDER PAINT CATALOG LOOK LIKE 30 CENTS!

BUT DEEPER DOWN IS THE SENSE OF POSSESSION— THE CONSCIOUSNESS OF BEING A SHAREHOLDER IN THE GRANDEUR OF ALL OUTDOORS.

YOU FEEL THAT ALL THIS IS YOURS— THAT THE TRAPPINGS AND PLAYTHINGS OF CIVILIZATION ARE LEFT INFINITELY BEHIND—

FORE!

?

# Chicago Sunday Tribune.

THE WORLD'S GREATEST NEWSPAPER

JUNE 28, 1931

# GASOLINE ALLEY

## THAT PHONEY NICKEL

## [Chester Gould]

Dick Tracy is a creature of a world gone wrong—lawlessness made it so and violence would set it right. Violence, that is, in the hands of a stand-up, four-square crusader. The comic strip cousin of countless pulp magazine and celluloid heroes conceived during the last bloody gasps of Prohibition and the onset of the Great Depression, Tracy, who made his debut in Chicago in 1931, was just the man for the job in just the right place, arriving just in the nick of time. Yet, Chester Gould's paragon of avenging normalcy was not your average, tough-guy detective. A unique combination of brawn and brains, he prefigured a whole new breed of scientific sleuths, whose recourse to technical innovations in criminology gave them the edge on grifters and hoods. "In drawing the character, it had been the idea to picture him as a modern Sherlock Holmes," Gould wrote, "if Holmes were a young man living today, dressed as a modern G-Man."[1]

## Villainy  Robert Storr

In fact, Tracy was a plainclothes, big-city cop rather than a federal agent, but the mystique cultivated by J. Edgar Hoover around the nascent F.B.I. during the same period attached itself to Tracy even in the mind of his inventor. Like Hoover's minions—if one were to believe that bureaucratic mastermind's PR—Tracy was Mr. Clean in a swamp of corruption, an Untouchable in a world where almost everybody else was an easy mark for inveigling crooks. To keep Tracy current, Gould hired a retired Chicago policeman, A. A. Valanis, to fill him in on evolving law enforcement

**207** Chester Gould
*Dick Tracy*
Newspaper Sunday page
(published January 31, 1943)
23 x 17 inches
Collection of Matt Masterson

**208** Chester Gould
*Dick Tracy*
Drawing for daily strip
(published July 17, 1943)
Pen and ink, 6 x 20 inches
Collection of Matt Masterson

practices, making the *Tracy* strip a precursor of today's numerous procedural crime-fiction television series such as *N.Y.P.D. Blue* and *CSI*. Eventually, this concentration on the hows of police work developed into the hot-tips featured in "Crimestoppers," one of the several graphic sidebars Gould incorporated into the strip. In sum, Tracy was an all-American, no-nonsense, can-do protagonist in a hostile world, a formula mix of realism and idealism, and the perfect antidote for a nation spooked by the economic and political dislocations of the 1930s and the nefarious forces that they seemed to have unleashed.

With all his virtues Tracy was ready-made for ridicule. In the early 1960s, when the conservative consensus (of which Gould's work was an expression) started to wobble, Andy Warhol used Tracy, along with Superman and Popeye, as symbols of paper-doll masculinity. This was not an example of high art's condescension to low art, or merely another incidence of piratical expropriation of vernacular culture by the avant-garde, but rather a perfectly timed, faultlessly camp salute of one great commercial draftsman (who was gay) to another (whose alter ego was preposterously straight). Closer to home professionally, Gould's admirer Al Capp honored Tracy with an affectionate parody in the person of the hapless Fearless Fosdick. But in contrast to Fosdick's perpetually bullet-riddled body—Gould was the artist who introduced Sam Peckinpah-like mayhem to the funny pages, and Capp rounded out the perforations—Tracy was almost impervious to satire. Indeed, with his unrelenting sense of mission always pointing the way ahead, and his first (though second in his attentions to pals Sam Catchem and Junior) and only love, Tess Trueheart at his side, he was already a grotesque of manly purpose and wholesomeness. The fact that Capp, gifted at burlesque as he was, couldn't come up with bad guys equal to the task of travestying those conjured up by Gould is a further indication of the inspired exaggerations characteristic of the latter's vision. In Gould's black-and-white imagination the underworld meant evil incarnate, and like all great masters of inherently diabolical genres for which goodness is the beard, he put his genius—which is to say his heart and soul—into the villains.

They are legion, and their telltale names are delicious: The Mole, Pruneface, Flattop, Nilon Hoze, Itchy, Selbert Depool, Laffy, Bookie Joe, Muscles Famon, Mumbles, Trigger Doom, Stud Bronzen, B. B. Eyes, The Blank, The Brow, Breathless Mahoney, Scorpio, Littleface, Supeena, Yogi Yamma, Deafy Sweetfellow, Mr. Smelt, Shaky, Mr. Bribery, Piggy, Mr. Wooley, Scardol, Pouch, Shoulders, Gargles, Krome, and 88 Keys are just a few. Then come those whose surnames are, in effect, wickedness spelt backward: Junky Doolb

209 Chester Gould
*Dick Tracy*
Drawing for daily strip
(published September 22, 1944)
Pen and ink, 6 x 20 inches
Collection of Matt Masterson

210 Chester Gould
*Dick Tracy*
Drawing for daily strip
(published February 28, 1947)
Pen and ink, 6 x 20 inches
Collection of Matt Masterson

(Blood), Mr. Kroywen (New York), Professor M. Emirc (Crime), Frank Rellik (Killer), and Frankie Redrum (Murder), the last anticipating by years the sanguinary murmur that runs through the final scenes of Stanley Kubrick's *The Shining*. In most, but not all, cases their horrible demeanor matched their moniker. For comic relief, there were other colorful ne'er-do-wells like the ham actor Vitamin Flintheart, and B. O. Plenty and Gravel Gertie, who, in a lampoon of Tracy's own nuclear family of Tess and daughter Bonnie Braids, married and produced the baby Sparkles. Only the French mystery story writer San Antonio has had more fun combining all-out gunplay with shameless wordplay.

The most naturalistic of Gould's thugs resembled classic heavies of the big screen—bosses, bruisers, and gunsels on the order of George Raft, Mike Mazursky, and Elisha Cook Jr. Gould rendered their features with an agile, calligraphic stroke, turning pomaded hair, dapper mustaches, shifty eyes, fancy suits, and jazzy hats into eye-catching patterns, contours, and arabesques. The sharp silhouetting of shapes and the virtual elimination of halftones results in stark contrasts of light and dark over broad areas against which every distinctive flick of the artist's pen vividly registers. Molls also tended to look like B-movie stars, with languid, Veronica Lake lashes and wide, rouged mouths, but here too Gould never missed the opportunity for adding a rococo curlicue to a twist of the lips or the curve of an eyelid into the eye socket. Gould's first efforts as a cartoon-

ist included a short-lived series based on current films, but in the delineation of Tracy's various nemeses, the true-crime orientation of the strip's narrative quickly gives way to caricature and ornamental caprice. That impulse is given free rein in the monstrous personalities that were his most memorable creations. They range in abnormality from the pretty-boy delinquent Joe Period—did his effeminacy trigger the sexual oxymoron of his joke name, or the reverse?—through Edward G. Robinson-like Flattop, to the sideshow freaks Midget & Mama, to the loathsome Brow, Littleface, Pruneface, and Pouch (who resembled a baleful, phallic slug and hid weapons and ill-gotten gains in the folds of his foreskinlike jowls).

In this regard, Gould carried to baroque extremes the late nineteenth- and early twentieth-century notion that criminal behavior was simply a distortion of humankind's better nature and that such aberrations were physically written on the body and could be clinically measured for proof of guilt—or at least of an innate propensity for viciousness. That Gould's source Valanis was a sketch artist who drew the image of suspects according to the testimony of eyewitnesses nicely underlines the tension between evidentiary likeness actually used in police departments and Gould's own preoccupation with essentialized archetypes of perfidy. There were no mild-mannered, self-effacing psychopaths, no boy- or girl-next-door thrill killers in his lineup. More or less extravagantly—generally more—every one of Tracy's foes bore his or her own idiosyncratic

version of the mark of Cain. Physiognomy was destiny, and as the stories unfolded, the weird traits of Tracy's next adversary foreshadowed a gruesome end on the way to which other carnage was guaranteed for the loyal reader's titillation.

In short, the repressed sadism of "ordinary" people was brought to the surface and mirrored in the disfigured countenances of the scum Tracy sought to clear out. However, in a fallen world such as the one Gould posited, primal abominations constantly reasserted their hold in ever viler forms. The second coming of evil, is, in this regard, epitomized not only by the return engagements of low-life recidivists such as The Mole, but by reincarnation through their progeny such as the appearance of Flattop Jr. Thus the gangsterism of Al Capone and John Dillinger set the stage for an urban eschatology that could be ceaselessly but ingeniously replayed in the daily paper and the Sunday color supplement for more than fifty years. As any business consultant knows—and before becoming a cartoonist Gould studied marketing in college—the customer is never wrong. When

the hero's worst enemy makes a death-defying comeback due to popular demand, evil has won. Of course it is evil's protean quality, its unceasing metamorphosis in opposition to the unchanging straight man Tracy that enthralls us. Case by case, justice is done, but the promise of Gould's episodic cops-and-robbers saga was that even worse was yet to come. In his *bande-dessine noire* the superhero was eclipsed by a spawn of super-villains and an unapologetic brutality—shootings, stabbings, stranglings, drownings, burnings, bludgeonings—that could, pun intended, outstrip the most ghastly things the headlines had to offer. Back in the 1960s the Black Power activist H. Rap Brown shocked an already frightened nation by declaring, "Violence is as American as apple pie." At that time, as throughout his career, Gould, no doubt, would have sided with the party of law and order, but he would not have disputed the basic contention. To the contrary, no one delivering the bad news with morning coffee made the point more bluntly or with greater verve.

Note

1 Gould, in *Comics and Their Creators: Life Stories of American Cartoonists*, by Martin Sheridan (Westport, Conn.: Hyperion Press, 1971), 123.

211 Chester Gould
*Dick Tracy*
Drawing for daily strip
(published August 15, 1947)
Pen and ink, 6 x 20 inches
Collection of Matt Masterson

212 *top:* Chester Gould
*Dick Tracy*

Drawing for daily strip
(published December 29, 1949)
Pen and ink, 6 x 20 inches
Collection of Matt Masterson

213 *bottom:* Chester Gould
*Dick Tracy*
Drawing for newspaper Sunday page
(published February 1, 1976)
Pen and ink, 23 x 17 inches
Private Collection

# Milton Caniff

## Pete Hamill

Milton Caniff was one of the greatest creators
of popular fiction of the twentieth century, his best work
still charged today with power and surprise. His medium,
of course, was the comic strip. As a mature artist, he developed a
visual style—a fluid, sinuous line, rich powerful blacks, dramatic, cinematic
compositions—widely imitated by two generations of cartoonists. His air-
planes were more than machines; they had a kind of majesty. But he also
created bravura drawings of Chinese junks and mountain passes and
freighters moving on the roiled sea. His male characters, particularly the
villains, were individuals, their faces and body language expressing an
often sinister character. But his women were his finest creations, each dis-
tinct, all with sophisticated emotional lives, all exuding erotic possibilities.

Those women are often what we remember most from Caniff's mas-
terwork, *Terry and the Pirates*. The strip began in 1934, but the great years
began in mid-1936 and lasted until Caniff walked away from it at the end
of 1946. His principal characters were an adventurer named Pat Ryan and
the young Terry Lee (who would grow older as the strip progressed). Along
the way, they would meet some extraordinary women. Above all, there
was the Dragon Lady, a beautiful Eurasian with high cheekbones, lus-
trous black hair, a voluptuous body, and a fierce intelligence. She was a
pirate, operating along the Chinese coast, and could be as ruthless as she
was beautiful. Later, even before Pearl Harbor, she turned into a guerrilla
fighter against the invading Japanese and used all her skills to kill her ene-
mies. Her name would eventually enter the American lexicon to describe
all tough, ruthless women.

**214** Milton Caniff
*Terry and the Pirates*
Drawing for newspaper Sunday page
(published April 8, 1945)
Pen and ink, 26 x 19 inches
Prints and Photographs Division, Library of Congress

215–216 Milton Caniff
*Terry and the Pirates*
Two drawings for daily strips
(published February 27 and June 11, 1937)
Pen and ink with watercolor, each 7 x 23 inches
Prints and Photographs Division, Library of Congress

217 Milton Caniff
*Terry and the Pirates*
Newspaper Sunday page
(published September 17, 1944)
11 x 15 inches
Private Collection

There was also Burma, as blonde as Jean Harlow, a tough drifter around Asia, a blues singer, sister to Somerset Maugham's Sadie Thompson, a woman with a past that she cheerfully ignores, in love with Pat Ryan. She knows what she wants, and is capable of rage when she doesn't get it. "I've had rajahs, movie stars and just plain millionaires make love to me!" she shouts at Ryan in one 1936 strip. "But you—you heart breakin' beachcomber—just stand there and grin!" And then smashes an Asian guitar over his head.

Then there was Normandie Drake, dark-haired daughter of a rich family, intelligent and humorous. Ryan wants to marry her, but their romance is smashed by the woman's mother, who is as tough about enforcing class lines as anyone in Edith Wharton. Or Raven Sherman, who appeared in 1941, a nurse caring for Chinese war refugees, a WASP clearly modeled on Katharine Hepburn. Prim, controlled, she falls in love with a character named Dude Hennick, but then is suddenly, brutally killed. Her death was unprecedented in comic strips and set off an outbreak of grief among millions of readers.

When I got to know him much later, Caniff told me that he thought of the strip—and his later creation, *Steve Canyon*—as a kind of picaresque novel, a form as old as Don Quixote. Typically a sequence would last three months, daily and Sunday, and then the principals would move on to a new adventure.

"I liked the notion of Pat and Terry drifting everywhere and learning something in every port," he said. "I could go with them, without leaving the studio. That's why I once described myself as 'an armchair Marco Polo.' But the real world made all that change."[1]

Around the time of Raven's death, the strip became more the story of Terry Lee, who was now about eighteen, with Pat Ryan fading from its panels (although, as in all picaresque novels, he would return). Terry would enlist in the Army Air Corps and make new friends, ranging from Flip Corkin to Hotshot Charlie. As the world turned more serious and dangerous, Caniff's story left boyish adventures behind for good. There was even a character named Sanjak, a woman disguised as a man, with distinct lesbian overtones, a spy for the fascists. At the same time, Caniff invented still another extraordinary female, Miss Lace, for a weekly strip called *Male Call*, distributed only through armed forces newspapers. Miss Lace was a dark-haired, lusher version of Burma, and the frankness of the strip's eroticism made it wildly popular. It's hard to imagine anything like *Male Call* being made available for American soldiers in today's more puritanical climate.

But *Terry* is the enduring masterpiece. And in the end, Caniff's talent as a writer made *Terry* stand above almost all others in the comics field. A useful comparison can be made with his wonderfully talented friend, Noel Sickles. They had come to New York together in 1932 from Columbus, Ohio, and both worked for the Associated Press. There, in 1933, the twenty-eight-year-old Caniff created a strip called *Dickie Dare*, directed at a teenage audience and drawn in a "cartoony" style. At the same time (in a shared studio), Sickles (three years younger) had taken over from another artist a strip called *Scorchy Smith*, about a pilot who resembled the later Pat Ryan. Sickles started using the dense black, impressionistic brushstrokes that Caniff would later adapt, which made some later scholars of the comics claim that Caniff merely borrowed the Sickles style. This wasn't exactly true. In those Depression years, they often worked on each other's strips and collaborated on some strips for advertising agencies. Sickles learned as much from Caniff as Caniff learned from Sickles.

What truly set them apart was the writing. In the less than two years that Sickles worked on *Scorchy Smith*, he created almost no memorable characters. The art was everything. He would soon move on to a fine career as an illustrator. But

**TERRY AND THE PIRATES**

appears in

The Washington Post

**219** Milton Caniff
*Terry and the Pirates*
Drawing for daily strip
(published June 29, 1946)
Pen and ink with opaque white, 7 x 23 inches
Collection of Bob Murphy

Caniff was seeing the possibilities of the narrative strip in a grander way. "Maybe it was because I wanted to be an actor when I was in college," he told me once. "I saw many things in dramatic terms, even the dialogue." That dialogue was crisp and sharp and often funny, but it also moved the story along while simultaneously revealing character—the mark of a very good writer. Caniff learned much from the movies, too, about varying the point of view—using the sequence of establishing shot, two-shot, and close-up—and about making emotion visible. He could have been a superb movie director.

Instead, he stayed at his drawing board as his audience slowly dwindled. The first five years of *Steve Canyon* were as good as the best of *Terry*. He had launched a new picaresque novel. Then, at the time of the war in Korea, he had Canyon re-enlist in the Air Force, where he would remain until Caniff's death in 1988 (the strip died with him). Too often, the strip had the feel of propaganda. Around the time of the Vietnam War, he started losing many papers. But there were other factors in the decline of his narrative strip and those of others. Television started eating into the audience, many of whom were losing their ability to read any kind of novel, never mind one that came one scene at a time over several months. Newspaper editors, for reasons of economy, were also choosing to bunch all strips into comics pages, reducing them to the size of entries in a stamp album. Caniff's dialogue became impossible to read. *Peanuts* was the new comics champion, each day's strip self-contained, the dialogue always legible. Caniff's work often seemed cramped and exhausted.

But every artist, every writer, deserves to be judged on his or her best work, and Caniff's best work remains one of the glories of American popular culture. It deserves to be retrieved, the way the work of artists as varied as Raymond Chandler and Louis Armstrong was given renewed life after their deaths and made available to a new generation. I'm part of the fortunate generation that first heard of Asia through *Terry*. In 1965, I went as a correspondent to Vietnam, and a woman named Madame Nhu was being called the Dragon Lady by the reporters. I knew she wasn't. As I wandered down Tu Do Street on my first evening in Saigon, I was sure that on some high floor, the real Dragon Lady was watching. And in that bar with the orange light, Burma was about to sing the "St. Louis Blues."

In the early 1980s, when I told Caniff about that feeling, he smiled in a pleased way and said: "Oh, they were there all right. If you were there, *they* were there."

**Note**
1 All quotes from Milton Caniff are from a series of conversations between Caniff and Pete Hamill at The Palm restaurant in New York City.

220–221 Milton Caniff
*Steve Canyon*
Two drawings for daily strips
(published August 21 and September 9, 1947)
Pen and ink, each 7 x 23 inches
Prints and Photographs Division, Library of Congress

# Charles M. Schulz

Patrick McDonnell

*I think cartooning has a certain quality and a certain charm unlike any other medium, whether it is somebody drawing for 2,000 newspapers, or if it's somebody drawing a little cartoon on the outside of an envelope to a friend. There is a communication there. There is a bringing of joy, a bringing of happiness—without being too pompous—but it is worth something and people like to draw funny pictures. Even if you don't draw, it is still fun to do it and I guess that's why I do it. I like to draw something that is fun.*

*I have no desire to do anything else.*[1]

Charles M. Schulz followed his dharma and found his bliss. He was born November 26, 1922, in Minneapolis, Minnesota, and two days later an uncle nicknamed him Sparky after the racehorse in Billy DeBeck's comic strip *Barney Google*. An only child, he and his father would purchase four Sunday papers in order to read the different comic supplements.

Sparky always loved to draw. In grade school he would create adventure comics and sketch popular characters such as Mickey Mouse, Buck Rogers, and Popeye to the delight of his classmates. (Even in his later years he still took pleasure and pride in doodling a classic Popeye.) When he was fourteen, his drawing of his dog Spike was published in the daily comic panel *Ripley's Believe It or Not*. Schulz also drew cartoons for his high school yearbook; in typical Charlie Brown fashion, none were printed.

As a senior in high school, Schulz took the Art Instruction School comic strip correspondence course and began submitting gag cartoons to magazines. In 1943, he was drafted into the army. Returning home, he found work grading student art assignments at the Art Instruction School and lettering Christian comic books. At the same time, he began drawing cartoons centered on small children trying to make sense of the world and

*Peanuts*
Drawing for newspaper Sunday page
(published October 19, 1952)
Pen and ink, 15 x 23 inches
Prints and Photographs Division, Library of Congress

**223** *bottom*: Charles M. Schulz
*Peanuts*
Drawing for daily strip
(published October 31, 1962)
Pen and ink, 6 x 27 inches
Collection of Craig Englund

**224** *top*: Charles M. Schulz
*Peanuts*
Drawing for daily strip
(published November 6, 1958)
Pen and ink, 6 x 27 inches
Prints and Photographs Division, Library of Congress

**225** Charles M. Schulz
*Peanuts*
Drawing for newspaper Sunday page
(published February 13, 1966)
Pen and ink, 15 x 23 inches
Charles M. Schulz Museum and Research Center

sold them to the *Saturday Evening Post* and the *St. Paul Pioneer Press*. Using these young characters, he then created a weekly panel for the *Press* constructed of four separate gags and called it *Li'l Folks*. He submitted the best of these to New York's United Feature Syndicate, who promptly bought them, renamed the strip *Peanuts*, and repackaged it. On October 2, 1950, what was to be the most successful and most loved comic strip ever debuted in seven newspapers. Bliss.

Sparky was now a comic strip artist following in the footsteps of his heroes. Some of his favorite comics and main influences were Percy Crosby's *Skippy*, J. R. Williams's *Out Our Way*, E. C. Segar's *Popeye*, Roy Crane's *Captain Easy*, Bill Mauldin's *Willie and Joe*, and George Herriman's *Krazy Kat*.

*...there were some other wonderful strips with little kids in them at the time. Of course, Skippy would be the best example.*

A major precursor to *Peanuts* was Percy Crosby's *Skippy*, a kid strip with adult sophistication whose main character was a streetwise boy who mused and philosophized. Schulz borrowed on that theme and refined it: as *Peanuts* unfolded, he lovingly revealed each character's philosophical and psychological makeup.

*There was no one who drew funnier and more warmhearted characters than J. R. Williams. One of the advantages I had was being brought up in the Midwest where my interests were not too sophisticated and yet not too bland. I think it is an actual drawback if you were to know only what is going on in New York City or San Francisco. They are too extreme in their cultures. This is why I think it was an advantage to me to be brought up in a place that is relatively calm as St. Paul, Minnesota.*

J. R. Williams's *Out Our Way*, drawn in a more realistic style, was a daily panel that tenderly poked fun at our simple daily lives. It was middle-America based, warmhearted, and swam in quiet nostalgia. Although *Peanuts* was drawn in a more abstract style and expressed radically new ideas, its small hometown feeling radiated an essence of Williams's work.

*The man who influenced me the most was Roy Crane.*

*Wash Tubbs/Captain Easy* was a beautifully rendered, realistic, character-driven adventure strip. Like most boys of his time, Sparky was caught up in the ups and downs of Captain Easy and Wash Tubbs and their stories; he cared about those characters and wondered what was going to happen next. Sparky recognized the magic in believing in the characters of a daily comic strip and created a cast that held that magic for the world.

*Although there seems to be no comparison on the surface, in many ways my comic strip is like Popeye...if you are able to break through the surface and see it. Many of the things that happen to Charlie Brown are outrageous, and likewise many outrageous things happened to Popeye. I think Popeye was a perfect comic strip.*

*...the fantasy elements just make (Peanuts) more flexible.*

A lesson of Segar's *Popeye* is: if your characters are solid and believable, you can play with their reality. Segar was a master at adding the fantastic, surreal element. Knowing that Popeye could meet Eugene the Jeep and Alice the Goon gave Schulz the freedom to make Snoopy a WWI flying ace.

*Mauldin's quite a guy.*

Bill Mauldin created infantrymen Willie and Joe for *The Stars and Stripes*, touching and affecting the lives of WWII GIs, including Schulz. He saw firsthand in *Willie and Joe* the healing power of art. Schulz would later create tributes to Mauldin in his *Peanuts* Veteran's Day strips. Every "loser" as well as all of us who experienced unrequited love have been in the trenches with Charlie Brown.

*Well, I am doing exactly what I want to do. There is no doubt about it. You know, I always thought if I could just do something as good as* Krazy Kat, *I would be happy.* Krazy Kat *was always my goal.*

*Krazy Kat* may have had the most impact on Schulz, showing him that comics can approach art and poetry and express deeper thoughts. Sparky and Herriman were both courageous in writing about unabashed love. It is the force that runs like a vein of silver throughout their work.

*A cartoonist is someone who has to draw the same thing every day without repeating himself.*

Both artists were also master innovators when it came to playing with themes. Herriman, like a jazz soloist, improvised strip after strip on the beaning of Kat with a brick. Schulz, like a classical composer, played with variations on many themes: the kite-eating tree, the Red Baron, Lucy's psychiatrist booth. Both were maestros of comic art.

To these comic strip inspirations, Sparky added the directness, simplicity, and sophistication of the magazine gag cartoon of the 1950s. *Peanuts*'s honesty and humanity brought the comic strip into the modern world. This small, simple strip was a quiet revolution in the funny pages. Schulz's humor differed from that of his peers; it was more natural and conversational, going beyond the contrived punch line. He was confident in allowing the strip to pace itself,

226 *top*: Charles M. Schulz
*Peanuts*
Drawing for daily strip
(published March 20, 1993)
Pen and ink, 6 x 27 inches
Private Collection

227 *bottom*: Charles M. Schulz
*Peanuts*
Drawing for daily strip
(published January 28, 1999)
Pen and ink, 6 x 27 inches
Collection of Patrick McDonnell

giving it the breadth of quiet moments. Sparky put himself into the strip and admitted that each of the characters represented a side of him. Schulz wasn't afraid to show fears, neuroses, and spirituality. He moved away from comic strip's slapstick past and took the industry with him.

*Of course, you can grind out daily gags but I'm not interested in doing simply gags. I'm interested in doing a strip that says something and makes some comment on the important things of life.*

*Peanuts* contained an element of melancholy—of sadness and loneliness—yet underneath was Schulz's pure joy in the line and the language, and love for his characters and the medium. He wrote and drew *Peanuts* from his heart with intense clarity in line, theme, and dialogue. And it was very funny.

*I think drawing a comic strip is the world's easiest job, but if you want to draw a good comic strip then it's one of the world's hardest jobs.*

When United took the strip, it was with the restriction that it would be divided into four equal panels that could run horizontally, vertically, or stacked as a square. This apparent limitation actually set Sparky free to come up with a less-is-more solution; it helped him take the strip to a graphic haiku. While Herriman made the most of the wide open page, Schulz made the most of the comic strip grid. His comic art became a shorthand of expressionism—Charlie Brown's squiggle-mouthed grief, Snoopy's pure joy of dance, the wet streaks of rain, and the life in each blade of grass.

*I want to keep the strip simple. I like it, for example, when Charlie Brown watches the first leaf of fall float down and then walks over and just says, "Did you have a good summer?" That's the kind of strip that gives me pleasure to do.*

Character driven, the *Peanuts* gang was alive on the page. Readers identified with them and were drawn into their day-to-day world. Schulz had created a daily communion with his readers. *Peanuts* lasted fifty years because Sparky, like his comic, constantly grew and evolved. To the end the strip never got stale. He continually introduced new characters and themes, with Charlie Brown, Sally, Lucy, Linus, and Snoopy at the core, and later Woodstock, Peppermint Patty, Marcy, Rerun, Snoopy's brother Spike...

*I have to sit here and draw comic strips. That's what I'm alive for.*

Whenever I spoke with Sparky he ended the conversation the way he did with all of us fellow cartoonists. "Keep drawing those funny pictures." The comic strip artist's mantra. Sparky put the best of himself on paper. It was the only thing he ever really wanted to do. His dharma.

Late in 1999, ill health forced him into retirement. Two months later, as newspapers carrying his last original strip were being delivered across the world, Sparky left this life.

Bill Mauldin said, "I rank Schulz with Gandhi in the scope and influence on people in this century. Sure, Gandhi spoke to multitudes, but has anybody counted Schulz's circulation? And the same message is conveyed: Love thy neighbor even when it hurts. Love even Lucy."

Once, when Schulz was asked what he would like for his epitaph, he replied, "He made us happy."

That he did.

**Note**

**1** All quotations by Charles M. Schulz are taken from *Charles M. Schulz: Conversations*, edited by M. Thomas Inge (Jackson, Miss.: University Press of Mississippi, 2000), and *Peanuts: A Golden Celebration*, edited and designed by David Larkin (New York: HarperCollins, 1999).

**228** Charles M. Schulz
*Peanuts*
Newspaper Sunday page
(published October 13, 1968)
15 x 11 inches
Charles M. Schulz Museum and Research Center

# COMICS

Edited by the

San Francisco Chronicle

A Section of the S. F. Sunday Examiner & Chronicle

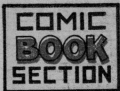

# COMIC BOOK SECTION

# RECORD
### PHILADELPHIA

**ACTION Mystery ADVENTURE**

## SUNDAY, MAY 3, 1942

[Will Eisner] In the rewriting/retelling (I should say righting) of *Oliver Twist* as *Fagin the Jew*, Eisner is able to restore illustration to its rightful place in the Dickensian order. Choosing not to abide by Dickens's usual practice of serializing longer work in shorter installments—a scheme he himself abandoned with his "funnies page" days at the helm of *The Spirit*—Eisner clearly prefers his own graphic novel approach for its greater possibilities in narrative exploration and investigation. Even at risk of losing his public completely, rather than leaving them waiting (and wanting for more), if it's the story that must go on and the public left behind, then let the public be damned—for the greater good of the narrative whole.

———

You, a conceptual artist for ten years running before lately calling it off... the whole "thing" having gotten too heavy to carry: Has no one ever asked you "where do you get your ideas?"

———

As I prepare to attend yet another groundbreaking big blockbuster of a "Comics as art" show, I know not to keep my hopes up... The "gag" cartoon of my specialty—underrepresented as usual? And will they ever "get it"?... Back to the drawing board, friends—with even more spite and envy than before. And coming back with the best drawings of my life. You bet.

**Eisner *by* Pettibon**

Raymond Pettibon

———

More and more as I witness the warm welcoming of the comic book into the shrine of High Art (long overdue, for which I bestow my approval), I come to realize what I have known all along: it was never the comics that did not belong among the high art. It's the *drawing*... Or is it...the *book*?

Comics, the jilted suitor of the high airs art world, come back as the savior of the book industry in the form of the graphic novel. Now we must find the nerve to ask: Where is the White Knight for our Old Maid of the Modern Library, Poetry? So often published but so seldom checked out: and still, I suspect, a virgin, signed or unsigned.

———

Comics were, according to Eisner, a *"literary* art form." Bad call that set us back in class another forty years.

"Significant Cartoons"…"Non-Significant Forms."

Eisner eventually came up with this name for comics: "Sequential Art"—about as elegantly descriptive as Donald Judd and his Specific Objects after his serial turn. Ugh. Can we just forget that one while it's still early?

———

Call it payback for the paper drives of WWI and II—and for not getting the "gag" at Lascaux (we go a long way back). For your cigarettes and ration books we sacrificed our *Whiz No. 1*s and our *Wonder Womans,* too… The cultural devastation resulting from our mere presence…is equal to that caused by that early Conceptual Art work, the burning of the Library at Alexandria.

———

For fans of comics the Museum of Art is as foreboding and scary a place as the Comics Convention is for lovers of art.

———

I know some artists, none of them of which I could call elitist. (Though some of them are just "out there.") Nor are gallerists all snobs and too grand to talk to. They are, in the main, just plain rude.

———

"What about Ebony?"

———

Those early days—the Golden Age, as we remember it in comics—saw him running his own production shop and turning out his own creation, *The Spirit.* It was here where many of the future greats of the industry—artists Jack Kirby, Joe Kubert, Jack Cole, Bob Kane, and Lou Fine—got their early starts. If you couldn't draw a straight line, you tried your hand at writing. If not that, then editing.

Will had that rare talent for doing it all, and doing all well: backgrounds, lettering, even inking over his own pencils at times. It was here that he developed his distinctive signature.

———

Eisner often expressed frustration with a comics audience that had to know everything in the universe—Marvel and DC both, in minute detail—without having accumulated the life experience and world knowledge necessary to make his most sympathetic reader. Ask a fanboy anything you need to know about the Superman, all-powerful one, and his own omniscient powers as a fan and letters column contributor will give you the score.

———

**230** Will Eisner
Detail from *The Spirit* ("Croaky Andrews' Perfect Crime")
Newspaper splash page
(published April 13, 1941)
11 x 9 inches
Collection of Denis Kitchen

The Spirit could take a mean punch and come back for more and more, and he did his utmost best, I guess, to stem the tide of Central City corruption and crime (which seemed to rise the higher for all his efforts—a situation even Superman must have had to recognize at some point, if his adopted country will not). Place them head-to-head, however—Siegel and Shuster's creation Superman, with Eisner's Spirit—and it's clear to all who is overmatched. Jack Kirby, who honed his combat skills on the battle fields of WWII and in Eisner's production mill, could throw Spirit's way a legion of costumed heroes and villains to make battle with, each one more colorful than the last and each sporting her own unique superpower. Yet, how much protection did they afford Jack? Where was Superman, in fact, when the two boys who created him, now grown to men, with manlike needs, needed him for what he could give back? They could not fathom the idea, not in their wildest imaginations, that for the creator there could be that kind of autonomy and creative control over his creations. Like Will had. Even if it was just for Spirit.

———————

Whether read for pleasure or for instruction, comic books are of no value for anything besides producing juvenile delinquents and illiteracy. On the other hand, their careful study by scholars, white-gloved of course for protection from contamination or infection, is recommended for anyone in the fields of art or literature, as well as cultural studies.

———————

Although comic books are made for reproduction while comics fans are not ("with my own thumbprints stuck so gluestick-thick as to ruin another's origin issue, do I dare pass it off as 'uncirculated mint'?"), I believe the comics fan, as the fanboy "other," has the best chance of "Tribbling," or colonizing the Academy, whether that may mean the founding of new life forms or breeding new life into the tired, old life forms. Navigating the spaces between Superhero, sidekick, and fan, while superimposed/superempowering the autoerotic and autoheroic, and configuring for a subject a secret identity in the arrested gazes mirrored between the panels that unfold boys to men to Superman, to culminate finally in one's own voyage of origin from fan to pro. With a scholarship composing the compost of deep knowledge and thick understanding, and using at times a stick contignation to build and construct and zealously maintain coexisting universes, his is the glue, the strands, and the threads that take sequential art and out of it make art.

———————

Today's comics fan couldn't be less thrilled or spooked with the Spirit and what he represents if there were indeed no pictures to look at. Would it kill him, we ask, to invest a thin dime with Mister Charles Atlas? (Turn to the back of the book and find him, alas, looking borderline anorexic by our higher standards of today.)

What to make of this Spirit, though? This Silver Age "Man in a Gray Flannel Costume Suit." One artist, Will Eisner, even if he did have help, or not—has managed to get *everything* totally wrong. His Spirit appears to be the archetype (or is "Archie-type" meant?) of the Silver Age "Man in a Gray Flannel Costume Suit." It is one he doesn't fill particularly well either, looking as he does

**231** Will Eisner
*The Spirit* ("Il Duce's Locket")
Drawing for newspaper splash page
(published May 25, 1947)
Pen and ink with opaque white, 20 x 14 inches
Collection of Denis Kitchen

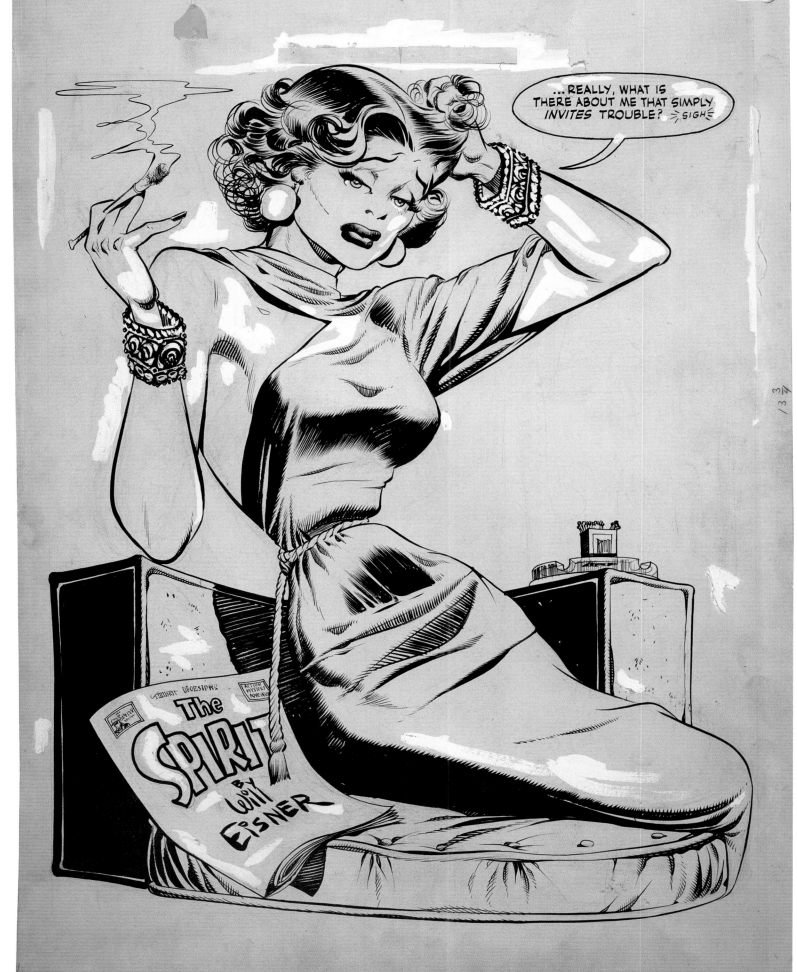

rather like a bylined, just indicted, sickly smug cub-clubby reporter resting on his sources and feeling superior about himself but in contempt for all others and their human interest stories. Oh, the prospect is utterly too depressing to be real, thinks the "fanboy." Why should he care, as a fan, about this *person* as a comic book *character*?* (He wasn't willing here to give him even the plain title of hero without seeing the evidence first, and he wouldn't have believed it if he'd seen it.)

*—with no powers unusual or even discernible? That this *Spirit* was written for a newspaper audience, not comic book, carried no weight here either; enthralled as subscribers to the Allies or Axis "powers" of their day—Hitler, Stalin, Togo, etc.—all long since dead, the heroes and villains *both* had changed to fit the *Times*. And if nothing less than the storied, high n' minding, the 100% pure rag lit *NY Times* shall be deemed a proper fit to print *The [Spirit]*, and the Metropolis Museum of Art, no less, to show it, here's the extra scoop to be read big as the *Daily News*: MILD-MANNERED REPORTER CLARK KENT BITES DOG, BEATS ROCKY RACCOON TO A DEADLINE. To a *pulp*, I should add, in fine print.

———

As an art form comics do not need museum validation with or without its conditions and allowances. As a medium comics have as much claim on serious art (funnies or no funnies) as any other competing for the same. As *museum* art—this is where the problems begin...

Comics are a book medium. Comic Books on the wall don't pass as comic books. You couldn't flip through one if you tried—and that's a shame. They aren't hung right unless they are framed by thumbs on either side. Batman wouldn't be in his natural habitat here even if you hung him upside down. Robin wouldn't be seen hanging there. If Will Eisner had wanted *The Spirit* laid out on a museum wall he would've made every page a splash page, and that would look pretty good—but we'd be missing too, the qualities that make comics books a sequential art. The vitrines act no better. Fans come to stand in line, but fans come to see more than the covers (in fact, a successful cover makes you want to see what's inside). A show of covers is a tease (and a pretty tease to look at), but it's not comics and it's not fine art—"Lou Fine art," maybe.

Comics, by which I mean comics *books*—if you are in such a liberal mood as to allow them their place apart, separate from the rest and equal to anything you can call art (but somewhat above, assumedly, the dishonored "artists" book). If that, then, makes them appear "street" or "pulp cheap," or too "popular," these are for me value judgments that lie on the wrong side of what's art and what's not. You may spurn them as "representative of [their] kind" or "the mother Pop doesn't like to talk about" or even "repros" (such an offensive epithet with their type too common in repeating as to not be unfit to print). They say with considerations that nobody's come out of that "ghetto" yet to make "major work," and that besides, they prefer what they have to ours. And yet an infrastructure of newsstands, drugstore racks—essentially, the major part of a distribution system that the healthy circulation of comics books should depend upon—has been left to erode and wither away. Therefore, the museum and gallery system is to be relied upon, in such case, purely for its distributive mode. Or make like poets and do what poets must for a little bit of—what?

———

GHOUL...A BIG TIME SYNDICATED CARTOONIST LIVING IN SUCH A DIVE? YOU MUST BE PENNILESS..

I AM..SINCE AL SLAPP BEGAN LAMPOONING MY NICK STACY WITH HIS FEARFUL FOOZNICK MY FOLLOWING HAS SHRUNK..

BUT HASN'T SLAPP'S KIDDING POINTED READER ATTENTION TO YOUR STRIP?

NO!.. IT WORKED IN REVERSE! I... GULP...I'D BETTER TELL THE WHOLE STORY...

I HAD CONCEIVED NICK STACY AS A SERIOUS CHARACTER..I SLAVED TO MAKE HIM BELIEVABLE...

I POURED MY HEART AND LOVE INTO IT..WHEN STACY LAY BLEEDING WITH WOUNDS..I SOBBED AS I WORKED...

WHEN HE WON I EXULTED...

BUT IN SLAPP'S HANDS FEARFUL FOOZNICK WAS A FOOL...

I WENT TO HIM...I BEGGED...GROVELLED.. IMPLORED...

LI'L ADAM
THE STUPID MOUNTAIN BOY

HE FINALLY RELENTED AND AGREED TO NEEDLE HOMELESS BRENDA..

BUT THE DAMAGE HAD BEEN DONE..ONE TIME STACY FANS HAD FORMED THE LI'L ADAM HABIT AND WERE LOST TO ME FOREVER..

PLEASE READ NICK STACY SOMEBODY PLEASE
The BUGLE

IN CENTRAL CITY NEARLY EVERYONE READS FEARFUL FOOZNIK
THE COURIER

6

July 20 Weekly Page 10

the SPIRIT
BY Will Eisner

$$\sqrt{\frac{3}{\text{THIEVES}} + \frac{1}{\text{TREASURE}} + \frac{1}{\text{GREED}}} = $$

IN THE ALGEBRA OF CRIME THERE IS
NO MORE DEADLY EQUATION THAN THIS

There was a time when comics had already everything to which the higher arts then aspired. During this time, which we in the industry fondly refer to as the Golden Age, the comics artist/worker, unspoilt by claims of bourgeois individualist exceptionalism and unsullied by market forces, toiled in happy anonymity producing/churning out the little four-color books that provided their fellow, faceless fandom with their daily read.

Each month a new installment would appear, and last month's issue, too worn and tattered after passing through impatient hands, was consigned (if they weren't completely devoured) to the recycling bin of the next war's paper drive, to disappear off the face of the earth to return someday under different cover and byline. While *Superman* and *Captain America* sold millions and became world renowned, their co-creators were hardly heard from in these parts and were paid in rations of bullets and bristol board. It was as if they, the fathers, were to be disowned by their orphaned prodigies who, grown up to be fabulously wealthy and famous, and their signatures or "X's" the only evidence on record left behind in those days before DNA, was covered in white-out of unknown indeterminate unsure origin, or its "X" lost in cross-hatches. These originals were, if anything, of less worth than the books, and less likely to be saved or collected, least of all by the artists. Of no value but for reproduction, the creator's reproductive rights were negligible as well. Until the 1970s and 80s this was, for the most part, the case. The comics artist, or artists, as the case may be, were hired and paid for their services, whether that may be for penciling, inking, lettering, or coloring. Eisner, unlike his peers, retained for himself rights and ownership of his originals. His business acumen might have had something to do with it, but perhaps being the first to recognize the value of comics as an art form made him uniquely the man best equipped to judge his own.

———

There will always be naysayers to tell the lie that the cartoon is unfit for carrying the news (in fact the comics section has long been carrying the news on many a paper); too unfit, even, for newsprint. Their kind wouldn't recognize the truth without a retraction. Still they make sure of it: the truth is out there, in small print, buried out back in the Old Gray Lady's file drawers, like Weapons of Mass Distraction; but here is Judith Miller instead, reporting and spreading for duty; embedded between ads for sheets and spring mattresses for her to lie on... Whereupon now none other than Thomas Friedman (we recognize him from TV) appears and begins to weigh in, testing for support. He will never be undermined, but here, from under the bed, just the head pokes through his lair... It's Bill Safire and his 1000 words once more, this time for hire to the right.

Do you get the picture? Or need I illustrate? The obtuse, puerile cartoon is a form incapable of adding anything of interest to the public forum that is *The New York Times* Editorial Page.

A gewgaw here and a hawhaw there do not contribute mightily to any serious discussion of our national interest when presided over—with moderation by of course—our serious journalists.

**233** Will Eisner
*The Spirit* ("The Jewel of Gizeh")
Drawing for newspaper splash page
(published March 12, 1950)
Pen and ink with opaque white, 20 x 14 inches
Collection of the Will Eisner Estate

Even in the hands of its most skilled practitioners, it is the lowest of the "art" forms that they call "editorial cartoon;" scratchy of line and corny of catchphrase, all black-and-white (and shading by zipatone). With these crudiments of the trade to work with we must insist that our public figures of note—including our President and the Pope—be treated with the respect with which they serve.

———

Eisner's humanism (as "humanist" as you might expect from what promises to deal with the human condition), a "storytelling" set in the "real world" grit of urban environs, turns out in the end to be further removed from the world which we must recognize today as our own than is the Marvel/DC universe of the superhero comic book. What's more, a perusal of any comic of the type from 1935 to 2005 would make it clear: it's not the superheroes and their worlds that have changed; it's ourselves and how we live. Our presidential speeches could be swiped balloon and word straight out of *Captain America* circa 1942, the only difference being in context.

The wars, if the ads are to be believed, are fought much differently. In between recruitment enticements are ads for war games fought with the latest, heaviest arms on the thumb of a computer or video job. Pre-scripted "by a neo-con" for protecting their visions on a real-life, unstable multi-virtual universe they never made (but did it get that way by over-plotting?) or man-dated—but needing badly the continuity that will begin anew with yet another origin story (or the old, old one re-fought again).

———

**234** Will Eisner
Drawing for *A Contract with God*
(published 1978)
Pen and ink, 12 x 9 inches
Collection of the Will Eisner Estate

[Jack Kirby] When Jack Kirby was nine years old, and still Jacob Kurtzberg, his family lived in the Bowery. It was 1926, and he lay on the cusp between the old country (oral tradition, stories told to him by his mother) and the new country (Hollywood, *The Black Pirate*, *The Covered Wagon*, *The Hunchback of Notre Dame*). For a while, he also lay between life and death, overrun by pneumonia that sent him past medical cure and into delirium.

So his mother called in the rabbis.

Kirby later reported that, "They all gathered around my bed and chanted in Hebrew: 'Demon, come out of this boy…What is your name, demon?'"

He survived, but some kind of fever remained, and Jack Kirby began to draw. He drew each of his 25,000 published pages of art by starting in the upper-left-hand corner and continuing until he was finished at the lower right. Then he turned the page onto the stack of finished art and started on the next one. He didn't sketch. He didn't lay out lines of perspective. He didn't erase. And sometimes he would find he'd drawn twenty-three pages that completely departed from the twenty-page story he'd thought he was doing. This was a man consumed by imagination (his wife, who clued in to this early, stopped allowing him to drive). In 1968, he drew the twenty pages of *Captain America* # 112 over one weekend, a Voltaire-on-*Candide*-like speed record unlikely to be surpassed. By the 1970s, the surface of his drawing table was so caked in pencil grit that the back of each page was covered in graphite seasoning.

Observers said Kirby's process was less like drawing than calling forth existing images from a blank page. I have wondered if he had eidetic imagery, in which the mind takes snapshots of memories, and in recalling

Lo, From the Demon Shall Come—the Public Dreamer!!!

Glen David Gold

**235** Jack Kirby and Syd Shores
Drawing for cover of *Captain America* #109
(published January 1969)
Pen and ink with graphite and opaque white
21 x 14 inches
Collection of Joe Maddalena

them, the rememberer seems to project them onto whatever he's looking at (in this case three-ply Strathmore). Kirby wasn't known to have a swipe file, unless you count the world. Which he apparently saw in a compelling way. When Roy Lichtenstein painted his iconic *Image Duplicator* in 1963, raising some definitive questions about the relationships among Pop art, low art, and high art, the panel he chose of all the panels in the world to sorta kinda duplicate was from *The X-Men* #1, originally drawn by that most definitive of comic book artists, Jack Kirby.

Why "definitive"? The superhero gig is a harsh one for creators—it seems that each person (or team) is allotted just one character that outlives them. Bob Kane and his many assistants got Batman—just Batman—and Siegel and Shuster got Superman. But Kirby? Captain America, the Fantastic Four, the X-Men, Hulk, Sandman, Thor, New Gods, Forever People, Mister Miracle, each of them with supporting casts that could carry their own comic books. And what a variety of genres he contributed to (or pioneered): superheroes, westerns, romance, kid gangs, science fiction, adventure, crime, horror, *Classics Illustrated*, animation, creator-owned independents, autobiography, and even, when things got slow in the 1950s, the bizarre *Strange World of Your Dreams* and *Win a Prize* comics.

But...so what? Between presentations at the 2002 San Diego Comicon, Will Eisner mentioned he was uncomfortable calling Kirby someone with heavy artistic intent. I paraphrase, but Eisner felt Jack was mostly concerned with hitting his page count, telling good stories, and keeping his family fed, not pursuing some aesthetic ideal. To seek that motive in Kirby's work was, he suggested, misguided. I happened to be holding the original artwork to the *Devil Dinosaur* #4 doublesplash, which I turned around and showed Eisner. Who took a moment, and said something uncharacteristic: "Okay, I might be wrong."

Kirby poses a problem in that his text is so dense, his surfaces so fully packed, his line so direct, there seems no room for subtext. And what could that subtext be? He wasn't exactly holding up a mirror to life—he was best known for drawings of bulky men in funny clothing beating the daylights out of each other.

Further, there is very little pure Kirby in the world. Mostly, he penciled, meaning he was at the mercy of inkers' interpretations. And Kirby is famous mostly as co-creator. He worked with Joe Simon first, and then with Stan Lee, who wrote (and there are men who will debate the exact meaning of "wrote" with a passion that makes the whole God-versus-Darwin thing look like schoolboys arguing over comic books) some of Kirby's most memorable stories at Marvel Comics. On his own, Kirby's dialogue betrayed a tin ear, a hipster techno-pastiche something like Thomas Pynchon's, groaning with the cargo-ship-tonnage conveying of theme.

And what about that art? Kirby's bodies were a mannerist parody of *Gray's Anatomy*. Women's feet were like angels' tap shoes. The buttocks on a retreating hero could look like the groin of one charging at you. Every gangster, no matter the era, wore a striped suit and a hat, which seemed as thick and wooden as a scuppernong. Perhaps most damning: he could never properly make the "S" on Superman's chest.

But I get chills when I look at a Jack Kirby page. The art is emotionally overwhelming, inimitable, and easily the most influential in superhero comics. Kirby was, for a great many professionals and fans, the best comic book artist of all time. They throw the word genius around, which I can't evaluate, but it's good to admit that certain words, like certain lit fuses, are in the room.

Academic folklorists differentiate among folktale, legend, and myth. Folktales are fairytales, fiction, lacking the tensile narrative strength to fool even a child, populated by talking animals,

**236** Jack Kirby and Vince Colletta
Drawing for cover of *Thor* #146
(published November 1967)
Pen and ink with graphite and opaque white
21 x 14 inches
Collection of Joe Maddalena

gold-spinning dwarves or (let's say) men who dress in capes and fight crime. A legend is a story that may or may not be true about a character that may or may not have existed—Achilles, Abraham, George Washington. A myth, however, is the jackpot, the 800-pound gorilla, the gravitation center of folklore, as it concerns events before the creation, the sacred play of gods and elemental figures that are beyond mere mortal ken.

So: Jack Kirby, a legend in his field, was employed to tell folktales, which he did well enough, but he wanted more, to describe events he alone could see, and so he created myths.

His abilities flourished due to a remarkable circumstance: at age fifty he could tell a continuous story for the first time. He had never before worked on the same character for more than a year or two. In 1966, however, he'd been focusing on the adventures and private lives of the Fantastic Four for about five years. It turned out that homeostasis was his enemy, and he began to expand, adding Inhumans, African superheroes, the Negative Zone (an anti-matter universe), new races (the Kree, enemy of the shape-shifting Skrulls he'd previously created), a perfect human being engineered by scientists (it goes badly for them), and a Microverse (ruled by a tyrant who manipulated emotions). Stan Lee dialogued much of this, but it's evident from page notations that Kirby plotted more and more of these stories as he grew in audacity. In *Fantastic Four* #48, having taken antagonists as far as they could, the plan (by Stan and Jack) was to have the Fantastic Four fight God. But since it was 1966, it had to be a stand-in for God, and so they cracked the idea of Galactus, a being as old as the universe, who eats planets to survive.

When Kirby turned in his pages, however, Galactus had pulled a Godot. In his place, to Lee's surprise, was a herald, coated in silver and riding the spaceways on a surfboard. Which is inherently ridiculous, until you actually see him. In the Silver Surfer, Kirby had created the most noble-looking creature in the genre, a blank slate with empty eyes and a balletic range of body postures that somehow conveyed emotions—humility, anguish, betrayal, empathy—previously unexpressed in the world of long underwear. The Surfer was both Jesus Christ to Galactus's God, and Adam, in that he rebels, embraces humanity and its various sins, and is punished by Galactus, who expels him from the wider universe, forcing him to dwell, in Lee's apt words, upon "the dunghills of man."

As Kirby's imagination exploded, so did the storytelling. The "camera" moved closer, the characters' expressions grew more vivid, the machines more complex, the violence more brutal. His forms became geometric and stylized. Every surface, including human skin, gleamed like chrome. Every starscape exploded with mysterious dots and "Kirby Krackle." Fight scenes, which had already looked sweaty, and punches, which had already resonated with the crack of bone on bone, found extra volume; they went up to eleven. When pencil wouldn't cut it, Kirby got out the scissors and paste and made collages.

The tensions brewing behind the scenes at Marvel Comics in the late 1960s have yet to be fully documented. Apparently, money was involved. So was creative control. There were profound misunderstandings between two honorable and creative men, Lee and Kirby. In 1968, Lee gave the Silver Surfer his own comic book, but did not ask Kirby to draw it. Kirby's imagination seemed to dry up. Story lines in *Fantastic Four* and *Thor* went stale. He began to add arbitrary splashes, as if eager to get each issue over with.

In fact, he withheld his most interesting ideas, and in 1970 took them (and himself) to rival publishers DC. There he launched *New Gods*, *Forever People*, and *Mister Miracle*, actually one incredibly complex saga that became known as the "Fourth World." If the Marvel work was his *Ulysses*, with Manhattan superheroes standing in

237 Jack Kirby and Joe Sinnott
Splash page from *Fantastic Four* #51
(published June 1966)
11 x 9 inches
Private Collection

SOMETIMES OUR WORST ENEMIES ARE NOT GAUDILY-GARBED SUPER-VILLAINS... BUT ARE OURSELVES!

# "THIS MAN... THIS MONSTER!"

QUITE POSSIBLY, THIS MAY BE ONE OF THE GREATEST ILLUSTRATED EPICS YET PRODUCED BY...

**STAN LEE** WRITER

**JACK KIRBY** PENCILLER

**JOE SINNOTT** INKER

**ARTIE SIMEK** LETTERER

BUT NOT EVEN *HE* IS A MATCH FOR *ME!*

THOUGH WE *BOTH* HAVE POWER-- AND *BOTH* CAN FLY---

MINE IS THE *POWER COSMIC!*

MY *SPEED* IS THE SPEED OF THE WINDS OF *SPACE!*

HE THOUGHT TO *CHALLENGE* THE SILVER SURFER--

BUT AFTER *THIS*, HE'LL THINK OF ME WITH BOUNDLESS *AWE!*

TOO LONG HAVE I DISPLAYED *RESTRAINT!*

*TOO LONG* HAVE I REFUSED TO FLAUNT MY *POWER!*

BUT *NOW*-- MY VERY *SOUL* IS AFLAME WITH BURNING *RAGE!*

IN A WORLD OF *MADNESS*-- I TRIED TO PRACTICE *REASON*---

BUT ALL I WON WAS *HATRED*--- AND EVERLAST-ING *STRIFE!*

SO I'LL HAVE *DONE* WITH REASON -- AND WITH *LOVE*-- OR *MERCY!*

TO *MEN* THEY'RE ONLY *WORDS*--TO BE UTTERED AND *IGNORED!*

19

for Dublin's wandering rocks, then the Fourth World was his *Finnegans Wake*, an epic, dreamlike story told in a language that was at times impenetrable. (If that metaphor strains credulity, I recommend an obscure but brilliant comic book called *Boom Boom*, in which David Lasky retells the life story of James Joyce using only panel swipes from Jack Kirby.)

Kirby created his own antipodal cosmopoles, New Genesis and Apokolips, worlds governed by equal parts science fiction, Judaism, and Lower East Side street ethics. His characters were fantastically colorful, flawed, Shakespearean in their triumphs or dooms. Each plotline became not just a series of fight scenes but an allegory about Vietnam, religious fervor, poverty, the nature of

aggression and evil. The panels got bigger again, and doublesplashes became a normal part of each issue.

And yet, it wasn't popular. You had the sense as reader that you were grabbing on to a train thundering down a mountainside at a dangerous clip, the scenery a blur. In part, Kirby was learning about his dreamworlds as he wrote; in part, it was hard to keep track of everything. None of the series lasted past eighteen issues. The remainder of his work is generally that of a man tired of having the rug yanked out from under him.

In 1975, he returned to Marvel as the equivalent of a day player. At age sixty, he was still producing art like the *Devil Dinosaur* doublesplash, which illustrates an ancient myth about a dragon

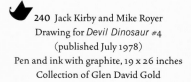

*previous pages*

**238** *left:* Jack Kirby and Herb Trimpe
Drawing for *Silver Surfer* #18
(published September 1970)
Pen and ink with graphite, 16 x 10 inches
Collection of Glen David Gold

**239** *right:* Jack Kirby and Herb Trimpe
Drawing for *Silver Surfer* #18
(published September 1970)
Pen and ink with graphite, 16 x 10 inches
Collection of Wally Wolodarsky,
courtesy of Glen David Gold

**240** Jack Kirby and Mike Royer
Drawing for *Devil Dinosaur* #4
(published July 1978)
Pen and ink with graphite, 19 x 26 inches
Collection of Glen David Gold

that eats the moon. At a glance, it's abstract, but, like his fantastic machinery, each element resolves into something entirely functional. Freud, who was onto myths like a hawk on field mice, suggested that myths were sacred because they were, by avenues not yet understood, public dreams. So, sidestepping that "genius" epithet, here's a title we might agree upon: Jack Kirby, public dreamer.

And yet...when I ran my thesis statement about myths and Kirby past Rob Stolzer, an art professor at the University of Wisconsin, he was polite but unconvinced. "Look at those Kirby crowd scenes—there's a reason there's always a soldier pointing toward us, and yelling—he's talking to us!" What works isn't necessarily the cosmic, but its relationship to the small person in the foreground. When Steve Rogers became Captain America in 1940, he wasn't a millionaire playboy, scientist, or last survivor of the planet Krypton—he was a 4F draftee. Thor wasn't just the god of thunder, he was a man (a lame physician), as well as a son and brother tormented by a dysfunctional, immortal family. They are our family, we are their relatives, we are at our best all characters in a Jack Kirby story. That link of myth, folktale, and our own dynamics is why they thrive.

Read classicist Edith Hamilton again and you'll see that myths have survived not because of their dressing, but because of their emotional content. When you strip away the women turning into laurel trees, you're left with love, lust, anger, desire—exactly what fuels Kirby's best work. It's almost blindingly personal, and not necessarily for the reader. I think no matter how outlandish, as Kirby matured, his stories were autobiographical. What was the last interesting character Jack created under his contract with DC? One funneled onto the page direct from a nine-year-old boy's consciousness: The Demon.

The 1968 *Silver Surfer* comic book—made without Kirby's involvement—failed. In 1970, Lee (somewhat insultingly) called Kirby to do a fill-in issue. It ended up being the last, or almost last, work Jack did for Marvel before leaving. And for eighteen of its twenty pages, it's uninspired. Fight, fight, fight. Misunderstandings lead to more fights. But then, on page nineteen, depriving readers and management of the final confrontation they wanted to see, the Surfer streaks away. It's hard not to read this as driven by Kirby taking his toys and declaring ownership one last time of a defeated, embittered Silver Surfer.

Look at the gathering darkness on this page, how the tiers go from mostly white to mostly black, how the horizontal speed lines at the top become, as he slows, diagonal slashes and vertical mountain features in the middle tier. And that last tier! Accumulating Kirby Krackle, a full cosmic storm, as the Surfer sulks, finds focus, begins to stand. Look how the inking (by Herb Trimpe), though black enough, doesn't even capture all the pencil work behind it—Kirby turned this page into graphite fury.

And then, that final splash: look at the horrific anger of a fully betrayed face. Kirby's last piece of art from his glory days at Marvel. There is no one in costume here, just a Kirby cipher standing in for all the hurt done to him. From nothing—from the dust of pencils, from a genre populated by blockheads, from a fill-in job on a book heading for the trash heap, from the dunghill of a career he felt none too good about—Kirby has made a mythic figure and yet also made him personal.

And that's the kind of resonance that makes the artwork actually matter—the connection of the epic and the emotional. Kirby felt it, he had the Surfer feel it, and then readers felt it too. Kirby elevates all of us into a realm where we fly among the beating wings of the immortal and the omnipotent, the gods and monsters, so that we, dreamers all, can play host to the demons of creation, can become our own myths.

[Harvey Kurtzman]  *If you want to start a revolution, start a magazine.*

—*V. I. Lenin*

Cartoonist-writer-editor, Harvey Kurtzman was a particular sort of New York intellectual with a particular sort of New York education.

The child of Russian Jews, Kurtzman was born in Brooklyn and raised in the Bronx; he experienced the Great Depression, grew up with the New Deal, spent several summers among the Yiddish-speaking leftists at Camp Kinderland, attended New York's new High School of Music and Art, and briefly studied at the free art academy Cooper Union.

A cartoonist since childhood, Kurtzman broke into the business apprenticed to a comic book artist who, among other things, provided a daily strip for the *Daily Worker*. He was drafted into the army (drawing cartoons for the base newspaper), freelanced fillers for Timely (later Marvel) Comics, got married to Adele Hasan (a proofreader at Timely), drew a government information comic on venereal disease, and landed at EC in 1950, just as the publisher's "New Trend" horror comics were taking off.

Six months after joining EC, Kurtzman conceived his first magazine. The emphasis was on another sort of horror, namely historical. *Two-Fisted Tales*, for which he not only scripted the stories but the breakdowns as well, was initially an adventure book. The first story of the first issue, drawn by Kurtzman and bluntly titled "Conquest," shows half a dozen grinning conquistadors pointing their cannon directly at the reader—and, in a suitable EC twist, ends with the European invader defeated and sacrificed

# Harvey Kurtzman's Hysterical Materialism

J. Hoberman

**241** Harvey Kurtzman
Drawing for cover of *Two-Fisted Tales* #28
(published July–August 1952)
Pen and ink with colored pencil and opaque white
20 x 14 inches
Collection of Glenn Bray

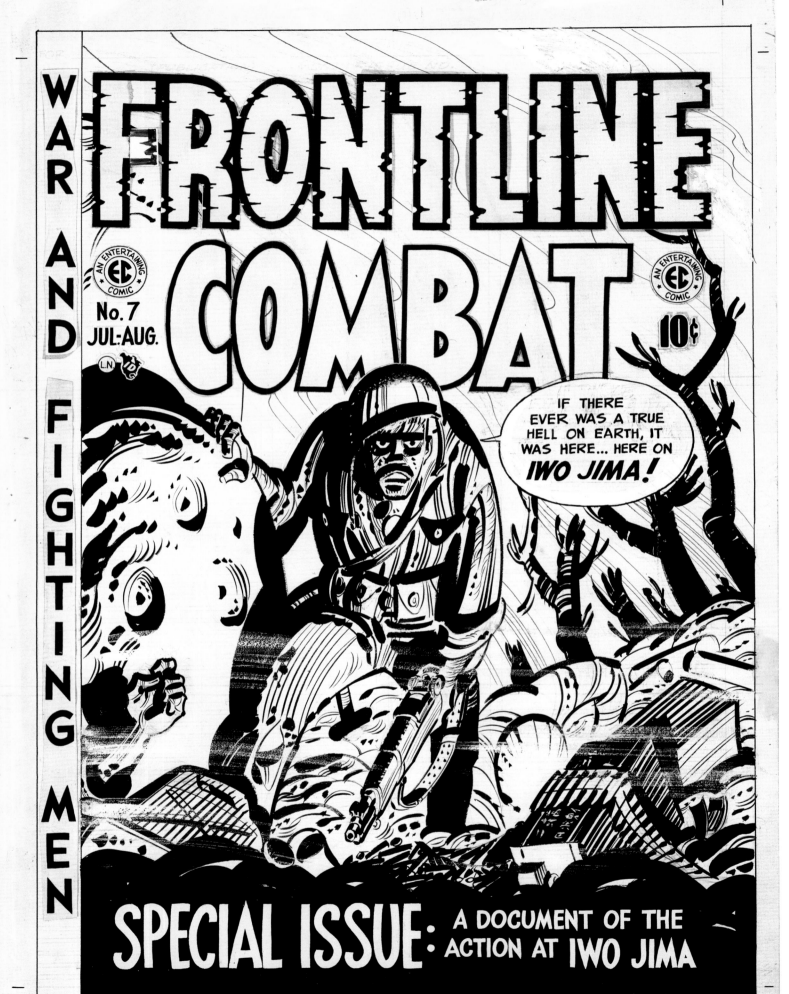

THE SCENE BELOW IS IN KOREA! THE MEN YOU SEE ARE PART OF THE REELING, BLEEDING CHINESE ARMY THAT IS SCRAMBLING BACK FROM ITS BIG SPRING OFFENSIVE! THE SPURTING DUST AT THEIR FEET IS BEING KICKED UP BY THE SPLINTERED STEEL OF AN...

# AIR BURST!

THAT HELLISH AMERICAN ARTILLERY DOES NOT LET UP FOR A MOMENT!

LET US GET AWAY FROM HERE AS QUICKLY AS POSSIBLE!

LEE! OUR WHOLE MORTAR SQUAD IS DEAD!

THERE ARE STILL FOUR OF US! COME, 'BIG FEET'! LIFT THAT MORTAR BARREL AND RUN!

by his Aztec "inferiors." (In case the point was lost, the second issue features "Jivaro Death," in which a less formidable white invader meets a similar fate.) However intuitive his analysis may have been, triumphalism was clearly not on the Kurtzman agenda.

Two-Fisted Tales debunked General Custer and ridiculed the Roman Empire; "Bunker Hill!," illustrated by Wallace Wood (issue #8), is about as patriotic as this remarkably grim comic book got. By the end of 1951, Two-Fisted Tales and its Kurtzman-edited, equally well-researched companion publication, Frontline Combat, were consumed by America's current and profoundly confusing war. Two-Fisted Tales #7 was all Korea; the ninth issue was a special, multi-part "Document of the Action at Changjin Reservoir," a brutal winter battle in which both sides claimed victory.

Kurtzman's war comic books showcased his boldest, most abstract drawing. The thick line and copious use of black suggest gouged-out woodcuts, the cartoony figures might have been conceived in a trench, and the "silent" serial frames are violently percussive. Replete with civilian casualties and hand-to-hand combat, "Kill!," "Rubble!," and "Corpse on the Imjin!," featured in three consecutive issues of Two-Fisted Tales (#s 6, 7, 8), are savagely unsentimental and utterly devoid of the gross jingoistic stereotypes endemic to the genre (especially during wartime). The enemy is human and even has a point of view— "Air Burst!," the Frontline Combat story that Kurtzman called his favorite (#4), unfolds entirely from the perspective of terrified North Korean infantrymen.

Given the tenor of the times, the radical humanism of Two-Fisted Tales and Frontline Combat might well have become subject to a Congressional probe, were the Senate Subcommittee to Investigate Juvenile Delinquency not already distracted by the horror of EC's horror line.[1]

As EC came under attack, Kurtzman proposed opening a new front, namely a comic book that would parody other comic books. In the summer of 1952 EC brought out the first issue of MAD, which Kurtzman edited, wrote, designed, and for which, at least initially, he drew the covers. Only a few months earlier, Partisan Review had signaled its acceptance of the Cold War status quo with the symposium "Our Country and Our Culture." MAD, however, was unreconciled. The first issue opened with a big "Hoo-Hah!" and ended, in a piece called "Ganefs!" (Yiddish for thieves), by evoking a nuclear test on a South Pacific island.

MAD #4 demolished Superman and issue #5 produced a particular sort of manifesto. In "Outer Sanctum," a mass of fetid garbage is given life by a drooling scientist. This heap likely served as a metaphor for MAD's sense of Western (or at least American) civilization as a clutter of cultural detritus—a view shared by such disparate modernists as T. S. Eliot and Kurt Schwitters. By issue #6 ("Teddy and the Pirates," "Melvin of the Apes," "Ping Pong") MAD had begun to conceive the media as a single system: Little Orphan Annie and Edward G. Robinson made cameo appearances in "Starchie" (#12). Later, Blondie's husband Dagwood was cured of a nervous breakdown by a transfer from the confines of his domestic strip to Terry and the Pirates, and Dick Tracy, revealed in moonlight as his parody, Fearless Fosdick.

Highly self-conscious, the MAD versions of Superman, Tracy et al. were acutely aware of the conventions of the comics in which they appeared—as well as the language of comics in general. In "Murder the Husband!" (issue #11), Kurtzman recycled artwork from an earlier EC suspense comic and added dialogue, also recycled, albeit from a variety of German, Russian, and Yiddish sources. His compositions found their fullest expression as drawn by his fellow Music and Art alum Will Elder, who started at EC with Two-Fisted Tales. Gifted with an uncanny ability to

mimic the entire range of comic book drawing styles, not to mention print ads and tabloid photographs, Elder would be *MAD*'s supreme draftsman and quintessential artist—his best panels are collagelike arrangements of trademarks, media icons, visual puns, and assorted non sequiturs (often in Yinglish).[2]

Writing on the Juvenile Delinquency hearings on comic books—and his young son's taste for EC comics—in the June 1954 issue of *Commentary*, Robert Warshow described *MAD* as "a wild, undisciplined machine-gun attack on American popular culture." (Another, perhaps more self-aware, Russian Jewish son of the Bronx, Warshow confessed that he read himself the magazine "with a kind of irritated pleasure.") Kurtzman's third—and most epochal magazine— gave full vent to his critical edge and formal playfulness.

With *MAD*, Kurtzman realized himself as a particular kind of modern artist. Like the animator Tex Avery, the filmmaker Frank Tashlin, and the television star Ernie Kovacs, he positioned himself at the margins of American popular culture and turned that culture in on itself. Even as Walt Disney prepared to open his antiseptic Disneyland, *MAD* #19 published the superbly scurrilous "Mickey Rodent." But, consciously (or, more likely, not) Kurtzman was ultimately the most political of the vulgar modernists. How to account for the deep skepticism that *MAD* articulated, from within American mass culture, at the acme of the Cold War? "The ten-year-old clutches his or her *MAD*," Marshall McLuhan would write in *Understanding Media*, "in the same way that the Russian beatnik treasures an old Presley tape obtained from a GI broadcast."

The April 1954 Senate hearings effectively killed EC's "New Trend," including *Two-Fisted Tales* and *Frontline Combat*. The publisher was basically left with *MAD*. (Kurtzman's cover for issue #16 is a fake tabloid headlined "Comics Go Underground.") But five issues after masterminding *MAD*'s mid-1955 transition from comic book to slick magazine, Kurtzman left EC, taking Elder, Wood, and Jack Davis with him. In late 1956, he founded and edited *Trump*, an even slicker bimonthly magazine printed with high-stock paper and color inserts, underwritten by *Playboy* mogul Hugh Hefner. When *Trump* folded after two issues, before Elder's brilliant Norman Rockwell parody could grace the cover, Kurtzman started *Humbug*—a monthly, owned by the artists themselves (including Elder and Davis). It sold for an impractical fifteen cents and lasted thirteen issues before folding in the summer of 1958.

Two years later, Kurtzman launched his last magazine. The provocatively titled *Help!* broke with the *MAD* prototype largely through its extensive use of captioned photographs and *fumetti* narratives. Along with early examples of underground comix, including some by R. Crumb, *Help!* did feature one major Kurtzman-Elder collaboration. After *Humbug*, Kurtzman had published a paperback original, *Harvey Kurtzman's Jungle Book* (1959), whose four satiric stories suggest a path not taken in the direction of the graphic novel. The Candide-like innocent Goodman Beaver, a perhaps autobiographical figure featured in "Organization Man in the Grey Flannel Executive Suite," returned in a series of *Help!* stories. The third of these, "Goodman Goes Playboy" (*Help!* vol. 2, #1), drafted the characters from *Archie* comics into a swinging sixties lifestyle—a parody that extended *MAD*'s famous "Starchie" and provoked the threat of a lawsuit.

*Help!* lasted into 1965, just long enough to usher in the "high sixties." By that time, Kurtzman was basically a *Playboy* hired hand, and Goodman Beaver had mutated into Little Annie Fanny. Brainstormed by Hefner (Little Orphan Annie as an "exquisite hunk of pulchritude"), written by Kurtzman, and painted by Elder, *Little Annie Fanny* was the vision of a new sort of sexual

245  Harvey Kurtzman
Drawing for cover of *MAD* #1
(published October–November 1952)
Pen and ink with colored pencil, gouache, and opaque white
20 x 14 inches
Collection of Glenn Bray

Kewpie doll—it appeared the same year that the comic strip sex goddess Barbarella made her debut in France and some eighteen months before the Terry Southern–Mason Hoffenberg novel *Candy* was finally published in the U.S.

The erotic misadventures of the absurdly top-heavy naïf ran in *Playboy* for twenty-five years. Not without certain aspects of topical satire, even a sort of pageant of the period, *Little Annie Fanny* was the glossiest, costliest comic strip ever produced. One can only imagine what the Kurtzman-written *MAD* parody would have done with this bejeweled drool (or Karl Marx, who, in regard to the short-lived, *Humbug*-like workers' utopia of the Paris Commune, noted that "the oppressed are allowed every few years to decide which particular representatives of the oppressing class are to represent and repress them").[3]

There was no way that an institution like *Playboy* could be subverted from within. If Kurtzman was ultimately permitted to create comic strip art on the most lavish imaginable scale, it was as a particular sort of foot soldier in someone else's revolution.

**Notes**

1 Gerard Jones writes that EC's war comics received "the Army's censure," but provides no details. *Men of Tomorrow: Geeks, Gangsters and the Birth of the Comic Book* (New York: Basic Books, 2004), 284.

2 The splash page for "Shermlock Shomes" (*MAD #7*), for example, has a deep-sea diver, a man wearing a refrigerator, the Mobil Flying Horse, a puzzled Saint Bernard dog, the Statue of Liberty, and the seven dwarves from *Snow White* wandering through the London fog. Like all *MAD* artists, Elder worked from Kurtzman's layouts. Nevertheless, he was encouraged by Kurtzman to clutter the background with all manner of signs, graffiti, and what Kurtzman called *chotchkes* (Yiddish for knick-knacks). Elder was also the *MAD* regular most attuned to Kurtzman's formalism—apparent as early as his *Silver Linings* strips. His stories regularly allow internal objects to tamper with the panel boundary, break continuous vistas into consecutive frames, offer visually identical panels with wildly fluctuating details, and otherwise emphasize the essential serial nature of his medium. The "special art issue" (*MAD #22*) is devoted to Elder's career.

3 Actually, this may be Lenin paraphrasing Engels paraphrasing Marx. See "Introduction, 'Address of the General Council of the International Working Man's Association on The Civil War in France, 1871,'" and "Experience of the Paris Commune of 1871: Marx's Analysis, Karl Marx and V. I. Lenin," *The Civil War in France: The Paris Commune* (New York: International Publishers), 20, 59, and 114.

246 Harvey Kurtzman and Will Elder
Drawing for "Bringing Back Father!" from *MAD #17*
(published November 1954)
Pen and ink with colored pencil and opaque white
20 x 14 inches
Collection of Glenn Bray

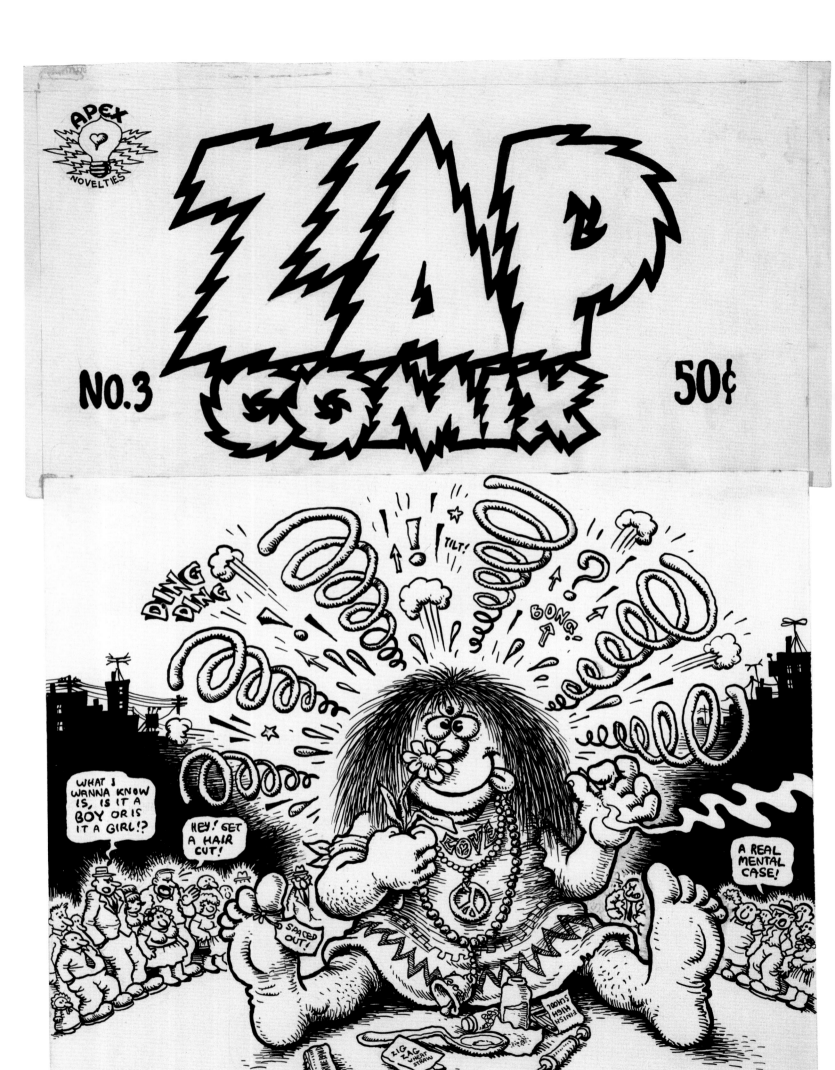

# [R. Crumb]

I came to R. Crumb's work with the full force of all my prejudices. I found his work unabashed in its vulgarity and was put off by the glorification of his own nerdiness, his occasionally repulsive depictions of women, blacks, and Jews, and his endless graphic representations of kinky, smelly, sweaty sex. But Crumb's influence was huge (every cartoonist we visited when starting *RAW* in the late seventies had had a "Crumb" period before he found his own voice). The man I met then seemed gentle and amiable (he also didn't jump on me), and, ultimately, the drawings were so appealing that I decided to "get over my hang-ups" and read the work. Crumb is very prolific and has never had a well-edited anthology, so it is arduous to weed through the repetitions and get to the masterpieces. Yet, I was most struck by the contradictions: yes, R. Crumb can be a sexist, misogynist, racist anti-Semite, but it's just as true that, far from being a misanthrope, he's a keen observer in the humanist tradition, that he has penned some of the most sensitive portraits ever made of obscure black musicians, and that he loves women and is married to one of the most charmingly and endearingly Jewish women I know.

## It's Only Lines on Paper

Françoise Mouly

Crumb's seemingly effortless drawings, worthy of an Old Master, coupled with the fluidity of his storytelling, which overflows with telling details, make one feel as if he's constantly defying the laws of gravity. We have all said at one point or another: "See what I mean?" and many writers and artists have attempted to do just that. Crumb is matchless in that he succeeds at making you see through his eyes and know what it feels like to be R. Crumb. Sometimes the experience is so magical that you forget you do not actually want to be R. Crumb, an anxiety-ridden perpetual loser, any more than he does. But the question remains: What can one say about someone who has presumably already told all?

**247** R. Crumb
Drawing for cover of *Zap Comix #3*
1968
Pen and ink, 14 x 10 inches
Collection of Eric F. Sack

Robert Crumb, the figurehead of what we now call the baby boomers, was born ahead of that curve in 1943, "the bloodiest year in the history of mankind," as he has remarked. A year younger than his brother Charles, Robert was the third of five children born in quick succession. The Crumb children were army brats who didn't stay long in any school and didn't get a chance to make lasting friendships. The parents—Dad a drill sergeant for the Marines, and Mom a nervous wreck, whose brain was eventually so fried by amphetamines that she beat up ceaselessly on her stone-mute husband while cursing and muttering to herself—were tragically unavailable to the kids. The siblings depended on each other, and their reliance on arts and crafts (which may have been fairly typical in the forties) got transformed into an extraordinary amount of creative endeavor at home. Led by Charles—described by their brother-in-law as "the twisted wizard of the Crumb children" (Charles ended up committing suicide at the age of fifty-three after being institutionalized for schizophrenic paranoia)—each of the five Crumb siblings created their own comic book with its own characters (Robert was only seven when he drew his first). In a 1969 strip, a wife walks in on her husband slumped in his armchair, entranced by the blank screen of a silent TV. "I can think up better shows," he explains, and that seems to have been true for Robert throughout his life.

It's fitting that one of Crumb's first jobs, after finally leaving what had become a suffocating home base, was to work for a man he deeply admired, Harvey Kurtzman, the master of irony. But Crumb felt he didn't have the chops neces-

248  R. Crumb
Drawing for *San Francisco Comics #3*
(published 1970)
Pen and ink, 10 x 14 inches
Collection of Eric F. Sack

249  R. Crumb
Drawing for *Burned Out—The East Village Other*
(published 1970)
Pen and ink, 14 x 10 inches
Collection of Eric F. Sack

sary to keep up with a Will Elder, nor did he have the affection for contemporary mass culture that was a hallmark of Kurtzman's approach to satire. Kurtzman himself was disappointed by the lack of sharp, biting humor in the sketchbook reports Crumb sent back first from Harlem, and later from Bulgaria (Crumb *loved* Bulgaria behind the Iron Curtain!). The critic Robert Hughes has called Crumb the Brueghel of the second half of the twentieth century, and Crumb does indeed carry forward Brueghel's love for simple people, however foolish they might be; it may even be true that he loves fools best.

Crumb had a hard time fitting anywhere. He was miserable as a working stiff for American Greetings, a card company in Cleveland, and became terrified of being locked in a nine-to-five future. Hanging out in the dives of Cleveland, he adopted the basic tenets of Beat philosophy—nonconformity and spontaneous creativity. Belonging to a subculture (and the Beats were one of the first) offered an escape from the stranglehold of the newly invasive mass medium, television. But Crumb didn't unreservedly become a Beatnik either. Instead, he found himself drawn to the visual detritus of urban landscapes, and he lovingly rendered in his strips the individualistic marks, the rapidly disappearing traces of the local stores and street signs before they got completely obliterated by the vinyl signage and bland logos of rapidly encroaching franchises. (The same impulse got him to collect locally issued 78s of the music of the twenties and thirties, which in turn allowed him to finally find one infinitesimally small subculture he could always belong to.) The fact that he found his inspiration in the relics of a handmade, homegrown trash culture (Ben Katchor and Chris Ware are two cartoonists who have followed Crumb wholeheartedly along this path), foreshadows two of the seminal works of the postmodern movement: Robert Venturi's *Learning from Las Vegas* (1972) and Rem Koolhaas's

*Delirious New York* (1978). Philadelphia of the early sixties, where Crumb had been a lonely adolescent with no social graces, also happens to be where Venturi built the first postmodern house. In his 1966 manifesto, *Complexity and Contradiction in Architecture*, Venturi evokes the pressure of the modern orthodoxy that a sensitive young man, even an autodidact like Crumb, must have felt: "In their attempt to break with tradition and start all over again, they (the modernists) idealized the primitive and the exemplary at the expense of the diverse and the sophisticated." Postmodernists went on to call for an approach that would embrace "the messy vitality" of the "ugly and the ordinary." They praised "the movement from a view of life as essentially simple and orderly to a view of life as complex and ironic," and stated that "A feeling for paradox allows seemingly dissimilar things to exist side by side, their very incongruity suggesting a kind of truth." It's arguable whether comics ever had a modern period (maybe Herriman was its Picasso and its Matisse?), but, in incorporating the discarded past in the present (Crumb's work of the sixties, a mix of E. C. Segar's *Popeye*, the Marx Brothers, Walt Kelly's *Pogo*, Carl Barks, Disney comics, and early *MAD* comics, was jarring and totally out of tune with the spare approach of a Charles Schulz or with the then-nascent Art Nouveau-inspired psychedelic graphics), by embracing paradoxes rather than attempting to resolve them, by using the popular form of comics as a means for artistic self-expression, Crumb undoubtedly propelled comics to their place as a fundamental postmodern art form, central to the culture of the twentieth century.

But how did this maladjusted schlub with short hair and glasses, having taken his first acid trip and moved to Haight-Ashbury in 1967, come to embody the hippies, whose philosophy he had little affinity for? Unlike Kerouac, who actively promoted the Beat subculture he came

to symbolize, Crumb, in his comics, offered a how-to manual of hippie attitudes and styles as a by-product of his skill as an alienated observer. He catalogued the artifacts, the language, the clothing code of the Flower Children, unwittingly creating a kind of Sears catalogue, a bible for the counterculture, which allowed it to coalesce. When he went around in 1967 to peddle *Zap*, the first underground comix, he was initially rebuffed by stores, who failed to see the relevance of a comic book, a child's amusement, to the times. But the persistence of Crumb's vision was such that, within a few months, not only did every head shop in the country have to have the "*Zap* books" (a term that became as generic as Kleenex or Xerox), but every underground comix had to have a Crumb drawing. No one seemed deterred by the fact that Crumb portrayed hippies mostly as naïve, foolish children, and the wise guy they revered, Mr. Natural, as either trying to con them or to run away from them.

But Mr. Natural is forever lured back to the hippie crash pad by his lust for women. In a reverse twist on Catholic morality, it seems to have been partly Crumb's sex drive that saved him from the solipsistic despair and oblivion of his brother Charles. Having claimed comics as his means of self-expression, Crumb, deeply committed to a brutal honesty with himself and his readers, went on to explore his darkest fantasies, which, at the height of the free love movement, tended to run towards more arcane S&M. This resulted in intensely resonant, if disturbing, fantasy images and stories, from a page where Eggs Ackley, a Tintin-like childish character, falls deep into a grotesque pile of armless, headless "Vulture Demonesses" (bodies stacked *into* each other—Crumb's women often end up headless, a large inviting rump harboring a womb the child can reenter), to modern fairy tales like "Whiteman Meets Bigfoot." At the same time, Crumb continued to use comics to render tenderly observed private moments in real time, bringing

the "camera" into the darkened bedroom in this 1968 *Fritz the Cat* strip: "I've learned to control it so th' chick can get pleasure out of it too…Yer not so bad yerself…" "Oh I know…I've lost a lot of my uptightness since I took acid 'n' all…I feel liberated…Life is a beautiful experience if you…" "Yeah…me too…" Balloons allow for what feels like a transcription of real dialogue, phonetic and unpunctuated. In "Mr. Natural Does the Dishes" (1971), the story is told without words: you see him simply soaping, rinsing, and drying (Crumb himself does the dishes at home).

Crumb has always held on to the contradictory parts of his own personality. When his unbridled work of the late sixties began to be viewed through the prism of political correctness, he responded with a strip, "A WORD TO YOU FEMINIST WOMEN," which starts with "I would like to be your friend" and ends it with "Well, listen, you dumb-assed broads, I'm gonna draw what I fucking-well please to draw, and if you don't like it, FUCK YOU!!" The man who has elaborated endlessly on his sexual fantasies and adventures has been in a stable and loving relationship with another artist, Aline Kominsky, for more than thirty years and is a stellar babysitter who has a real knack with kids. He is retiring and prefers to stay in the background on social occasions, but he is attentive, warm, sweet, and funny in private. He once drew a page advertising "Eat Nigger hearts for lunch!" yet he also drew a sensitive life of Jelly Roll Morton for *RAW* magazine in 1985.

It is Crumb's ability to embrace his own paradoxical relationships to the world around him that reinforces his vision. In Crumb's world there's no escape, neither in sex, nor in drugs, nor in revolutionary theory. The ex-Catholic boy is deeply in love with the fools and the simple folks and just as overwhelmed by the weight of evil in the world. The only enemy is easy answers. As fallible as the lesser of us, Crumb is endlessly in the confessional, but he's resigned to the fact that no priest is on the other side, that no one is there to give him absolution.

*following pages*

252  R. Crumb
Drawing for "A Word to You Feminist Women" from *Big Ass* #2
(published 1971)
Pen and ink, 14 x 10 inches
Collection of Eric F. Sack

253  R. Crumb
Two pages from "Cubist BeBop Comics" from *XYZ Comics*
(published 1972)
Each 11 x 9 inches
Private Collection

[Art Spiegelman] Most of us could be other people. Given different personal and historical contingencies, I could have been a jeweler in Washington, D.C., a Talmudic scholar in Galicia, or things even harder to imagine, like dead. To pretend that I am who I am because I *had to* be is to pretend.

But there are certain people in the world whose calling is so specific—not even calling, but *personhood*—that it's impossible to imagine them being anyone else. Woody Allen is a great example. If Woody Allen weren't Woody Allen, who would he be? A White House correspondent? A dairy farmer? And who would be Woody Allen?

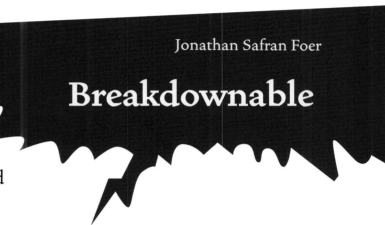

Jonathan Safran Foer

**Breakdownable**

I don't know if there's anything inherently good about being such an original, but they're easy to envy. They imply something essential, unbreakdownable...

It took a lot of historical contingencies to make Art Spiegelman. He was born in Stockholm in 1948, the son of survivors of death camps. As anyone who has read *Maus* knows, his older brother, Richieu, was a victim of the Holocaust, which makes it impossible not to think about birth order and chance. And what if the Spiegelmans *hadn't* immigrated to the United States, but to Israel or South America, as did so many in similar positions? Would Art Spiegelman be Art Spiegelman? What if they *hadn't* moved from Pennsylvania to New York, the singular place in the world in which one can imagine Art Spiegelman developing? What if Art Spiegelman *hadn't* drawn his first comic strips at the age of twelve, but instead composed his first song? (He's currently writing a libretto, so it doesn't seem out of the range of possibility.) Who would Art Spiegelman be if Art Spiegelman *hadn't* spent a month in Binghamton State Mental Hospital, if his mother *hadn't* committed suicide that same year (1968), if he *hadn't* found refuge in the avant-garde comics scene?

**254** Art Spiegelman
*Comics as a Medium of Self Expression*
1981
Pen and ink, brush, and watercolor, 30 x 18 inches
Collection of the artist

Over the past two years, I've had the good fortune of getting to know Art personally. So it's not only as a fan but as a friend that I have to wonder what to feel about all that was necessary to make him. What price is too high for an original?

———

Art Spiegelman became a household name in 1992 when he won the Pulitzer Prize for *Maus*. It was one of those wonderful shames—wonderful because it elevated not only his work, but his entire genre to a level of serious critical attention it hadn't before known; a shame because *Maus* became so huge that now, when people think of Art Spiegelman, they think of *Maus*—a classic, to be sure, but only a piece of his large and eclectic body of work.

By the age of fifteen, Spiegelman was already the publisher of his own magazine, charmingly titled *Blasé*. He "majored in cartooning" in high school (who knew such a thing was possible?), began selling comics to local newspapers, publishing in underground magazines, and in 1966 established what became a twenty-year relationship with Topps Chewing Gum Company, for whom he created such novelty products as *Wacky Packages* and *Garbage Pail Kids*. By the 1970s, he was not only a hugely influential comics artist (the first to publish in *The New York Times* Op-Ed pages, among many other firsts), but one of the genre's most important champions, regularly giving lectures, publishing essays, and, along the way, founding both *Arcade* (with Bill Griffith) and *RAW* (with his wife, the inimitable Françoise Mouly).

**255** Art Spiegelman
*Lead Pipe Sunday*
1990
Double-sided lithograph
22 ¼ x 30 ¼ inches
Collection of the artist

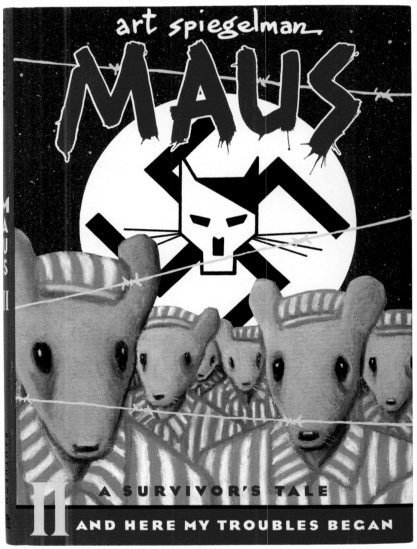

256–257 *left*: Art Spiegelman
Cover of *Maus: A Survivor's Tale, I. My Father Bleeds History*
(published 1992)
9 ¼ x 6 ½ inches

*right*: Art Spiegelman
Cover of *Maus: A Survivor's Tale, II. And Here My Troubles Began*
(published 1992)
9 ¼ x 6 ½ inches

**258** Art Spiegelman
Drawing for *In the Shadow of No Towers*
(published 2004)
Felt-tip pen, 12 x 9 inches
Collection of the artist

**259** Art Spiegelman
Drawing for *In the Shadow of No Towers*
(published 2004)
Watercolor, gouache, and ink, 15 ½ x 10 ½ inches
Collection of the artist

IN THE SHADOW of NO TOWERS #2:
"EQUALLY TERRORIZED BY AL QAEDA AND HIS OWN GOVERNMENT
OUR HERO looks over some ancient comics pages instead of working.
He dozes off and relives his ringside seat to That Day's disaster
yet again, trying to figure out what he actually saw..."

In 1986, Pantheon collected the first six chapters of *Maus*—which had appeared as works-in-progress in *RAW*—and published them as a book. It went on to be translated into eighteen languages and receive a National Book Critics Circle nomination. Five years later, Pantheon published the remaining chapters as *Maus II*, which became an even more major critical and popular success. Along the way, Spiegelman became the most visible cover artist for *The New Yorker* (creating a major scandal with his 1993 Valentine's Day cover, on which a Hasidic man and a black woman are locked in romantic embrace), and the publisher (with Mouly) of the children's series *Little Lit*. His most recently published work is a collection of strips pertaining to the September 11 attacks on New York. *In the Shadow of No Towers* was met with popular success and a mixture of critical enthusiasm and confusion—as if it, too, were an original.

————

The last time I sat down with Art was my first time in his studio. I was surprised (and impressed) by how many work areas there were. At the center of the office was an enviable Captain Kirk-like raised computer station: a pretty serious screen, two scanners, a pad on which to draw straight onto the computer, a side area for sketching, bottles of inks, a can of writing implements, shelves of CDs, a stereo console, and various unidentifiable miscellany that, even in their unidentifiableness, seemed like things I couldn't live another day without possessing.

Beside this setup was a very cool light table, on which rested a drawing-in-progress. Across from that, against the window, was an old-fashioned drafting table. If memory serves, there was a scratched-up desk across from that. There must have been half a dozen desks throughout the office. How could one person, I wondered, need so many surfaces? Where is the army of Art Spiegelmans?

We talked about the originals of his drawings. I wanted to use the excuse of this short essay to see them. Art explained that given the way he works, moving freely between paper and the computer, pen, pencil, and ink, no such things exist. There are sketches. And there are drawings done directly on the computer. And there are more fleshed-out drawings. And there are altered, cobbled-together images on the computer. But if one's dream were to hang *In the Shadow of No Towers*, from beginning to end, one would be disappointed.

I found that...*disappointing*.

Why?

I've spent the intervening weeks trying to figure out why.

I think the lack of originals disappoints me because I'm guilty, like many young artists, of wanting to believe in the sanctity of making something from nothing, and that something being somehow—it's embarrassing even to write this—pure. Despite all cynicism and rationality and self-consciousness and self-protection, I believe in *the thing itself*.

What disappointed me, what shook me, was that for one of my favorite artists, there is no *thing itself*.

There are half a dozen work surfaces.

————

*Breakdowns*, the first book-length collection of Art's work, was published in 1977. The cover features a self-portrait in the upper left quadrant. Art is at his drafting table, drinking down a bottle of ink. The other three quadrants are filled with smaller versions of the same image, broken down according to composite colors, revealing how the printed image is a series of overlays. The frontpapers are filled with yet more breakdowns of the breakdown, some closely related to the original, some only barely recognizable.

Or is original the wrong word?

Original *is* the wrong word.

261 Art Spiegelman (with additions by R. Crumb)
Drawing for *In the Shadow of No Towers*
(published 2004)
Pen and ink, 12 ½ x 8 inches
Collection of the artist

262 Art Spiegelman
Drawing for *In the Shadow of No Towers*
(published 2004)
Pen and ink, 11 x 14 inches
Collection of the artist

Every made image, whether it be a freehand circle or a collage of materials, is a composite. Literally speaking, everything can be broken down—into composite shapes (a circle is an infinite collection of intersecting lines), into composite colors, into planes, into slices of time. But more than that, everything that's made is a composite of the maker's life to that point. When asked how long it took him to draw one of his naïve sketches, which had obviously been made with only a few strokes, Picasso answered, "Seventy-six years." Nothing is possible without everything that came before it, and in the case of Art Spiegelman, the high price of his past pays for his value as an artist.

Or maybe it's the other way around.

Or maybe there's an entirely different way of looking at it...

Art Spiegelman didn't *have* to be Art Spiegelman, and to suggest as much is to undermine his unrelenting artistic will. He didn't fulfill his destiny. He worked against it, willing himself and his art into being. He took a form that was at best underappreciated—it was looked down upon—and breathed life into it. The existence of comics and graphic novel sections in Barnes & Noble is because of Art Spiegelman.

*Maus* is not the product of the Holocaust. It is in defiance of it. It's too easy, given that we live in a world partially created by *Maus*, to assume that artists have always been taking such creative liberties with World War II. But no one was doing what Spiegelman was doing before he did it. No one was handling history in that way, and no one was using comics in that way. The same could be said of *In the Shadow of No Towers*. What makes the work difficult is its newness. And it's what makes the work important.

The moral of the story?

There are no originals.

None of us is forced to become anyone.

Which is why when someone becomes Art Spiegelman, it's worth celebrating.

# [Gary Panter]

## Genius and Pal

Matt Groening

*Business*

*1 to create a pseudo-avant-garde that is cost effective.*
*2 to create merchandising platforms*
*on popular communications and entertainment media.*
*3 to extensively mine our recent and ancient past*
*for icons worth remembering and permutating:*
*recombo archaeology.*

—*Item 11 from Gary Panter's* Rozz-Tox Manifesto *(1980)*

In my highly disorganized brain I keep a secret roster of creative weirdos—prolific auteurs, self-possessed outsiders—whom I've actually met, been influenced by, and annoyed. About seventy-five people are on that list at the moment, partly because I keep running into talented folks at upscale gallery openings and downscale flea markets, and partly because I think you're a genius if you have dark circles under your eyes or you can do cool yo-yo tricks.

Way at the top, up there with Stephen Hawking and Lynda Barry and Phil Hendrie and Harry Shearer and Brad Bird and Amy Tan and Thomas Pynchon and Yma Sumac, is my pal Gary Panter, the super-modest ultra-genius who is a virtuoso pen-and-ink drawer, a fractured cartoonist of postapocalyptic, urbanoid nightmares, the head designer of *Pee-wee's Playhouse* (the most psychedelic Saturday morning TV show ever), and the creator of the Screamers logo, that shrieking, stencilized, exploding-head trademark that was chronically ripped off and bootlegged on T-shirts and posters and stickers and flyers and in newspaper ads throughout the punk/new-wave era (1977–89ish).

**263** Gary Panter
Cover of *RAW* #3
(published 1981)
12 x 10 inches
Collection of Art Spiegelman

Gary and I met in 1978, when we both happened to be toiling in obscurity in separate dinky apartments in a couple of the sadder neighborhoods of Hollywood. Unbeknownst to each other, we cowered in sweat in our stifling abodes, where we drew and hand-stapled our own photocopied comic books, and then sold them to the few squalid record and clothing stores that we had the nerve to shuffle into. I didn't know who Gary was then, but I bought a few of his wild zines (the term hadn't been invented yet) at Billy Shire's original Soap Plant store on Sunset Boulevard in Silver Lake. The stories in Gary's zines seemed jumbled, almost incoherent, but the scratchy, scraggly art was undeniably the work of a demented prodigy, and I grabbed every Gary Panter document I could find. Soon I discovered Gary's monthly *Jimbo* comic strip in *Slash*, the brand-new smart-ass tabloid that chronicled the burgeoning L.A. punk scene.

Then out of the blue I got a letter from Gary himself! He'd gotten my Valentino Place address from one of my own little Xeroxed comics and had scrawled out a single-page note in tortured, cacographical, but somehow gifted-looking handwriting, saying he liked my cartoon rabbits. The letter "Y" in Gary's signature looked like an "S," so I took the name as GARS, and since Panter's strips and zines were full of Japanese words, I got it into my head that this Gars was a crazed Japanese punk, maybe trying for some sort of mis-

spelled, punning Garish Painter pseudonym, and at first I was too scared and lazy to call the phone number scratched at the bottom of the letter.

But eventually I contained my frazzlement and did call, and this mild, gentle voice with a sweet East Texas drawl on the other line answered, and it was Gars. We met on neutral turf—Astro Burger on Melrose Avenue, down the street from Paramount Pictures—and, over burgers and cokes, found we shared an obsessive enthusiasm for trash culture, monsters, punk rock, Godzilla, R. Crumb, *Zap* comix, Frank Zappa, Captain Beefheart, Cal Schenkel, Carl Barks, George Herriman, Philip K. Dick, Ennio Morricone, psychedelic rock, Pop art, outsider art, folk art, and burgers and cokes. We ended up hanging out for a few years, often at Astro Burger, sometimes at Burrito King, where we talked about sex and drugs and occasionally debated art and culture. Cranky artist Byron Werner (whose painted statues have adorned the lobby of the Nuart movie theater for the last couple decades) was our foil, accusing us of being sellouts as Gary and I plotted how to sneak our work into mainstream pop culture. None of us had much money in those days, so we often split our burgers, but I don't recall ever being so desperate that we shared a coke.

Gary's career took off and soon he was able to buy burgers and burritos galore. Every week it seemed like Gary was in another exciting art show, and he continued to churn out weekly

264–268 Gary Panter
Five drawings for *Dal Tokyo*
c. 2003
Pen and ink, each approx. 6 x 15 ½ inches
Collection of the artist

MAY 5 1983

269  Gary Panter
Drawing for *Jimbo*, 1987
Pen and ink, 29 x 23 inches
Collection of the artist

270  Gary Panter
Drawing for *Jimbo in Purgatory*
(published 2004)
Pen and ink, 23 x 16 inches
Collection of the artist

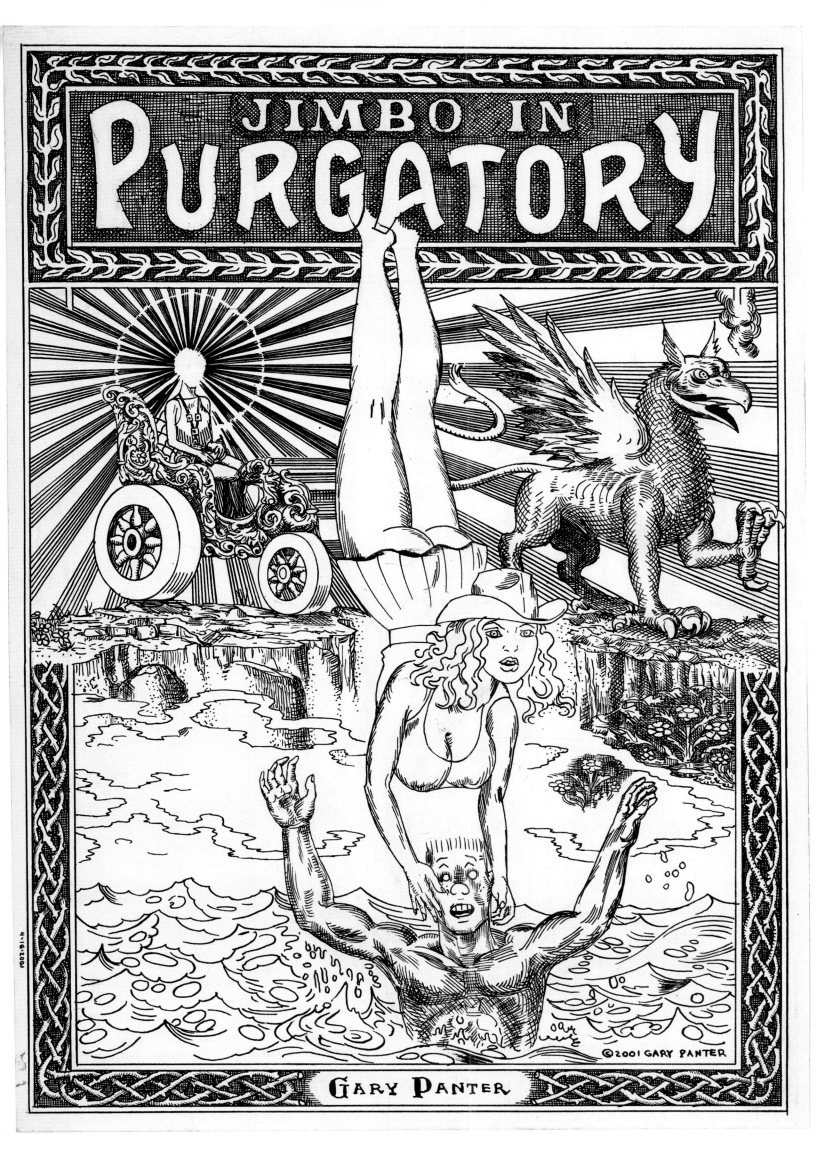

comic strips, posters, murals, the influential *Rozz-Tox Manifesto* (worth tracking down online), and tons of commercial illustration work, including a *Time* magazine cover of The Who in 1981. The visual vocabulary of Gary's work, which he termed "recombinant art," exploded with styles used and discarded after a single painting or illustration. He continued drawing and designing his Dal Tokyo science-fiction world, and the results appeared in Art Spiegelman and Françoise Mouly's *RAW* magazine, as well as in assorted zines, European and Japanese magazines, and in *Jimbo* books and comic books. Gary also recorded a crazy single, "Tornader to the Tater," with the Residents and put out the psychedelic country album, *Pray for Smurph*, on the Japanese Overheat label. He also did three Cal Schenkel-influenced Frank Zappa album covers, not finding out till later that Warner Bros. Records was working without Zappa's cooperation. (I once asked Frank what he thought of Gary's art, and except for the small, x-ray skull illustration in the middle of the collage that makes up the back cover of *Orchestral Favorites*, Zappa said he dug Gary's work.)

During this whole time, and in the years since, Gary has filled one sketchbook after another with amazing drawings, diagrams, maps, and blueprints of his feverish, futuristic, half-dream, half-nightmare worlds. These sketch-books also detail Gary's travels and observations, including the heartbreaking, jangled drawings of the attack on the World Trade Center that Gary produced from the rooftop of his Brooklyn home on September 11, 2001. And just last year Gary put out *Jimbo in Purgatory*, a twisted, tour-de-force cartoon book that convolutes *The Divine Comedy* with a bad acid trip in a way that would blow Dante Alighieri's mind.

Although Gary is often lumped in with the talented but tightassed virtuosos of the lowbrow art scene, I think his work, despite sharing a surface vulgarity with his peers, remains in a stubbornly untamed school of its own. He's too modest to say so himself, but Gary's art has influenced a generation of underground cartoonists, illustrators, and painters, including a few dozen commercial artists who have built, perhaps unconsciously, entire careers on some of Gary's stylistic quirks. I'm sure his imitators amuse Gary, because he is—here comes the corny part—a truly nice guy.

And because he's so sweet, I can admit here that yes, I've copped a thing or two from Gary. Check out Jimbo's spiky hairline and then take a look at Bart Simpson's picket-fence-topped noggin. Eerie, isn't it?

Thanks, Gars, for your inspiration, your friendship, and for not suing my ass.

271  Gary Panter
Sketchbook pages for *Jimbo*
1980s
Pen and ink, 8 ½ x 21 inches
Collection of the artist

272–275  Gary Panter
Four drawings for *Dal Tokyo*
c. 2003
Pen and ink, each approx. 6 ¾ x 15 inches
Collection of the artist

# Interview with a Silly Person Who Thought Ware Could Not Draw

**Q**  *You once thought Ware could not draw?*

**A**  Because his comics are so carefully constructed and his lines so neat, there were more than a few people who thought **a**) that he was drawing and composing every-thing on the computer and with the aid of computer-drafting tools; **b**) that thusly he was a sucky draftsman. I can't be blamed for riding with this herd mentality.

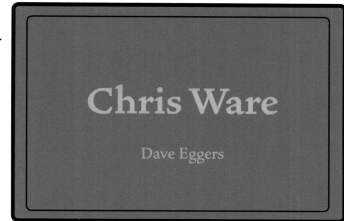

**Chris Ware**

Dave Eggers

**Q**  *What changed your mind?*

**A**  Well, clues began to emerge. First, anyone who had a chance to see any of his sketches or works in progress knew that he drew everything by hand, on large boards, in blue, non-repro pencil. There is an almost off-putting level of craft apparent in these sketches. They are architectural in their precision and daunting in the complexity of their planning. Though erasures and corrections appear, even the mistakes are tidy and intelligent. The final and loudest clue into Ware's draftsmanship came with the release of *The Acme Novelty Datebook*, wherein pages from Ware's sketchbooks were reproduced, giving unfiltered access to his process of creation, revision, and, most frequently of all, frus-tration. The book was startling in its candor—lots of embarrassing sexual admissions and far more self-doubt—but was most noteworthy in that it demonstrated how beautifully Ware draws. In pencil, in ink, with gouache, in cafes or on the street or from photos, he excels in a number of styles, but is always teetering between great facility and an endearing shakiness.

**Q**  *Did you just say "endearing shakiness"?*

**A**  Yes.

**276** Chris Ware
Drawing for *Jimmy Corrigan, The Smartest Kid on Earth*, 1994
Pen and ink with brush, colored pencil, and opaque white
23 ¾ x 15 inches
*7* Collection of the artist

277 Chris Ware
Drawing for *Rusty Brown*
2002
Pen and ink with brush, colored pencil, and opaque white
30 x 20 inches
Collection of the artist

278 Chris Ware
Souvenir pullout calendar for *Rusty Brown*
2001
30 x 20 inches
Collection of the artist

## Interview with a Petulant and Maybe Pretentious Lover of Chris Ware's Work

*Q   Why are you a lover of Ware's work?*
A   I think it's beautiful. I wish we had more good words in English that meant the same thing as beautiful, but we don't.

*Q   In what way is Ware's work beautiful?*
A   I've spent some time thinking about this, and I think it's beautiful in the way that Nabokov's work is beautiful. In both cases it's clear that the creator believes in beauty for its own sake, and, more crucially, is capable of creating beauty anywhere and always. Ware's work, in this way, is also quite like Bach's.

*Q   Did you say Bach? I think you mean Mozart maybe.*
A   I didn't mean Mozart. I meant Bach. I like Bach better, so I said Bach. Mozart is more fluid, not as structured, perhaps, as Bach, and when you talk about Ware, you need to be talking about structure as much as anything else. The structure is what makes his stuff transcend the limitations of the medium, and makes it more beautiful than it should be. There's glory there. We look at his work and we think of words like sumptuous, and exacting, and rhapsodic, and precise, and musical.

*Q   How can his work be so precise and exacting, and at the same rhapsodic and musical?*
A   I don't know. Or maybe I know, but can't explain it. Ware's work is at once the most elaborate and the most controlled example of the comics medium yet produced. I don't think anyone in any visual medium is making art that is more elevating. He makes us remember what is possible with very hard work and great planning and conceptual strength. Indeed, I think that's a strange but essential by-product of people viewing his comics: they want to work harder on their own things. In that way he's among the most exacting and prolific and industrious art-makers who also benefit from genius: they make the rest of us look like chumps, so we want to try harder.

279 Chris Ware
Plan for proposed wind-up toy
2002
Pen and ink with brush, colored pencil, and opaque white
12 x 20 inches
Collection of the artist

280 Chris Ware
Box design for wooden toy: *Quimby the Mouse:*
*Giant-Size Distillation of Earthly Corpus*, 2003
Pen and ink with brush, colored pencil, and opaque white
20 x 16 inches
Collection of the artist

## Monologue by Someone Who Wants to Talk About Ware as a Designer

Chris Ware, to many, seemed for a while to be as much designer as draftsman. After the world of design and illustration discovered his comics in the late nineties, he was asked and did design a number of book covers, and these designs were so extraordinary that for a while, he was asked to design the covers of just about everything produced in the United States and abroad. From the cover of *American Illustration Annual* to *This American Life*'s CD cover, every last thing he did was of exceedingly high quality. And that's another side-note that's difficult to explain: just how does he maintain such a level of across-the-board quality? There is never a drop-off. Everything is equally elaborate and thought through, and he almost never repeats himself. He seems to attack each new project, and each new page, with the mission to do better and to do something new. And this is how he stretches the boundaries of the comics medium, again and again and again. His use of the page is unparalleled because, while many comics artists work within consistent structures—say, twelve more or less equal boxes per page—Ware's pages are never alike, and he always keeps in mind the whole. On a macro/design level, he succeeds in making interesting pages, pleasing and innovative, while on a micro level, there is intense attention paid to every detail. The details, like the placement of a tragicomic hero's hand or the droop of fall's last leaves on a Chicago elm, are never left uncared for. Ware's ability to work on these two levels, the sweeping/formal/structural and the minute/lyrical, is very rare, we all know.

281 Chris Ware
*1* Drawing for 2002 Whitney Biennial Poster:
*The Whitney Prevaricator*, 2002
Pen and ink with brush, colored pencil, and opaque white
30 x 20 inches
Collection of the artist

## Interview with Someone Who Thinks He Knows Something about Ware

Q *What is it you think you know about Ware?*
A  Ware, or at least a part of Ware, thinks that he is a bad artist. He is brutally self-eviscerating, and no amount of success or acclaim seems to diminish the self-flagellating with which he punishes himself. Actually, you might say that the better he gets, the more ashamed he is to be so good.

Q *For example?*
A  On the cover of the sketchbook mentioned earlier, he calls himself "the immodestly spotlight-seeking genre miniaturist, layout man, and children's entertainer." Also, there is a page in the sketchbook that is illustrative, if you'll allow me that pun. In the drawing, Ware depicts himself at his drafting table, with the thought balloon above his head saying, "Why is it so hard to get *started*?" Around his head and shoulders are various mini-muses, most of whom are discouraging or cruel. One, in the form of his oft-seen superhero character, says into his ear the word "Honesty." A two-headed Quimby the Mouse character says both "Be yourself" and "You're lost." His familiar robot-man character says simply, "You suck." Meanwhile, on Ware's forehead is stamped the word FOOL.

Q *Hmm.*
A  Yes. In every way, Ware gives the impression in his work of being, himself, antisocial, self-lacerating, dystopic, and perhaps dangerous to his fellow man and pets.

Q *We all know this. We have read what you've read and seen what you've seen.*
A  Yes, but in person he's extremely friendly and funny, and supportive of fellow artists, and very articulate about the medium and optimistic about its future. He's also rather tall and was reportedly something of a stoner in high school.

## Two People Arguing about the Content of Ware's Work

Dumb Person: *I think Ware's work is all style, no content.*

*Smart Person*: You're saying that because like many unobservant people, you think that if something is very aesthetically pleasing, it can't also be intellectually challenging or emotionally resonant.

D.P.: *Yes, I guess you're right. I am a dumb person.*

S.P.: You have no idea how dumb you are. You're the sort who thinks all people with yellow hair are vapid or that nothing that glitters can in fact be gold. It's a bigoted, specious and, I think, transparently embittered point of view, usually favored by the aesthetically challenged—you feel threatened by that which is visually appealing, and thus you think it's empty of meaning. As an experiment, you should do this: take the text of Ware's novel *Jimmy Corrigan* and remove the images from it. Type the words onto a computer and see what you end up with. Without the art, you'll still have something profound, written with consummate skill and economy. Ware's writing is as subtle and delicate—in subject matter and execution—as anything the genre has produced. Read Ware's essays; read his tiny-type apologies, for god's sake. This is a great writer who also knows how to draw. As I've said before, to punish him for having two skills—which some people want to do, for they cannot hold both concepts in their minds at once—is just silly.

D.P.: *Sorry to have exasperated you.*

S.P.: Indeed you have. But thank you for saying you're sorry.

## Closing Monologue about Ware and Nostalgia and a Restatement of the Role of Beauty

Most of what Ware produces is soaked in melancholy and nostalgia. And the nostalgic images he uses depict scenes from a life he couldn't really have known—the Chicago World's Fair of 1911, for example, or the period when ragtime held sway. His covers have a floridness (floridity?) and a patterned intensity reminiscent of Arts and Crafts and sometimes Art Deco. But all of this is in the service of the mood and of beauty in general. The World's Fair images, some of Ware's best work, probably wouldn't have been included in the novel were they not so beautiful. They serve the plot only insomuch as they serve Ware's, and our, desire to see his protagonists—almost always brutally lonely men who never have hair—exist along with the most delicate and impermanent kind of architecture. It's clear that Ware looks fondly back to a time before modernism crushed almost all of art's flourishes, eccentricities, and organic forms. But instead of simply reappropriating old forms, he channels the past by sublimating it, creating a style that, in the end, is sui generis, and almost untraceable to any artist before him. And that, finally, is one of the most interesting things about Ware's art: he really has no stylistic predecessors, and he has no imitators, either. No one can do what he does, so no one is even trying. That, like Ware's art, is simultaneously depressing and enormously heartening.

**282** Chris Ware
Drawing for *Jimmy Corrigan, The Smartest Kid on Earth*, 1994
Pen and ink with brush, colored pencil, and opaque white
23 ¾ x 15 inches
Collection of the artist

HA HA YOU REMEMBER THAT ONE? THE COMIC SCENE...THAT WAS GOOD

POOR OLD "UNCLE TOM"... :snfff:

HA HA

:fff:

HA HA I LIKED THE PICTURE SLIDE WITH THE PIE BEST, DIDN'T YOU?

:snfff: HA HA :fff: DIDN'T YOU LIKE THAT?

GRAB

I DON'T CARE WHAT IT IS -- IF IT IS ON SOMEONE ELSE'S PROPERTY IT IS STEALING, LITTLE MISTER!

WHAT IF EVERYONE SIMPLY TOOK WHATEVER THEY WANTED? HMM?

I SAW THAT    GIVE IT TO ME...NOW

WHAT IF EVERYONE WHO WENT BY HERE TOOK ONE? WHAT WOULD BE LEFT?

HMM? THEN WHERE WOULD WE BE?

# SELECTED BIBLIOGRAPHY

Adelman, Bob, ed. *Tijuana Bibles: Art and Wit in America's Forbidden Funnies, 1930s–1950s*. New York: Simon and Schuster, 1997.

Bang, Derrick. *50 Years of Happiness: A Tribute to Charles M. Schulz*. Englewood, Colo.: Peanuts Collectors Club, 1999.

Barrier, Michael, and Martin Williams. *A Smithsonian Book of Comic Book Comics*. Washington, D.C./New York: Smithsonian Institute Press/Harry N. Abrams, Inc., 1981.

Beauchamp, Monte, ed. *The Life and Times of R. Crumb: Comments from Contemporaries*. New York: St. Martin's Griffin, 1998.

Becattini, Alberto, and Antonio Vianovi, eds. *Profili Caniff—Milton Caniff: American Stars and Strips*. Florence: Italy: Glamour International Productions, 2001.

Becker, Stephen. *Comic Art in America*. New York: Simon and Schuster, 1959.

Benton, Mike. *Masters of Imagination: The Comic Book Artists Hall of Fame*. Dallas: Taylor Publishing Company, 1994.

———. *The Comic Book in America*. Dallas: Taylor Publishing Company, 1989.

Blackbeard, Bill, and Dale Crain, eds. *The Comic Strip Century*. 2 vols. Englewood Cliffs, N.J.: O.G. Publishing Corp., 1995.

Blackbeard, Bill, and Martin Williams, eds. *The Smithsonian Collection of Newspaper Comics*. Washington, D.C: Smithsonian Institution Press and New York: Harry N. Abrams, Inc., 1977.

Callahan, Bob, ed. *The New Smithsonian Book of Comic-Book Stories*. Washington D.C.: Smithsonian Books, 2004.

Canemaker, John. *Winsor McCay: His Life and Art*. New York: Abbeville Press, 1987.

Canemaker, John. *Winsor McCay*. Berkeley, Calif.: University of California Press, 1981.

Caniff, Milton, Arthur and Robert C. Harvey, ed. *Milton Caniff: Conversations*. Jackson, Miss.: University Press of Mississippi, 2002.

Carlin, John, and Sheena Wagstaff. *The Comic Art Show: Cartoons and Painting in Popular Culture*. Exh. cat. New York: Whitney Museum of American Art, 1983.

Caswell, Lucy Shelton, ed. *See You in the Funny Papers*. Columbus: Ohio State University Libraries, 1995.

———. *Historic Virtuoso Cartoonists*. Columbus: Ohio State University Libraries, 2001.

Clark, Alan, and Laurel Clark. *Comics: An Illustrated History*. London: Greenwood, 1991.

*Coconino World*. http://www.coconino-world.com/

*Comics Research Bibliography*. http://www.ComicsResearch.org/

Couch, N. C., Christopher, and Stephen Weiner. *The Will Eisner Companion*. New York: DC Comics, 2004.

Couperie, Pierre, and Maurice Horn. *A History of the Comic Strip*. New York: Crown Publishers, 1968.

Crumb, Robert. *Yeah, But is it Art?* Exh. cat. Cologne, Germany: Museum Ludwig und Verlag der Buchhandlung Walter König, 2004.

———. *The R. Crumb Checklist II*. Portland, Ore.: CounterMedia, 1992.

Daniels, Les. *DC Comics: Sixty Years of the World's Favorite Comic Book Heroes*. Boston: Little, Brown & Company, 1995.

———. *Marvel: Five Fabulous Decades of the World's Greatest Comics*. New York: Harry N. Abrams, Inc., 1993.

———. *Comix: A History of Comic Books in America*. New York: Bonanza Books, 1971.

Diehl, Digby. *Tales from the Crypt: The Official Archives*. New York: St. Martin's Press, 1996.

Dooley, Michael, and Steven Heller, eds. *The Education of a Comics Artist: Visual Narrative in Cartoons, Graphic Novels, and Beyond*. New York: Allworth Press, 2005.

Duin, Steve, and Mike Richardson. *Comics: Between the Panels*. Milwaukee: Dark Horse Comics, 1998.

Eisner, Will. *Comics and Sequential Art*. Tamarac, Fla.: Poorhouse Press, 1985.

———. *Graphic Storytelling*. Tamarac, Fla.: Poorhouse Press, 1996.

*Will Eisner*. http://www.willeisner.com/

Estren, Mark James. *A History of Underground Comics*. Berkeley, Calif.: Ronin Publishing, Inc., 1974.

Feiffer, Jules. *The Great Comic Book Heroes*. New York: The Dial Press, 1965.

Feininger, Lyonel, Ulrich Luckhardt, and Matthias Mühling. *Lyonel Feininger: Menschenbilder*. Ostfildern, Germany: Hatje Cantz Verlag, 2004.

Fiene, Donald M. *R. Crumb Checklist of Work and Criticism: With a Biographical Supplement and a Full Set of Indexes*. Cambridge, Mass.: Boatner Norton Press, 1981.

Forget, Thomas. *Art Spiegelman*. New York: Rosen Publications, 2005.

Garrick, P. R. *Masters of Comic Book Art*. New York: Images Graphiques, 1978.

Geis, Deborah R., ed. *Considering "Maus": Approaches to Art Spiegelman's "Survivor's Tale" of the Holocaust*. Tuscaloosa, Ala.: University of Alabama Press, 2003.

Geissman, Grant. *Foul Play: The Art and Artists of the Notorious 1950s EC Comics*. New York: HarperCollins Publishers, 2005.

———. *Tales of Terror: The EC Companion*. Seattle: Fantagraphics Books, 2000.

George, Milo, Gary Groth, and Donald Phelps. *R. Crumb*. Seattle: Fantagraphics Books, 2004.

Goulart, Ron. *Over 50 Years of American Comics*. Lincolnwood, Ill.: Publications International, Ltd., 1991.

———. *The Encyclopedia of American Comics*. New York: Facts On File, 1990.

———. *The Funnies: 100 Years of American Comic Strips*. Holbrook, Mass.: Adams Publishing, 1995.

———. *The Great History of Comic Books: The Definitive History from the 1880s to the 1980s*. Chicago: Contemporary Books, 1986.

———. *The Adventurous Decade: Comic Strips in the Thirties*. New Rochelle, N.Y.: Arlington House, 1975.

———. *The Great Comic Book Artists*. New York: St. Martin's Press, 1986.

Grandinetti, Fred M. *Popeye: An Illustrated History of E. C. Segar's Character in Print, Radio, Television and Film Appearances, 1929–1993.* Jefferson, N.C.: McFarland & Company, 1994.

Groensteen, Thierry. *Krazy Herriman.* Angoulême, France: Musée de la Band Dessinée, 1997.

———. *Popeye: Est C'Qu'il est Voila Tout C'Quil Est.* Angoulême, France: Musée de la Band Dessinée, 2001.

Groth, Gary, ed. *The Comics Journal.* Seattle, Wash.: Fantagraphics Books, 1976–present.

Harvey, Robert C. *The Art of the Funnies: An Aesthetic History.* Jackson, Miss.: University Press of Mississippi, 1994.

———. *Children of the Yellow Kid.* Exh. cat. Seattle: Frye Art Museum, 1998.

———. *The Genius of Winsor McCay.* Columbus: Ohio State University Libraries, 1998.

Heintjes, Todd, ed. *Hogan's Alley.* Atlanta, Ga., 2002–present.

Heller, Steven. *The Graphic Design Reader.* New York: Allworth Press, 2002.

Herriman, George. *Krazy & Ignatz, 1931–1932: "A Kat Alilt with Song."* Edited by Bill Blackbeard and Derya Ataker. Seattle: Fantagraphics Books, 2004.

Higgs, Mike. *Popeye: The 60th Anniversary Collection.* London: Hawk Books, 1989.

Hignite, M. Todd, ed. *Comic Art Magazine.* St. Louis, Mo.

Hirschfield, Al, Jules Feiffer, Art Spiegelman, and Chris Ware. *The Comics Journal Special Edition: Winter 2004: Four Generations of Cartoonists.* Seattle: Fantagraphics Books, 2003.

Holm, D. K., ed. *R. Crumb Conversations.* Jackson, Miss.: University Press of Mississippi, 2004.

Horn, Maurice, ed. *75 Years of the Comics.* Boston: Boston Book and Art, Publisher, 1971.

———. *100 Years of American Newspaper Comics.* New York: Gramercy Books, 1996.

———. *The World Encyclopedia of Cartoons.* Detroit: Gale Research Company, 1980.

———. *The World Encyclopedia of Comics.* Philadelphia: Chelsea House Publishers, 1999.

Howe, Sean, ed. *Give our Regards to the Atomsmashers! Writers on Comics.* New York: Pantheon Books, 2004.

*Image and Narrative.* http://www.imageandnarrative.be/

*Indy Magazine.* http://www.indyworld.com/indy/

Inge, M. Thomas. *Comics as Culture.* Jackson, Miss.: University Press of Mississippi, 1990.

———. *Great American Comics.* Columbus: Ohio State University Libraries and Smithsonian Institution, 1990.

———. *The American Comic Book.* Columbus: Ohio State University, 1985.

———, ed. *Charles M. Schulz: Conversations.* Jackson, Miss.: University Press of Mississippi, 2000.

Johnson, Rheta Grimsley. *Good Grief: The Story of Charles M. Schulz.* New York: Pharos Books, 1989.

Juno, Andrea, ed. *Dangerous Drawings: Interviews with Graphix & Comix Artists.* New York: Juno Books, 1997.

Katz, Harry L., and Sara W. Duke. *Featuring the Funnies: One Hundred Years of the Comic Strip.* Washington, D.C.: Library of Congress, 1995.

Kidd, Chip, ed. *Peanuts: The Art of Charles M. Schulz.* New York: Pantheon Books, 2001.

King, Frank, and Chris Ware, ed. *Walt and Skeezix: Book One.* Montreal: Drawn & Quarterly Books, 2005.

Kunzle, David. *The History of the Comic Strip: The Nineteenth Century.* Berkeley, Calif.: University of California Press, 1990.

———. *The History of the Comic Strip: The Early Comic Strip*, vol. 1. Berkeley, Calif.: University of California Press, 1973.

Kurtzman, Harvey. *My Life As A Cartoonist.* New York: Simon & Schuster, Inc. 1988.

Kurtzman, Harvey. *From Aargh! To Zap! Havey Kurtzman's Visual History of the Comics.* New York: Prentice Hall Press, 1991.

Lent, John A., ed. *The International Journal of Comic Art.* Drexel Hill, Penn., 1999–present.

Maeder, Jay. *Dick Tracy: The Official Biography.* New York: Plume, 1990.

Marschall, Richard. *Daydreams and Nightmares: The Fantastic Visions of Winsor McCay.* Westlake Village, Calif.: Fantagraphics Books, 1988.

———. *America's Great Comic-Strip Artists.* New York: Abbeville Press, 1989.

———. *The Best of "Little Nemo in Slumberland."* New York: Stewart, Tabori & Chang, 1997.

———, and John Paul Adams. *Milton Caniff: Rembrandt of the Comic Strip.* Endicott, N.Y.: Flying Buttress Publications, 1981.

Martin, John. *The Archival Collection of R. Crumb, 1958–1986.* Santa Barbara, Calif.: Am Here Books, 1986.

McDonnell, Patrick, Karen O'Connell, and Georgia Riley de Havenon, eds. *Krazy Kat: The Comic Art of George Herriman.* New York: Harry N. Abrams, Inc., 1986.

Murrell, William. *A History of American Graphic Humor (1865–1938).* New York: Macmillan, 1938.

Nadel, Dan, ed. *The Ganzfeld.* New York: PictureBox, Inc., 2000–present.

*The R. F. Outcault Society's* Yellow Kid *Site.* http://www.neponset.com/yellowkid/index.htm

Orvell, Miles. *Writing Posthistorically: Krazy Kat, Maus and Contemporary Fiction Cartoons.* American Literary History 4, 1992.

O'Sullivan, Judith. *The Great American Comic Strip: One Hundred Years of Cartoon Art.* Boston: Little, Brown & Company, 1990.

Panter, Gary. *Jimbo: Adventures in Paradise.* New York: Pantheon, 1988.

*Gary Panter.* http://www.garypanter.com/

Phelps, Donald. *Reading the Funnies.* Seattle: Fantagraphics Books, 2001.

Poplaski, Peter, ed. *The R. Crumb Coffee Table Art Book.* Northampton, Mass.: Kitchen Sink Press, 1997.

———. *The R. Crumb Handbook.* London: MQ Publications LTD, 2005.

Raeburn, Daniel. *Chris Ware: Monographics.* New Haven, Conn.: Yale University Press, 2004.

RAW (*A Tribute Website*). http://www.garethkaple.com/raw/raw.html

Reidelbach, Maria. *Completely MAD: A History of the Comic Book and Magazine.* Boston: Little Brown & Company, 1991.

Reitberger, Reihold, and Wolfgang Fuchs. *Comics: Anatomy of a Mass Medium.* Boston: Little, Brown & Company, 1971.

Roberts, Garyn G. *Dick Tracy and American Culture.* Jefferson, N.C.: McFarland & Company, 1993.

Robinson, Jerry. *The Comics: An Illustrated History of Comic Strip Art.* New York: G. P. Putnam's Sons, 1974.

———. *Cartoon: A Celebration of American Comic Art.* Washington, D.C.: John F. Kennedy Center for the Performing Arts, 1975.

Rosenkrantz, Patrick. *Rebel Visions: The Underground Comix Revolution, 1963–1975.* Seattle: Fantagraphics Books, 2002.

*The Rozz-Tox Manifesto.* http://www.altx.com/manifestos/rozztox.html

Sabin, Roger. *Comics, Comix & Graphic Novels.* London: Phaidon Press, Ltd., 1996.

Sagendorf, Bud. *Popeye: The First Fifty Years.* New York: Workman Publishing, 1979.

Sanderson, Peter. *Marvel Universe.* New York: Harry N. Abrams, Inc., 1996.

Scheyer, Ernst. *Lyonel Feininger: Caricature and Fantasy.* Detroit: Wayne State University Press, 1964.

Schulz, Charles M. *Around the World in 45 Years.* Kansas City: Andrews and McNeel, 1994.

———. *Peanuts: A Golden Celebration.* New York: HarperCollins Publishers, 1999.

———. *Peanuts Jubilee.* New York: Holt, Rinehart and Winston, 1975.

———. *You Don't Look 35, Charlie Brown!* New York: Holt, Rinehart and Winston, 1985.

Schumer, Arlen. *The Silver Age of Comic Book Art.* Portland, Ore.: Collector's Press, 2003.

Sheridan, Martin. *Comics and Their Creators: Life Stories of American Cartoonists.* Westport, Conn.: Hyperion Press, 1971.

Skinn, Dez. *Comix: The Underground Revolution.* New York: Thunder's Mouth Press, 2004.

Spiegelman, Art. *Art Spiegelman: Comix, Graphics, Essays & Scraps.* New York: Raw Books, 1999.

———. *In the Shadow of No Towers.* New York: Pantheon, 2004.

Steranko, James. *The Steranko History of Comics: Volume One.* Reading, Penn.: Supergraphics, 1970.

———. *The Steranko History of Comics: Volume Two.* Reading, Penn.: Supergraphics, 1972.

Storr, Robert. "Art Spiegelman's Making of *Maus*." *Tampa Review* 5 (1992): 27-30.

Thompson, Ilse, ed. *Your Vigor for Life Appalls Me: Robert Crumb Letters, 1958–1977.* Seattle: Fantagraphics Books, 1998.

Trimboli, Gionvanni. *Charles M. Schulz: 40 Years Life and Art.* New York: Pharos Books, 1990.

Walker, Brian. *The Comics Before 1945.* New York: Harry N. Abrams, Inc., 2004

———. *The Comics Since 1945.* New York: Harry N. Abrams, Inc., 2002

———. *The Sunday Funnies: 100 Years of Comics in American Life.* Bridgeport, Conn.: The Barnum Museum, 1994.

Ware, Chris. *Jimmy Corrigan, The Smartest Kid on Earth.* New York: Pantheon, 2000.

Waugh, Coulton. *The Comics.* New York: Macmillan, 1947.

Weschler, Lawrence. *Shapinsky's Karma, Bogg's Bills and other True-life Tales.* San Francisco: North Point Press, 1988.

White, David Manning, and Robert H. Abel, eds. *The Funnies: An American Idiom.* New York: The Free Press of Glencoe/Macmillan, 1963.

Witek, Joseph. *Comic Books as History: The Narrative Art of Jack Jackson, Art Spiegelman, and Harvey Pekar.* Jackson, Miss.: University Press of Mississippi, 1989.

Wood, Art. *Great Cartoonists and Their Art.* Gretna, L.A.: Pelican Publishing Company, 1987.

Wyman, Ray, Jr. *The Art of Jack Kirby.* Orange, Calif.: The Blue Rose Press, Inc., 1992.

Yoe, Craig. *Weird But True Toon Factoids.* New York: Gramercy Books, 1999.

Yronwode, Catherine, and Denis Kitchen. *The Art of Will Eisner.* Princeton, Wis.: Kitchen Sink Press, 1982.

## REPRODUCTION CREDITS

**283** R. Crumb
Drawing for cover of *Artistic Comics*
(published 1973)
Pen and ink, 12 x 9 inches
Collection of Art Spiegelman